AMERICAN PRINTS AND PRINTMAKERS

AMERICAN PRINTS AND PRINTMAKERS

A chronicle of over 400 artists and their prints from 1900 to the present

UNA E. JOHNSON

Doubleday & Company, Inc., Garden City, New York 1980

TO THE AMERICAN ARTIST whose prints have made this chronicle possible

BOOK DESIGN BY BEVERLEY GALLEGOS

LIBRARY OF CONGRESS CATALOGING IN PUBLICATION DATA JOHNSON, UNA E.

AMERICAN PRINTS AND PRINTMAKERS. BIBLIOGRAPHY: P. 255.

INCLUDES INDEX. I. PRINTS, AMERICAN. 2. PRINTS—20TH CENTURY—

UNITED STATES. 3. PRINTMAKERS—UNITED STATES. I. TITLE. NE508.J63 769.92′2

ISBN: 0-385-14921-2 LIBRARY OF CONGRESS CATALOG CARD NUMBER 79–8931

CONTENTS

LIST OF ILLUSTRATIONS

Measurements for all intaglio prints refer to the plate mark. In all other media, measurements refer to the actual image unless otherwise noted. Height precedes width.

COLOR ILLUSTRATIONS

1 SCHANKER, LOUIS (b. 1903), *Carnival,* 1948. Woodcut, 14¼×21 (36.2×53.4). Collection, The Brooklyn Museum. (See p. 82.) *following page 42*

2 PRENDERGAST, MAURICE (1859–1924), *Children at Play,* c. 1901. Monotype, 7⅛×11½ (18×29.2). Collection, The Brooklyn Museum. (See p. 8.)

3 DAY, WORDEN (b. 1916), *Mandala II,* 1957. Woodcut, 22×22½ (56×57.2). Collection, The Brooklyn Museum. (See p. 86.)

4 YUNKERS, ADJA (b. 1900), *Ostia Antica IV, Roma,* 1955. Woodcut, 21¼×35¼ (54×89.5). Collection, The Brooklyn Museum, Dick S. Ramsay Fund. (See p. 92.)

5 RYAN, ANNE (1889–1954), *In a Room,* 1947. Woodcut, 13¼×15⅝ (35.2×39.5). Private collection. Photographer, Scott Hyde. (See p. 92.)

6 CASARELLA, EDMUND (b. 1920), *Triggered,* 1959. Cardboard relief, 27⅛×20⅝ (69×52.5). Courtesy of Sidney Mehlman. Photographer, Scott Hyde. (See p. 134.)

7 BOLOTOWSKY, ILYA (b. 1907), *Rectangle Red, Yellow,* 1974. Screen print, 35×26 (89×66). Photo courtesy Grace Borgenicht Gallery. (See p. 141.)

8 OLDENBURG, CLAES (b. 1929), *Floating Three-Way Plug,* 1976. Etching, aquatint, 42×32¼ (106.5×82). Photo courtesy The Brooklyn Museum. (See p. 148.)

9 PONCE DE LEON, MICHAEL (b. 1922), *Succubus,* 1967. Cast-paper, collage, 22¼×24 (56.3×61). Photo courtesy Pioneer-Moss Reproductions Corp. (See p. 158.) *following page 106*

10 JOHNS, JASPER (b. 1930), *Plate No. 6 after Untitled,* 1975. Lithograph, 30⅛×29¾ (76.5×75.5). Photo courtesy Gemini G.E.L. (See p. 180.)

11 ALBERS, JOSEF (1888–1976), *Variant IX* from *Ten Variants,* 1967. Screen print, 17×17 (sheet) (43.3×43.3). Photo courtesy The Brooklyn Museum. (See p. 186.)

12 YOUNGERMAN, JACK (b. 1926), *Untitled,* Plate I from *Suite of Changes,* 1970. Screen print, 43×33 (sheet) (109.2×84). Photo courtesy Pace Editions. (See p. 188.)

13 PETERDI, GABOR (b. 1915), *Poppies of Csobanka I,* 1977. Relief etching and engraving, 23¾×35½ (60.6×90). Photo courtesy Jane Haslem Gallery. Photographer, John R. Tennant. (See p. 194.)

14 MOTHERWELL, ROBERT (b. 1915), *The Wave,* 1974–78. Soft ground etching with collage, 31×26 (78.7×66). Photo courtesy Brooke Alexander, Inc., New York. (See p. 189.)

15 SCHRAG, KARL (b. 1912), *Portrait of Bernard Malamud,* 1970. Aquatint, 24×18 (61×45.8). Photo courtesy Kraushaar Galleries. (See p. 194.)

following page 138

following page 202

BLACK AND WHITE ILLUSTRATIONS

ACKNOWLEDGMENTS

The present work was carried out in its earlier stages by research grants from the Rockefeller Foundation and from the Chapelbrook Foundation. Many American artists have freely shared their insights and information concerning their prints and I am grateful for their many courtesies.

Generous cooperation and helpful information has been received from many others. Included are Clinton Adams, Director of the Tamarind Institute, University of New Mexico; Brooke Alexander, Director of Brooke Alexander, Inc., New York; Rachel M. Allen, Assistant Chief, Office of Visual Resources, Smithsonian Institution, Washington, D.C.; Stephen B. Andrus, Director of Impressions Gallery and Workshop, Boston, Massachusetts; Karen F. Beall, Curator of Fine Prints, Library of Congress; Robert Blackburn, Director of The Printmaking Workshop, New York; Maurice Bloch, Director of the Grunewald Center for the Graphic Arts, University of California, Los Angeles; Grace Borgenicht Brandt, Director of the Borgenicht Gallery, New York; Michael Botwinick, Director of The Brooklyn Museum; Department of Prints and Drawings, The Brooklyn Museum, with special appreciation to Ripley Albright and Dorothy Weiss; Jacqueline Brody, Editor of The Print Collector's Newsletter, New York; Kathan Brown, Director of Crown Print Press, Oakland, California; Riva Castleman, Director, and Alexandra Schwartz, Assistant in Research, Department of Prints and Illustrated Books, The Museum of Modern Art, New York; Sylvan Cole, Director, and Susan Teller, Assistant in Research, Associated American Artists, Inc., New York; Virginia Dehn, New York; Gertrude Denis, Director of The Weyhe Gallery, New York; Terry Dintenfass, Director of Dintenfass Gallery, New York; Fendrick Gallery,

Washington, D.C.; Alan Fern, Director of Research, Library of Congress, Washington, D.C.; Janet A. Flint, Curator of Prints, National Collection of Fine Arts, Smithsonian Institution, Washington, D.C.; Gemini, G.E.L., Los Angeles, California; Amy Goldstein, Pace Editions, New York; Miriam Goodman, Director, Multiples, Inc., New York; Amy Greenberg, Martha Jackson Gallery, New York; Tatyana Grosman, Director, Universal Limited Art Editions, West Islip, New York; Jane Haslem Gallery, Washington, D.C.; Sinclair Hitchings, Curator of Prints, The Boston Public Library; Colta Fellers Ives, Curator, Department of Prints, Metropolitan Museum of Art, New York. Arno Jakobson, Photographer, in charge of Photographic Services, The Brooklyn Museum; Harold Joachim, Curator of Prints and Drawings, The Art Institute of Chicago; Kennedy and Company, Fine Print Room, New York; Antoinette Kraushaar, Director of Kraushaar Galleries, New York; John Lefebre Gallery, New York; William S. Lieberman, Chairman of Twentieth Century Art, Metropolitan Museum of Art, New York; Kneeland McNulty, Curator of Prints, Philadelphia Museum of Art; Sidney Mehlman, New York; Midtown Galleries, New York; Jo Miller, Director of The Print Cabinet, Wilton, Connecticut; Pace Editions and Pace Gallery, New York; Dorothy and Leo Rabkin, New York; Lessing J. Rosenwald, Collector and Founder of Alverthorpe Gallery, Jenkintown, Pennsylvania; Elizabeth Roth, Keeper, and Robert Rainwater, Assistant, The New York Public Library; Karl and Ilse Schrag, New York; Samuel Shore, Director of Shorewood Publishers, New York; Andrew Stasik, Director of Pratt Graphics Center, New York; Martin Sumers Graphics, New York; Stanley Tankel, Pioneer-Moss Reproductions, Corp., New York; Francine

Tyler, Writer and Researcher in Prints, New York; Jean Anne Vincent, Senior Editor, and Ann Sleeper, Assistant to the Editor, Doubleday & Company, Inc., New York; The Washburn Gallery, New York; June Wayne, former Director of Tamarind Lithography Workshop, Los Angeles, California; Zabriskie Gallery, New York; Peggy Zorach, Art Librarian, The Brooklyn Museum.

And, lastly, a special appreciation to the late John Gordon for his perceptive views of twentieth-century American art and his long encouragement of the present work.

PROLOGUE

A chronicle of twentieth-century American prints must concern itself with professional artists—usually painters and sculptors—who employ the extensive media of the fine print as another means of creative expression. Within this framework the present volume attempts to sketch the principal graphic developments in the United States during the past three quarters of this century, from 1900 to the late 1970s.

Many renowned artists through past centuries have pursued a lively and noteworthy graphic expression along with their painting or sculpture. The informal and less self-conscious print becomes a vehicle wherein an artist may capture and delineate a unique point of view. It may herald an entirely new train of thought in his painting or sculpture. The artist's response to his time in terms of repeatable images has been demonstrated in the prints of Degas, Gauguin, Munch, Toulouse-Lautrec, Kollwitz, Kirchner, Nolde, Villon, Segonzac, Matisse, Chagall, Rouault, and Picasso, to mention but a few of the distinguished modern European masters.

The changing drama of the twentieth-century print in the United States is played within a loosely defined, nationwide community of artists who have steadfastly pursued the dictates of their own particular vision. Many live and work not only on the East and West coasts but also in other areas of the United States. They often have traveled and studied abroad; some have lived in European countries for extended periods of time. Still others were born and grew up in Europe or in the Orient. Perhaps the vigorous development of the American print lies partly with the métier itself—a métier that encompasses various approaches and widely differing points of view. There are artists who enjoy and who are inspired by a media whose very technologies challenge their abilities to create a full graphic statement that has all the fluency and force of any well-conceived work of art. A chronicle of the modern American print must give credence to "the new" and its flamboyant imagery, or lack of it, as well as to the accomplishments of those artists who, with imagination, skill, and a consistent personal idiom, clarify and enliven the visual language of the twentieth-century print. Unfortunately for writer as well as reader this development does not always fall neatly into regular decades of progress or change. The interweaving of ideas, styles, or movements and the cultivation of new print technologies create differing images and changing patterns of perception. The present chronicle is loosely presented in decades but acknowledges the fluidity of time and the changing or recurring visual sensibilities that characterize this century.

The term print or graphic art in this study refers to those works of art achieved through the specific processes known in printmaking as relief, intaglio, lithography, and other surface printing methods. These include woodcut, engraving, etching, drypoint, lithography, and screen printing singly or in combination with specific processes including photography or photographic aids, and occasionally with commercial printing methods. Numerous and important essays and catalogs on the works of individual American artists have been published. Also, different decades of work have been presented in national and regional exhibitions. Surprisingly enough at the present time no single volume that addresses itself to a general survey of the American print in this century has been made. It is the hope of the author that others—artists and writers—will continue to enlarge and perhaps change some of the views presented in the present work.

New York, 1979 U.E.J.

And if imitating nature is as difficult as it is admirable when one succeeds in doing so, some esteem must be shown toward him who, holding aloof from her, has had to put before the eyes forms and attitudes that so far have existed only in the human mind . . .

<div align="right">

from the announcement of Goya's Los Caprichos *published in* Diario de Madrid, *February 6, 1799.*

</div>

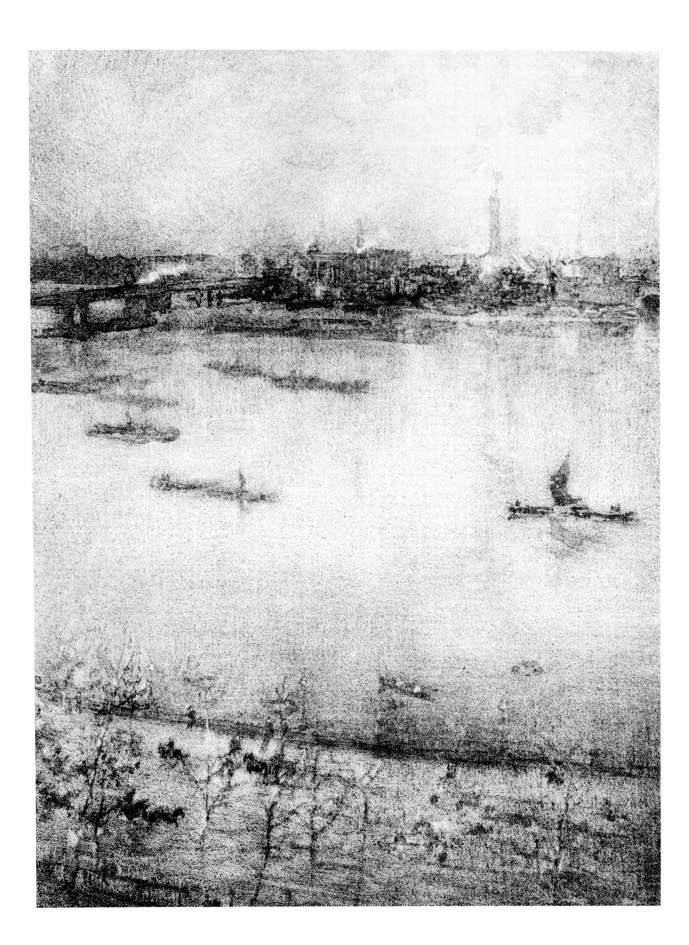

1 WHISTLER, JAMES McNEILL (1834–1903), *The Thames,* 1896. Lithotint, 10½×7⅝
(26.5×19.4). Collection, The Brooklyn Museum, Gift of Harold K. Hochschild.

THE EARLY DECADES-
1900 THROUGH THE 1930s

Influence of Whistler • Early Development of the Color Print in the United States • Changing Modes and the Pictorial Tradition • The Figurative Print and the American Scene • Mexican Influence • New Ventures • The Federal Arts Project • Regionalism • Toward an Abstract Image • The American Print in Public View

INFLUENCE OF WHISTLER

American printmaking in the early years of the twentieth century was dominated by the imposing shadow of a colorful expatriate, James McNeill Whistler, and his English colleagues. Although his last print was issued in 1900–1 and he died in 1903, Whistler's influence extended far into this century. Easily at home in both French and English, he was capable of attacking his detractors with nimble wit and convincing logic. He was impatient with the Victorian artists and their "storytelling" prints and paintings. If his hand recorded vitriolic attacks on his critics, it also created etchings and lithographs of singular clarity. In 1896 Whistler composed six lithographic views of London. Of the series *The Thames,* a lithotint is the most famous and the most avant-garde in its unusual layerings of soft grays touched with fugitive whites and faint blacks. Its fine atmospheric quality was obtained through subtle reapplications on the lithographic stone of slight washes of tusche and scarcely visible scrapings. A fastidious craftsman, Whistler once observed that a picture is finished when all trace of the means used to bring about the end has vanished. In *The Thames* Whistler brought a fresh and challenging vision to the everyday scene. Perhaps

his orchestration of infinite variety of gray tones was to be rivaled in the United States by the lithographs of Charles Sheeler in the 1920s and those of Jasper Johns in the 1960s. Whistler's immediate followers, nonetheless, were chiefly influenced by the brilliance and scope of his etchings and drypoints that formed the greater part of his graphic oeuvre.

Among his followers were a number of American artists whose early training had been chiefly in architecture. Enterprisingly enough, they employed their draftsman's training and knowledge of historic European architecture as a means of realizing a "grand tour" of Europe and the Near East. The logical media were etching and drypoint, made famous by Rembrandt, Meryon, Whistler, and Haden.

Series of Italian and French views and the miscellaneous reportorial architectural notations were astutely promoted by successful art dealers in the United States and Great Britain. These artists were able to capitalize on the prevailing desire of well-to-do Americans of the period to be worldly collectors of fashionable and precious arts. They achieved a specialized technical brilliance, and their work was in reality a visual travelogue through the European scene.

Assiduously following the current academic point of view, their dismissal of the experimental work of the Fauves in Paris, Die Brücke in Munich, and the Futurists in Milan removed them from the changing visual emphasis of the twentieth century. Cubism at its height in Paris was seldom reflected in American prints of the time. Perhaps the disciplined conservatism of the architectural training of these printmakers permitted little experimentation. Also, the American artists who made prints in Europe were often more in sympathy with the English vision of romantic realism than with the probings of the avant-garde on the Continent. Heedful of their dealers' insistence that prints of the American scene were neither fashionable nor marketable, they, along with their British colleagues, turned out scores of picturesque European views.

Joseph Pennell was Whistler's most ardent admirer and follower. His prodigious oeuvre between 1877 and 1924 records, within the prevailing tradition, his indefatigable interest in the American and European pictorial scene. His lithographs of 1912, making up his *Panama Canal* series, present his favorite theme— "the wonder of work"—as do his 1914–17 series of European and American munitions factories. His oeuvre of more than fifteen hundred etchings and lithographs mirrors his restless wanderings, amazing energy, enthusiasm, and his ability to focus onto the surface of a copper plate or lithographic stone the myriad images gleaned from his travels. The extensive range of his prints from charming notations of small streets in Brooklyn Heights to the great munitions centers of World War I give to Joseph Pennell a distinguished place in American graphic expression. To the many students who sought his guidance Pennell was a firm and uncompromising taskmaster who diligently strove to insure the continuance of the Whistlerian vision.

Among the artists whose work often has been ignored or nearly forgotten is Ernest Haskell. He issued 414 prints during the first twenty-five years of the century. He lived and worked in California and in various eastern areas from Florida to Maine. He had gone to Paris in 1897 to pursue his studies independently. After two years abroad he returned to New York, where he designed posters and completed some portrait drawings. His interest in etching developed after meeting Whistler on his second trip to Europe. In 1911 he exhibited his prints, including a few lithographs, in New York, where they were enthusiastically received. By 1915, after extended visits to Florida and to California, the obvious influences of Rembrandt and Whistler disappeared, and he turned to a personal interpretation of nature. His etchings display not only virtuosity, but also considerable power. The drypoint *The Pinnacles* (1915) and the strangely abstract etching *Torse of the Witch* are memorable. The rather baroque etching *Heavenly Hosts* and the vast panorama of nature, *Mirror of the Goddess,* an etching and engraving of 1920–22, show Haskell at the height of his career. Finally in the haunting *Ghost Cypress—Florida,* with its eerie mass of hanging moss, the artist has evoked a mood that is primeval and mysterious. The friend of his days in Maine, John Marin, recalls:

"Although he was a painter of considerable sensitivity most of his working self was expressed through the medium of the etching needle handled by a master who knew his medium and whose medium knew him so that medium and man were welded together."[1]

Cadwallader Washburn, whose work also spans the early decades of the century, was a private pupil of William M. Chase. He studied for two years in Spain under Sorolla and in Paris in 1898 under Albert Besnard. He traveled and worked in Italy in 1903 and the following year served as war correspondent in the Russo-Japanese War. He covered the Maderos insurrection in Mexico in 1908, after which time he became a confirmed world traveler. Returning some years later from a second sojourn in Mexico, his work, including many of the etched plates, was lost in a shipwreck at sea. After many wanderings he returned to Maine, where he had spent much of his childhood. Here he issued his ambitious graphic project, the *Norlands Series* of 1906–10, composed in four sections and totaling sixty drypoints in all. Although Washburn too was influenced by the Whistlerian style, his work has a purity and depth not often seen in the numerous pictorial efforts of his time. He himself remembers:

"In the Norlands drypoints . . . it was my desire to record the varying phases under which

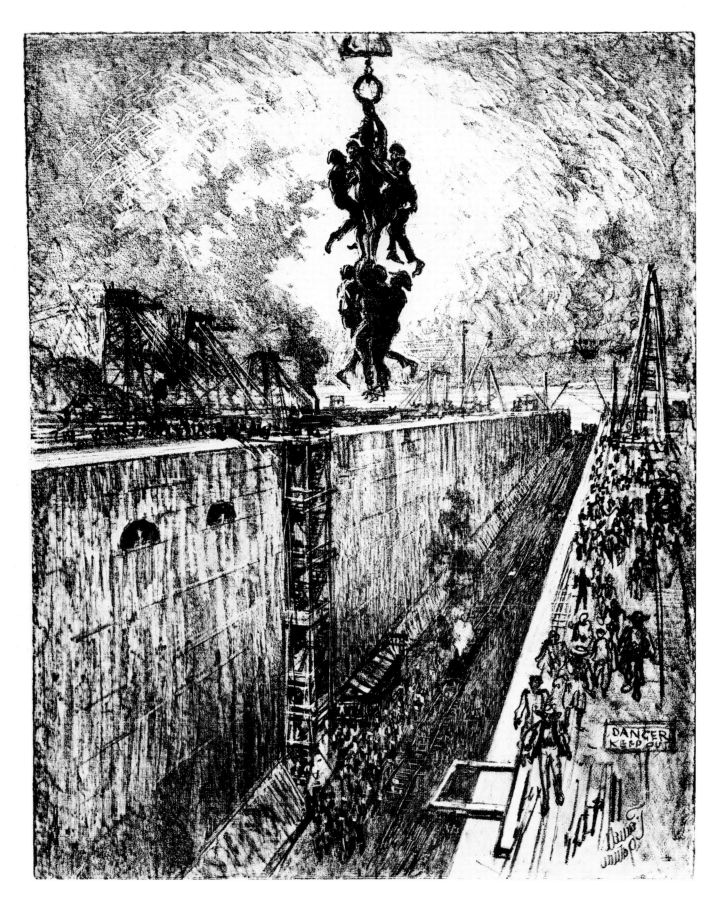

2 PENNELL, JOSEPH (1859–1926), *End of Day, Gatun Locks* from *Panama Canal* series, 1912. Lithograph, 21⅞ × 16⅝ (55 × 42.4). Collection, Library of Congress, Prints and Photographs Division.

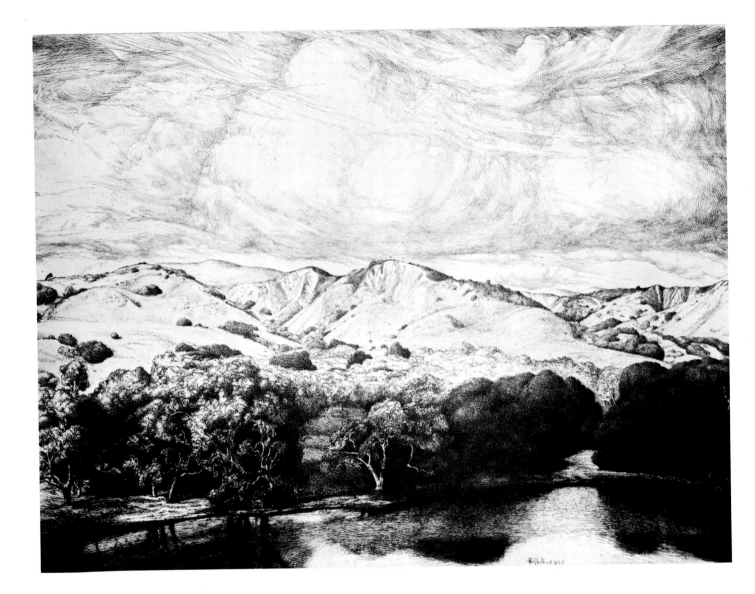

3 HASKELL, ERNEST (1876–1925), *Mirror of the Goddess,* 1920–22. Etching and
drypoint, 8×10 (22.8×30.4). Collection, The Brooklyn Museum, Gift of the Society of
Etchers.

nature has shown herself to me, with such keen appreciation as is possible only to one who has lived in close intimacy with her from childhood."[2]

Examples from the *Norlands Series* are *Creek Ferns* and *Midsummer Pool*, drypoints produced in 1910. In his later *New Jersey Series* of 1914 Washburn continues his impressionist compositions of exquisite sensibility. During his years of travel he made a number of portrait studies which demonstrate his ability for visual analysis of specific personalities.

The graphic work of Ernest Roth reflects even more closely the prevailing Whistlerian influences. Born in Stuttgart in 1879, Roth came to the United States at an early age. He returned to Europe as a young artist in 1905 and remained in Italy and France, with a few brief trips back to the United States, until 1920. He issued numerous etchings of villages and hill towns in Italy and southern France. Roth, as many another American artist had done, made prints as a means of maintaining himself in Europe and by 1914 had issued more than 130 etchings. In his *Hill Towns of Italy*, c. 1914–15, and in some of the series on Spain and France, he captured the mood and the shimmering quality of light that enveloped the landscape. His etching and drypoint entitled *A New Jersey Farm House*, 1916, lightly sketches a modest scene and gives it an atmosphere of antique charm.

Artists of this earlier period preserved much of the nostalgic charm of the late nineteenth century. Such an artist is Donald Shaw MacLaughlin, a Canadian by birth who studied first in Boston and in the 1900s lived in France. In following Robert Browning's travels in Europe, MacLaughlin produced the usual series of English, French, and Swiss views. His oeuvre of some three hundred prints, generally architectural, is stronger and livelier than much of the comparable work of the period. Less characteristic, but basically more original, is his etching called *Road Song No. 1*, 1913.

Lester Hornby, born in Lowell, Massachusetts, in 1882, went to Paris in 1906 and was also one of the large coterie of artists whose work was dominantly influenced by the prevailing tradition rather than by the newer art movements developing about them. Hornby traveled to North Africa in 1908. In 1912 he spent another of his many summers in the Marne Valley living with French peasants. At this time he issued a series of nine etchings under the title *Ciel et Champs* which are personal notations of the Marne countryside. In 1916 Hornby experimented briefly with color etchings, but these efforts were interrupted by World War I. He became an official observer of both French and British mobilizations. In 1918, he was at the Front with the American troops. Provided with a pass by General Pershing, Hornby went in and out among the American armies, through barrages, air raids, and machine-gun fire, participating in the costly advances along the Marne and the Meuse. It was against this background and his more peaceful memories of the region that he later composed his series of twenty-four *Etchings of the Great War*.

Kerr Eby, born in Tokyo, also recorded with exceptional skill the turbulent years of World War I. Perhaps his most famous etching of the war is *September 13, 1918*, commemorating the American troops in the devastating Battle of Saint-Mihiel. A remembered event, it was inspired by his earlier dramatic drawing *The Great Black Cloud* and was issued in 1935. His wide travels throughout France and in North Africa afforded him a rich reserve of subjects which appear in his work from 1910 through the 1930s. Respected by many fellow artists, Kerr Eby was sought out by Childe Hassam for instructions in etching. Years later Eby gave a large number of his etchings to the New York Public Library collection.

A dramatic break in the prevailing romantic tradition soon became evident in the etchings of John Marin. He had gone to Paris in 1905 at the age of thirty-four, and, with Paris as his base, he traveled to the Low Countries, to Italy and England. Under the spell of Whistler, he followed in the older artist's footsteps, and his first etchings of Amsterdam, Venice, and London reflect his admiration. Soon he was setting down his own observations, much to the disappointment of his dealers in New York and Chicago. It has been noted that the greater part of Marin's early etchings were never on the market. He regarded his prints from 1905 to 1911 as failures because he could not interest his dealers in them. Thus

4 WASHBURN, CADWALLADER (1866–1965), *Creek Ferns* from *Norlands* series, No. 2, 1906. Drypoint, 6×12 (15.3×30.3). Collection, The Brooklyn Museum, Dick S. Ramsay Fund.

5 EBY, KERR (1890–1946), *September 13, 1918*, 1935. Etching, 10½ × 15¾ (26.4 × 40.6).
Collection, Library of Congress, Prints and Photographs Division.

he saw no reason to print full editions, and, consequently, they often exist only in a few proofs. Unfortunately, the plates for the early subjects, as well as the few published editions, were either destroyed or lost. From 1905 to 1932, when he made his last print, Marin produced over 130 graphic works, all etchings, with the exception of two engravings. His *Street Scene Paris,* 1907, and *Cathedral, Rouen,* 1909, reminiscent of Whistler's work, have an individual vigor, but they still retain a distinct nineteenth-century flavor. Neither Fauvism nor Cubism colored his European efforts, although he was aware of the experimental movements. On his final return from Europe in 1910, John Marin, in his enthusiasm for the strident rhythms and fast tempo of New York, cast off the last vestiges of the nineteenth century.

He was fascinated, and a little frightened, by this explosive environment. The quickening pace, the swift upward thrust of massive architectural forms and their pulsating lines became a vigorous part of his etchings. In his excitement over new visual elements, he embarked on the fine series of the *Brooklyn Bridge,* 1911–15, and the impressive etching of *The Woolworth Building,* 1913.

At the time of the Armory Show and his own exhibition at the Stieglitz Gallery in 1913, Marin remarked in Whitmanesque prose:

> "I see great forces at work; great movements; the large buildings and the small buildings; the warring of the great and the small; influences of one mass on another greater or smaller mass . . . each subject in some degree to the other's power . . . I can hear the sound of their strife . . . and there is great music being played and so I try to express graphically what a great city is doing."[3]

Thus the greater part of his etchings is devoted to portraying the structural masses of a modern city. Like Édouard Manet before him, Marin was not inhibited by the proprieties of traditional etching methods and brought vigor and a rare vision to the prints of his time.

EARLY DEVELOPMENT OF THE COLOR PRINT IN THE UNITED STATES

There are always a few who rebel against established tradition or are immune to it. Mary Cassatt was one, although her influence on American artists was negligible. Friend of Degas, Berthe Morisot, Camille Pissarro, and other French Impressionists, Mary Cassatt lived and worked in Paris during the late nineteenth and early twentieth centuries. Her brilliant color prints were issued just prior to 1900. Shortly thereafter she produced a number of etchings, drypoints, and a few lithographs that reflected her impeccable taste and pursuit of unacademic art. Also, it was her sound judgment and taste that were relied upon by a few wise American collectors who went to Paris in the 1890s and early 1900s to buy works of art. Among Mary Cassatt's most characteristic and accomplished prints of this later period are *Jeannette and Her Mother Seated on a Sofa,* a drypoint of 1901, and *Sara Wearing a Bonnet and Coat,* c. 1904, in transfer lithography—a method of printmaking she used late in life.

An early pioneer in the modern color print in the United States was Maurice Prendergast, although he received little recognition as an artist until after the Armory Show in 1913. He studied at the Académie Julien in Paris in 1891, and in 1892 he first began experimenting in the medium of the monotype. He was influenced by the work of Cézanne, Seurat, and other Post-Impressionists. A later visit to Paris brought to his work an even greater freedom in the use of color and simplification in his compositions. This new freedom and engaging point of view are clearly noted in his monotypes. (See color illustration no. 2.) Basic forms are carried out in deft color notations. Friends recalled that Prendergast, after his return to Boston, had no room in his cramped quarters for a work bench. He made his monotypes on the floor, using a large spoon to rub the back of the paper which had been placed on the painted plate in order to transfer his design from the plate to the paper itself.

Prendergast always considered his monotypes an

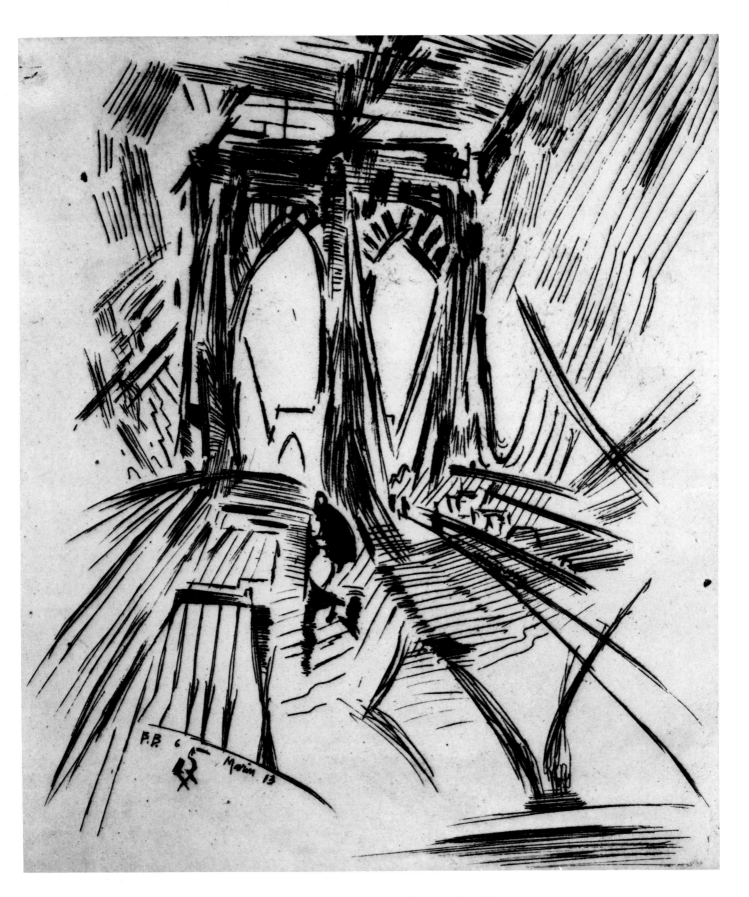

6 MARIN, JOHN (1872–1953), *Brooklyn Bridge,* No. 6, 1913. Etching, 10¾×8¾
(27.2×22.2). Collection, The Brooklyn Museum.

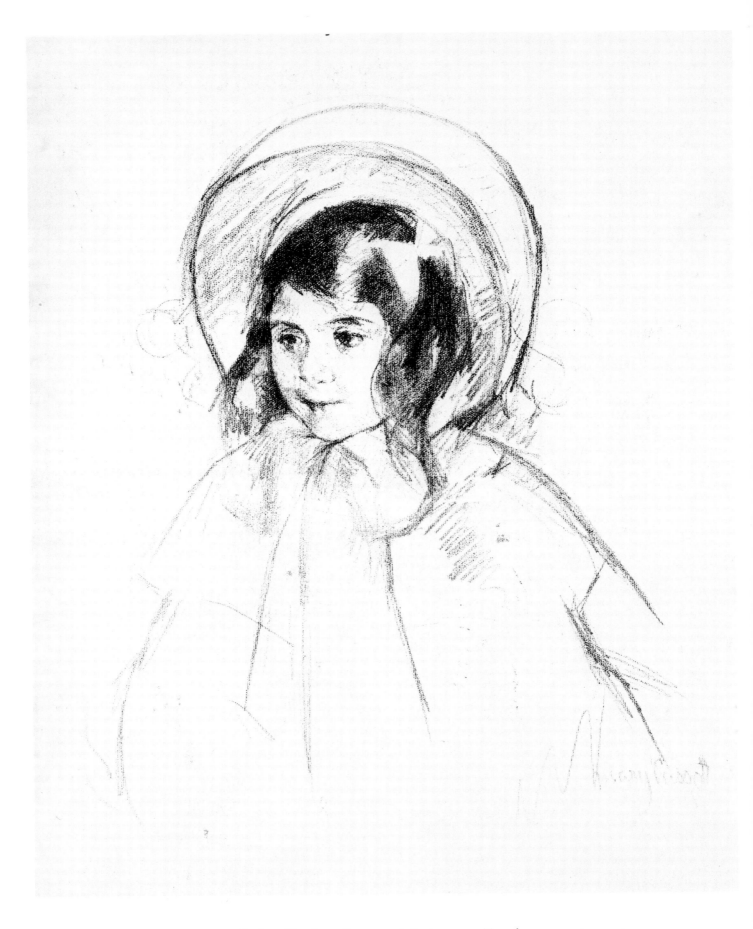

7 CASSATT, MARY (1845–1926), *Sara Wearing a Bonnet and Coat,* c. 1904. Transfer lithograph, 19¼×15¾ (48.7×39.8). Private collection.

important part of his work and exhibited them with his early paintings in Chicago, Boston, and Cincinnati. Often, during the years from 1892 until 1905, he sketched special subjects in oil on plates and printed them to see how particular ideas might appear in a painting. In thirteen years, he made more than two hundred monoprints or monotypes that form an outstanding section of his oeuvre. They add an innovation in color and a pervasive poetic quality to American graphic art of the early twentieth century. The rare, early monotypes of George Luks and Edwin Dickinson continue the soft color tonalities of Prendergast.

Influence of the Japanese Print

In the United States artists working in the simplified medium of the woodcut were aware that the underlying problem pointed up by the Japanese print and the style of Art Nouveau was one of applying new approaches to old methods and techniques and adapting them to contemporary needs and interests. Some artists not only sensed a challenge but attempted a solution. Outstanding among them was Arthur W. Dow, who had made a long and thoughtful study of oriental art, especially Japanese painting and its governing philosophy. In the summer of 1902, at his studio in Ipswich, Massachusetts, he began to experiment with broad simple forms in color woodcuts. He explained:

> "They were undertaken at first purely from interest in the mode of expression which I produced by the Japanese method, a kind of painting with woodblock and watercolor."[4]

Later, he conceived the idea of issuing these experiments in a series as new, freely workable guides for teachers of art. Dow was one of the first teachers of art in the United States who presented his subject in terms of contemporary expression. His innovative ideas and experiments contributed to the break with nineteenth-century style and themes.

English and German magazines of the 1890s through the early years of the twentieth century often reproduced in color many European and American woodcuts that revealed the prevailing interest of western artists in the more romantic elements of the Japanese print. The influence of the Japanese print on western art had been known since the mid-nineteenth century in London and Paris where Van Gogh, Gauguin, Degas, Toulouse-Lautrec, Mary Cassatt, and others were influenced by its flat color, oblique design, and sophisticated simplicity. Many artists in Europe and in the United States began working in the manner of the Japanese woodblock color print. Bertha Lum, an American artist born in Iowa, first traveled to Japan in 1903 and again in 1908 where she studied with Japanese masters in Kyoto and in Tokyo. Subsequent study gave her a remarkable command of the medium. Like many another western traveler to the Orient, she was influenced by the exotic atmosphere of an alien culture. Later work in Mexico and the United States still reflected her long preoccupation with the Japanese print.

Helen Hyde first came under the influence of the Orient in the Chinese Quarter in San Francisco. From 1905 to 1913 she made a serious study of the Japanese print in Japan under the supervision of Japanese masters. It is to be remembered that the Ukiyoe prints of Japan were the achievements of three individual artists and craftsmen—the artist who conceived the original design, the engraver, and the printer. Not until the twentieth century was this procedure changed with the advent of the Sosaku hanga, or creative print.

Panama-Pacific Exposition

In 1915 the first extensive showing of prints by American artists was held at the Panama-Pacific Exposition in San Francisco. A single room was devoted to the prints of Whistler and his follower, Joseph Pennell; a room was also set aside for the color prints in all graphic media; and three rooms were given over to other contemporary American work. This was the most complete coverage of the modern print in the United States to that date. The artists represented by color prints were: woodcuts by Arthur Dow, Gustave Baumann, Helen Hyde, Bertha Lum, and B. J. Olsson-Nordfeldt; aquatints in color by George Senseney, Maude Squire, and Pedro Lemos; and etchings by Benjamin Brown and Earl Horter.

Greater range in colors and large scale mark the woodcuts of Gustave Baumann, who came to the

8 Dow, ARTHUR W. (1857–1922), *Rain in May*, c. 1907. Woodcut, 6$\frac{3}{16}$×5
(15.8×12.7). Collection, Ipswich Historical Society.

9 Lum, Bertha Boynton (1879–1954), *Point Lobos,* 1920. Woodcut, 16¼ × 10¾ (41.1 × 27.1). Collection, Library of Congress, Prints and Photographs Division.

United States from Magdeburg, Germany, in 1906. After graduating from the Art Institute of Chicago he began his career as an artist in Brown County, Indiana, "where people lived frugally but comfortably." It was here that he began serious work in the relief print. In one of his early works, entitled *The Forge, 1909,* he skillfully combines the sharp, direct qualities of the traditional woodcut with a contemporary spirit. Its muted colors and strong composition bring a welcome note to early twentieth-century woodcuts in the United States. Baumann had the idea of making large woodcuts in color for use in schools in order that students might become familiar with original works of art which had some connection with their own lives. He attempted to sell them for five dollars each, but found no buyers. He later remarked:

> "I found the greatest interest among schools that had no money . . . I finally discovered that by cutting down the size and upping the prices, that I could make a go of it."[5]

In spite of winning a gold medal for his color prints at the Panama-Pacific Exposition in San Francisco in 1915, he found little response to his work. After several years in New York, he moved to Santa Fe, New Mexico, and remained in the Southwest, where he enjoyed a large following of friends and collectors. In celebration of the Armistice after World War I, Baumann issued a little-known color woodcut entitled *Fifth Avenue, 1918.* Its flags and festive atmosphere recall the same subject in a lithograph by Childe Hassam. Some of his more unusual woodcuts are those inspired by the artifacts and pictographs of an Indian people who long ago inhabited caves in the tufa cliffs of the Frijoles Canyon in New Mexico. This subject makes up a large segment of the prints Baumann issued in the 1920s through the 1940s. The artist's interests and observations are recorded in nearly 200 prints that make up his graphic oeuvre covering a period of more than forty years.

Bror J. Olsson-Nordfeldt, born in Sweden, came to the United States at the age of thirteen. He studied at the School of the Art Institute of Chicago and in 1900 went to Paris, where he worked in the media of woodcut and etching. In 1911, he returned to the United States, preferring the American industrial scene, especially around Chicago. In 1912, he went to San Francisco and other regions along the Pacific Coast and New Mexico. His woodcuts in color have the flat tones of the Japanese print, but are less romantic than those of Helen Hyde and Bertha Lum. *The Long Wave* of 1902 and *The Rock, Nahant,* 1906, are typical examples. Late in the 1920s and 1930s, Olsson-Nordfeldt issued a group of etchings which are unusual in their portrayal of dwarfs and odd characters. His ability to define the psychological facets of these penetrating portrait studies make them of more than general interest.

Still another artist from Chicago, Otto J. Schneider, came to New York in 1903. His drypoint portraits, some of which were in color, earned him the reputation of being the American Helleu. Notable in his work is the *Portrait of Mrs. Julian Street,* 1904. Charles W. Dahlgreen was born in Chicago in 1864 and studied in Düsseldorf in 1886. He returned to the United States and for fifteen years carried on a business career. However, in 1905 he enrolled in classes at the Art Institute of Chicago, after which he again returned to Europe, where he traveled in Holland, Germany, France, and England. His first etchings were made in 1908 and were mostly dark, rhapsodic landscapes. In 1913 he produced numerous etchings in color, again with a pictorial theme. The Chicago Society of Etchers, who held their first group exhibition in 1911, published his print *Heathlands* a few years later.

Baumann was joined in his interest and depiction of the West by a Scandinavian artist, Sven Birger Sandzen. Born in Skåne and trained in Stockholm and Paris, Sandzen came to the United States in 1894 to teach art and music at Bethany College in Lindsborg, Kansas. He began printmaking in 1916 and spent a busy and rewarding life attempting to capture in his paintings and prints the changing contours and the impressive strength of the plains and mountains of western United States. Of the 320 prints that constitute his graphic oeuvre, his woodcuts and linoleum cuts are the most successful. Using a nail, a knife, and a burin for tools, he built compositions by means of dots, dashes, and short lines, producing a primitive and naïve effect. The graphic work of Baumann and Sandzen is a far different expression from the romantic and meticulous prints of George Elbert Burr and

10 LINDENMUTH, TOD (1885–1956), *Low Tide,* 1915. Woodcut, 14¼×11 (36.2×28).
Collection, New York Public Library.

11 FEININGER, LYONEL (1871–1956), *Houses in Paris,* 1918. Woodcut, 21½ × 16⅛
54 × 41). Collection, The Brooklyn Museum, Dick S. Ramsay Fund.

the studied, broadly objective etchings of Roi Partridge, although they record a similar western landscape.

Among the woodcuts in color produced in the 1920s, those of Tod Lindenmuth and Benjamin Miller are characteristic. Lindenmuth considered the color print a "small painting." His flat color passages and simplified design recall the Japanese print. His scenes of harbor life in cool, muted colors are well exemplified in his woodcuts. Lindenmuth was born in Allentown, Pennsylvania, in 1885 and worked in Provincetown. Benjamin Miller, a California artist, made a number of woodcuts that were directly influenced by German Expressionism. They often carry a social theme, noted in *The City,* issued in 1928.

CHANGING MODES AND THE PICTORIAL TRADITION

In the development of ideas and in the continuing search for contemporary visual forms, perhaps Lyonel Feininger, in his graphic work, is an immediate successor to Maurice Prendergast, discussed earlier. Unlike Whistler and Mary Cassatt, Feininger, after many years in Europe, returned to the United States in 1937 to take up permanent residence and to become actively involved in the milieu of American art. He is the only American artist whose work gives recognition to the major art movements in the first half of the twentieth century. Nearly fifty years of his creative life were spent in Europe, mainly in Germany, with frequent trips to Paris. He was in Paris at the time of the first showing of Fauve work in 1905. In 1911, when again in Paris, he saw the revolutionary efforts of the Cubists. In 1913, at the invitation of Franz Marc, he exhibited with the Blaue Reiter group in the first German Autumn Salon in Berlin. His early graphic work began with two lithographs, *The Decrepit Locomotive* and *The Old Locomotive,* and a series of unique comic strips for the Chicago *Sunday Tribune* entitled *The Kinder Kids* and *Wee Willie Winkie's World* published in three-color newsprint half-tones. These were done in 1906 while Feininger was on his second visit to Paris. They have a toylike quality and an almost childlike literalness, but also carry suggestions of his later mature style. From these early efforts, Feininger embarked on larger and more serious work in etching and drypoint between 1910, after he had seen the work of the Cubists in Paris, and 1924, at the close of his first period of teaching painting and graphic art at the Bauhaus in Weimar. Some twenty intaglio prints have been recorded in this fourteen-year period. Including a variety of subjects, they trace his development in the direction of Cubism. They also reflect his independent exploration of space and infinite nuances of expression made possible through his astute and sensitive use of line.

The major part of his graphic work was begun after World War I and extends through his tenure as artist in residence at the Bauhaus in Dessau in 1933. The black and white woodcuts form the most experimental and perhaps the most fully realized expression in his graphic oeuvre. The basic discipline of this medium, its sharp uncompromising lines and forthright forms appealed to Feininger. His straight lines are shafts of light exploring space and creating spatial elements capable of great depth. On the other hand, the dotted lines and longer broken lines create vibration, tension, as well as space. His unique expression is evident in the woodcuts *Houses in Paris,* 1918, *Gelmeroda,* 1920, and *Promenade,* 1921. Feininger's prints, numbering more than four hundred woodcuts, etchings, and lithographs, are closely allied to his paintings and are an exceedingly important part of his total oeuvre.

For the American artists who sought new visual forms and ideas in the early twentieth century the climate for their work was often bleak. It should not be forgotten that it was Alfred Stieglitz who first promoted and presented photography as a fine art in his Photo-Secession exhibitions of the early 1900s in New York. At the same time his efforts also heralded the dramatic shift from a conservative pictorial vision to the new aspects of modern art in his magazine *Camera Work* and at his 291 Gallery on Fifth Avenue. He was the first to show examples of modern European artists in exhibitions of work by Matisse in 1908

and Toulouse-Lautrec in 1909–10. Also included were Cézanne's lithograph *The Bathers* and Renoir's large lithographs in color which had been published in Paris by Ambroise Vollard. In 1910 Stieglitz was the first to show the work of modern young American artists, including Max Weber, John Marin, Arthur B. Davies, Abraham Walkowitz, Ernest Haskell, Eugene Higgins, and Alfred Frueh. This exhibition was received with either hostility or massive indifference by critics and public alike.

Outstanding among the artists who were preoccupied with the Impressionist aspects of the world about them was Childe Hassam. Hassam was born in Boston and studied and traveled in Europe in the 1880s, when he became interested in the French Impressionists. In 1915, at the age of fifty-six, he began to work in etching under the tutelage of Kerr Eby. In the fall of this same year he issued a series of prints from his studio at Cos Cob. Hassam's entire graphic work consists of some 376 etchings and about forty-five lithographs. His intaglio prints carry a nostalgic charm and the pleasant contemplation of familiar scenes caught within a linear web of arrested time. His keen perception is evident in the early etchings of the Cos Cob scenes and in the prints depicting the tree-lined streets, harbors, and old houses around Easthampton, where he lived. These etchings date from 1915 to approximately 1924. His lithographic prints are less known. Nevertheless, the lithograph *Nude* issued in 1917 and *Lafayette Street, New York,* which appeared a year later, are comparable to his etchings. One of the most accomplished of America's Impressionist artists, Childe Hassam reflects in his prints his concern with the recurring play of light and shadow in a pictorial composition.

Arthur B. Davies, born in Utica, New York, in 1862, was among the most experimental of those artists working immediately before and after World War I. He actively promoted the Armory Show. Davies' graphic work dates from about 1912 and ends in the 1920s. Interested in depicting the human figure, this artist, in his early woodcuts, shows the influence of Gauguin; later his etchings record a brief oblique interest in Cubism, expecially noted in his *Figure in Glass* of 1918, a drypoint on zinc. His lithographs, faintly classical in mood, are reminiscent of

the romantic prints of Roussel. Most of his etchings were printed by Frank Nankivell and his lithographic stones were printed by Bolton Brown. A painter and printmaker of perceptiveness, Davies' work in etching, lithography, and woodcut mirrors an unusual knowledge and understanding of European art movements.

Changes in style and the expansion of a visual vocabulary are noted in many of the prints of this period. The somewhat revolutionary point of view was instigated by artists who were known as painters or sculptors. They considered any medium not as a technical performance but as another means or vehicle of creative expression. This had been demonstrated in the graphic work of Maurice Prendergast, Lyonel Feininger, John Marin, and Childe Hassam. A similar point of view is evident in the prints of Max Weber, A. H. Maurer, and Marsden Hartley.

Max Weber's paintings did not receive favorable comment when he exhibited them at Stieglitz's gallery at 291 Fifth Avenue after his return from Europe. Yet, his early woodcuts have become a landmark in the story of twentieth-century American graphic art, out of all proportion to their small size. His small gemlike woodcuts are among the earliest and most sensitive expressions of Cubism in America. Max Weber, at the age of ten, came to America from Byalostok, Russia. At sixteen he entered art classes at Pratt Institute, where he came under the influence of Arthur Wesley Dow, who had cast aside uninspired copybook methods of teaching art. Thereafter followed three busy and enlightening years of study at the end of which Weber himself decided to teach in the field of art. After several years, he had saved enough money to go to Europe, and from 1905 to 1909 he studied and worked in Paris, with travels to Spain, Italy, and the Low Countries. In Paris, Max Weber was one of a small group of artists who met regularly in the studio of Henri Matisse. Weber found in the teaching of Matisse a re-emphasis of logical construction and special organization which Dow had pointed out in Weber's earlier student days. Matisse, little known at the time, demanded that his pupils exert greater freedom and boldness in the use of color. This touched a responsive chord in Max Weber, whose heritage stemmed from Russian folk

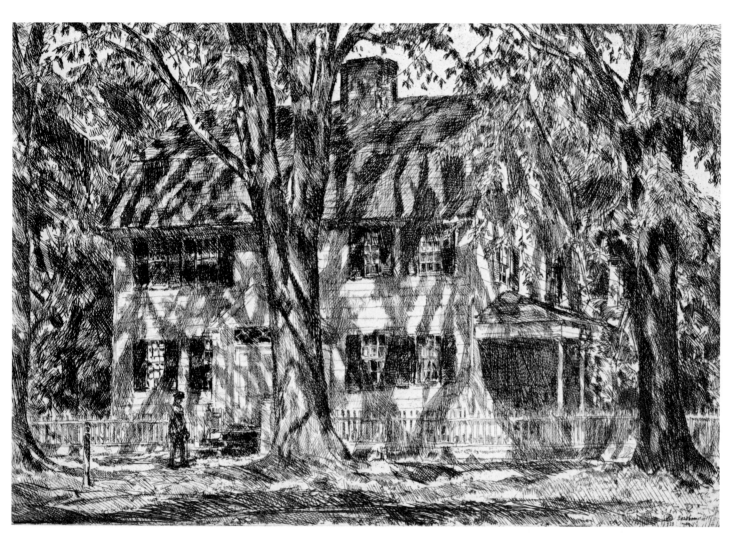

12 HASSAM, CHILDE (1859–1935), *Lion Gardner House, East Hampton,* 1920. Etching,
9⅞×14 (25.1×35.5). Photo courtesy Associated American Artists, Inc.

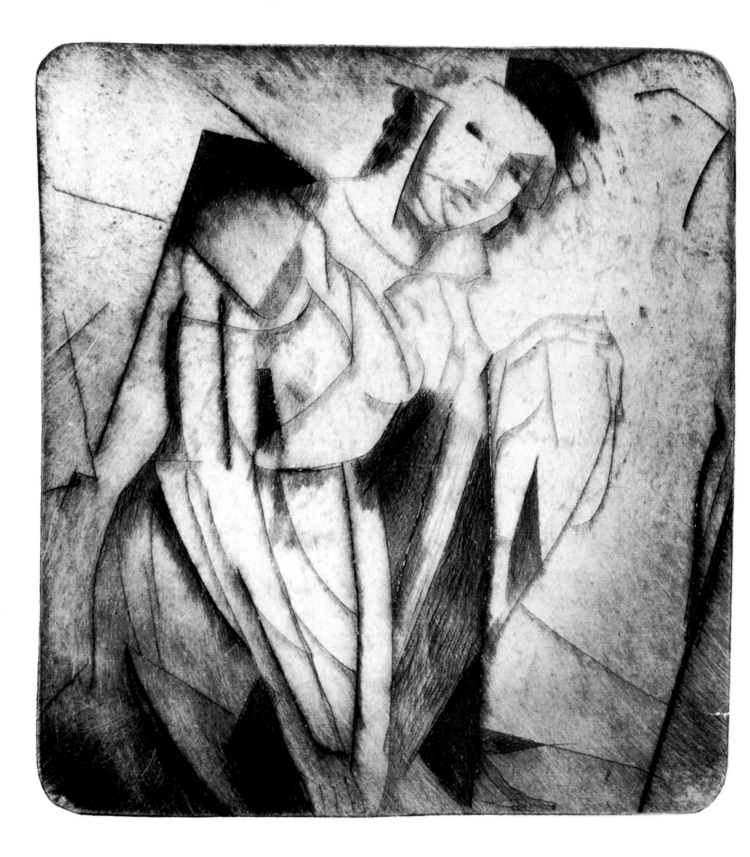

13 DAVIES, ARTHUR B. (1862–1928), *Figure in Glass*, 1910. Drypoint, 5½ × 6¼ (14 × 18). Collection, The Brooklyn Museum.

art. Matisse also insisted on a rigid discipline in draftsmanship. Weber recalls that Matisse had his students drawing like cameras, using plumb lines, but to purposes other than the mechanical, futile constructions of the academicians.

In 1909, Weber returned to America to find that the art critics and public alike not only misunderstood his work, but ridiculed it. It was during this austere time that he began to make woodcuts and linoleum block prints. His first experiment was made on a small piece of linoleum which he had rescued from a heap of building scrap near his modest quarters. He later disarmingly describes his method of printing:

"Not knowing the technique or methods of the art of woodcutting, the first and smaller of the series of woodcuts were made of honeycomb sections in an impulsive spirit of experiment and play. The larger woodcuts were subsequently made of harder wood and linoleum. No tool other than the ordinary penknife was used in cutting the figures and designs . . ."[6]

The neat, rectangular bass honeycomb blocks appealed to Weber, and he ably fitted his compositions into the functional forms of the blocks; some straight rectangles, others with curved sides, still others with the joining edge of the box serving as part of the design. These sections, only one eighth of an inch in thickness and a mere two by four and one quarter inches of surfaces, approximate the size of his small gouaches of this period, and recall his work with Matisse and the Fauves. A number of his woodcuts are Cubist studies and reflect his interest in and preoccupation with primitive art. Weber utilized abstraction and semi-abstraction as well as exaggeration and distortion, but never at the expense of the emotional content and effectiveness of the work.

Weber's own recollections as to the dates of his prints have led to some confusion. Recent research has established that the small woodcuts and linoleum cuts were completed in the decade of the 1920s and into 1930.[7] Weber made a number of lithographs employing the lithographic crayon in the free manner of a draftsman lightly sketching his subject. More realistic than his woodcuts, Weber concerns himself with landscapes, still life, portraits, or studies of the nude figure. These are done after various paintings and follow closely the compositions of specific oils. A large

lithograph entitled *Beautification,* 1932, shows his use of exaggeration and distortion of forms to give a sense of poise, dignity, and repose. Weber's modest graphic oeuvre numbers approximately forty woodcuts and fifty lithographs.

Alfred Maurer's career as a gifted academic painter was already launched when he came in contact with the work of the Fauves in Paris about 1905. The first American artist to follow the ideas of the Fauves, and a friend of Matisse and Gertrude Stein, he was greatly influenced by the avant-garde movements in Paris. His first one-man show was held at the Stieglitz Gallery in 1909. From 1924 through 1928 his work was regularly exhibited at the Weyhe Gallery. It was for the Weyhe shows that Maurer issued a small number of fine linoleum cuts. Printed as broadsides in brown or in black ink, they are figures reminiscent of Matisse and the Fauves, but carrying the personal graphic notation of Maurer himself. The first one was issued in 1924 in an edition of 250 copies. One hundred of these were signed by Maurer and by Sherwood Anderson, who wrote the brief accompanying text.

Marsden Hartley was also influenced by Cézanne and by the Fauve painters in Paris. Although his interest in prints dates from 1903, when he demonstrated the technique of etching to Lee Simonson and a few other friends, he did not seriously embark on his own prints until 1923. It was during a sojourn in Germany that he briefly turned to lithography, which served as an accompaniment to his drawings. His first transfer lithographs were thirteen still life compositions of flowers or fruits viewed close up issued in 1923. Their simplified, strongly stroked rendition gave them a monumental, sculptural quality. Some ten years later on another trip to Germany he issued a few more lithographs, bringing his total to eighteen. Landscape views of the Bavarian Alps, they are tentative studies or notations which record the massive contours, shadings, and highlights of a mountain landscape.

In 1927 the Downtown Galleries under the direction of Edith Halpert initiated an annual exhibition of American prints. In her third annual exhibition the work of thirty-two artists was represented.

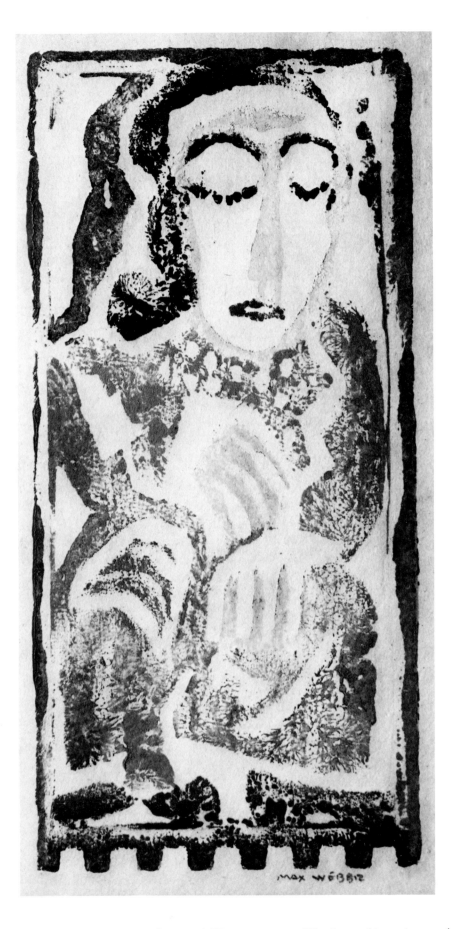

14 WEBER, MAX (1881–1961), *Seated Women*, c. 1919. Woodcut, 4¼×2 (10.7×5).
Collection, The Brooklyn Museum.

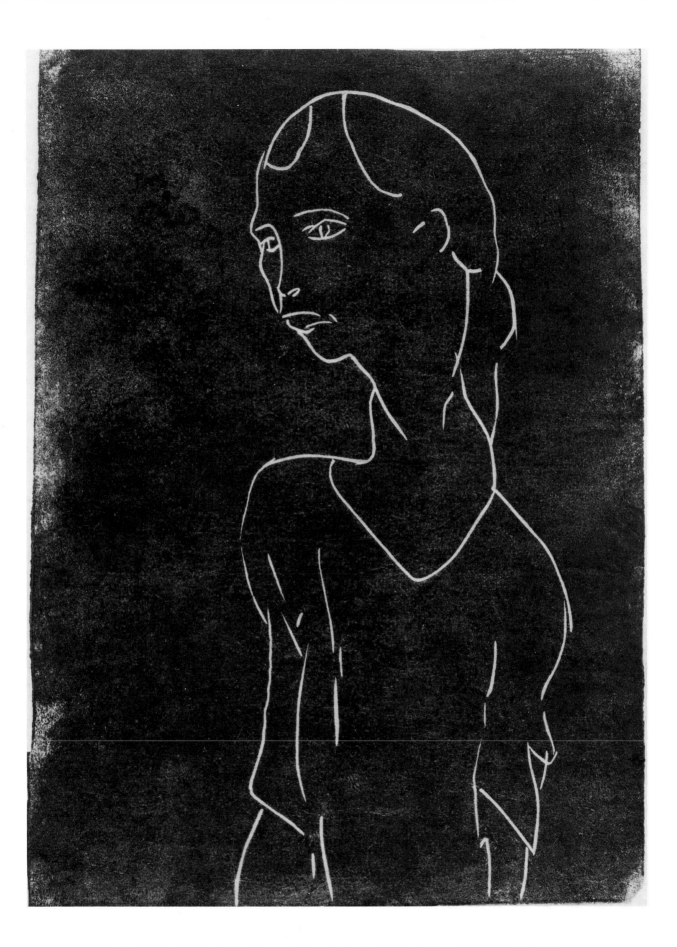

15 MAURER, ALFRED (1868–1932), *Portrait of a Girl,* c. 1925. Linoleum cut, 11⅜ × 8¼
(28.9×21). Collection, The Brooklyn Museum.

Among them were Peggy Bacon, Stuart Davis, Adolf Dehn, Ernest Fiene, Emil Ganso, "Pop" Hart, Edward Hopper, Yasuo Kuniyoshi, Reginald Marsh, Abraham Walkowitz, and Max Weber. The exhibition itself was diverse in the ideas and points of view of the painters it presented.

Artists living in the larger urban areas of the United States found the cityscape and the industrial scene of special visual significance. Aware of the European artists' ventures in Cubism, Futurism, and Constructivism, they observed their own environment with a fresh vision. Their knowledge of the new art movements brought to their work a simplified vision that was objective and shorn of illustrative detail.

The lithographs of Charles Sheeler issued in the 1920s reveal a new awareness of the industrial scene. Less well known are the black and white lithographs of Niles Spencer, Louis Lozowick, Abraham Walkowitz, Arnold Ronnebeck, and a few others. However, it is the lithographs of Stuart Davis that record the more dramatic and revolutionary departure from a realistic to a semi-abstract imagery. Stuart Davis and his friend, Arshile Gorky, followed European art movements with a growing involvement. In 1928–29 Davis went to Paris, where he issued the first of his lithographs. Among them was *Place Pasdeloup No. 2,* whose flattened composition still held to a semblance of a specific scene. On his return to the United States a further development is to be noted in his lithograph *Sixth Avenue El,* 1931. His work met with little recognition although many of his artist friends responded to the new relationships of abstract forms and their evolving tensions. His lithographs acknowledge a new tempo and exuberant rhythm in American life.

Arshile Gorky, in 1931, completed three recorded lithographs that reveal his intense interest in modern European art, especially in the work of Picasso. Apparently the artist was much less interested in the print media than he was in a manner of drawing. It has been noted that editions of possibly twenty-five were printed, and several were exhibited in the Downtown Gallery's Fifth Exhibition of American Printmaking in New York in December 1931. The three presently known lithographs are: *Mannikin, Painter and Model,* and an unlocated *Self Portrait.* A gray and black screen print, a study for his painting *Painting,* 1936–37, now in the collection of the Whitney Museum of American Art, is untitled.[8]

Artists who held to a familiar pictorial tradition but who managed to develop and maintain a personal independence and originality brought a less confined view to the American print. No longer heeding warnings from dealers that only European or romantic Near East views would sell in the market, they began to look at America with new insights. Some were attracted to the throbbing life and burgeoning growth of American cities, others traveled west to the Rocky Mountains and the desert country, south to New Mexico, east to New England and into the Middle West to Ohio, Illinois and the vast Mississippi Valley. The country, with its sweeping landscapes and its more intimate enchantments, challenged the artists' imaginations.

Seldom noted are the prints of George Elbert Burr, who was born near Cleveland, Ohio, in 1859, just two years before the Civil War. He first attempted etching in 1880; however, he felt that he needed more knowledge of the fundamentals of fine draftsmanship. He came to New York, where he accepted a commission to illustrate the Heber R. Bishop collection of jades, porcelains, and bronzes with a thousand pen and ink drawings which kept him fully occupied for the next four years. This stupendous work was comparable to an earlier undertaking by the French artist Jules Ferdinand Jaqumart, who, in 1865, produced for his government the colossal series of etchings illustrating the *Gemmes et Joyaux de la Couronne* in the collection of the Louvre. Having completed his own project, Burr set out for Europe, where he spent the next five years in Italy, Switzerland, Germany, England, and Wales. On his return to the United States, fragile health sent him to Colorado, and thence to the desert country of New Mexico, Arizona, and California. This region was the inspiration for many watercolors and some 300 prints which make up his graphic work. Burr began his graphic work when popular belief held that the Far West was simply too grandiose for small pictorial representation. Earlier, Bierstadt and Moran had successfully painted characteristic western views on tremendous canvases.[9]

Burr captured, in the fine weblike lines and soft

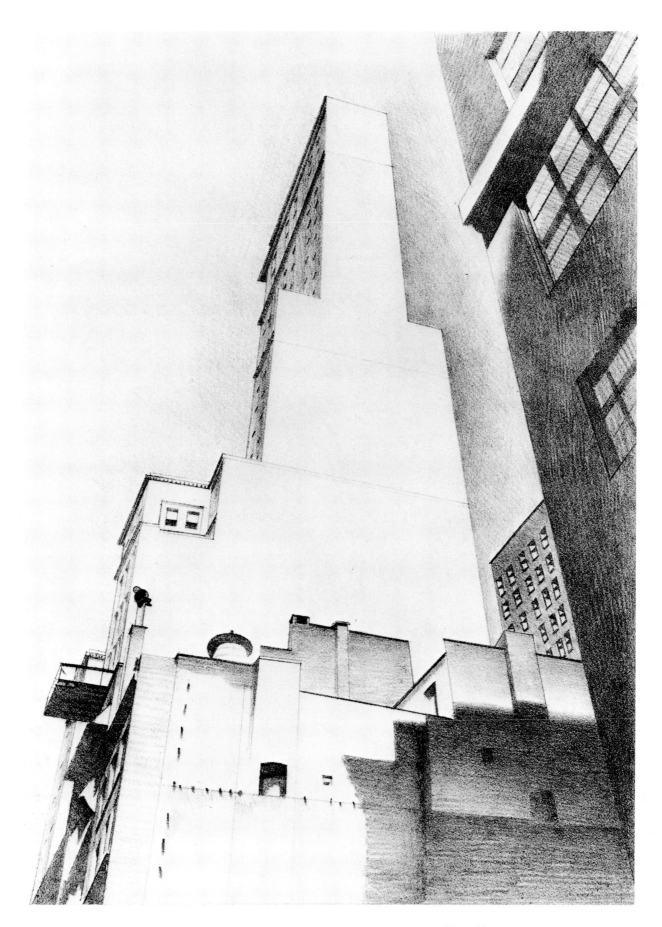

16 SHEELER, CHARLES (1883–1965), *Delmonico Building,* 1927. Lithograph, 9⅝×6¾
(24.6×17.1). Collection, The Brooklyn Museum.

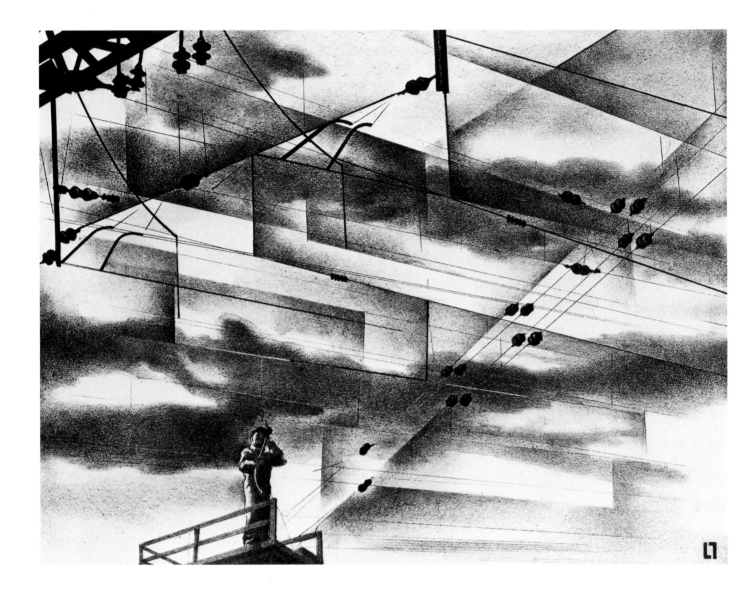

17 Lozowick, Louis (1892–1973), *Design in Wire,* 1949. Lithograph, 8⅝ × 11⅜
(22×29). Collection, The Brooklyn Museum.

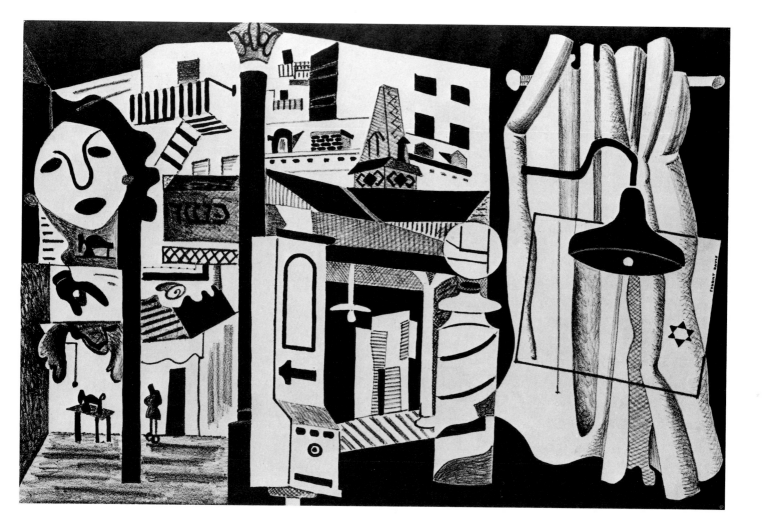

18 DAVIS, STUART (1894–1964), *Sixth Avenue El,* 1931–32. Lithograph, 11⅞ × 17⅞
(30.2 × 45.3). Photo courtesy Associated American Artists, Inc.

19 BURR, GEORGE ELBERT (1859–1939), *Whirlwinds, Mojave Desert,* 1921. Drypoint,
4⅞×6¾ (12.3×17.3). Collection, Library of Congress, Prints and Photographs Division.

tones of his small copper plates, not facts of nature but its restless grandeur and its ever-shifting moods. His prints contain the strange quality of suspended motion which Willa Cather so succinctly described as "country waiting to be made into a landscape." Burr himself has explained his own graphic notations:

"If I think of a deep-toned evening cloud with full rich tones, I only see it in watercolor, or, in etching, as an aquatint. If the chief charm is form, then line as simple as possible seems the way to express it. Some very rich old tree, full of blacks, I only think can be rendered by cutting deep slashes with a sharp drypoint. Some very delicate distance or fleecy cloud, I would render with lines barely scratched on the copper with a fine sewing needle."[10]

His prints, mainly drypoints and etchings, were sketched directly from nature on prepared copper plates without any preliminary drawing. The rare mastery and precise discipline of his work reflect Burr's feeling for landscape and his love for its vastness and its subtleties. His finest landscapes, with their luminosity and immaculate rendition, have a fantastic quality that is an overwhelming part of the Southwest desert country.

The graphic work of George Elbert Burr, including a few experimental prints in color, covers an extensive period from 1880 through the early 1930s. His most successful prints are those which compose his *Desert Series*—a group of thirty-five prints issued in 1919–21. Among them are *Whirlwinds, Mohave Desert, Needles Mountain on the Colorado River,* and *Navajo Church, New Mexico*—all drypoints. Although this series was completed some nine years before the publication of Willa Cather's novel of the Southwest, *Death Comes for the Archbishop,* it makes a splendid visual companion piece to her perceptive descriptions of a country where

. . . every mesa was duplicated by a cloud mesa, like a reflection, which lay motionless above it or moved slowly up from behind it. These cloud formations always seemed to be there, however hot and blue the sky. Sometimes they were flat terraces, ledges of vapor; sometimes they were dome-shaped, or fantastic, like the tops of silvery pagodas, rising one above another, as if an oriental city lay directly behind the rock.

Preoccupied with line and its many possibilities, Charles H. Woodbury was enabled by similar knowledge of the changing moods of the sea and shore to eliminate all nonessential elements from his graphic work. He remarked:

"My general interest in line is for its suggestive value, as it conveys the thought of force of motion . . . It is as abstract as a word and stands for a sensation as a word does for an object."[11]

In spare but fluent lines he has depicted the structure of waves and the swirl of the sea along the Maine coast where he spent much of his life. Less well known, in their brief but knowing summation of carefully observed characteristics, are his animal studies.

Woodbury was born in Lynn, Massachusetts, in 1864 and studied painting and etching in Boston and Paris. His major works extending from the period of World War I through the 1920s are etchings, although he exhibited a number of woodcuts and lithographs during the late 1920s.

Earl Horter, self-taught painter and draftsman, became interested in printmaking in 1910 and first received recognition for his work at the Panama-Pacific Exposition of 1915. His earliest work reflects the influence of Whistler, although his response to the Post-Impressionists, especially Cézanne and Seurat, is evident in the skillfully executed aquatint washes that appear in his mature work. Compositional values, the play of light and shade, and the special mood of a subject hold his attention and lend vigor and a special individuality to his work. His sharpness of vision and draftsmanship are to be noted in an aquatint entitled *The Kitchen* and in an etching, *Lights and Shadows,* issued in the early 1930s.

The English-born artist Arthur Millier traveled to California at the age of fifteen and in the 1920s produced credible etchings of western scenes. Preoccupied with landscape, he used figures merely to emphasize the wide expanse of a particular view. This is to be noted in the etching and drypoint *Rest on the Flight,* which also carries the subtitle *Santa Monica Canyon and a Model T Ford,* issued in the early 1920s.

Other artists are noted in this pictorial group. Alfred Hutty, born in 1887 and trained as an architect, began a lively career in printmaking in 1921. His etchings and lithographs of street scenes in the old section of Charleston, some portraits and a series of tree studies in which he captured the unique quality of each species, were very popular and commanded high prices. In retrospect, the tree studies still evoke a special charm.

Andrew Butler, born in Yonkers, New York, began etching under the severely critical eye of Joseph Pennell. He also studied at the Art Students League. After a long stay in France and Italy he returned to the United States, and in 1929 revisited the Southwest, where he issued a number of etchings. His compositions, whether they depict old houses and barns of New England or bare stretches of farmlands and deserts, are carried out with a neat economy of line and often witty point of view. Butler was also intrigued by the compositional problems of diagonals, as posed by a railroad track or a fence, or a line of trees as they stitch their way through a motionless winter landscape or an airless desert. Among his better-known etchings are *Kansas*, 1929, and *Mount Holly*, 1933. Still another artist noted for his pictorial winter scenes is R. W. Woiceske, who was born in Illinois in 1887. In his oeuvre of etchings, aquatints, and drypoints, the most outstanding were issued in the 1920s and '30s.

The graphic works of Fiske Boyd, painter and printmaker, extensive woodcuts and etchings, appeared in the late 1920s through the early years of the 1960s. His intent of breaking up pictorial images in Expressionist patterns of light brought a fresh vision to the more conventional landscapes of the 1930s. He traveled to France and Italy in the 1920s and began working in the medium of the woodcut in Florence in 1926 to '27. He came to consider the woodcut as "merely another painting technique" and preferred the "deliberation" necessary in achieving his images through the relief method. By his own estimate his graphic work consisted of more than two hundred woodcuts and an undetermined number of etchings and drypoints.

The work of Henry Keller remains little known except for those collectors and students who knew him in Cleveland, Ohio, where he spent most of his life. Born in 1869, he first went to Europe in 1890 and studied for a time in Munich. At a period when most artists turned to New York, Keller chose to remain in Cleveland, his native domain—although he counted among his many friends Arthur B. Davies, Walt Kuhn, George Luks, and Jerome Myers. He began printmaking about 1914 and continued it through 1948. The major part of the approximately one hundred etchings and lithographs which make up his graphic oeuvre were issued during the 1920s and '30s. Like the German artist Emil Pottner, Keller was interested in animals, birds, the circus, and, later in his career, still life compositions. He taught for many years at the Cleveland School of Art and traveled extensively throughout the United States. A painter as well as a printmaker, his watercolors and lithographs show his immense assurance and understanding of these media.

Artist-Travelers

There were a few artists who ventured beyond the European scene, and their prints record their observations and experiences. Among them, George Overbury "Pop" Hart was the most exuberant traveler. Born in Cairo, Illinois, in 1868, he began his vagabonding life in 1900. His wanderings took him to Italy, France, Egypt, Mexico, Central and South America, Cuba, Honolulu, Samoa, and Tahiti. He was in Tahiti in 1903 at the time of Gauguin's death, but Hart had not known him. Returning from an early trip to the South Seas, he explained:

"I thought it would be nice to have a beard—a Van Dyke, you know, like an artist. Well it didn't make the desired effect on my friends. They started calling me 'Pop.' I shaved off the beard but I couldn't shave off 'Pop.' "[12]

Hart was content with the mere basic necessities of life. It has been said that his idea of affluence was enough money to pay for a one-way ticket to some distant and preferably warm country. He was over fifty years of age when he seriously began to make prints in 1921 during a sojourn in Mexico and in the West Indies. His prints and watercolors attest his ability to portray the richness and excitement of life about him with amusement and delight. The nearly one hundred prints that constitute his work are uneven in quality because of his predilection for experimentation. Among his finest etchings, litho-

20 HORTER, EARL (1883–1940), *Lights and Shadows,* 1932. Aquatint, 10×11⅜
(25.5×29). Collection, The Brooklyn Museum, Frank S. Benson Fund.

21 BOYD, FISKE (1895–1975), *American Cotton,* 1950. Woodcut, $9\frac{5}{8} \times 7\frac{5}{8}$ (24.5 × 19.5).
Collection, The Brooklyn Museum.

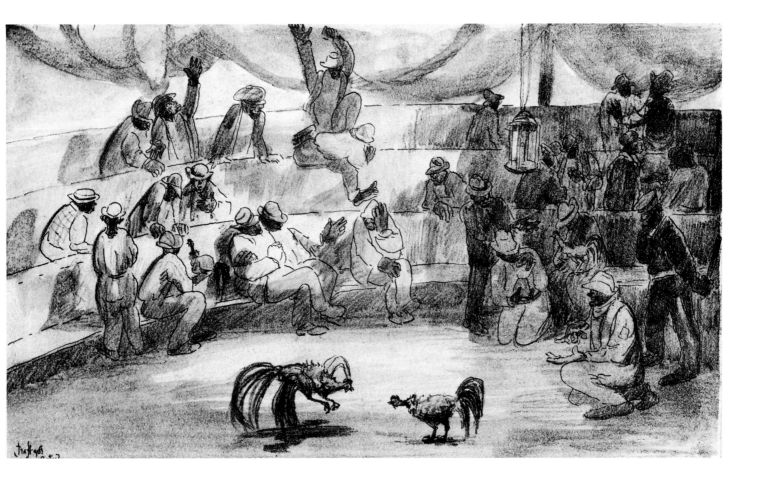

22 HART, GEORGE OVERBURY (Pop) (1868–1933), *Cock Fight, Santo Domingo*, 1923.
Lithograph, handcolored, 7⅞×13 (19.8×33.2). Collection, The Brooklyn Museum.

23 KENT, ROCKWELL (1882–1971), *Mala, an Eskimo Woman*, 1933. Lithograph,
11⅜×9¾ (28.7×25.1). Photo courtesy Associated American Artists, Inc.

graphs, and monotypes are those which exuberantly present the color and liveliness of cockfights and fiestas, fairs and outdoor markets.

Howard Cook, born in Springfield, Massachusetts, in 1901, decided early to become an artist. After three years of formal training, he too began extensive travels that were to take him to Europe, Panama, Mexico, Japan, China, and most sections of the United States. Cook first began working in prints at Thomas Handforth's Paris studio in 1925. The following year during a summer spent in Maine, Cook turned to woodcuts. After further travel he established a studio and living quarters in the southern United States. He served as a war correspondent in the South Pacific during World War II. It was not until the later 1940s that he issued a number of lithographs based on his earlier war drawings. In his many travels Howard Cook has been the observer who records the scene itself, its moods, and the diversity of its pictorial and social elements. Of special merit are several woodcuts issued in the 1920s—*Taos Pueblo, Moonlight,* and *Railroad Sleeping*—and lithographs of the war issued in the later 1940s.

Rockwell Kent is perhaps best known through his adventures in Greenland and the northern reaches of the continent. He illustrated his own writings with woodcuts and wood engravings which were popular in the 1920s. The mannered romanticism of his graphic work was a fitting accompaniment to his stories of adventure in the Far North. His wood engravings starkly framed were often found in modern interiors of the 1920s and early '30s where their sharp black and white accents were particularly admired. His lithographs, although technically less spectacular, are on the whole more successful as single compositions. Among them are *Seated Nude,* 1931, and *Mala, an Eskimo Woman,* 1933. The print entitled *Smerilik Fjord* is one of his few lithographs in color.

Other artist-travelers are George Biddle, Thomas Handforth, and Levon West. George Biddle's interest in printmaking materialized some years after he had embarked on a law career in Philadelphia. After World War I he traveled to Europe, the South Seas, Mexico, and throughout the United States. His prints reflect his interest in decorative design. Only after a chance meeting in Paris with Jules Pascin, whose work he admired, did his own graphic work become free of self-conscious distortion. Much of his graphic work falls in the latter part of the 1920s.

Levon West was born in South Dakota and came to New York, where he studied printmaking with Joseph Pennell. The greater part of his work appears in the last half of the 1920s and shows the influence of English artists James McBey and D. Y. Cameron. The best known of his some 125 etchings are those concerned with his trips to Ireland, Newfoundland, and the western United States. At the time of Lindbergh's flight to Europe, Levon West graphically etched this event on a copper plate, printed an edition, and had it out with the morning papers heralding the epoch-making event. He later became an accomplished professional photographer under the name of Ivan Dmitri.

The mannered and decorative work of Thomas Handforth demonstrates this artist's precise draftsmanship. He was born in Washington State in 1897 and studied in Paris. In 1931 he went to China, where he remained for many years. His early compositions issued in 1924 and his later more romantic and idealized visions of the Chinese scene are exemplified in the etching *Pekin Camel,* 1936, and his lithograph *The Wanderer,* 1937.

Detailed Realists

There is a special cluster of American artists who have held steadfastly to a minutely detailed "naked eye" Realism. The greater majority of them were born in the late decades of the nineteenth century. Their engravings, etchings, woodcuts, and lithographs generally span the period from the 1920s through the 1950s. Their carefully controlled compositions register their sharp observations and are executed with a pristine technical mastery. Highly skilled in the traditional methods, they ground their own inks and printed their own editions, often on handmade papers that they extracted from the flyleafs of old books. Their special contribution to the development of the print in the United States has been in their concentrated pictorial observations and an immensely disciplined craftsmanship. Perhaps John Taylor Arms was their most ardent and energetic

spokesman and colleague holding to the firm belief that only the most proficient craftsman was capable of understanding and judging the true merits of a print.

John Taylor Arms, whose unusual microscopic vision was periodically studied at Johns Hopkins medical laboratories, etched many prints of cathedrals throughout Europe, delineating their imposing structures and their wealth of lacy details with an observant eye and a skilled hand. In such details as weathered gargoyles, Arms captured a timeless and bizarre presence. It is in his series entitled *Gargoyles* that the delightfully engaging and accomplished etching *Gothic Spirit* of 1922 appears. His total oeuvre of intaglio prints numbers approximately 440 examples.

Other artists working in this realistic manner employed a diversity of print media to obtain the desired results. Grace Albee, whose wood engravings approach those of nineteenth-century masters, chose to record rural themes and landscapes. She found amusing an old carriage or surrey abandoned and nearly obscured in a thicket of overgrown brambles. The graver, under her guidance, was capable of producing, with great finesse, the slanting hairlike lines of

rains and winds and storms that battered old buildings. Today, at age eighty-nine, she continues to work in her studio in Rhode Island. Paul Landacre also was highly skilled in wood engraving, issuing many prints in the 1930s and '40s. Thomas Nason worked with equal competence in both wood and copper engraving. Of interest are the wood engravings of Asa Cheffetz and Julius J. Lankes. Luigi Rist's medium was the color woodcut, and his modest subjects carry the nuances of many colors through an intricate series of blocks. Three artists, all born in 1900, work in this finely realistic manner. Luigi Lucioni's unwavering conventional vision of highly cultivated landscapes is recorded in his extensive etchings. The lithographs of Stow Wengenroth record with elaborate shadings the haunting bleakness of landscapes, old houses, and quiet harbors. The many moods of landscapes also chart the distinguished wood engravings of James Havens. The youngest artist of this observant and fastidious group is Reynold Weidenaar, born in 1915, who works in the difficult and rarely utilized medium of mezzotint. His prints cover a variety of themes and are accomplished in their degree of burnished perfection.

THE FIGURATIVE PRINT AND THE AMERICAN SCENE

The traditional landscape held little charm for a large and diversified group of artists whose work appears in the first several decades of the twentieth century. Their prints reflect and record the social realities of their time and are unmistakably American in atmosphere and tempo. This is recognizable in the prints of John Sloan, Albert Sterner, Mahonri Young, Boardman Robinson, and George Bellows. It also appears with many variations in the work of other well-known artists who found more substance in human events and in the small dramas of everyday life than in the existing formalities of landscape.

The work of John Sloan, painter, illustrator, and printmaker, covers the first half of the twentieth century. His early newspaper illustrations and posters indicate the influence of Walter Crane, William Morris, and the Japanese print. In 1902 he began a series of etchings for a deluxe edition of the novels of

Paul de Kock. In 1904 Sloan was devoting all of his time to painting and printmaking. Under the inspired guidance of Robert Henri, who had lived in Paris for a number of years, Sloan became familiar with contemporary European art. In 1905 he completed his etching *Fifth Avenue* and in 1906 issued several others, including *Turning Out of the Light,* a subject no proper print dealer of the time would display in his portfolios. These were followed in 1908 by a lithograph entitled *Sixth Avenue at 27th Street,* in which his skill as a draftsman and his "slice-of-life" reporting is amusingly evident. Although Sloan himself considered his lithographs of lesser interest, they often set the tone of his earlier graphic work and have warmth and gusto. In 1908 with Robert Henri he helped to form the famous group "The Eight" who pioneered in the American movement for freedom in art. However, the artists of "The Eight" were in revolt within the realistic tradition. Their chosen

24 ARMS, JOHN TAYLOR (1887–1953), *The Gothic Spirit* from *Gargoyle* series, No. 8,
1922. Etching, 11¾×7¼ (29.9×18.2). Collection, The Brooklyn Museum, Dick S.
Ramsay Fund.

25 WENGENROTH, STOW (1906–1978), *Untamed*, 1947. Lithograph, 12¼ × 18 (31.1 × 45.7). Collection, The Brooklyn Museum, Gift of John W. James.

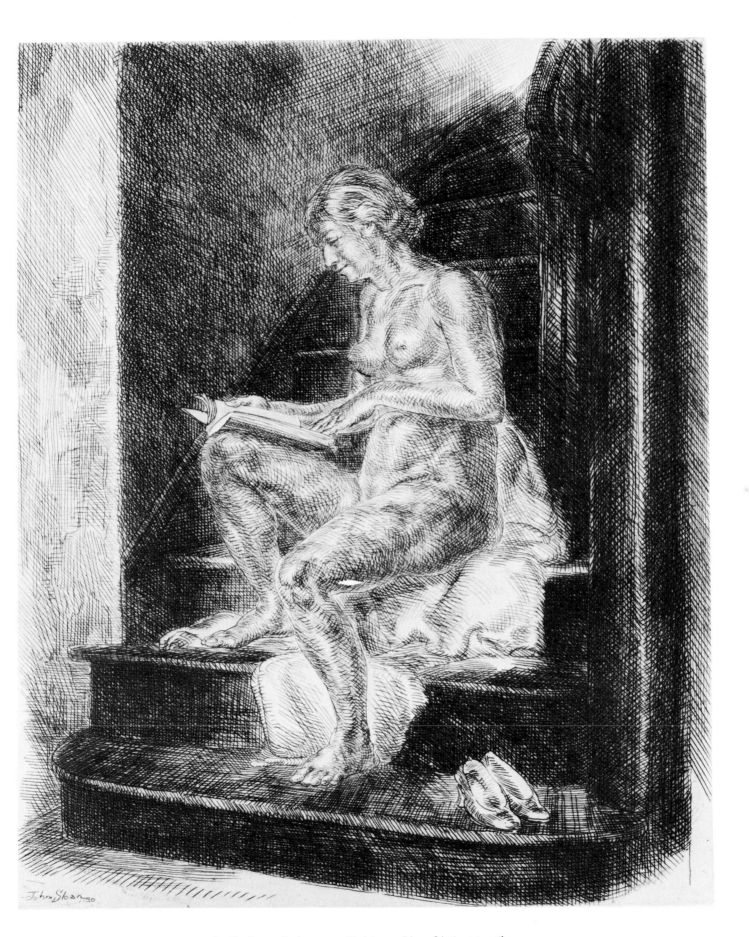

26 SLOAN, JOHN (1871–1951), *Nude on Stairs,* 1930. Etching, 9⅞×7¾ (25×19.6).
Collection, The Brooklyn Museum, Dick S. Ramsay Fund.

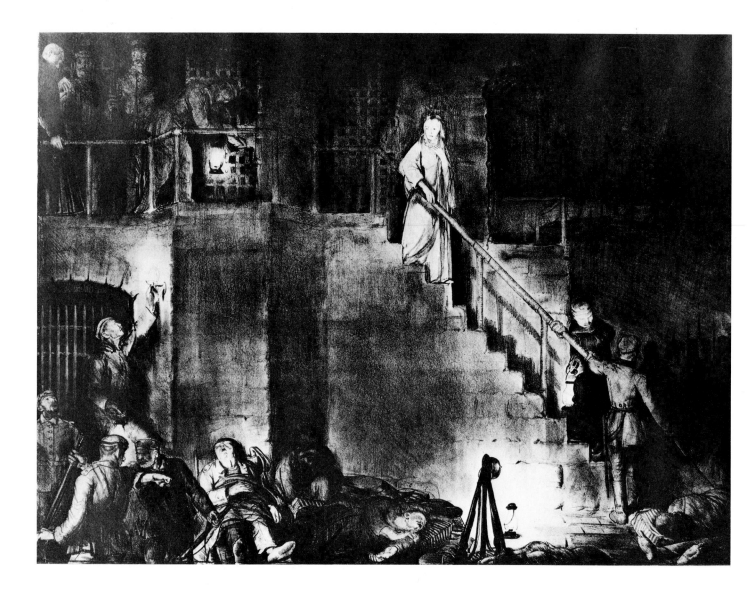

27 Bellows, George (1882–1925), *Murder of Edith Cavell,* 1918. Lithograph, 18⅞×24⅞ (48×63). Collection, The Brooklyn Museum, Gift of the Estate of Edith Cavell.

subject matter offended not only the public but also critics, who dubbed them "The Ash Can School." Sloan's etchings of New York streets and their earthy characters are often humorously anecdotal in their shrewd observations of city life. In the 1930s John Sloan turned to the more formal aspects of the nude figure as the sole image in his compositions. These accomplished etchings reveal a new power of delineation as well as the artist's skillful simplification of his medium. This is clearly evident in his small study entitled *Nude on Stairs* issued in 1930. His graphic oeuvre of etchings and lithographs contains 313 recorded prints.

Albert Sterner's earliest graphic work was done during his first sojourn in Paris and in Munich prior to 1906. His most distinguished lithographs are those dating from his second period of work, 1913 through 1915. His subjects range from the anecdotal *Mussel Openers* and *Narragansett Bay* to the romantic *Amour Mort,* all issued in Paris in 1913. Much of his work was experimental, and its resulting tentative statement often lacks the force and authority of his more carefully composed prints. However, the conviction and the scope of his best work reveal his gifts as an artist. His sixty recorded lithographs and etchings were issued through the 1930s.

Mahonri Young, who, like Sterner, made his most effective prints just prior to World War I, was born in Salt Lake City in 1877. As a young man he studied art in Chicago and New York and in 1901 went to Paris to enroll at the Académie Julien. It was in Paris in 1902 that he began a serious study of etching, although his major interest was sculpture. He was concerned with people at work or at leisure, and to him a landscape was incomplete without inhabitants. Mahonri Young returned regularly to the western country he knew and to the general theme of the American Indian, whom he eloquently portrayed. His *Navajo* and *Apache* series of etchings (1932–34) in their simple directness and exuberant warmth demonstrate his constant delight and involvement in the lives of the people around him.

Kenneth Hayes Miller, painter, teacher, and printmaker, first studied at the Art Students League and later attended the New York School of Art, where he worked with its founder, William Merritt Chase. In 1911 he returned to the League as an instructor, a position he held for many years. When he retired from the League, he had taught several generations of American artists. His influence was acknowledged by the many artists who studied with him and who, later, often gathered at his studio on Fourteenth Street in New York. Among them were George Bellows, Edward Hopper, Reginald Marsh, Rockwell Kent, Isabel Bishop, and Yasuo Kuniyoshi. Miller's etchings and drypoints date approximately from 1918 through the early 1930s. His subjects were the individuals who made up the passing scene when the street was full of mercantile houses whose merchandise appealed to a diverse segment of the city's population. Miller's portraits and his studies of the nude figure, although small in scale, reveal the directness and simplicity of his draftmanship. His best-known etchings are the series of shoppers on Fourteenth Street. They record his observant musings on the American scene in the late 1920s and 1930s. His graphic oeuvre of approximately one hundred examples was rarely issued in designated editions. They were signed in pencil "Hayes Miller" but were not dated or numbered.

Boardman Robinson came to New York from Nova Scotia, where he was born in 1876. He lived in Paris from 1898 until 1904 and became a fine draftsman, prolific illustrator and cartoonist and concerned himself with current social and political themes. His sturdy draftsmanship seemed ideal for the lithographic stone, but despite the efforts of his young friend and fellow artist Adolf Dehn, he made less than twenty lithographs from the time he issued his first print in 1915 until 1942. Among his earlier works are two of special note: *Blind Kovel* and *Wounded Russia.* Between 1924 and the 1930s, he made thirteen more prints and also taught at the Art Students League. His interest in the events of his time is reflected in the hundreds of drawings that make up his principal work. Among his lithographs are *Street Car,* 1918, *Midnight, Central City,* and his more familiar *Head of Lincoln,* 1938. No American artist has depicted war with such effectiveness as did the European artists Otto Dix, Max Beckmann, George Grosz, or André Dunoyer de Segonzac. Although Lester Hornby and Kerr Eby served in

World War I, their prints seem romantic by comparison. However, the American artist had not known war on his own soil since the Civil War, when Winslow Homer sent back sketches of the battlefield.

George Bellows, painter and printmaker, born in Columbus, Ohio, in 1882, was associated with "The Eight" and as a painter enjoyed wide popularity. In 1903 Bellows remarked to a shocked cousin that he "hated these holy grails and landscapes and junk." He moved to New York in 1904 and never traveled outside of the United States. Not until 1916 did he turn to lithography, when he embarked on a series of lithographs inspired by the reported brutalities of the War. *Edith Cavell*, 1918, was the most telling example. Joseph Pennell disparagingly suggested to Bellows that he should not have depicted Edith Cavell on her way to be executed as he had not been there. Bellows answered in his usual outspoken manner:

> "It is true that I was not present at Miss Cavell's execution but I've never heard that Leonardo da Vinci had a ticket of admission to the Last Supper . . ."13

However, the first lithograph of Bellows' to attract wide public attention was *Stag at Sharkey's*, done in 1917 after his painting of the same name. Also at this time he issued his disturbing *Dance in a Mad-house*, after a drawing he had made of the inmates of an asylum. His work in lithography begins in 1916 and extends through 1924, during which time he made nearly two hundred prints. In his association with Bolton Brown, a skilled technician in early American lithography, Bellows learned much about the medium and employed it with both skill and power. It was Bolton Brown who printed most of Bellows' graphic works. Uninhibited by tradition, Bellows' prints have a richness and dramatic force that often makes the lithographic work of some of his contemporaries seem pale by comparison.

Jerome Myers and Joseph Margolies recorded with amusement and understanding social scenes of New York's streets in the early years of the twentieth century. Myers, born on New York's Lower East Side in 1867, issued color etchings of children playing, old men sitting on park benches, the activity surrounding the neighborhood markets with equal enjoyment and skill. His deft notations are imbued with a nostalgic

charm familiar among French artists at the close of the nineteenth century. Joseph Margolies, born some years later, in 1896, favored character studies and personality types. Among his earlier lithographs are a portrait of *Joseph Pennell*, 1925, and *Old Clothes Peddler*, c. 1929.

Various European influences may be recognized in the prints of William and Marguerite Zorach, Walt Kuhn, and a few lesser-known artists. Their knowledge of the woodcuts and lithographs of Paul Gauguin and the German Expressionists, especially Franz Marc and Heinrich Campendonk, led them to an early interest in prints. The relief prints of the Zorachs were issued from about 1915 through the early '30s. Prior to these, from 1906 through 1910, Marguerite Zorach completed a few etchings and her lithographs, in small editions, appeared in the 1930s.

Walt Kuhn's interest in modern European art led him to be one of the principal organizers of the Armory Show in New York in 1913. His woodcuts *Odalesque* and *Fecundity* have a forthright directness and simplicity of conception. His lithographs of models and theater people are engagingly anecdotal in character. A strict stylization of forms characterize his distinguished series of portrait heads issued in the 1920s.

J. J. A. Murphy, an American artist who lived in England for several years while he served as Frank Brangwyn's assistant, contributed a new sense of form and composition which he achieved by means of an overemphasis of planes. His more traditional white line engravings are calligraphic in their spare simplicity. The series of fourteen engravings entitled *The Way of the Cross*, despite their minute size, have a clear brilliance whose theme unfolds with a special individual conviction. However, his *Shadowed Faces* reveals more fully his exploration of shifting forms and broken rhythms. If not Cubist by intent, it is reminiscent of an earlier drypoint, *Figure in Glass*, by Arthur B. Davies.

Fidelity to a point of view characterizes the etchings of Edward Hopper and Eugene Higgins. Their prints are free of fashion and technical flourishes. A continuing sense of detachment and a deep loneliness pervade their works. The prints of Edward Hopper cover the years between 1915 and 1928, when he produced some fifty etchings and drypoints. Of these,

1 SCHANKER, LOUIS (b. 1903), *Carnival,* 1948. Woodcut, 14 1/4 x 21 (36.2 x 53.4).
Collection, The Brooklyn Museum.

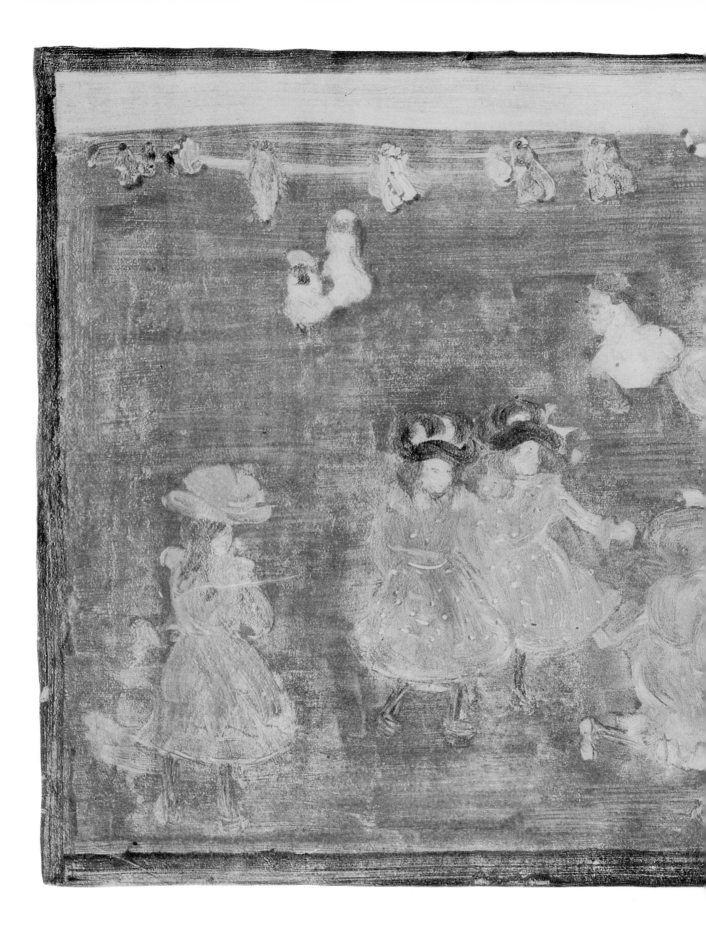

2 PRENDERGAST, MAURICE (1859–1924), *Children at Play,* c. 1901. Monotype,
7 1/8 x 11 1/2 (18 x 29.2). Collection, The Brooklyn Museum.

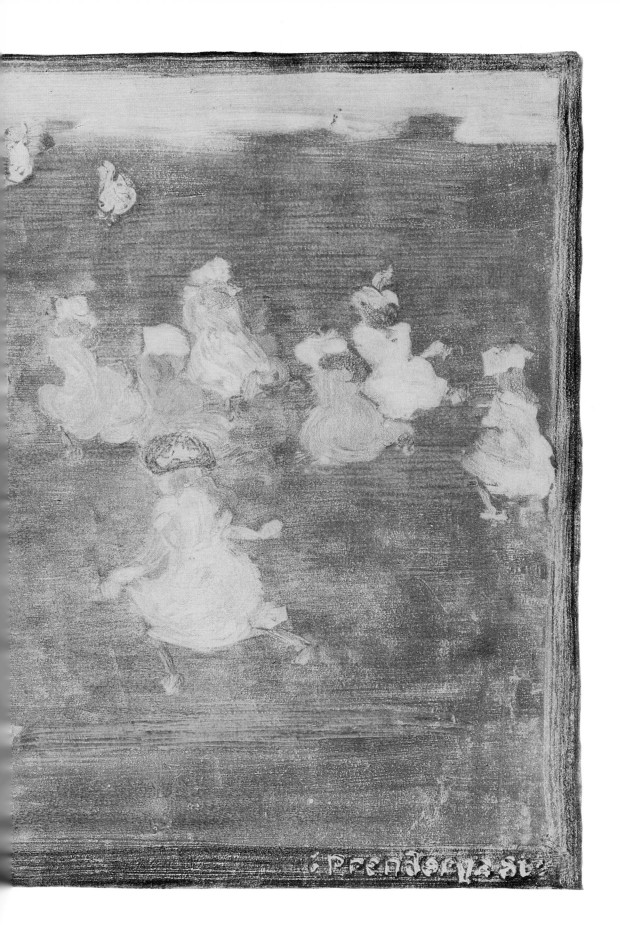

3 DAY, WORDEN (b. 1916, *Mandala II,* 1957. Woodcut, 22 x 22 1/2 (56 x 57.2).
Collection, The Brooklyn Museum.

4 YUNKERS, ADJA (b. 1900), *Ostia Antica IV , Roma,* 1955. Woodcut, 21 1/4 x 35 1/4
(54 x 89.5). Collection, The Brooklyn Museum, Dick S. Ramsay Fund.

5 RYAN, ANNE (1889–1954), *In a Room,* 1947. Woodcut, 13 1/4 x 15 5/8 (35.2 x 39.5).
Private collection.

6 CASARELLA, EDMUND (b. 1920), *Triggered,* 1959. Cardboard relief, 27 1/8 x 20 5/8
(69 x 52.5). Courtesy Sidney Mehlman.

7 BOLOTOWSKY, ILYA (b. 1907), *Rectangle Red, Yellow,* 1974. Screen print, 35 x 26 (89 x 66). Photo courtesy Grace Borgenicht Gallery.

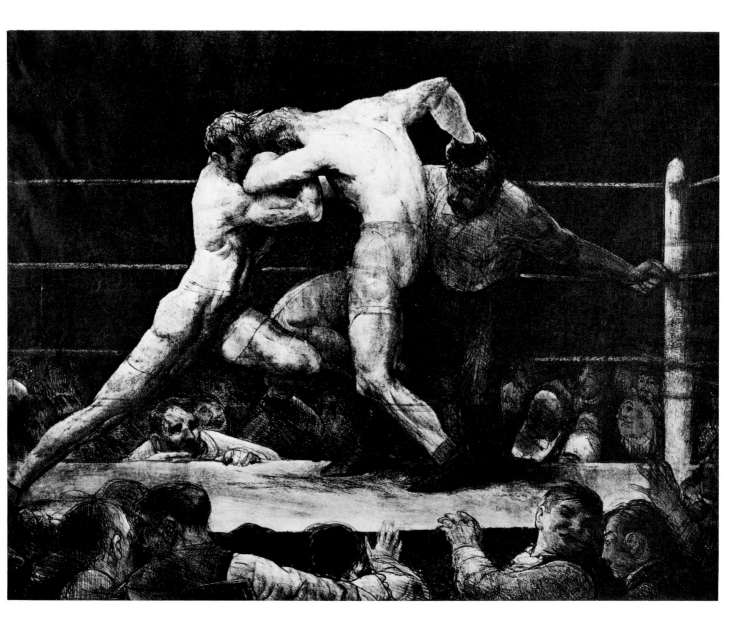

28 BELLOWS, GEORGE (1882–1925), *Stag at Sharkey's,* 1917. Lithograph, 18½×23¾
(47.5×60.4). Collection, The Brooklyn Museum, Gift of Frank L. Babbott.

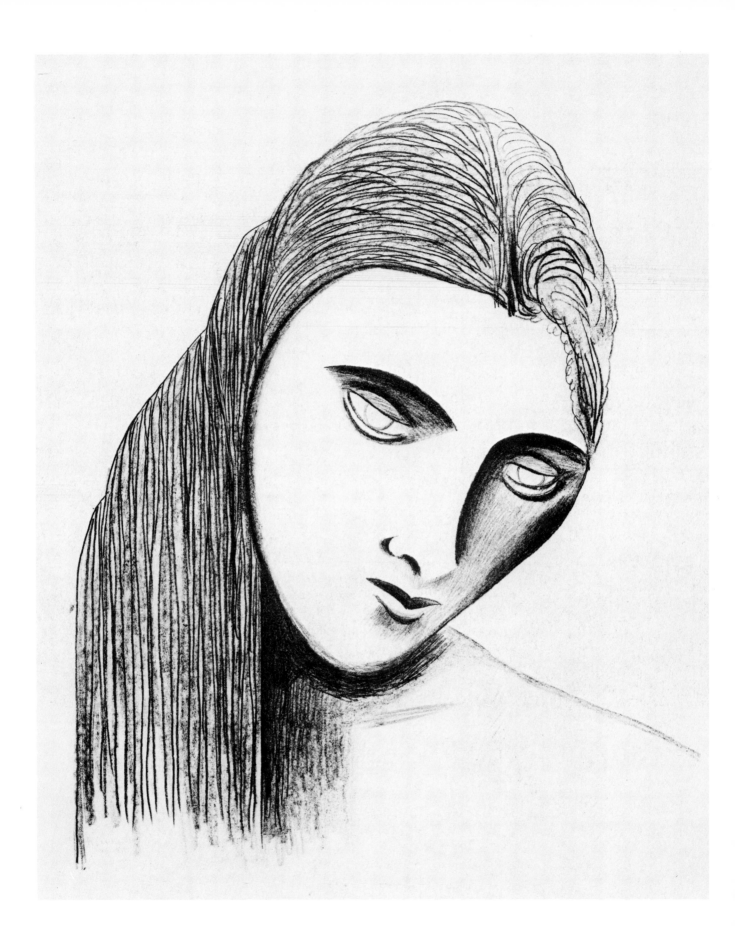

29 KUHN, WALT (1877–1949), *Girl's Head,* c. 1926. Lithograph, 22½ × 18¼
(57 × 46.3). Photo courtesy Kennedy Galleries.

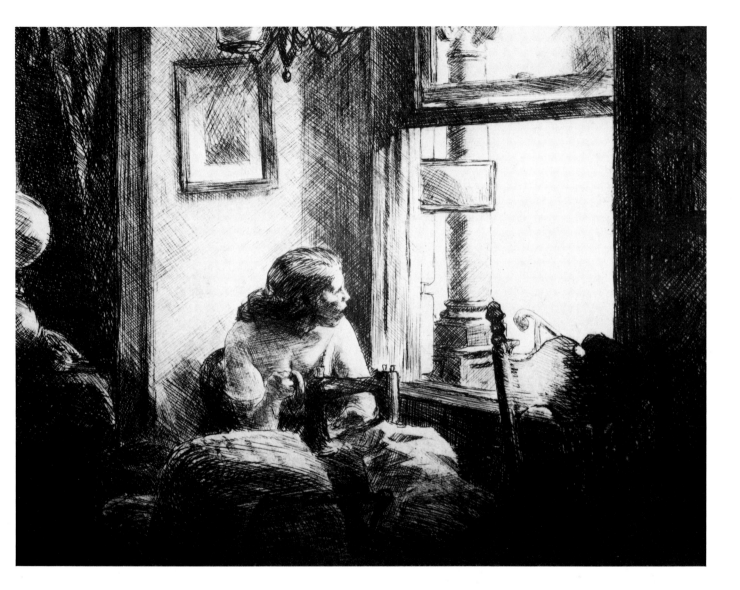

30 HOPPER, EDWARD (1882–1967), *East Side Interior,* 1922. Etching, 8×10 (20.2×25.5).
Photo courtesy Associated American Artists, Inc.

twenty-six were issued between 1919 and 1923. Hopper portrayed ordinary scenes with an objective, almost bleak simplicity. When his attention is focused on the human figure as in *East Side Interior,* 1922, and in *Les Deux Pigeons,* 1920, a cool objectivity gives his etchings a mood of aloofness. Hopper seldom printed formal editions of his plates because the disciplines of printing interested him not at all. Only later in his life did he allow a professional printer to do the job because the results never pleased him. The etchings are printed on fine sturdy paper and are duly signed and dated. The outstanding characteristic of Hopper's work is the sparseness of his pictorial structures, which do not tolerate or need embellishments. The play of light throughout his composition, whether it is a landscape, an isolated house, or the bleak turn of a railroad track, carries a strong emotional quality which is tempered by understatement and an uncompromising sense of line. Night scenes under the lights of city streets held a special fascination for him. Among his small oeuvre of recorded prints, *Night Shadows* and the interior view entitled *Evening Wind,* completed in 1921, reveal his superbly tuned vision.

The work of Eugene Higgins records the more somber aspects of life, which he views with a calm acceptance and resigned detachment. Higgins was born in Kansas City in 1874 of Irish-American parents. He studied in Paris in the early 1900s under the guidance of Jean Paul Laurens and J. L. Gérôme. His oeuvre of 236 etchings seldom carries any urgent social comment or dissatisfaction, but it does describe the lot of the underdog and wanderer with sustained intensity. The wistfulness of his *Midnight Duty,* c. 1914, and *The Forgotten Trench,* 1917, achieve a simple universality of expression and resignation. In his paintings and prints, the theme of man as a wanderer is in the strong tradition of the Irish poets whose writings he admired.

Peggy Bacon, daughter of an artist, observes the life about her with sagacity and unfailing wit. Her accurate and amusing observations are often in the demanding medium of drypoint. A highly personal style augments her work, as noted in her print *The Bellows Class* of 1919 and in *Aesthetic Pleasure* of 1936. Her graphic oeuvre contains nearly 200 compositions issued between 1918 and 1972.

Reginald Marsh was preoccupied all of his life with perfecting the drawing of the figure. His work is filled with the confusion of crowds in the streets, in the theater, on the beaches, and wherever throngs of people gathered. Marsh, in considering the subjects of his work during the late 1920s and through the 1930s, remembered:

"I paid frequent visits to the beach at Coney Island where a million near naked bodies could be seen at once, a phenomenon unparalleled in history. New York City was in a period of rapid growth; its skyscrapers thrillingly growing higher and higher. There was a wonderful waterfront with tugs and ships . . . and steam locomotives on the Jersey shore . . . dumps, docks and slums—subways, people and burlesque shows . . ."[14]

In his passionate desire to "put it all down" in a unified whole, Marsh relies on a transparency of light which characterizes his prints as well as his paintings. He began printmaking in 1928 with a group of lithographs, but he found the disciplined draftsmanship of etching more to his liking. Between 1928 and 1935 Marsh issued 236 prints, thirty of which were lithographs of locomotives, a subject he often returned to in both his etchings and his later lithographs. His etching entitled *20th Century Limited,* completed in 1931, is representative of his locomotive series. One of his finest etchings, *Breadline,* 1932, with its insistent movement and its forlorn lockstep shuffle, was the artist's bitter comment on the economic depression of the 1930s. It has none of the earthbound rhythm of Ferdinand Hodler's marching columns, but presents a more questioning bitterness through the tensions of lines and repeated forms. In the etching *Steeplechase Swings,* issued in 1935, Marsh returns to a more typical subject, which he delineates with unabashed exuberance and knowing draftsmanship.

A concentration on the figure itself, without background embellishments, has dominated the distinguished etchings of the painters Isabel Bishop and Paul Cadmus. In both paintings and prints Isabel Bishop has long been concerned with the human figure in its many attitudes and changing spatial patterns. Born in Cincinnati, Ohio, early in this century, she came to New York, where she enrolled in the art classes at the Art Students League. In 1920 she began her study of painting under the guidance of Kenneth

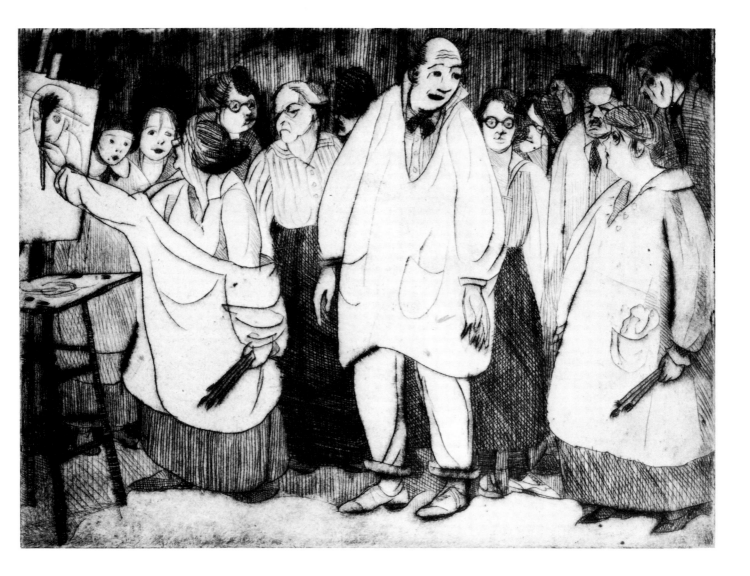

31 BACON, PEGGY (b. 1895), *The Bellows Class,* 1919. Drypoint, $5^{15}/_{16} \times 7^{15}/_{16}$ (15×20.1). Collection, The Brooklyn Museum, Dick S. Ramsay Fund.

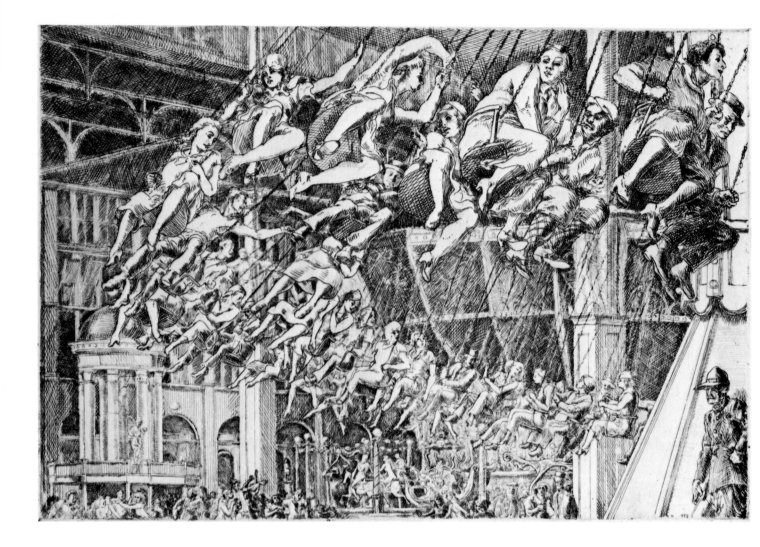

32 MARSH, REGINALD (1898–1954), *Steeplechase Swings,* 1935. Etching, 8⅞ × 12⅞
(22.6 × 32.7). Collection, The Brooklyn Museum, Bristol Myers Fund.

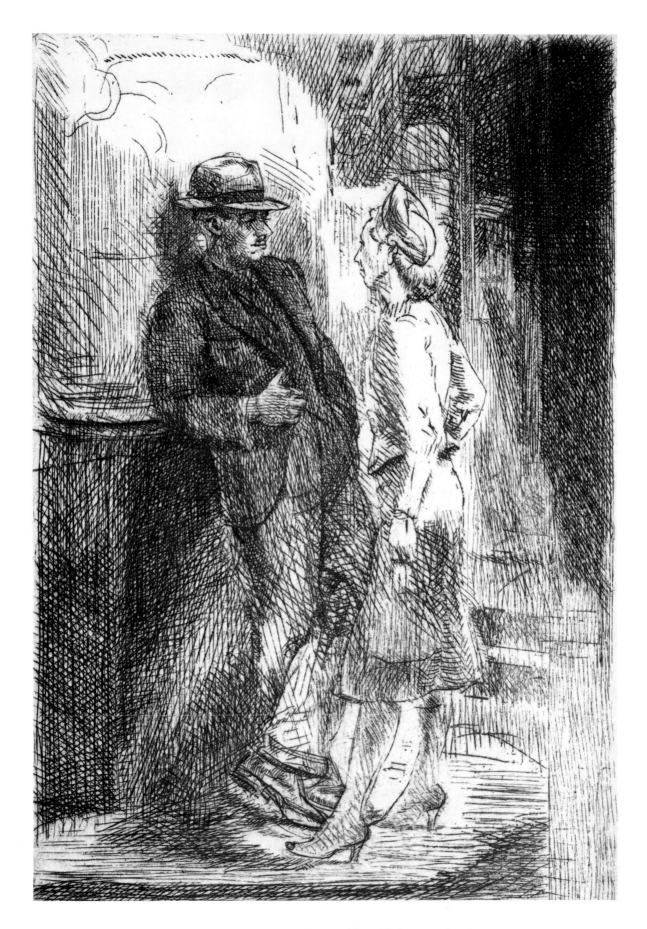

33 BISHOP, ISABEL (b. 1902), *Encounter*, 1939. Etching, 8⅛×5½ (20.7×14). Photo
courtesy Associated American Artists, Inc.

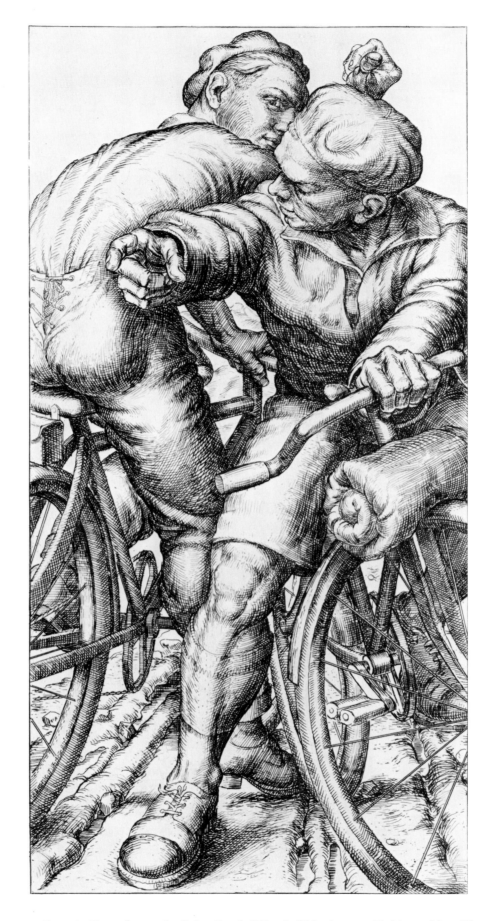

34 CADMUS, PAUL (b. 1904), *Going South (Bicycle Riders)*, 1934. Etching, 9¾ × 4⅞
(25 × 12.2). Collection, The Brooklyn Museum.

Hayes Miller and Guy Pène du Bois, who were then teaching at the League. Her first etchings were studies of the nude figure, completed in the mid-1920s. Much later she worked briefly at Atelier 17. Her fine draftsmanship is amply evident in the more than eighty etchings and aquatints that make up her present graphic oeuvre. For years she has observed the teeming life of Union Square from her studio. She has captured the casual moment or chance encounter as she ceaselessly delineates the many characters that seem to "inhabit" this busy square. She observes with delight the dalliance of loafers and "bums" who, she musingly notes, are "possibly America's only leisure class."

Although Isabel Bishop would disclaim any such comparison, her prints remind one of those small Old Master prints in which a single figure makes up the complete composition. The artist enjoys the casual manner in which people sit in public squares and lounge on monuments, and her prints and drawings reveal an informal charm rare in the impersonal environment of a large city. Among her earlier etchings are *Girls Sitting in Union Square Fountain*, 1936, and the well-known *Encounter* of 1939.

It is of special interest to note that Isabel Bishop consistently works directly from a model in her studio who assumes the pose of a specific figure that has caught her attention. The artist develops her etchings directly on the prepared copper plate with her etching tool, a method that obviously requires a disciplined vision and carefully controlled draftsmanship. When the plate is completed and printed, a photographic enlargement is made to the scale desired for a projected painting. This photographic sketch permits further study of the values and basic rhythms for the final composition. It is from this enlargement that the artist develops her distinguished and sensitively realized paintings.

The etchings of Paul Cadmus, approximately thirty in number, strike a firm but audacious chord which sometimes shocked but always intrigued an appreciative audience. His meticulous rendering of the human figure in action or in relaxed abandonment has seldom been equaled in American prints. His glittering draftsmanship is reminiscent of a sixteenth-century artist, but his statement bears the harsh impact of the twentieth century. He issued his first

prints in the 1930s. In subject matter they often follow his more formal paintings. Among his etchings are the raucous *The Fleet's In*, 1934, and the splendidly articulated *The Bicycle Riders*, sometimes called *Going South*, 1934.[15]

Wanda Gag was born in the small village of New Ulm, Minnesota, in 1893, of Bohemian-Hungarian parents. She came to New York "to become an artist." She studied at art schools in Saint Paul and Minneapolis and later at the Art Students League in New York. Her first one-man at the Weyhe Gallery in 1926 was well received. However, she earned but a precarious living in spite of the fact that she lived frugally in a small shack in rural Connecticut and later in New Jersey. Her sense of draftsmanship and composition led her to a very personal style in which she delineated severe interiors, kitchen utensils, and other everyday objects of austere country rooms lighted by a single lamp. In Wanda Gag's re-creation of selected facts she retains an indomitable feeling of exuberance in the midst of dilapidation. Her prints indicate an understanding of the stark realities of life. Her lithograph *The Stone Crusher*, 1929, becomes, in the creative imagination of the artist, a great gray caterpillar in its grotesque movement. She began her work in lithography, etching, and wood engraving around 1918 and continued them along with her painting and illustrating. All told, she issued some 125 prints, excluding the numerous illustrations designed for her own writings.

The art of satire and caricature has not been of special interest to the American artist. Nevertheless, the work of several artists should be noted—Peggy Bacon, Adolf Dehn, Don Freeman, William Gropper, Al Hirschfeld, and an earlier artist, Alfred Frueh.

Adolf Dehn, born in Minnesota in 1895, issued after his return from some eight years in Europe a number of highly satirical lithographs in 1929 and in the '30s. His first efforts in lithography had been in 1920, and since that time he has issued more than three hundred prints. Dehn's later work charts his continuing concern with pictorial composition and becomes larger in scale and more simplified in form. His handling of the lithographic medium gave to his prints the many nuances in tone usually found only in watercolor. In the 1960s, Dehn composed a few

35 GAG, WANDA (1893–1946), *Two Doors—Interior,* 1921. Lithograph, 11½×8⅝ (29.2×21.9). National Collection of Fine Arts, Smithsonian Institution.

36 DEHN, ADOLF (1895–1968), *Mayan Queen,* 1961. Lithograph, 27⅜×21⅛ (69.6×53.2). Collection, Virginia Dehn.

very large composite portraits of Mayan women, the result of many travels in Mexico. Their strong, blunt countenances have the elemental qualities of a majestic "landscape." Composed in color and also in black and white, they were issued in small editions of approximately thirty-five impressions each.

William Gropper's lithographs are almost entirely of political subjects, which he delineates with broad harsh lines. Among his most famous and perhaps controversial subjects are his series on the Supreme Court. Some of his prints noting special social foibles are exaggerated and raw in their biting satire. Many are extremely apt. His later landscapes are pleasant and technically brilliant, though they lack the sharp bite and boldness of his earlier work.

Another artist, Al Hirschfeld, issued lithographs of the Supreme Court which were more subtle but no less devastating. He perhaps is better known for his later drawings of stage and screen personalities.

During the uneasy years of the 1930s, many of the younger artists issued distinguished prints in a variety of idioms and graphic media. This wide range of ideas, expressed within the realistic tradition, is to be found in the prints of Gene Kloss and Doel Reed in the Southwest, Benton Spruance in Philadelphia, and George Constant and Ben Shahn in New York. Gene Kloss, although her work is seldom seen, has a large oeuvre of intaglio prints. Born in California in 1903, most of her life as an artist has been spent in Taos, New Mexico. Among her more than four hundred intaglio prints, those depicting Indian rituals and the landscape of the Southwest are the most distinctive. Her graphic work achieves its strength and its dramatic intensity through an astute simplification of forms and a deeply etched aquatint. Noted among her works are *Eve of the Green Corn Ceremony,* 1934, *Penitente Fires,* issued in 1939, and *Moonlight Circle Dance,* a drypoint of 1956. Now in her seventies, Gene Kloss still issues intaglio prints. They are landscapes—mountains, rocks, and great trees shaped by the winds and sands of a country she so surely understands.

Primarily a painter, George Constant issued a number of fine portrait heads. He worked almost exclusively in drypoint, a medium that well suited his skills as a draftsman. Born in Greece, he studied at the Art Institute of Chicago and later with George Bellows in New York. His themes are in the modern classic tradition of portrait heads and still life with occasional landscapes. As an artist, overt social themes held small appeal for him, as may be noted in his drypoint, *Head of a Miner,* and the still life *Quince and the Grapes,* 1937.

Raphael Soyer came from a family where painting was an absorbing way of life. Born in Russia in 1899, he came to the United States at the age of twelve. His first etchings were issued in 1917. In 1930 and through the later decades he worked intensively in lithography. Few artists, employing conventional lithographic means, have achieved such subtleties in line and wash. The total effect of his lithographs and intaglio prints is one of deceptive simplicity. Soyer has been influenced by many artists, ranging from the Old Masters and the Impressionists to the Expressionists. However, these influences have been thoughtfully absorbed into his own imagery. His ability to capture the veiled intensity of an attitude or a shadowed emotion implements his unvarying style and point of view. Dancers, backstage personalities, models, seamstresses, and portraits (including a prolonged series of eloquent self-portraits) make up his graphic oeuvre of more than 125 lithographs and etchings. His prints have appeared with unfailing regularity and continue in the even tenor of a very personal idiom through the 1970s.

Martin Lewis, born in Australia, spent many of his early years on cattle ranches, in logging and mining camps and as an ordinary sailor. He arrived in San Francisco in 1900 and began his career as a painter there. In 1915 he issued his first etchings of New York City. His finely orchestrated compositions reveal a vision that is at once reflective and warmly realistic. Of his approximately fifty prints, his most familiar are *Haunted,* 1932, and *The Arc Welders,* 1937. The artist is equally capable of presenting the tensions of *The Arc Welders* or the enveloping silence of *Stoops in Snow,* 1930. His graphic work, mostly in drypoint, covers more than thirty years and extends through 1949. His carefully balanced prints often delineate the urban scene. Its ceaselessly moving figures and its silent shadowed streets are presented

37 KLOSS, GENE (b. 1903), *Penitente Fires,* 1939. Drypoint and engraving, 11×14⅜
(27.9×36.6). Photo courtesy Pratt Graphics Center and Gene Kloss.

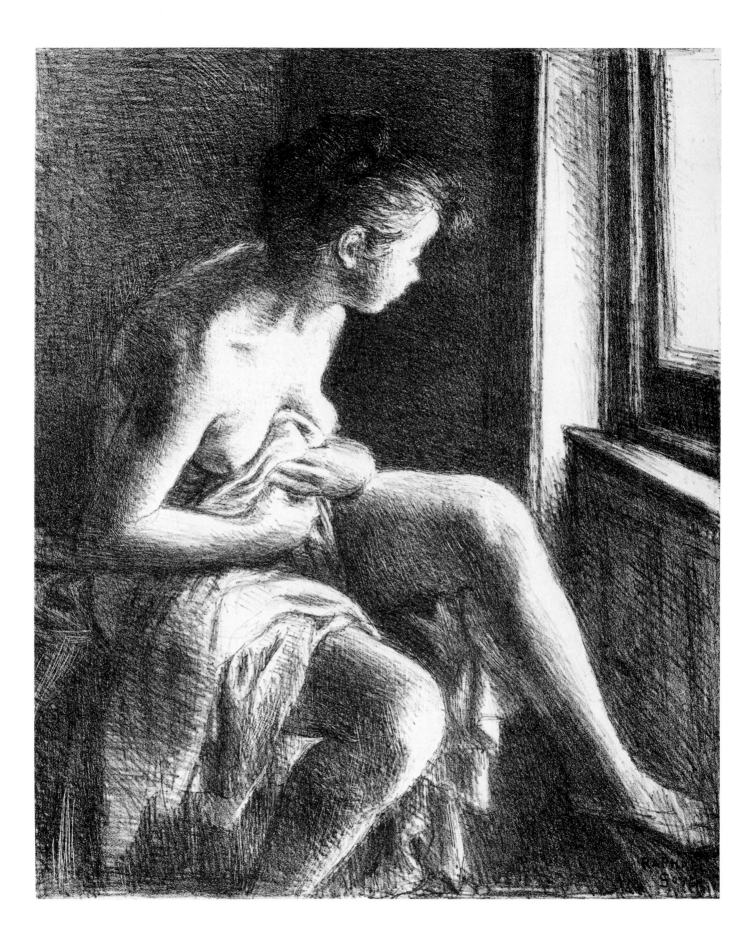

38 SOYER, RAPHAEL (b. 1899), *Toward the Light*, c. 1935. Lithograph, 15¼ × 12½
(38.7 × 31.8). Photo courtesy Associated American Artists, Inc.

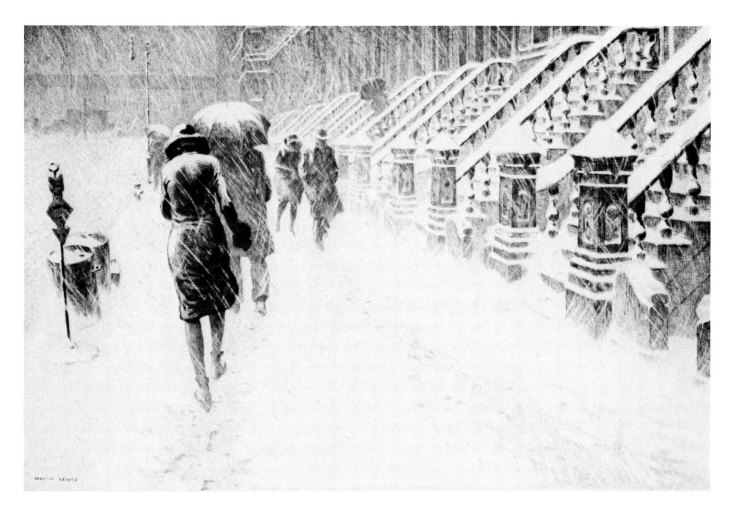

39 LEWIS, MARTIN (1881–1962), *Stoops in Snow,* 1930. Drypoint, sandpaper
ground, 10×15 (25×38). Collection, The Brooklyn Museum, Gift in Memory of Dudley
Nichols.

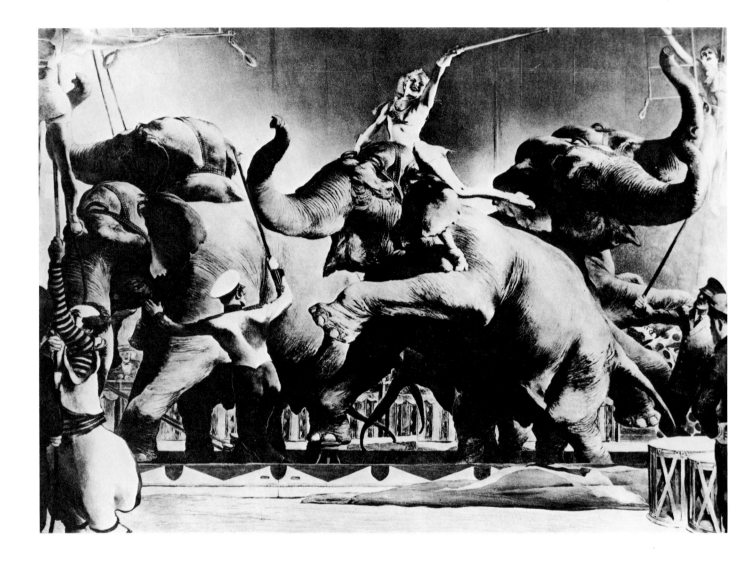

40 RIGGS, ROBERT (1896–1972), *Elephant Act,* c. 1937. Lithograph, 14¼ × 19½
(36.2 × 49.6). Collection, The Brooklyn Museum.

with a flawless realism. His direct observations and his technical skills were appreciated by his longtime friend Edward Hopper, who sought his instruction in the medium of etching.

A skilled lithographer, Robert Riggs worked principally in the 1930s and '40s. His subjects are the circus, sports, the accident wards in hospitals, and a few portraits. In 1934 he issued a series entitled *Hermit Priests;* in 1934 a group of prints entitled *Hawaii.* His solid draftsmanship is evident in his large lithographs *Elephant Act,* c. 1937, and *Accident Ward,* issued in 1940.

Victoria Huston Huntley has produced some 300 prints, mostly lithographs. Nonetheless, her work is largely unknown. She studied at the Art Students League and with John Sloan and Max Weber. Her early prints are concerned with urban and industrial landscapes in which details are eliminated to create abstract, silhouetted forms. Still later the more exotic landscape of Florida is cleanly delineated in nuances of black and white lithographic tones. Compositions of floral studies record the sharply observed essentials of their abstract structure. Her unpretentious prints were issued between 1930 and 1950.

Mabel Dwight viewed urban life and its tragi-comic innuendoes with an amused detachment. Her lithographs first appeared in 1927 during a sojourn in Paris. Her range of subjects include tranquil landscapes, portraits, and satirical comments, the latter exemplified by a 1933 lithograph entitled *Dance Macabre,* depicting Hitler, Mussolini, and Uncle Sam. Her graphic work was featured in the 1930s and '40s at the Weyhe Gallery, where it received much favorable attention.

Among the first of the oriental artists to enter the milieu of American art was Yasuo Kuniyoshi. Born in Japan, he came to the West Coast in 1906 at the age of thirteen. He moved to New York in 1910, eventually to become a highly respected painter and printmaker. Between 1916 and 1917, Kuniyoshi made some forty drypoints and etchings. Small figurative sketches, they often exist in a single proof and have the tentative quality of notations in a sketchbook. The artist abandoned this medium after the early 1930s. Apparently not satisfied with this venture, he brought them to his longtime friend and artist Bun-

pei Usui, with instructions to destroy them. Luckily, these instructions were not carried out, and the etchings remain a visual diary of an early period in the oeuvre of Kuniyoshi.

Meanwhile, he found that the lithograph was, for him, a more rewarding and expressive medium. In it he could achieve the subtle tones that were so much a part of his brush drawings. Beginning in 1922, and extending through 1949, he issued some eighty lithographs. His most productive period was during a sojourn in Paris in 1928, when he worked in the printing shop of Desjobert. He portrayed the female figure, whether seated at table or as an acrobat on a high wire in the circus, with skill and sensitivity. Among his lithographs of this period are *Girl Dressing, Two Acrobats,* and a number of fine still lifes. During the 1930s he continued to issue prints that were direct and simplified statements of his unique vision. In 1948, after a lapse of six or seven years, Kuniyoshi again returned to lithography. In these later compositions, a greater plasticity of line and a more severe imagery are apparent. Scenes and personalities of the circus and carnival still prevail but are supplemented by a number of deft landscapes. His lithographs were printed at George Miller's shop in New York and by the artists Emil Ganso and Grant Arnold in their studios at Woodstock, New York. Kuniyoshi's last compositions in lithography, entitled *Mash,* 1948, and *Carnival,* 1949, although somber and disturbing, are among his most eloquent graphic achievements.

John Winkler migrated to California from Austria, where he was born in 1894. As a young man he earned a modest living as a lamplighter in San Francisco in the days when gas lights lined the city's hilly streets. Perhaps his intimate knowledge of these out-of-the-way streets acquired from his lamplighter days served as a source for much of his work. His etchings were in the tradition of the day, although he had not seen the prints of Whistler or Pennell until the Panama-Pacific Exposition in San Francisco in 1915. Working directly from nature, he produced etchings and drypoints that are delightfully free and engagingly whimsical. Sensitive draftsmanship is evident in his ability to place the figure within a specific landscape with remarkable ease and assurance. His excellent series on small shops—*The Ginger Shop,*

41 KUNIYOSHI, YASUO (1893–1954), *Carnival,* 1949. Lithograph, 15¹¹⁄₁₆×9¾
(45×24.8). Collection, The Museum of Modern Art, New York, given anonymously.

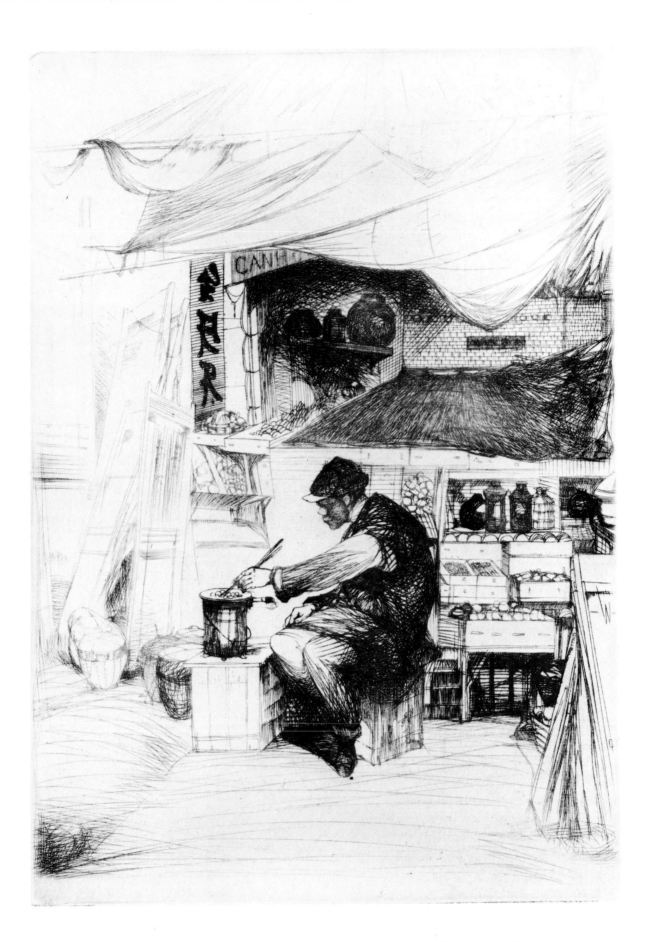

42 WINKLER, JOHN (1894–1979), *Chou Seller,* 1919. Etching, $7\frac{1}{2}\times5\frac{15}{16}$ (19×15.1).
Collection, The Brooklyn Museum, Gift of the Estate of Louis E. Stern.

The Delicatessen Maker, and *Chinese Shop*—have a crisp precision.

Occasionally when Winkler found a subject of special interest, he issued both a small and a large plate, as was the case in *The Ginger Shop* and *The Delicatessen Maker.* The small plates were completed in 1916 and the larger ones issued in 1922. In 1922 Winkler traveled to Paris, where he found in the small teeming streets of the Latin Quarter much to hold his attention. While in Europe he made another 100 etchings. He returned to the United States in 1930 to find many of his favored scenes vastly changed. As did a number of artists of the time, Winkler printed his own plates on old papers whose tones and textures he preferred. He issued his prints in a number of states and in small varying editions that were seldom dated. It has been noted that prior to 1918 he often signed his impressions in pencil in the lower right margin. After his return from Europe in 1930, his signature usually appears in the lower center margin of the sheet. His total graphic work is composed of more than 400 individual titles, including some 200 of San Francisco's Chinatown. In contrast to his work in prints, Winkler also carved a number of boxes during the years between 1933 and 1957. Some were odd shaped and covered with semiabstract compositions.

The impact of the American scene had influenced countless artists. Nevertheless, there have been those who sought out and presented a more eclectic point of view. The prints of Emil Ganso stand out for their scope of subject matter and technical range. Ganso was born in Halberstadt, Germany, in 1895 and arrived penniless in New York at the age of twelve. With indomitable perseverance he continued his early interest in drawing and began to learn English. After some years he came to the notice of Erhard Weyhe, bookman and art dealer, who encouraged him in his artistic efforts and who made it possible for Ganso to devote all of his energies to art. Largely self-taught, he came under the early influence of Jules Pascin, whose draftsmanship he admired. A painter and printmaker, Ganso practiced all the graphic media—etching, woodcut, wood engraving, lithography—and he experimented with stencil prints in color—a technique from which the screen print was developed. Ganso had a painterly approach to printmaking, which is especially noted in his lithographs.

His range of subjects was wide, and his many studies of the nude figure, still life, and pictorial compositions are in the tradition of European art. In the last ten years of his life he made more than fifty woodcuts and wood engravings, over a hundred etchings, and another hundred lithographs. His lithographs in color and in black and white show a brilliant use of the medium. Ganso was the first artist-in-residence to receive a full professorship in art at the University of Iowa. There he taught painting, and it was his pioneering interest and enthusiasm for graphic art that later led the University to set up a graphic workshop under the direction of Mauricio Lasansky.

Among the many works by Ganso are *Halberstadt I,* 1929, an etching with aquatint and drypoint, a woodcut entitled *Seated Nude,* also of 1929, a lithograph (tusche), *Eddyville,* 1935, and a nude figure entitled *Morning,* a soft ground etching and aquatint issued in 1939. His death in 1941 at the age of forty-six cut short a career entirely devoted to art, which he pursued with zest and devotion.

Throughout the decades of this century there have been important American artists who have given a lucid and timely vision within a modest but distinguished graphic oeuvre. Already mentioned are the prints of Max Weber, Edward Hopper, and Stuart Davis. To this group belong the drypoints, woodcuts, and monotypes of Milton Avery, who made his first drypoint plates in 1933, more as a happenstance than as a beginning interest in printmaking itself. He began by working on some small copper and zinc plates that had been discarded by a commercial printing shop. He found the furry drypoint line an appealing variation from that of his drawings. A larger and more ambitious drypoint entitled *Head of a Man,* 1935, was soon followed by a series of portraits including *Rothko with Pipe,* 1936, *Self Portrait,* 1937, and *Sally with Beret,* 1939. Two years later, in 1941, Avery composed one of his largest drypoint prints, entitled *Nude Standing.* Its strongly stroked lines accent the easy stance of a monumental female figure. A different but no less sensitive mood is found in his *Window by the Sea,* also completed in 1941, where a single trailing floral branch is held gracefully within the severe line of a window facing onto the sea. Its casual placement, balance, and understated imagery carry a nostalgic grace.

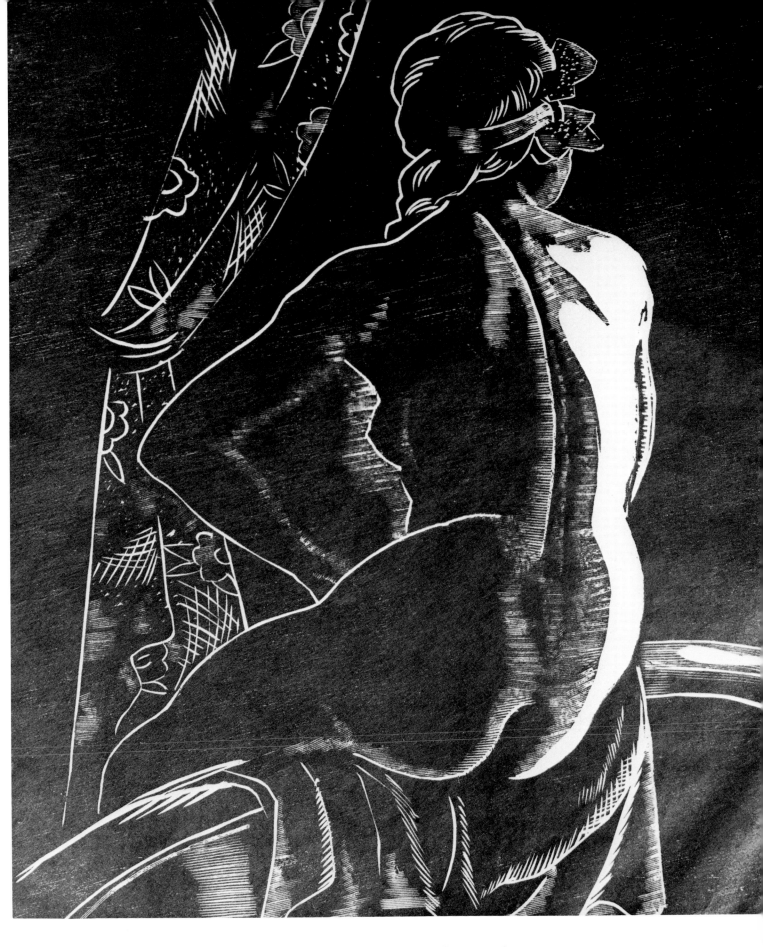

43 GANSO, EMIL (1895–1941), *Seated Nude,* 1929. Woodcut, 11½ × 9⅛ (29 × 23.2).
Photo courtesy The Brooklyn Museum.

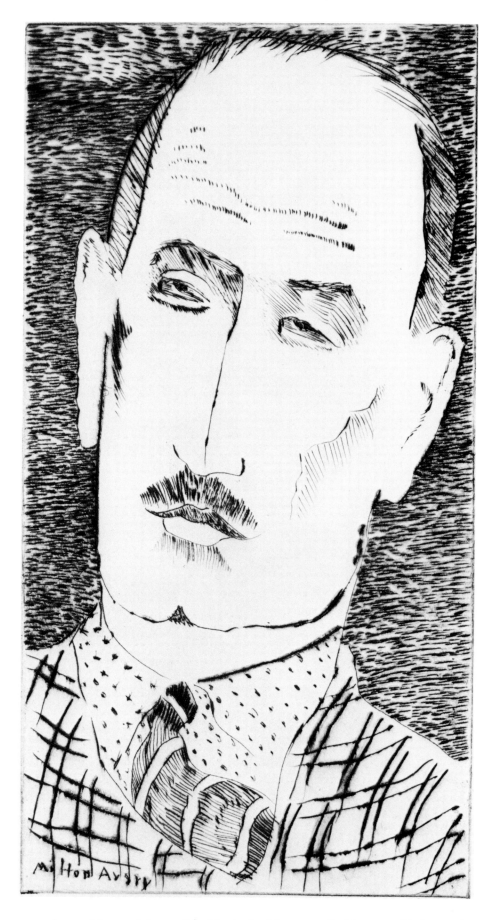

44 AVERY, MILTON (1893–1965), *Head of a Man*, 1935. Etching, 9×4¾ (23×12).
Photo courtesy The Brooklyn Museum.

MEXICAN INFLUENCE

A few artists in their pursuit of an authentic art in the 1930s turned to the Mexican artists, who were producing murals and prints in forceful Expressionist images that were challenging and revolutionary. Some artists traveled to Mexico to partake in this strong art movement. Also, they were guided by the very practical reason that they were able to live and work in Mexico in spite of greatly reduced or even nonexistent incomes in the United States. They were intrigued by the Mexican artists Diego Rivera, José Orozco, David Siqueiros, and others whose colorful visits to the United States were both notable and controversial. The Weyhe Gallery in New York held exhibitions of their prints and occasionally commissioned their woodcuts and lithographs. In 1936 Siqueiros set up a workshop in New York to explore experimental techniques and the testing of new materials for artists. He was joined in this venture by fellow Mexican artists Luis Arenal and Antonio Pujol. They fully understood the difficulties of working with inferior materials or the lack of access by artists to newly developed and available papers, printing inks, oil pigments, and the adaptation of applicable commercial items. In the United States there was much for the artist to choose from but few experiments or evaluations had been made. The Siqueiros shop attempted to explore and evaluate the many possibilities. It operated for a brief time on enthusiasm, ingenuity, and practically no funds. Aside from its strong political motivation, it demonstrated to artists the need for experiment and review of the new materials then available to them.[16]

NEW VENTURES

In 1933 a very different venture in the teaching of the arts was begun at Black Mountain College in North Carolina. It carried on some of the concepts of the Bauhaus in Germany. Among its faculty were Josef and Anni Albers. It received limited approval and some notoriety from the more conservative circles of education. Its small group of students eagerly participated in the new programs, ideas, and methods. It was the beginning of Josef Albers' long and influential career as an artist and teacher in the United States. It also gave encouragement and direction to some of the avant-garde artists whose work was to appear in the 1960s.

THE FEDERAL ARTS PROJECT

The national economic depression reached massive proportions in the 1930s, and the American artist was among the first to experience its effects. His professional efforts seemed expendable in these very lean years. Finally drastic measures became necessary.

In 1935, under the auspices of the Federal Government, the Works Progress Administration organized and set up graphic workshops as well as studios for painting, sculpture, and decorative arts in various cities throughout the United States. These workshops and studios were planned and equipped to give meaningful employment to the American artist whose livelihood had been wiped out in the prevailing crises. The largest and most experimental project served the greater New York area, where many of the artists lived. Each artist was assured of a regular income that permitted him to work in either his own or one of the Project's studios. This vast undertaking also supplied the artist with materials for his work and gave him an opportunity to develop new ideas and new forms of visual presentation rather than merely repeating works that the general public often

preferred. In turn it proved to be a liberal education in the arts for many individuals in communities that had never seen an artist engaged in his own work. Some of the more significant work was accomplished in the graphic studios or workshops of the Federal Arts Project during 1936 through 1938. The disciplines of the various print media demanded a clearly conceived composition and revived the interest in lithography and the woodcut and initiated the screen print in color. The latter was fashioned and developed from the commercial method by Anthony Velonis and Hyman Warsager in the New York WPA graphic studios.

REGIONALISM

In the 1930s a militant Regionalism whose principal focus centered in the middle western region of the United States was encouraged by the critical excesses of its chief spokesman, Thomas Craven. This proved to be of dubious value because it obscured the more laudable images and ideas of those artists whose work seriously attempted to envision the more significant elements inherent in the American scene.

In prints as well as in paintings the most popular exponents of regional art were Thomas Hart Benton, John Steuart Curry, Grant Wood, and John S. De Martelly. Their graphic works were confined to black and white lithography, through which their story-telling was presented in regional landscapes and portraits. This interlude was praised by a number of contemporary critics, who felt that at last the U.S. artist had come upon a truly "native expression" with a legitimate national theme. In the expanding horizons of American art it came to be a particularly limited point of view. Nevertheless, this trend was actively encouraged by regional committees, who suggested various historical themes for the murals, paintings, and graphic works that might appeal to a lethargic public taste. Also, some of the galleries, in their zeal to sell American paintings and the five- or ten-dollar print, encouraged artists to produce prints for the popular taste. The phenomenal success of this venture into regional art led many artists to join its ranks. At best, it was a faint echo of Mexican achievements.

Thomas Hart Benton was the most talented and colorful artist in the return to Regionalism. Born in 1889 in Missouri, he went to Paris in 1908 and absorbed with interest the more advanced modern work, especially that of Stanton Macdonald-Wright. Benton returned to the United States in 1912 and after World War I rejected the abstract trends in favor of native subjects, expressed in a highly personal style. Rumor has it that Benton had produced a few early abstract lithographs while in Paris, but these he destroyed when he renounced all nonrepresentational art. He found enjoyment and amusement in the native American themes and often turned them into a mocking, sometimes comic parody of regional or folk events. A knowing draftsman, Benton, along with Ivan Le Lorraine Albright, gave character, through their distorted images, to the usual bland expression found in the American scene prints of the day.

John Steuart Curry was born in Kansas in 1897 and studied at the Art Institute of Chicago. Later he came to New York, where he taught at Cooper Union and at the Art Students League. In 1926 he went to Paris but found little that interested him there and returned the following year. He first earned a living as a professional illustrator. He began lithography in 1927 but most of his graphic work falls in the 1930s and extends to World War II. Regional in subject matter, the print *John Brown*, 1939, is a typical example. *Circus Elephants*, issued in 1936, and a series of midwestern landscapes, are less illustrative examples.

Grant Wood possessed many of the homespun, shrewd qualities of a folk artist, to which he added a soft tonal posterlike realism. Highly successful, his prints and his paintings were awaited by an eager public before the ink or the paint was dry. Wood began making lithographs in 1937 and issued about

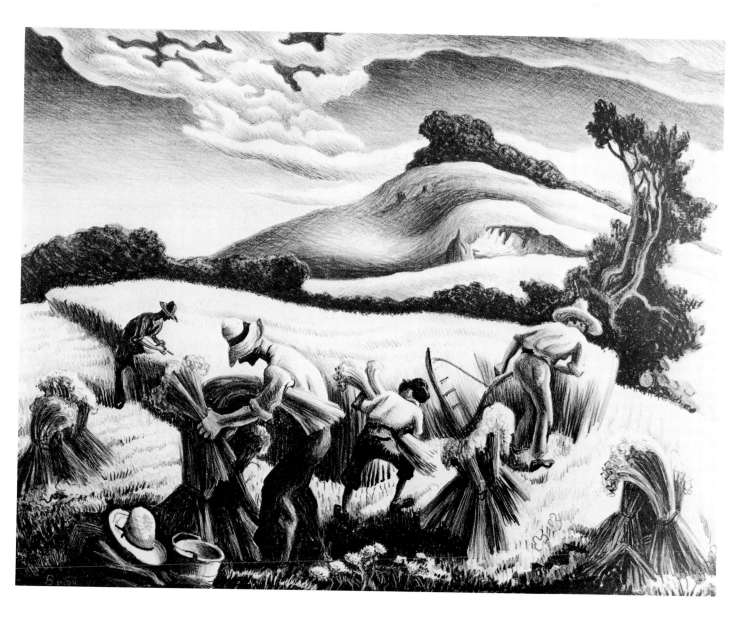

45 BENTON, THOMAS HART (1889–1975), *Cradling Wheat,* 1939. Lithograph, 9¾×12
(24.7×30.5). Photo courtesy Associated American Artists, Inc.

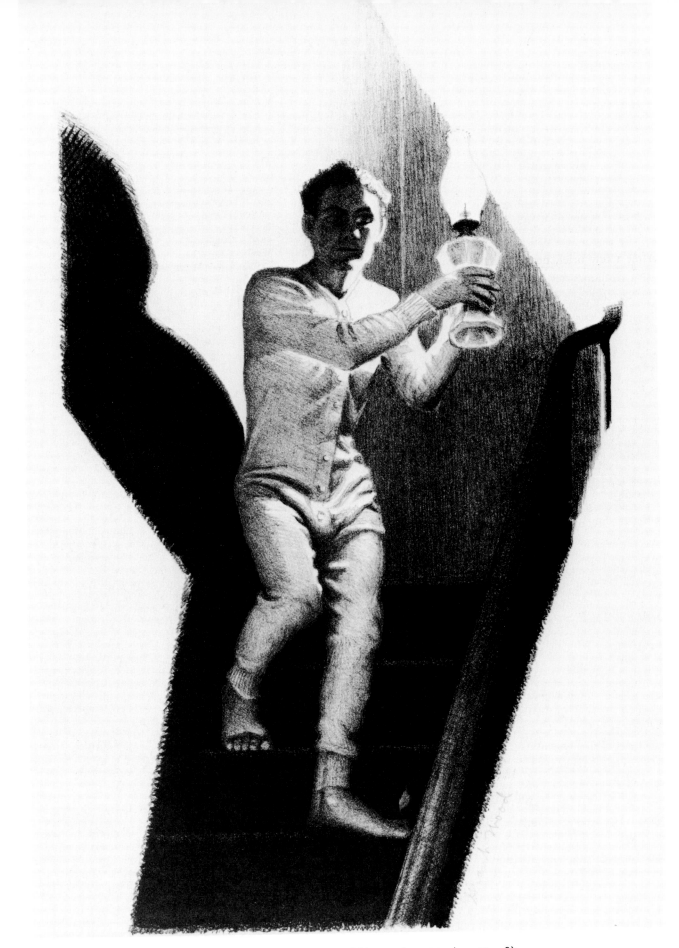

46 WOOD, GRANT (1892–1942), *Midnight Alarm*, 1931. Lithograph, 12×7 (30.5×17.8).
Photo courtesy Associated American Artists, Inc.

twenty during his lifetime. A somewhat unusual example is his *Midnight Alarm, 1931*. Another artist who developed his own brand of regional art was a friend and pupil of Thomas Benton, John De Mar-telly. His topical lithographs, like those of Benton, Curry, and Wood, were extremely popular, and the editions were soon exhausted at prices ranging from five to ten dollars for each print.

TOWARD AN ABSTRACT IMAGE

After a few brief, heady years regional art lost its appeal as a major expression in American art. A strong concerted reaction against its narrow precepts by knowledgeable and aggressive artists gave another and still more vigorous thrust to the movement of abstract art in the United States. This was evident in the new prints that began to appear in the Federal Arts Projects and in the work of individual artists.

Werner Drewes, whose training in art was at the Bauhaus in Weimar and Dessau, Germany, came to the United States in 1930. He had worked under the aegis of Klee, Kandinsky, and Feininger. In 1932 he issued a series of twelve woodcuts entitled *Manhattan*. Expressionist in style, they were viewed as a radical departure and a threat to the conservative prints of the time. Two years later, in 1934, Drewes completed a series of ten woodcuts under the provocative title *It Can't Happen Here* in a limited edition of twenty impressions. They were strong graphic statements in black and white and were among the earliest fully abstract prints created in the United States. Several years later Curt Valentin published the Drewes series of ten woodcuts based on rhythms and abstract images of the modern dance. Drewes continued to work in an abstract idiom, but the major part of his large graphic oeuvre bears the direct influence of German Expressionism.

Working in the mid-1930s, Charles William Smith began a series of geometric and semiabstract compositions in color that were printed from unembellished, movable blocks. These experimental works were carried to completion at Bennington College in Vermont, where the artist was teaching graphic art and painting. A selected number were printed on Japan paper in a limited edition in 1939–40. They were the forerunners of later woodcuts printed from movable blocks issued by Antonio Frasconi, Harry Bertoia, and a few others.

THE AMERICAN PRINT IN PUBLIC VIEW

An active and determined search for a new and more meaningful style in painting, sculpture, and prints led a dedicated but aggressive minority of American artists to abandon a representational manner of working and to create an abstract idiom whose images were strong, colorful, and "contemporary." Their growing awareness of the international abstract movement led to a consolidation of their efforts. In 1936 the American Abstract Artists group was formally organized by a number of young artists who no longer believed in the relevance of a romantic figurative tradition. They met with considerable resistance from traditional artists, dealers, collectors, and a number of critics. Their first annual exhibition was held at the Squibb Galleries in New York in April 1937. As a promotional effort, each of its thirty-nine members contributed a sketch or drawing that was then transferred to print by offset lithography at the Cane Press in New York and issued as a portfolio for sale at the exhibition for a mere fifty cents. The Abstract Artists hoped by this means of reproduction to obtain funds for future exhibitions and publications of their paintings and sculpture. In spite of the skepticism of many galleries and critics, the exhibition was a surprising success and traveled to other large cities. As an organization with a well-defined point of view, it continues today, and well-known artists, at some time in their careers, have been as-

47 DREWES, WERNER (b. 1899), *Untitled* from portfolio *It Can't Happen Here,* 1934.
Woodcut, 9½×12½ (24×31.7). Collection, The Brooklyn Museum.

sociated with it. Among its earlier members a sizable number have issued distinguished prints. To be noted are prints in a variety of graphic media by Josef Albers, Ilya Bolotowsky, Ralston Crawford, Werner Drewes, Lyonel Feininger, Perle Fine, Fritz Glarner, Peter Grippe, Fannie Hillsmith, Alice Trumball Mason, and Louis Schanker.

Several other events in the 1930s concerning prints should be mentioned. The American Artists Congress representing some three hundred professional artists assembled a large exhibition of one hundred contemporary prints whose editions were large enough to be exhibited simultaneously in thirty cities in the United States in December 1937. Many of the prints were the result of the Works Progress Administration projects. The exhibition entitled "America Today" measured the growing interest among both artists and public in the modern print as it portrayed both social themes and abstract ideas. Probably it was the most comprehensive showing of prints in the United States since the Panama-Pacific Exposition in San Francisco some twenty years earlier (see p. 11). Like the Armory Show of 1913, it was organized and presented by the artists.

The majority of the artists whose work is represented in the first three decades of the century ob-served the conventional methods of printmaking and a combination of several media was rare. This was partly due to the limited facilities and materials, especially in lithography, where closely guarded "secrets of the trade" occasionally hampered experimentation in techniques and ideas. The status of the American print was not generally acknowledged.

The Chicago Society of Etchers, founded in the first decade of the century, held its first exhibition in 1911. Thereafter it actively concerned itself with the modern American print and published a few editions by its members. In the New York area the Brooklyn Society of Etchers was founded in 1913 by artists John Taylor Arms, Pop Hart, John Sloan, Ernest Roth, and a few others. Later it was reorganized and its scope expanded. Finally it became the Society of American Graphic Artists and today continues to hold regular exhibitions.

Collectors and the larger museums often preferred the prints of established European artists. Among the public collections whose early acquisitions included American prints were the Library of Congress, the New York Public Library, the Boston Public Library, the Brooklyn Museum, the Philadelphia Museum of Art, the Museum of Fine Arts, Boston, and a few others.

CHAPTER II

THE 1940s AND 1950s

European Influences and Atelier 17 • Surrealism and the American Print •
Innovators and Experimenters in Ideas and Images • Partisans and Visual
Poets • Print Organizations and Exhibitions

EUROPEAN INFLUENCES AND ATELIER 17

The decade of the 1940s opened with war spreading over Europe and the active involvement of the United States. It curtailed the work of some of the more creative artists, but it also brought an influx of new ideas and talents from Europe and Latin America. The most forceful influences in American printmaking during this disturbing time were the establishment of Stanley William Hayter's Atelier 17 in New York and the appearance of a large group of young and also well-established European artists who came to the United States shortly before and during World War II. They brought to the American scene a knowledgeable and dedicated participation in the arts of their time. They enlarged the horizons of the American artist and gave a new dimension and international point of view to the professional artist in the United States. These artists, in turn, were influenced by a new environment, its sense of youth, its vitality, and its predilection for development and change. In this fluid milieu their own creative work changed and grew.

Hayter had first opened his modern graphic workshop in Paris in 1927 and through his own enthusiasm and determination held to high standards of craftsmanship which were brought to bear on the controversial visual idioms of the twentieth century. Hayter had been inspired by the work of the artist-engraver Joseph Hecht, who was then living and working in Paris. Hayter's ability to attract to his stu-

dio workshop the most talented painters and sculptors in Paris made his quarters on the Rue Champagne Premier a gathering place for many of the avant-garde artists. His own articulateness, his energy and professional authority attracted many painters and sculptors with Surrealist leanings. Hayter was not interested in printmakers as such but in artists who would employ and develop the print media as another means of creative expression. Max Ernst, Giacometti, Miró, Chagall, Lipchitz, Yves Tanguy, and, later, Braque, Picasso, Léger, and other distinguished artists came to the Paris Atelier 17 to participate in a new venture in graphic art. For a time the individual artists were submerged into a concerted effort and under the demanding tutelage of Hayter set a new course for twentieth-century printmaking.

Far-reaching developments were advanced during the fifteen years from 1940 to 1955 that Atelier 17 functioned in New York. This studio was a place apart. Hayter generated a new sense of craftsmanship and instigated new approaches to the printed image. Beginning in 1940 and during the years of World War II there congregated well-known European artists—Chagall, Max Ernst, Léger, Lipchitz, Masson, Miró, Tanguy, and others—who had worked with Hayter in his Paris Atelier 17. It was a time of excitement and the workshop's appeal to artists was extraordinary. The high standards of work, the lively discussions concerning the accomplishments of the

48 HAYTER, STANLEY WILLIAM (b. 1901), *Amazon,* 1945. Engraving, etching, soft
ground, 24¾×15⅞ (62.9×40.3). Private collection.

49 POLLOCK, JACKSON (1912–1956), *Untitled, No. 5* from series of seven, 1944–45.
Engraving, 12×9⅜ (30.5×24). Collection, The Brooklyn Museum, Gift of Lee Krasner
Pollock.

50 MASON, ALICE TRUMBULL (1904–1971), *Inverse,* c. 1946. Etching, aquatint, soft
ground, 7¾ × 10 (19.7 × 25.4). Collection, Philadelphia Museum of Art.

51 LANDECK, ARMIN (b. 1905), *Rooftops, 14th Street,* 1946. Engraving, drypoint, 8¼ ×
14 (21×35.7). Collection, The Brooklyn Museum.

great graphic artists of the past, and the reapplication of old methods combined with fresh ideas were widely felt. The application of various print media within a single composition dramatically enlarged the possibilities of the printed image. The problems of new forms, soaring lines, color, infinite textures, and the expanding size of the print itself were carried forward. Here were developed intaglio prints as deft and small as Fred Becker's *Hook and Eye* and as large as Peterdi's *Metamorphoses of Violence* and Lasansky's strident series *Eye for an Eye*. Lights often burned all day and far into the night in the cramped quarters of Atelier 17 as artists designed, etched, engraved, and printed their plates. Combined with this demanding activity was the age-old aroma of all printing shops—that of printing inks, stinging solvents, and dampening papers. Other artists were attracted to this busy studio—also visitors and curious critics. Some came over from the neighboring quarters of "The Club" or from the Cedar Bar—many were New York's avant-garde artists.

The more conservative critics and artists who opposed Surrealism also disparaged the philosophy and methods of Atelier 17. A number of the more traditional printmakers felt threatened by the new trends and whenever possible excluded this work from the national exhibitions. The artists who were exploring the changing emphases and the possibilities of less conventional pictorial representation were well aware of the fact that their prints might be unsalable, but this problem was ignored in the pursuit of new images and techniques. It is of considerable interest to note that Atelier 17 in New York continued to operate for nearly a decade and a half without the support of special grants or other funding.

Hayter himself found time during these active years to issue many of his own finest prints. A number of artists who had worked at Atelier 17 set out with Hayter's encouragement to establish graphic workshops in other sections of the United States. Still others continued work in their own studios. For a few years after Hayter's return to Paris, Atelier 17 continued to function under the direction of Karl Schrag, followed by the duo-directorship of Terry Haass and Harry Hoehn and subsequently by James Kleege, Peter Grippe, and Leo Katz. During this time many more American artists worked in the studio. However, in 1955, when the building in which

Atelier 17 was located became earmarked for demolition, Hayter permanently closed the shop in New York and re-established it in Paris, where it continues at the present time.

Jackson Pollock, one of the artists who worked at Atelier 17, made his first lithographs at the Art Students League in the early 1930s. A few years later, between 1935 and 1938, he completed eleven black and white lithographs showing his interest in the Mexican painters and muralists Rivera and Orozco. Their influence is noted in his print entitled *Miners,* 1937. In 1944–45 Pollock worked at Atelier 17, influenced by Surrealism and the work of Picasso, Arshile Gorky, André Masson, and Joan Miró. He had studied the work of the Surrealists and that of Picasso and Gorky. At Atelier 17 he was familiar with Hayter's large etchings and engravings wherein flowing but turbulent lines filled the entire compositions. Special note may be made of Hayter's prints: *Myth of Creation* of 1940 and *Cruelty of Insects* issued in 1942. Pollock also observed with interest Hayter's experiment which called for a perforated container suspended above the canvas which, when filled with paint, could be swung in a variety of rhythmic motions over his canvas, leaving traces or arcs of color. This was one of many experiments conducted at Hayter's own nearby studio as well as at Atelier 17.

The Pollock plates executed at Atelier 17 in 1944–45 were not printed at the time save for a few trial proofs that had been pulled by Pollock and Hayter. It was not until the late 1950s that the Estate of Jackson Pollock undertook their publication. The seven plates were first sent to ascertain whether they were still printable, and Peterdi pulled several proofs from each plate, one plate being incomplete. The Estate then commissioned Emiliano Sorini to print formal editions. The six complete plates were issued in fifty numbered impressions each and one printer's proof on white Italian paper and ten numbered impressions on buff paper. The seventh and incomplete plate was printed in an edition of ten impressions and one printer's proof on white Italian paper and ten impressions on buff. Each impression carries the dry stamp of The Estate of Jackson Pollock. After this printing the plates were sealed and placed on deposit at the Museum of Modern Art, New York. In 1951 Pollock completed a portfolio of six screen prints, but

they lacked the directness of his drawings and his earlier etchings.

Alice Trumball Mason, one of the most gifted of the early abstract painters in the United States, worked at Atelier 17 in the mid-1940s. Although her graphic oeuvre is modest, her etchings are sensitive and demonstrate a fine understanding of the medium and of the abstract idiom. When an allergy forced her to discontinue her work in the intaglio print, she turned to the woodcut. Her prints, issued in small editions, are to be found in only a few public collections.

There was a small coterie of American artists who came to Atelier 17 for the much-admired technical knowledge of Hayter himself rather than for the international concepts of the modern print that so vitally interested him. Often these artists were well established in the field of American prints and pursued their particular imagery with conviction. Among this group the prints of Armin Landeck may be noted. Not a newcomer to printmaking, he had begun etching in 1927. His early formal training in architecture is to be seen in much of his work. This is especially evident in his handling of the soaring masses of his composition *Manhattan Canyon* of 1934. He worked at Atelier 17 in 1941, intent on acquiring a knowledge and technical proficiency in the demanding medium of copper engraving. Five years later, in 1946, Landeck issued one of his most distinguished prints, entitled *Rooftops, 14th Street*. It records his special ability to delineate the oblique perspectives and architectural details of the miscellaneous buildings that line the streets of a large metropolis. A crisp objectivity and a disciplined craftsmanship characterize the more than 127 prints that comprise his graphic oeuvre.

SURREALISM AND THE AMERICAN PRINT

At Atelier 17, American artists were making prints that reflected their interest in Surrealist images. These included Alice Trumball Mason, Fred Becker, Lee Chesney, Fannie Hillsmith, and others. Dorr Bothwell, an early experimenter in the screen print medium, also issued a number of Surrealist works. She often employed the heart symbol rendered in microscopic detail as part of her surreal compositions.

However, in the realm of prints, Kurt Seligmann remained Surrealism's most consistent and sophisticated exponent in the United States. Swiss by birth, he had joined the movement in Paris in 1929 and ten years later settled in New York. His graphic oeuvre extends from 1929 to his death in 1962. Although he worked in both etching and lithography, the precision of the incised line best suited the fevered intensity of his surreal imagery. When his Surrealist friends returned to Paris, Seligmann elected to remain in New York. He became thoroughly involved in the vast possibilities of the printed image. In order to achieve exactly what he desired he acquired his own etching press and sought further technical advice from his former printer in Paris. With characteristic thoroughness, he explored all the nuances of printing that might clarify his own work. Thus a very personal quality prevails in his etchings. In 1940–41, Seligmann issued a number of etchings, each of which was accompanied by the work of a modern poet. These were published by the Nierendorf Gallery in editions of from thirty to fifty prints. The majority of his single works were untitled and often unsigned. His total graphic oeuvre numbers approximately 125 prints.

Seligmann completed a portfolio of six large etchings in 1944 entitled *The Myth of Oedipus*. Published in an edition of fifty, by Durlacher Bros. in New York, it is one of his most authoritative works. His figures are rendered with a baroque fluency. Spiral rhythms and labyrinthian forms are the purveyors of themes of magic, heraldry, and mythology that occupied much of his art.

André Racz, working at Atelier 17, seriously explored the many pictorial elements in automatic methods in both intaglio prints and collages. His ambitious intaglio print in three colors entitled *Perseus Beheading Medusa VIII*, 1945, is a notable example.

52 SELIGMANN, KURT (1900–1962), *The Marriage* from portfolio *The Myth of Oedipus,*
1944. Etching, 25⅝×15⅜ (57.5×39). Collection, The Brooklyn Museum.

53 CASTELLON, FEDERICO (1914–1971), *Spanish Landscape,* 1938. Lithograph,
9⅞×14⅞ (25×37.7). Collection, The Brooklyn Museum.

At this time he issued a portfolio of small engravings under the title of *Reign of the Claws*. These were composed of sea creatures and their battles for survival. They represent the fine combination of a keenly observant eye and a skilled hand. His *Twelve Prophets,* a series of fourteen etchings, was published by Curt Valentin in 1947. The following year, he completed a second portfolio, also published by Curt Valentin, entitled *Via Crucis.*

According to André Breton, author of the first Surrealist manifesto in 1924 and activist in the movement, Surrealism's purpose was to present visual images of free association rather than an interpretation of the results. Directly influenced by the theories of Freud, its early advocates were intent on uncovering new resources of imagination and new images. The United States artists' background held few overt manifestations of Surrealist thinking, which was an integral expression in the lives of their counterparts in Europe and Mexico. In 1938, ten years after the large exhibition of Fantastic and Surrealist at the Museum of Modern Art, the Municipal Art Galleries in New York held their thirty-third exhibition of art. A New York critic remarked that "Surrealism overruns the print group" in this exhibition.

In New York, Surrealism's greatest impact came through the activities of the Surrealists-in-exile.

Among them were Matta, André Masson, Max Ernst, Tanguy, Miró, Kurt Seligmann, and Salvador Dali. In prints, the Surrealist expression was most evident at Atelier 17. Many of the Surrealists-in-exile had known Hayter in Paris, where his studio was full of the ferment of Surrealist discussions and graphic experiments. Now at the New York Atelier 17 they again found a warm reception. Gabor Peterdi, working at Atelier 17 in Paris, had issued his first engravings in Surrealist imagery. Later in New York he continued further graphic works in an expanding idiom.

Federico Castellon, a young painter in his twenties, completed a small group of black and white lithographs of Surrealist intent. These landscapes and figures, imaginatively composed and skillfully executed, were issued in a brief period in the late 1930s and early 1940s. Among the titles are *Self Portrait with Model,* c. 1937, *Spanish Landscape,* 1938, and *Of Land and Sea,* issued in 1940. His first etchings were completed in 1941 and for the ensuing decades form a major part of his prints.

Still another Surrealist artist, George Marinko, completed a group of paintings and a few lithographs depicting bent and twisted objects in strange compositions under the general title of *Orpheus in Agony.* The lithographs were issued in the early 1940s.

INNOVATORS AND EXPERIMENTERS IN IDEAS AND IMAGES

An unusually large number of American artists, in the decades of the 1940s and 1950s, produced relief prints or woodcuts of distinction and substance. They also were involved in the exploration of new images, ideas, and methods that were being developed in the middle years of this century. One of the most sweeping changes in printmaking has been in the size or scale of the individual print. Not until the mid-century were prints produced that frankly vied with large-scale paintings or even murals. Larger plates, blocks, papers, and printing presses of greater size carried the modern print out of its modest portfolio and onto a large expanse of wall space.

Color in its harmonies or strident dissonances has

been one of the chief characteristics of the mid-twentieth-century print. The neglect of the black and white print perhaps was caused by the insistent public demand for color. Although the black and white print often transmits a more powerful statement, it also demands more careful attention than many observers are willing to give to it. Another distinguishing feature of prints in the United States through the 1950s is that the works generally are printed by the artist himself and not by a professional masterprinter. Thus each print is uniquely the creation of the artist, and the edition is free from the often mechanical perfection of the professional printing shop. In fact, uniformity of an edition was not

what many artists were seeking. Today there remain many artists, especially in intaglio and the relief print, who prefer to print their own editions.

In 1940, Louis Schanker, whose woodcuts in color had first appeared in the later 1930s, began teaching his methods and new approaches to the woodcut medium to a small group of artists at the New School in New York. For a brief season Schanker and his fellow artists shared a small, cramped studio with Hayter's Atelier 17. Soon, however, such quarters became far too small, and Atelier 17 was moved to an independent studio in a nearby section of Greenwich Village. In 1942 Schanker began a long series of very large woodcuts in color that included *Don Quixote and Sancho Panza* and *Abstract Landscape*. In them he first explored the possibilities of printing a solid black on which he then overprinted other colors. The colors thus overprinted on undampened Japan paper have an enhanced richness and luminosity. *Carnival,* a woodcut issued in 1948, is a tour de force in the extended range of colors made possible by skillful overprinting and the controlled movement of abstract images in two-dimensional space. (See color illustration no. 1.) Schanker's intuitive sense of rich color and his ability to successfully employ it in his gouaches and woodcuts had a strong influence on his own painting and on those of his contemporaries. An intricate study in the movement of large, diversified forms within a composition is carried out in his woodcut *Static and Revolving,* issued in 1948. The intermingling of colors and large gestural circular images with many variations became the leitmotiv of Schanker's graphic work throughout the 1950s.

Boris Margo, working independently, issued many Surrealist etchings and cellocuts. He had arrived in the United States in 1930 by way of Canada, after a childhood and youth spent in Russia. In his student days his interest turned to the paintings of Bosch and Brueghel and to the romantic mysticism and luminous color of medieval icons which he observed in the museums of Odessa, Leningrad, and Moscow. A later concern with philosophies of the Far East and the scientific accomplishments of the western world have colored his mature work. These wide interests together with a thorough knowledge of painting,

sculpture, and prints have made him an exceptional artist and an inspiring teacher.

In 1932 Margo had begun his first experiments in what he termed the cellocut medium. Since that time he has developed this particular medium into a unique expression in twentieth-century prints. His first series, entitled *Portfolio of Early Cellocuts,* was completed during the years from 1932 to 1942. A second, *Portfolio Planned for Letter Press Printing,* contained twenty examples and covered a short period of his work from 1947 to 1949. This was a pioneer effort in which the artist employed the power press as a means of producing original prints from his own plates. Among Margo's early cellocuts are his *Space Ship* and *Night and the Atom,* both issued in 1946, which reveal his interest in nature and its resources.

In 1949 he issued an elaborate portfolio of large cellocuts entitled *The Months.* His imaginative invention and exploration of the medium and its vast possibilities combined with his own superb skill in printing made this series a high point in his work. Margo attempts to set down graphically some of the impersonal concepts and calculations of the scientist and engineer in terms of the personal and intuitive expression of the artist. The recording of light images, imaginary lines in the measurements of arcs of light, and the interrelation of translucent planes are frequently seen in his compositions. Clear primary colors emphasize the tensions and rhythmic flow of images in deep space.

In the more than 160 prints which compose his graphic oeuvre Boris Margo has not only created the image on the plates but also printed them. He is capable of controlling the printing press as he does a brush or chisel. He considers this total involvement in a particular metier necessary in the realization of his compositions. In the seeming simplicity and unobtrusive order of their calligraphic imagery the later cellocuts evoke a mysterious presence.

Spanning a long period of printmaking are the graphic works of Will Barnet, Max Kahn, and Benton Spruance. As teachers and artists they influenced and trained many younger artists in the various media of prints. Will Barnet, well-known painter and printmaker, is fully at home in all the media of modern printmaking. Early in the 1930s he experimented

extensively in both intaglio and in lithography. He became especially interested in the fluid results of sugar-lift ground aquatint. This was the same method that Picasso employed ten years later in his famous illustrations of Buffon's *Histoire Naturelle.*

Barnet's early prints show influences of German Expressionism and also the work of eighteenth-century American itinerant painters. His earlier prints mirror the ordinary patterns of family life which Barnet interprets with heartiness and pleasure. His figurative work of the 1940s, both in lithography and woodcut, charts his progress toward abstraction through a severe simplification of visual statement. His more objective imagery heightened by carefully articulated forms and free use of earth colors gave validity to his work. Barnet's prints may suggest a new approach to his painting, or they may implement ideas already carried to completion in his painting. In the period of the 1950s Will Barnet created a series of woodcuts in color, lithographs, and a few etchings. Among his abstract woodcuts of this period are *Province by the Sea* and *Wine, Women and Song,* both issued in 1959. Other abstract prints were issued during the 1960s and are among the most imaginative examples of his vast graphic oeuvre.

Antonio Frasconi is one of the most well-known and readily understood of the printmakers working in the United States. Born in Uruguay of Italian parentage in 1919, he spent the first twenty-six years in the seaport capital of Montevideo. In 1945 he was the recipient of a scholarship to the United States for study at the Art Students League. In the spring of 1946 he was given his first one-man exhibition of prints at the Brooklyn Museum. In the Latin American tradition of the woodcut or relief print so magnificently identified with Posada in Mexico, Frasconi concerns himself with a visual narrative of ordinary people as they pursue their lives in familiar landscapes and cities in America. This steadfast interest, Frasconi readily concedes, stems from his long admiration for the woodcuts of a spirited Uruguayan printmaker, Carlos González.

In 1944 Frasconi began working in the color woodcut and throughout many productive years has issued hundreds of prints and illustrated books. Fishing boats and nets in Maine, farmlands and vineyards, rows of vegetables on truck farms in California, the fish, fruit, and vegetable markets and the teeming life around Brooklyn Bridge in lower New York City— all are woven into the imagery of his woodcuts. Perhaps his most imaginative and sophisticated compositions appear in his *Don Quixote* series, 1949. The theme, well loved by Frasconi, is presented with both nostalgia and inventiveness and knits together his youthful years in South America and his mature life as an artist in the United States. In many of Frasconi's prints, he combines a regular printing block with smaller movable or repeat blocks within the composition. This method had been employed by Charles Smith and Harry Bertoia in an abstract idiom. Also it was employed in Frasconi's prints *East Wind* and *Rain.* He introduces color and textures not merely to enhance but to enlarge the plasticity of a print. His most effective woodcuts are those in which the subjective and objective elements are fused into a formal composition. He often records with fervent concern the personalities and events that measure the achievements or the shortcomings of contemporary society. This is noted in his Brecht series of woodcuts and etchings issued between 1959 and 1962. At this time he also completed at Tamarind a series of sixteen lithographs entitled *Oda a Lorca,* 1962. Frasconi, like his older Japanese counterpart Munakata, combines the sophistication of a professional artist with the directness of a folk artist. His extensive graphic oeuvre contains more than five hundred prints.

The prints of Seong Moy are free of the tensions and dissonances that often mark the creative expression of this century. Born in Canton, China, in 1921, he came to the United States ten years later to live with members of his family who had settled in St. Paul, Minnesota. Here he studied painting under the guidance of Cameron Booth. Since 1941, Seong Moy has lived in New York, save for three years spent as an aerial photographer with the United States Air Force in China. In this capacity he had an unusual opportunity to observe the contours of his native land. Although principally a painter, he has worked in the woodcut medium since he came to New York. He finds, as do a number of contemporary painters, that printmaking affords an opportunity to work out new ideas and experiments for painting.

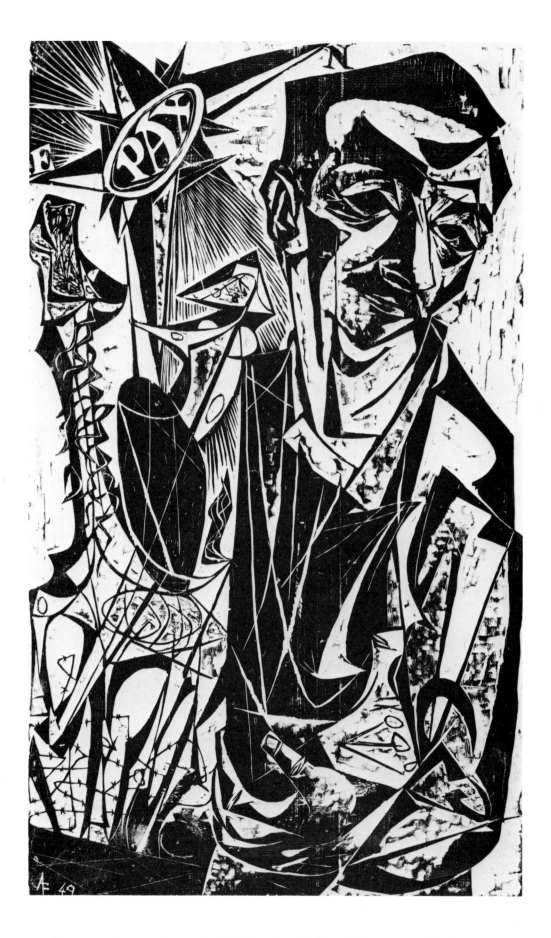

54 FRASCONI, ANTONIO (b. 1919), *Self Portrait with Don Quixote,* 1949. Woodcut, 33×18⅝ (84×47.5). Collection, The Brooklyn Museum.

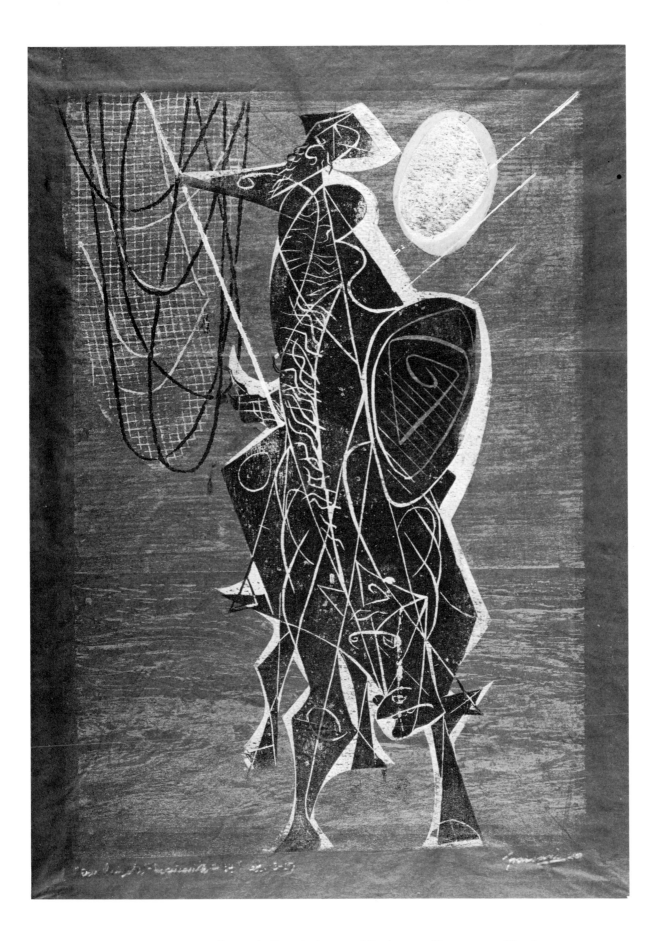

55 FRASCONI, ANTONIO (b. 1919), *Don Quixote and Rocinantes, No. 14,* 1949. Woodcut, 19¾×13¼ (50.2×33.6). Collection, The Brooklyn Museum.

Seong Moy has issued nearly 100 woodcuts in color to date. A medium well suited to the artist's temperament, it has been made a personal vehicle by Moy for his own particular abstract expression. The facility and seeming ease of his art recall his own Chinese heritage. Here, sifted through a highly creative temperament, are the deft skills and controlled strength that are required in fine calligraphy, and the disciplined movements and sustained symbolism demanded of the actors in the Chinese classical theater. His work is no slight patternmaking, but a full orchestration of living forms and subtle harmonies moving rhythmically within a prescribed space. His woodcut *Theatrical Personage,* 1946, is closely allied to his paintings of this period and contains within its long, narrow framework strong calligraphic rhythms heightened and enhanced by brilliant colors. In 1952 a portfolio of five color woodcuts was published by Ted Gotthelf in New York, in a limited edition of 225. This was an unusually large edition for Moy, as he prints his own work. Magnificently printed, it is a fitting summation of a decade of his graphic work.[1]

Concern for the many abstract images of landscape is noted in the woodcuts of Worden Day. Her professional training has included work at the Art Students League in New York and special studies with Maurice Sterne, Jean Charlot, Vaclav Vytlacil, and at Atelier 17. She has traveled and lived in many areas of the United States, from the Everglades of Florida to the sheepherding regions of the Northwest. In Wyoming, while teaching at the University, she converted a bunkhouse on a ranch near Laramie into a studio where she painted and completed a number of woodcuts. The surrounding mountains, with their geological variety and the elusive petroglyphs scratched on the stony slopes, have influenced her work. In the related development of her paintings, prints, and sculpture, Worden Day has held a preference for free, flowing forms and high-keyed colors. Through them she records her reflections and ideas concerning the changing moods and dramatic panorama of nature. The luminosity of clear colors and the lyrical movement of forms emerge from the textured surfaces into a mystical, floating world. She has said that executing a large woodcut is very much like playing a good game of chess. One must be able to think many steps ahead and maintain a sustained

effort toward a final goal. Although the artist has issued prints since 1937, the woodcuts that were done in the 1950s and '60s rank among her outstanding graphic achievements.

The artist has captured an aura of the past through suggested ancient symbols and muted colors. In the distinguished print entitled *The Burning Bush,* 1954, a different theme and mood prevails. In this tall, narrow composition, the primitive forms of her earlier work are fused with brilliant cascading colors in an unusual delineation of space. The movement of forms and the oblique perspective create an atmosphere reminiscent of Far Eastern painting.

Worden Day has experimented with what are termed "found forms." Thus in the *Mandala* series of 1957 she has used the rough, cross-cut end of a great log as the key block and has composed and cut other printing blocks which are superimposed on the printed surface created by the found block. (See color illustration no. 3.) This is not a haphazard work but a well-organized composition and demonstrates the astute perception and ingenuity of an artist who is capable of using seemingly unrelated elements to disclose memorable visual experiences. Her large-scale color woodcut, *Continental Divide,* 1962, is, perhaps, her most ambitious graphic work and is the forerunner of her present sculpture.[2]

Max Kahn, artist and teacher at the School of the Art Institute of Chicago, first inspired Misch Kohn, then a young student at the John Herron Art Institute in Indianapolis, to embark on a long and productive career in printmaking. In 1939, at the invitation of Kahn, he moved to Chicago, where he began extensive work in lithography at the graphic studios of the WPA Art Project. During the next five years he completed some sixty lithographs in color and in black and white and a small number of wood engravings.

Misch Kohn's graphic oeuvre covers a full range of the print media. His large-scale wood engravings are as deft as those of Georges Aubert, whose engraving skills so admirably recorded the many black and white compositions of Georges Rouault in Paris some three decades earlier. In Chicago, Kohn studied with Max Kahn and Francis Chapin and began wood engraving and lithography in 1939. Some years later, in 1943–44, he worked in Mexico at the Taller de

56 Moy, Seong (b. 1921), *Dancer in Motion* from *Rio Grande Graphics* portfolio,
Pl. 5, 1952. Woodcut, 16×11⅝ (40.7×29.5). Private collection.

57 DAY, WORDEN (b. 1916), *Burning Bush,* 1954. Woodcut, 51¾×12 (131.5×30.5). Collection, The Brooklyn Museum.

58 KOHN, MISCH (b. 1916), *Kabuki Samurai,* 1955. Wood engraving, 20×14¾
(51×37.5). Collection, The Brooklyn Museum.

59 YUNKERS, ADJA (b. 1900), *Aegean II,* 1967. Lithograph with embossment, 30×22
(76.2×56). Photo courtesy The Brooklyn Museum.

Gráfica Popular and assisted José Clemente Orozco in completing a large mural in Mexico City. In France, during extended sojourns, Kohn worked in the printing shop of Mourlot and the Auguste Clot shop. Large-scale wood engravings occupied his efforts from 1948 to 1955. Early in the nineteenth century wood engravings of a comparable size were attempted by the American follower of Thomas Bewick, Alexander Anderson. However, Anderson gave up his project when the large joined boxwood blocks cracked under the pressure of printing. The blocks that Kohn fashioned were sealed together with special adhesives that withstood these great printing pressures. His wood engravings average twenty by thirty inches in size and are usually printed on a lithographic press in editions of thirty. His use of dampened fine china paper laid down combined with extraordinary printing pressure produce sharp black and white contrasting forms which are actually embossed. The boldly incised forms and the repetitive rhythm give a compelling strength to his work. In Kohn's wood engravings, entitled *Hostile Landscape,* 1953, and *Kabuki Samurai,* 1955, the heavily embossed white areas appear as flashes of light in the dark mystery of his printed images.

Because of the great difficulties in obtaining large-scale engraving blocks of cross-grained wood and the enormous precision and physical effort required to engrave them, Kohn turned to the intaglio print, a medium he has employed with numerous variations since 1957. Among his many intaglio works are the *Three Kings* of 1957, an aquatint printed in relief, and *Oedipus,* a sugar-lift aquatint on zinc issued in 1959.

In the midst of the early development of the modern print Adja Yunkers came to New York in 1947 after having spent some ten years in Stockholm. Born in Latvia at the turn of the century, he moved with his family to Petrograd at an early age. His studies at the Art Academy in Petrograd (now Leningrad) were terminated by the 1917 Revolution. Of necessity he became a seasoned traveler and an enthusiastic wanderer. He lived in many European cities and made extended journeys to Africa, Morocco, Cuba, and Mexico. Thus he amassed a vast visual reserve of ideas, reflections, and contrasting environments. These experiences, augmented by an easy command of half a dozen languages, added maturity of vision and richness of imagery to his creative work. Previous to his arrival in the United States, he had already issued some twenty-five woodcuts along with many paintings. He worked briefly in New York, where he taught at the New School and served as visiting artist at the University of New Mexico.

Yunkers was greatly stimulated by New York—its twentieth-century atmosphere, its youthful, vigorous tempo, and its activities in the arts. The modern print was also much in evidence at Atelier 17 and elsewhere. Schanker's large woodcuts in color, Margo's new cellocuts, and Frasconi's woodcuts in his *Don Quixote* series added to the scope and liveliness of the new prints. During Yunkers' first year in New York he completed six woodcuts in color, among them an Expressionist work entitled *Still Life with Black Candle.* He also issued a number of unusual monotypes, a medium he later was to develop into a major expression.

In 1950 Yunkers set up quarters in New Mexico, where he was director of a new graphic workshop at Alameda, near Albuquerque. Yunkers responded strongly to the wildness of the desert country, its sudden storms, its heightened color intensities, its shifting forms, and its broken vistas. His new woodcuts and monotypes reflected these desert forms and intense colors noted in *Enchanted Meza* and in the large-scale *Pietà d'Avignon,* both completed in 1951. Among the many works created during this period was a very large-scale woodcut in color entitled *Magnificat,* 1952, a single great female figure that was the immediate forerunner of an ambitious polyptych of the same name.

After three years of work and two disastrous floodings in his studio, Yunkers returned to New York in 1953. He set to work at once on his great five-panel project, *Magnificat,* completed in 1955. Its imagery was derived from his own experiences and reflections —the joys and concerns of a life that ranged from Latvia to Leningrad, Morocco, Rome, Paris, London, Stockholm, New Mexico, and finally a return to New York. The central panel, designated as *Magnificat,* has fifty-six colors printed from eight blocks. Its flanking panels are titled: *Personal Epiphany* and *Chaos of Unreason.* Its outer panels further delineate the artist's concept and are called *The Power of Circumstance* and *The Graveyard of Cathedrals.* In total

the five large panels are a summation of the artist's theme "that the unit of man-woman is greater than the sum of the disasters that overtake them." The size of the work, an all-over expanse of fourteen by three and three-quarter feet, its multiplicity of colors, and its forceful imagery sustain and re-enforce its sweeping concept. Two years later, while on a Guggenheim fellowship in Italy, he produced his *Ostia Antica* series. (See color illustration no. 4.) Ostia, an ancient harbor town in Italy, still retains traces of old mosaics and remnants of temples, bridges, and trattorias. Its many levels of history appealed to the artist. He visualized in these romantic environs a microcosm of the past in the mellowed, burnished colors and fragments of architecture. He sought to capture the changing and nostalgic moods that seemed to arise from the airy vistas and blunt, worn sculptural forms. In the artist's large oeuvre his *Ostia Antica* series of woodcuts and monotypes ranks high among his most distinguished accomplishments.

Following the *Ostia Antica* series was a formal series of lithographs in black and white called *Skies of Venice.* Completed at Tamarind Lithography Workshop in 1960, this suite of prints contains nine large lithographs. Although light and color dominate the Venetian City, Yunkers chose to work with the disciplines of black and white. The resulting prints are remarkable in their subtle washes, in their range of tone, and in the movement of the constantly changing patterns of light. Since issuing *Skies of Venice,* Yunkers had been preoccupied with painting and collage. However, he has produced more than a dozen woodcuts, intaglios, lithographs, and screen prints that are closely related to his abstract paintings in their strict economy of means and restrained colors. His compositions hold layers of meanings, not always revealed at a first viewing. They build toward a realm of thought that seems to merge with an enveloping cosmos.

Anne Ryan's woodcuts in color appeared in the decade of the forties. A writer of poetry and fiction, a painter and a printmaker, she was active in the intellectual life of Greenwich Village in New York during the 1920s. The following ten years were spent in Europe, especially in Spain, writing and publishing short stories and essays. At the urging of Hans Hoffman and Tony Smith she returned to New York in the late 1930s to take up life as an artist. In 1941 she worked with Hayter at Atelier 17 and also worked with Louis Schanker in woodcuts at The New School. Her exceptional sense of color made the woodcut a preferred medium of expression. Her enthusiasm ranged through the entire field of art. She was directly influenced by the popular folk woodcuts of the sixteenth and seventeenth centuries, Georges Rouault's work, and especially the experimental ingenuity she found in the collages of Kurt Schwitters. Her woodcuts in color and monotypes were mostly issued between 1945 and 1949. (See color illustration no. 5.) Her exquisite collages, for which she is well known, cover the period from about 1948 until her death in 1954. Anne Ryan's compositions are orchestrations of visual poetry. Their structure and appealing color harmonies proclaim a rare lyrical affirmation of life by an exceptional artist.

John von Wicht has been described as "a complete example of the mature artist: technically consummate, serious, but at the same time youthful and revolutionary."[3] Born in Germany, where he received his formal training in art, he came to the United States in 1923. He was long established as an abstract painter before he seriously began printmaking in the early 1950s. He belongs to the group of nonfigurative painters who in their interweavings of abstract forms have searched out and developed new concepts of space. Von Wicht issued a few early lithographs but found that his ideas called for graphic works in large scale. Thus he began experimenting in the stencil technique, which allowed intermingling of forms and colors within many spatial levels. His orchestration of abstract images into subtle balances and sustained tensions has produced graphic compositions of exceptional authority and grace. Prior to his death in 1970, he was at work on large-scale screen prints which were a logical development from the earlier stencils and lithographs. He belongs to those artists who through a mastery of technique may then forget the demands of their métier and work with consummate imagination and intuition. His work, whether in painting, pastels, or in prints, retains its freshness and its authority.

Carol Summers began his work in the modern woodcut in 1950 at a flourishing time in American

60 VON WICHT, JOHN (1888–1970), *The Juggler,* 1963. Stencil, 71×35 (177.7×89).
Collection, The Brooklyn Museum.

61 CONOVER, ROBERT (b. 1920), *Collision,* 1958. Woodcut, 24×17½ (61×44.5).
National Gallery of Art, Lessing J. Rosenwald Collection.

prints. His formal studies in art began at Bard College under the guidance of Louis Schanker, whose earlier innovations in the modern woodcut Summers carried forward into a very personal statement. Later travels in Europe and the Orient extended his vision. Influenced by the landscape and ancient architecture of Italy and the unembellished forms of Italian primitive paintings, he had built his large woodcuts on symbolic extractions from nature into great chords of color. The large forms that compose his work are as carefully simplified as those of Jean Arp. His work has been compared to that of an earlier modern artist, Arthur G. Dove, whose "extractions" from nature are among the earliest abstract painting in the United States. Summers' colors are volatile and mist-like and are also reminiscent of the sweep of oriental landscape paintings. His sojourn in India and Japan brought a rich character to landscapes touched by symbolic suns. In order to obtain a richness of image, Summers developed his own special approach to the relief print. He explains:

> "The prints were printed like a rubbing—a woodblock is cut in the normal manner, on plywood for size, and the paper is placed on the uninked block and the ink is applied directly to the paper with a roller. The print is thus a positive of the block. Color is built up slowly—the print always being visible during the process so that the desired intensity can be reached. The roller is applied carefully so that the ink only adheres to the paper where there is a solid backing, i.e., the raised image of the block . . . After printing the print is lightly sprayed with a solvent to set the ink into the paper fibers so that it functions more as a glaze than impasto."[4]

Summers' early woodcuts of the 1950s are a few in black and white and a number in simplified color. It is in the work of the 1960s that he utilizes a wide range of rich colors and large forms.

Robert Conover also began printmaking in the 1950s employing the conventional woodcut and cardboard relief methods. His strongly structured images are geometric in form and large in scale. His compositions are printed in rich blacks and often carry an assisting color in clear blues, yellows, or reds. Among his notable oeuvre are *Vertical Structure,* 1955, and *Collision,* 1958. His graphic work continues in two decades.

Arthur Deshaies, painter and printmaker, studied in France and spent a number of winters at the MacDowell Colony for creative artists in Peterborough, New Hampshire. He has also traveled extensively in the Mediterranean regions and in Mexico. An inventive and prodigious experimenter, he has issued etchings and large stencil prints and has worked in the demanding medium of wood and lucite engraving. His *Landscape Sign,* an engraving of lucite, and *The Alchemists No. II,* a wood engraving, were both issued in 1954. The engraving entitled *The Death That Came for Albert Camus,* issued in 1960 soon after the death of Camus in an automobile accident in the South of France, is one of Deshaies' most forceful prints.

Early in the 1950s Edmund Casarella and James Forsberg, working independently, began extensive explorations into the cardboard relief print. This was a method of building up forms rather than gouging out forms in a block or plate. Casarella's prints were elaborate abstractions in many colors (see Chapter III, p. 134). Forsberg's prints were simplified black and white images severely limited to the variations of flat circular forms that became pillar-like abstract objects set within a well-balanced composition. His prints differed considerably from the usual abstractions of this period. Unfortunately his modest work, issued in very small editions, is all too rarely seen.

Ralston Crawford, in both paintings and prints, envisioned and defined the basic structures in the scenes and events that captured his imagination. Born in the province of Ontario, Canada, he spent his youth in Buffalo, New York. As a painter, photographer, and printmaker he had a fine eye for the sharp-focus imagery of urban patterns of bridges, shipyards, and factories. He came to express the underlying rhythms of urban life in bold geometric images. A restless traveler, he was familiar with many regions of the United States and Mexico as well as Europe. Nothing escaped his observant eye and his enjoyment of the myriad patterns and thrusts of contemporary life. The conviction of his work lies in a simplified kaleidoscopic vision that records the images of the jazz musicians of New Orleans, the running of the Indianapolis 500, the blunt structure of the old Third Avenue El, the somber "penitente"

62 DESHAIES, ARTHUR (b. 1920), *The Death That Came for Albert Camus,* 1960.
Engraving on lucite, 19⅝×31⅝ (49.9×80.3). Collection, The Brooklyn Museum,
Gift of the Artist.

63 CRAWFORD, RALSTON (1906–1978), *Cologne Landscape, No. 12,* 1951. Lithograph,
11½ × 19 (28.8 × 48.5). Collection, The Brooklyn Museum, Dick S. Ramsay Fund.

processions in Spanish villages, or the atomic bomb explosion on the Bikini atoll. The integration of abstract images into balanced visual statements carries much of his own personal warmth and involvement. Tensions are created not for the fragmentation of a surface but for the realization of an underlying harmony and for uncluttered abstract compositions. Even in chaotic scenes a thoughtful order and sequence are maintained. During some forty-five years Ralston Crawford issued more than 120 lithographs, etchings, and screen prints. His favored graphic medium was lithography, mostly carried out at the printing shops of Mourlot and Desjobert in Paris in the 1950s and the 1960s.

In lithography in the 1950s other significant works were issued by Garo Antreasian, Perle Fine, Jose Guerrero, Paul Jenkins, Nathan Oliviera, Romas Viesulas, and June Wayne.

Artists recognized for their intaglio prints are Robert Broner, Lee Chesney, Minna Citron, Leonard Edmondson, Ernest Freed, Doris Seidler, and James L. Steg.

During this period pioneering work was accomplished in the new medium of the screen print, first known as the silk screen print or serigraph. Among the more unusual examples are to be found the prints of Sylvia Wald, Dean Meeker, Norio Azuma, and Richards Ruben.

The collagraph, a development in prints made possible by new plastic materials, lends itself to the many forms of abstraction. Artists who have successfully employed this medium are Glen Alps, Dennis Beall, Roland Ginzel, Clare Romano, John Ross, and a few other artists.

Artists from Atelier 17 Enlarge Scope of American Prints

American artists who had worked with Hayter at Atelier 17 soon embarked upon their own individual careers. Some were appointed to new or recently established graphic workshops in widely distributed regions of the country. These studios were usually in art schools and universities. Others set up private studios. Among the most notable in this earlier group of artists are Gabor Peterdi, Mauricio Lasansky, and Karl Schrag. They exerted considerable influence on

intaglio printmaking in the United States through their own work and their individual interpretations of the basic principles of modern printmaking. Their recognition and understanding of the rich history and development of great prints since the fifteenth century and the force of their own creative vision have given a strong and lucid direction to modern prints in the United States.

Gabor Peterdi, a Hungarian-born painter, spent several years at Atelier 17 in Paris, where he explored the exacting art of burin engraving. When it became evident that France was to be embroiled in another war, Peterdi, as did many of the foreign-born artists then living in Paris, decided to emigrate to the United States. In August of 1939 he arrived in New York and later entered United States military service. After World War II he returned to New York and resumed his painting and printmaking.

Among Peterdi's early engravings is the brilliant *Black Bull* series published by Jeanne Bucher in Paris in 1939. In it the artist acknowledges the probing visions of Surrealism as a liberating force in his growing oeuvre. Later, disturbing memories of war were evident in his line engravings *Still Life in Germany* and *Crucifixion,* both issued in 1946. His large etching and engraving entitled *Apocalypse,* 1952, with its thrusting lines and its allegorical implications, is a tautly stretched web that veils a symbolic death. Two powerful series, *Fight for Survival* and *Triumph of Life,* followed in the next several years. *Vision of Fear* mirrored Peterdi's disturbing reflections on man's ability to destroy life. Almost as an antidote to the withering destruction portrayed in *Vision of Fear,* another series, *The Web and the Rock,* enlarges on a more propitious theme.

In 1958–59 Peterdi produced more than a dozen large intaglio color prints whose explosive compositions are a visual record of fleeting, luminous moments in nature. These landscape prints include *Cathedral* and the *Big Summer* of 1958. A contrasting vision appears in *Burning Rocks* and in *Vertical Rocks* of 1959, wherein the artist embarks on a familiar theme but now presented in a more direct and simplified framework. With a few exceptions, Peterdi's prints are large in scale. His tools are the conventional burin, etching needle, and also the power drill. Occasionally he employs smaller movable

64 PETERDI, GABOR (b. 1915), *Vertical Rocks,* 1959. Etching, engraving, aquatint,
33×23 (84×58.5). Collection, The Brooklyn Museum, Dick S. Ramsay Fund.

65 LASANSKY, MAURICIO (b. 1914), *España,* 1956. Etching, engraving, aquatint, soft ground, 31⅞×20¾ (80.9×52.7). Collection, The Brooklyn Museum.

etched plates superimposed onto the basic plate to vary the depth of the printing surface and to permit a wider range of colors. These deft variations give an added richness to his imagery.

Karl Schrag, one of the artists who came to the United States from Europe shortly before World War II, was born in Karlsruhe, Germany, in 1912. He later lived in Geneva and in 1932 moved to Paris, where he spent some years. He studied at the Beaux Arts under Lucien Simon and later worked with Roger Bissière. Although Schrag had been interested in prints, he did not work in printmaking until he came to New York and began attending Harry Sternberg's classes at the Art Students League and later at Atelier 17. Schrag's early etchings chart his response to New York's accentuated tempo, its clamor, and its shifting crowds of people. In 1944 the artist composed a group of prints entitled the *Black Series,* devoted entirely to figurative themes. They are aquatints in black and white wherein the black of the aquatint creates the background that defines the moving figures. The drama is carried out by a few figures as the artist combines ideas of consolation, solace, and hope with his own dark meditations. This series is reminiscent of Expressionist tradition and the compassionate themes of Käthe Kollwitz.

When the artist first began working at Atelier 17 in 1945, he issued a number of landscape prints. At this time most of the artists were not concerned with concepts of landscape. Rather, their interests were in abstractions or in an implied Surrealism. Schrag's linear compositions brought a refreshing vision of the natural environment and its wide spatial patterns and changing moods. He has spent many summers on Deer Isle off the coast of Maine. He has traveled into other landscapes in Florida, Mexico, Martinique, Italy, and Spain. On occasion he has returned briefly to France and Germany. His sojourns in Mexico and Spain brought new and intensified color to both his prints and his paintings. He has observed that "vivid spots of very bright and strong colors do not only provoke surprise and increased involvement in the work, they may also gray down, make mysterious, or even momentarily silence all of the other colors in the print." This is evident in much of his graphic work and is present in *Lonely Heights,* 1955, and in his *Dark Trees at Noon* of 1961.

Mauricio Lasansky, born in Buenos Aires in 1914, comes directly from the Spanish-Latin American tradition. His father, a printer, migrated to Argentina from Lithuania early in the century. From 1933 to 1939 Lasansky studied and worked in his native Argentina, during which time he became director of the Taller Manualidades in Córdoba. Although closely identified with his fellow artists, he had little opportunity to see either great prints by Old European masters or the contemporary works of twentieth-century artists. A Guggenheim fellowship in 1943 permitted him to travel to New York, where for a year he avidly studied the extensive public print collections in that city. The fresh, early impressions of Goya's brilliant series of the *Caprichos* and the *Disasters of War* made Lasansky impatient to expand his own already highly competent graphic vocabulary. Thus in 1944 he joined the artists working at Atelier 17. The tremendous impact of Picasso's work keyed to the revolutionary forces in Spain and the ensuing war led Lasansky to thrust aside more traditional themes of social comment to embark on his own more vehement statements. His four-panel series of etchings *An Eye for an Eye,* issued between 1946 and 1948, reveals in harsh visual terms his concern with the many disparate forces at work in his time. Although the impact of Picasso's graphic work is evident, Lasansky's own involvement with his special métier and his reactions to the rapidly moving events of the time are uppermost. His most ambitious print of this period is *Pietà,* 1948. Its subtle, exceedingly rich colors glow with a dark brilliance. The limp figure of Christ and those attending ones in burnished tones give it a special intensity. It becomes Lasansky's tribute to the medieval *Pietà of Avignon.* In 1953 Lasansky spent a year in Spain and France. Several years later he issued *España,* 1956, a large color intaglio printed from a single plate in warm yellows and rich blacks. More simply stated than *Pietà,* it sums up in a single revealing composition his work in the United States and crystallizes his personal ideas as artist and superb craftsman.

Lasansky has long been concerned with the analytical problems and character traits revealed in the self portrait. One of his most expressive and artistically daring compositions is his large profile, *Self Portrait, 1957,* an engraving printed in the same manner as *España.* In it his concentration is on the head in pro-

file and the clasped hands, all held together by the thin tenuous lines that merely outline or suggest the torso. It is engraved on a magnesium plate, which permits neither changes nor corrections, in a tour de force of lines. A later full-length *Self-Portrait, 1959,* an intaglio print standing 5½ feet, and a smaller frontal *Portrait of an Artist,* 1961, well demonstrate his skills as a draftsman and his sharp analytical eye. Lasansky has issued a group of very large color intaglio prints portraying members of his family. In them intricate colors and carefully delineated lines approach the scale and the intent of paintings.

PARTISANS AND VISUAL POETS

Countless degrees and facets of representation characterize the figurative tradition in American prints in the decades of the 1940s and '50s. The artist may view his time with the zeal of a partisan or the lyrical sensibility of a poet. This is exemplified in the graphic work of Rico Lebrun, Leonard Baskin, Ben Shahn, Sid Hammer, Philip Evergood, Ben-Zion, Jack Levine, John Paul Jones, Milton Avery, and other artists whose work appears in later decades.

Rico Lebrun, a renowned muralist and draftsman, is less known for the few dozen lithographs he composed in 1945 and again in 1958–63. Some were studies for his mural *Crucifixion,* which occupied his creative energies in the 1940s until its completion in 1950–51. Born in Naples, Italy, in 1900, Lebrun came to the United States in 1924. His work must be considered against a background of Italian religious painting and his memories of his childhood in Naples, which he described as a town "of dream and delight and also of sordid life . . . of abysmal darks and dazzling lights."[5] The theme of tragedy haunts his work whether he depicts the Crucifixion, the terrors of Buchenwald, or the depths of Dante's Inferno. Probably, Lebrun's most familiar early lithograph is one entitled *Rabbit,* 1945, which, in its romantic connotation, ranks with Pablo O'Higgins' *Man of the 20th Century,* issued in Mexico in 1943.[6] The special theme of these compositions represent the artists' response to an age-old romantic vision of man as a wanderer or mendicant which Lebrun continues in his color lithograph *Ballad of the Wind,* 1945. It may be recalled that Eugene Higgins had often recorded this theme in the lonely moods of his etchings and monotypes. Antonio Frasconi in his *Don Quixote* series of the later 1940s and Norma Morgan in an etching and aquatint entitled *Tired Traveler,* 1950, graphically visualize this same theme. Still later, in 1962, Chaim Koppelman issued an etching entitled *Tiredness* in another version of man as a wanderer.

Leonard Baskin has long been recognized as both a gifted sculptor and a printmaker. Drawing his inspiration from the great humanists of history and from art and literature, he has stated that "the only originality is the originality of content." He aligns himself with that venerable company of moralists and partisans who concern themselves with human turmoil and the ultimate destiny of mankind. Baskin's immediate forerunners are Ernst Barlach and Käthe Kollwitz, whose works fall within the early years of the twentieth century. They chart, with withering clarity, the costs in human terms of industrial revolution, war, and religious persecution. Baskin looks with unblinking vision on war and its bitter consequences. In his sculpture and prints the artist has viewed with clinical objectivity the weaknesses of man and his ignominious death. His prints first received wide attention in the early 1950s when he issued a group of woodcuts in gigantic scale and disturbingly powerful in their immediacy of expression. His *Man of Peace,* 1952, and its grim companion, *Hydrogen Man,* 1954, were followed a year later by the *Hanged Man.* These works carry with relentless imagery the awesome theme of man's degeneration. In 1959 Baskin completed one of his most impressive compositions, *Angel of Death.* A macabre but commanding figure is orchestrated with a full composition of controlled lines and meaningful forms. In terms of his own stark and uncompromising images Baskin views mankind's dilemmas and also the occasional achievements. Although the artist has presented the human figure in exaggerated form, he has also fashioned small wood engravings in exquisite detail. His later

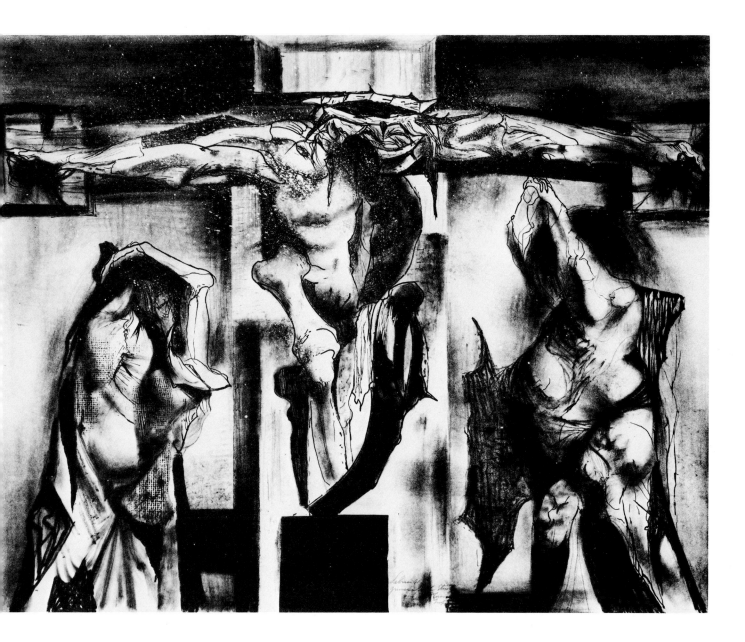

66 LEBRUN, RICO (1900–1964), *Grunewald Study,* 1961. Lithograph, 25⁹⁄₁₆ × 30⁷⁄₁₆ (65.5 × 77.3). Collection, The Museum of Modern Art, New York, Gift of Kleiner Bell & Co.

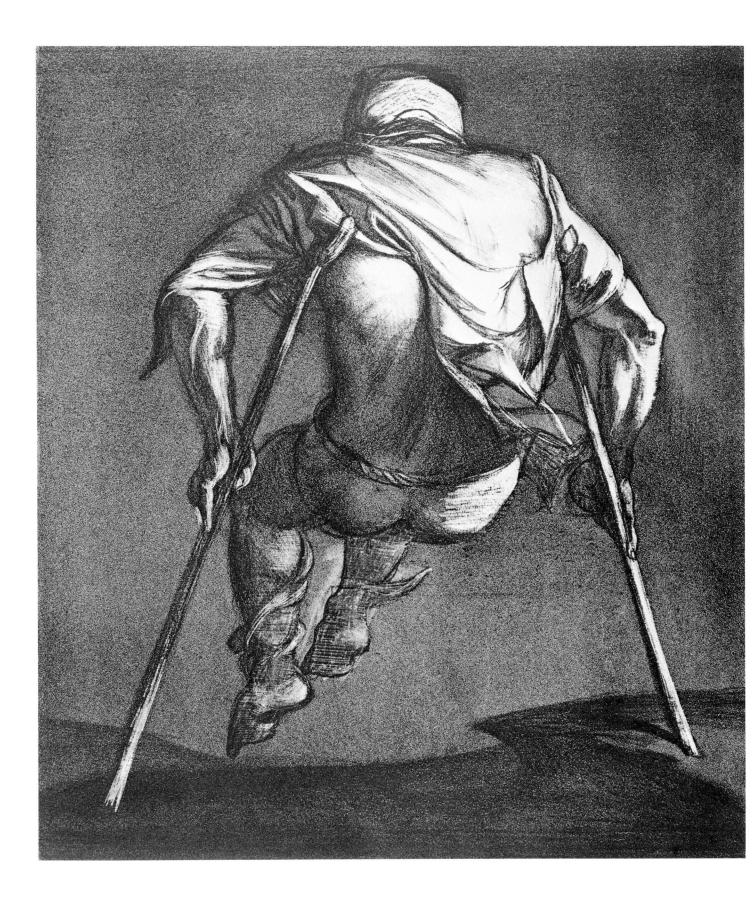

67 LEBRUN, RICO (1900–1964), *Rabbit,* 1945. Lithograph, 14⁷⁄₁₆ × 12⁵⁄₁₆ (36.5 × 31.3).
Collection, The Museum of Modern Art, New York, Spaeth Foundation.

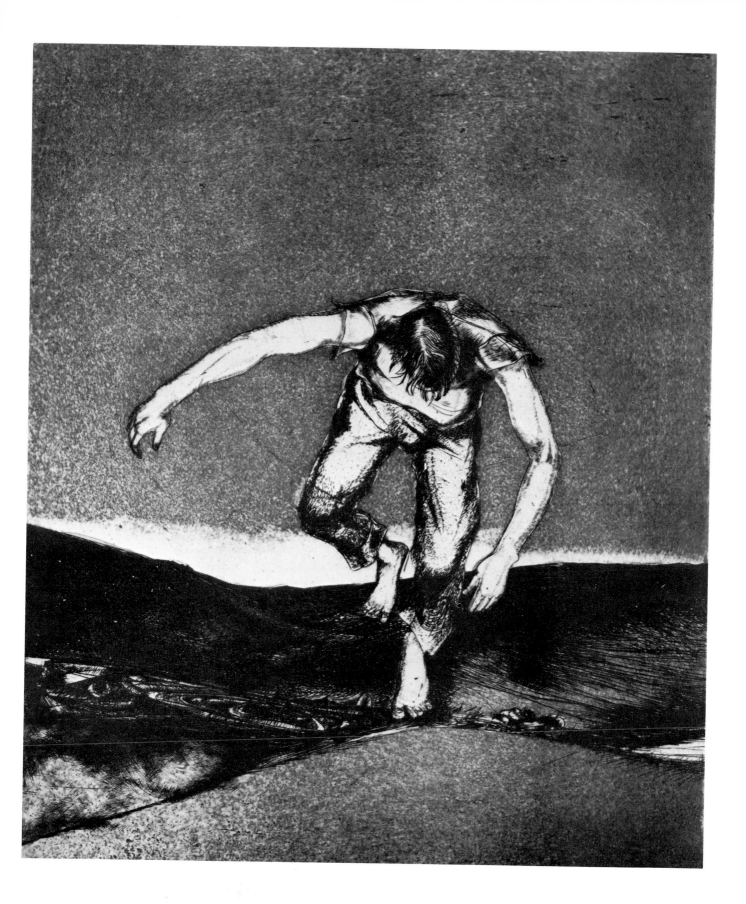

68 MORGAN, NORMA (b. Connecticut), *Tired Traveler,* 1950. Aquatint, engraving,
10⅛×8½ (24.8×21.5). Collection, Library of Congress, Prints and Photographs
Division.

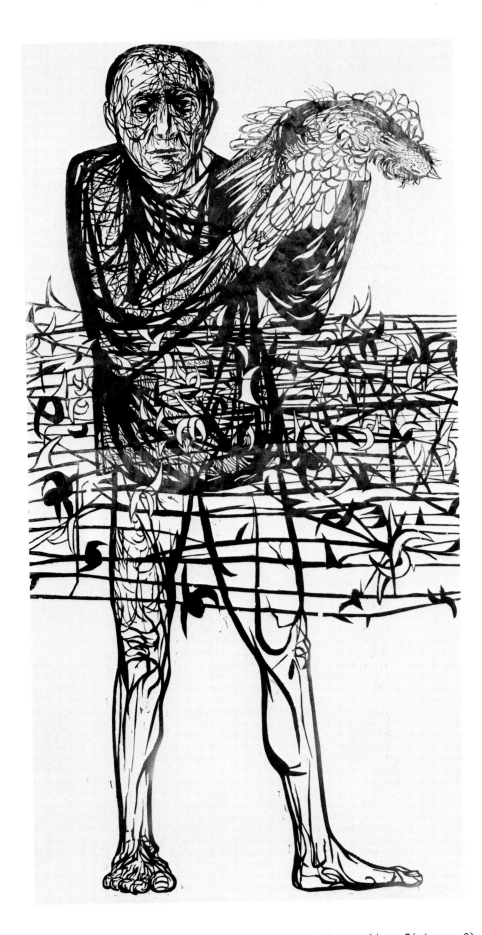

69 BASKIN, LEONARD (b. 1922), *Man of Peace,* 1952. Woodcut, 59½ × 30⅞ (151 × 78). Collection, The Brooklyn Museum.

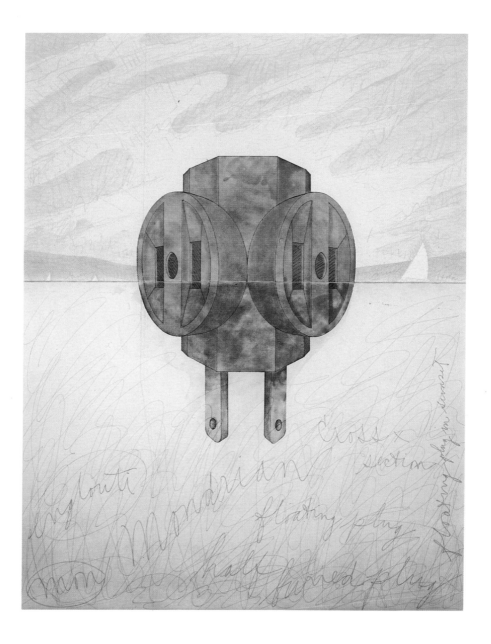

8 OLDENBURG, CLAES (b. 1929), *Floating Three-Way Plug,* 1976. Etching, aquatint, 42 x 32 1/4 (106.5 x 82). Photo courtesy The Brooklyn Museum.

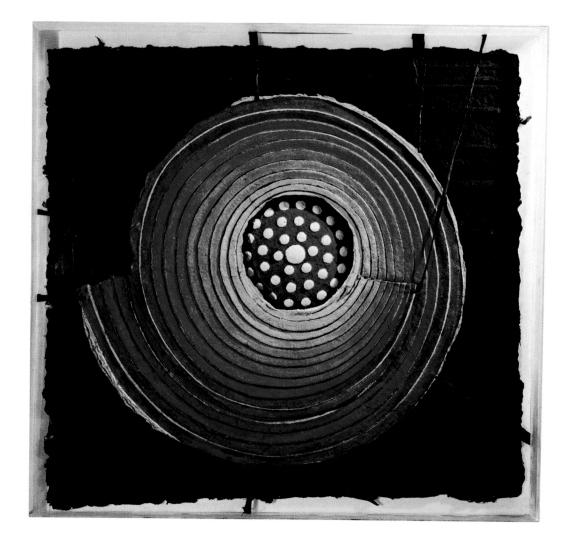

9 PONCE DE LEON, MICHAEL (b. 1922), *Succubus,* 1967. Cast-paper, collage, 22 1/4 x 24
(56.3 x 61). Photo courtesy Pioneer-Moss Reproductions Corp.

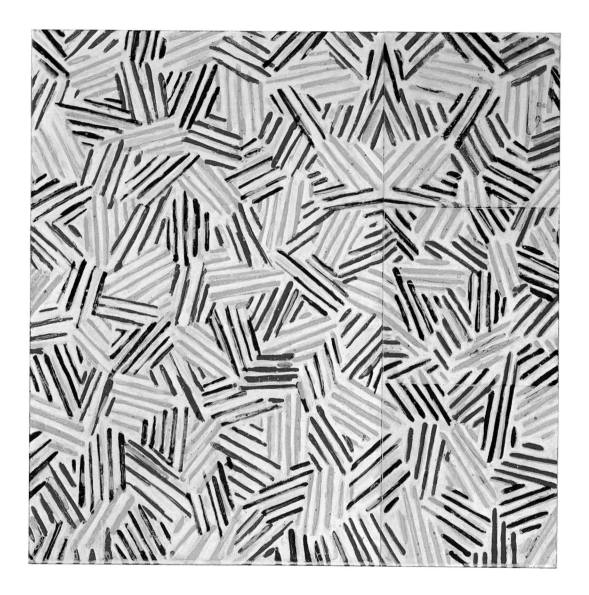

10 JOHNS, JASPER (b. 1930), *Plate No. 6 after Untitled*, 1975. Lithograph, 30 1/8 x 29 3/4 (76.5 x 75.5). Photo courtesy Gemini G. E. L.

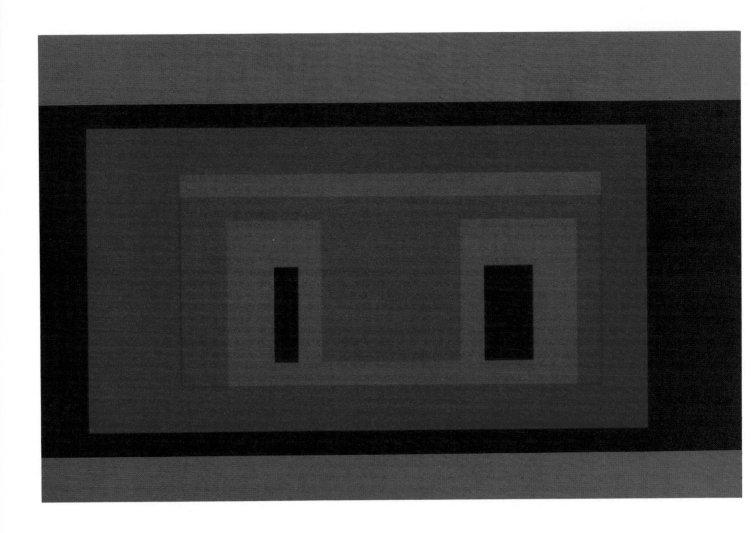

11 ALBERS, JOSEF (1888–1976), *Variant IX* from *Ten Variants,* 1967. Screen print,
17 x 17 (sheet) (43.3 x 43.3). Photo courtesy The Brooklyn Museum.

12 YOUNGERMAN, JACK (b. 1926), *Untitled,* Plate I from *Suite of Changes,* 1970. Screen print, 43 x 33 (sheet) (109.2 x 84). Photo courtesy Pace Editions.

13 PETERDI, GABOR (b. 1915), *Poppies of Csobanka I,* 1977. Relief etching and engraving,
23 3/4 x 35 1/2 (60.6 x 90). Photo courtesy Jane Haslem Gallery.

14 MOTHERWELL, ROBERT (b. 1915), *The Wave,* 1974–78. Softground etching with
collage, 31 x 26 (78.7 x 66). Photo courtesy Brooke Alexander, Inc., New York.

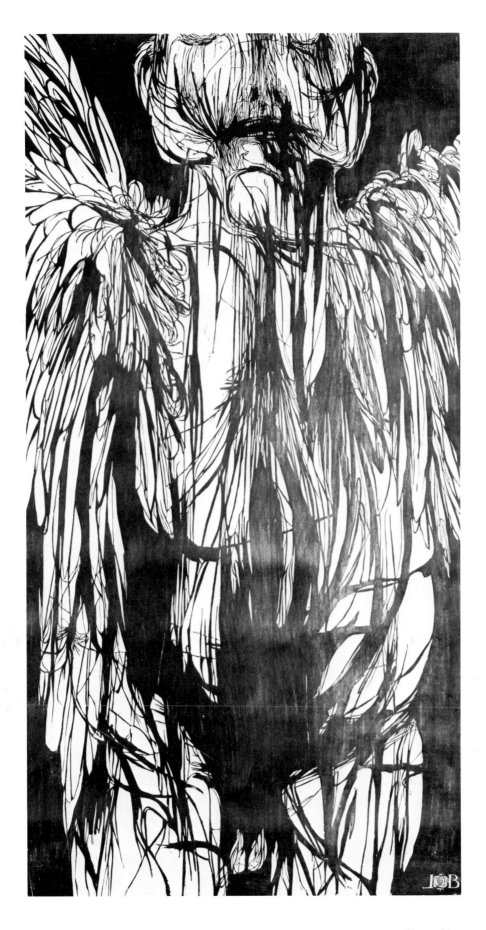

70 BASKIN, LEONARD (b. 1922), *Angel of Death,* 1959. Woodcut, 41⅝×30¾
(105.3×78). Collection, The Brooklyn Museum, Dick S. Ramsay Fund.

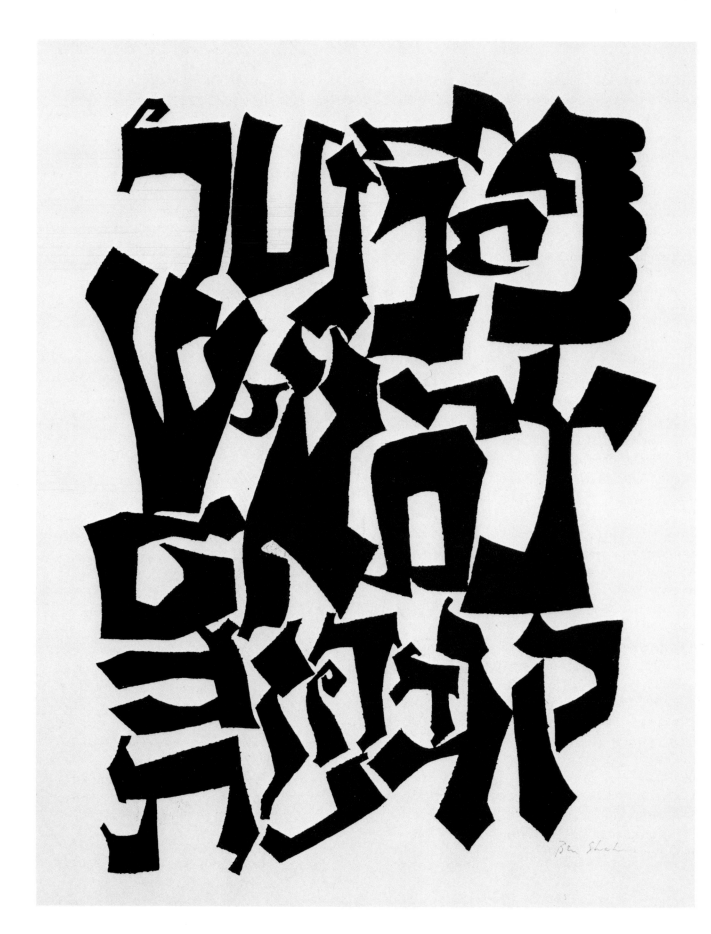

71 SHAHN, BEN (1898–1969), *Alphabet of Creation,* 1958. Screen print, 31×22
(78.5×56). Collection, The Brooklyn Museum, Dick S. Ramsay Fund.

graphic work has included intaglio prints and lithographs as well as wood engravings. Many of his intaglio prints are portraits of historical personages who, in the long tradition of humanism, have held for Baskin a special significance. In spite of a devoted following of younger artists, Baskin's work stands alone as a somber but eloquent visual expression of the moral turbulence of this century. He has remarked:

> "I should characterize my prints and drawings as didactic and moralistic, and trust they become so through the devices of what was once called 'significant form.'"[7]

Ben Shahn, long known as a painter and graphic designer, composed lithographs, posters, and screen prints. Early in 1931 he issued a portfolio of ten lithographs, *Levana and Our Ladies of Sorrow,* which were graphic comments on one of four essays in *Suspiria de Profundis* by Thomas de Quincey. Shahn was capable of distilling from a seemingly ragged line a sense of urgency and purpose. It delineated warmth and compassion and also indignation when the occasion or event demanded such a statement. Shahn held to a realist's vision, as recorded in the lithographs and screen prints that make up his modest oeuvre of approximately sixty-five lithographs and screen prints. He has captured with rare poignancy of observation the failings of his time and has reminded an indulged world of its weaknesses and its fragile sense of justice.

Whether he delineates a special event or a casual scene, his sense of humanity, enjoyment of life, and wide-ranging curiosity give to his graphic work that extends through the mid-1960s a special exuberance. His love for calligraphy itself is as deep-rooted as that of the Chinese painter-poets. Symbols of social inequalities, a field of grain, the head of a poet, a maze of market carts, and an ancient alphabet become his working graphic vocabulary. His drawings and prints influenced a generation of artists and his own writings proclaim the role of the artist. In a brief summation, Ben Shahn in his *Paragraphs on Art* states his own philosophy:

> "I think any artist, abstract or humanistic, will agree that art is the creation of human values. It may have cosmic extension. It may reflect cosmic abstraction, but however earnestly it reaches out into the never-never land of time-space, it will

always be an evaluation through the eyes of man. It may deny but can never cast off its human origin."[8]

Sid Hammer joins the partisans of his time, first as a painter and writer and later as a printmaker, whose vision of humanity is filtered through both the virtues and the misfortunes of society. Along with a number of individual prints he has composed several portfolios, including *Apocalypse,* 1961, and, subsequently, the series *Dance of Death.* Hammer found that intaglio was, for him, a sympathetic medium. However, he has not employed the conventional copper or zinc plate and the corresponding tools but a plastic sheet and a heated tool. The resulting technique he terms a thermo intaglio or thermo print. For his particular needs, he fashioned a number of small tools that were designed to be easily interchanged in the soldering iron.[9] A skilled draftsman, Sid Hammer, through provocative delineations of the human figure, attempts to express in such ancient themes as the *Dance of Death* his sense of the continuing tragedy of man.

Philip Evergood was first introduced to printmaking in 1924 at the studio of Philip Reisman in Greenwich Village, where he had access to Reisman's etching press. His early work was classic in theme and the figures were traditional. Perhaps it was his friendship with John Sloan that led him to the everyday scenes of the artist-reporter. In 1930–31 Evergood worked at Hayter's Atelier 17 in Paris. Thereafter, he was to continue prints as a regular accompaniment to his paintings. Influenced by Jules Pascin and Max Beckmann, he was guided by a concerned social awareness, noted in his etching *Portrait of a Miner,* 1938, and *Aftermath of War,* 1945. A skilled draftsman, he is capable of willful distortion to arrest the eye and to drive home a point. Among his later lithographs, *Cool Doll in Pool,* 1961, and *Self Portrait with Hat,* 1961, are notable.

A distorted "magic" realism haunts the paintings and prints of Ivan Albright, who views the American scene through a strangely sordid light. His figures and objects are achieved through the bizarre embroidery of surface textures. The French artist Jean Dubuffet has remarked with understandable fascina-

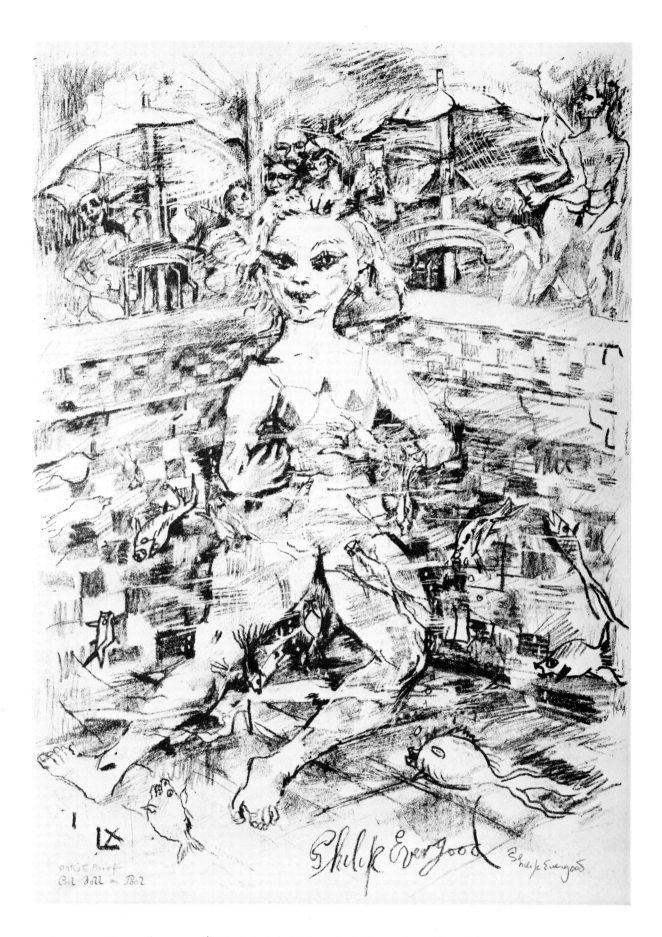

artist Proof
Cool Doll in Pool

Philip Evergood Philip Evergood

72 EVERGOOD, PHILIP (1901–1973), *Cool Doll in Pool,* 1961. Lithograph, 17½ × 12¼ (44.5 × 31). Photo courtesy Associated American Artists, Inc.

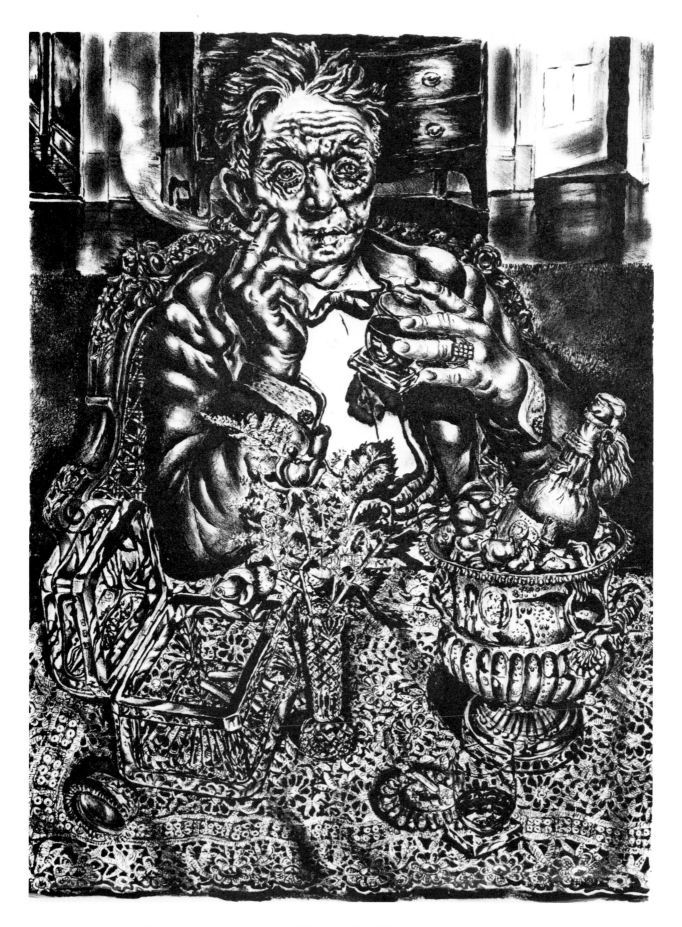

73 ALBRIGHT, IVAN LE LORRAINE (b. 1897), *Self Portrait: East Division Street,* 1947–48.
Lithograph, 14⅜×10⅛ (36.5×25.8). Collection, The Brooklyn Museum.

tion that the work of Ivan Albright reveals "the frightening liberty which all objects seem to enjoy—an abandoned world from which all authority has retired." He further observes that "each of the painted objects perpetuates its flowering without, it seems, the slightest thought of its surroundings."[10] Albright's lithographs were fashioned between 1931 and 1977. The early prints, completed before 1939, were original studies but in the later lithographs he turned to his own earlier paintings for inspiration. Among the fifteen subjects that compose his modest lithographic oeuvre are a few that exist only in several impressions, due to the breakage of the stone in the printing operation. In the late 1940s the Associated American Artists organization, which had embarked on a large print publishing program, commissioned Albright to compose three lithographs. Entitled *Fleeting Time Thou Hast Left Me Old*, 1945, *Self Portrait*, 1947, and *Follow Me*, issued in 1947–48, they were printed by George C. Miller in editions of two hundred fifty impressions each. In 1954 Albright's lithograph *Show Case Doll* also was printed by Miller and published by the artist. It continues to record Albright's unabated interest in decay and death in a delirium of objects. The print was based on his earlier painting of the same name completed in 1931–32. *Show Case Doll* commemorated those dolls that were waxen effigies dressed in the clothes of children who had died at a very young age. Such dolls, according to the artist, were manufactured in Thuringa, Germany, the original home of the Albrechts. It was customary to place them at the grave site or in shadow boxes in the home.

It was not until 1969, at the age of seventy-two, while serving as artist in residence at Dartmouth College, that Albright was persuaded to begin work in intaglio printing. Between 1972 and 1975 he completed five etchings and drypoints, among them *The Grover Etching*, freely adapted from an early portrait. Albright insists that he is not a Realist. His works are a mirage of fragments fully delineated in an unlikely disorder. Like the work of the later superrealists, Albright's prints have no central focal point. Albright's approach—unlike that of the superrealists—reflects an underlying alienation that is much more profound.

Ben-Zion, painter, printmaker, and sculptor, began his career as a poet in Poland and in Vienna. Born in the Ukraine, he came to the United States in 1920 and soon thereafter decided to become a painter. In the figurative tradition, his work reflects his continuing interest in ancient literature, legends, and the prevailing relevance of ancient myths. His first serious work in prints was in 1949 when, at age fifty-two, he began acquiring the rudimentary techniques of intaglio printing from Karl Schrag at the latter's graphic studio. It was at this time that an ambitious series of portfolios based on Old Testament stories and on ancient legends began to take shape.

His earlier portfolios were published by the distinguished art connoisseur and modern art dealer Curt Valentin. *The Pentateuch,* a series of etchings, appeared in 1950 in an edition of sixty-five. The second portfolio, entitled *The Prophets,* was published in 1952. A third combined the *Book of Ruth, Job, and the Song of Songs* and was issued in 1954. Ben-Zion's *Judges and Kings* was completed ten years later, in 1964. The latter was published after Curt Valentin's death by Graphophile Associates. The first four portfolios were printed by Lacourière in Paris. Each portfolio contains eighteen etchings or a grand total of seventy-two individual compositions in a unique graphic distillation of Old Testament themes.

In 1965 Ben-Zion completed a series of etchings entitled *The Life of a Prophet,* printed by Letterio Calapai in an edition of thirty-three and published by Graphophile Associates. The following year the same publisher issued Ben-Zion's series of thirty-six drypoints, a visual story of *The Epic of Gilgamesh and Enkidu.* This ancient epic unfolds with the strong cadence and spare eloquence of the artist's drypoint lines, which capture the essence of the Gilgamesh myth. The antique-toned ink mixed especially by the artist blends with the soft tone of the paper and enhances the artist's unerring vision and his technical accomplishments. This exceptional portfolio was printed with meticulous care by Letterio Calapai.

A more personal note characterizes a later portfolio entitled *In Search of Oneself.* In a series of fourteen self-portraits Ben-Zion has translated into superb drypoints a group of sketches made over a period of thirty years, from 1937 to 1967. Printed by Jean Farrar in an edition of thirty-three, this portfolio has been published by the artist. Included are individual compositions depicting the artist with a "cat's cradle,"

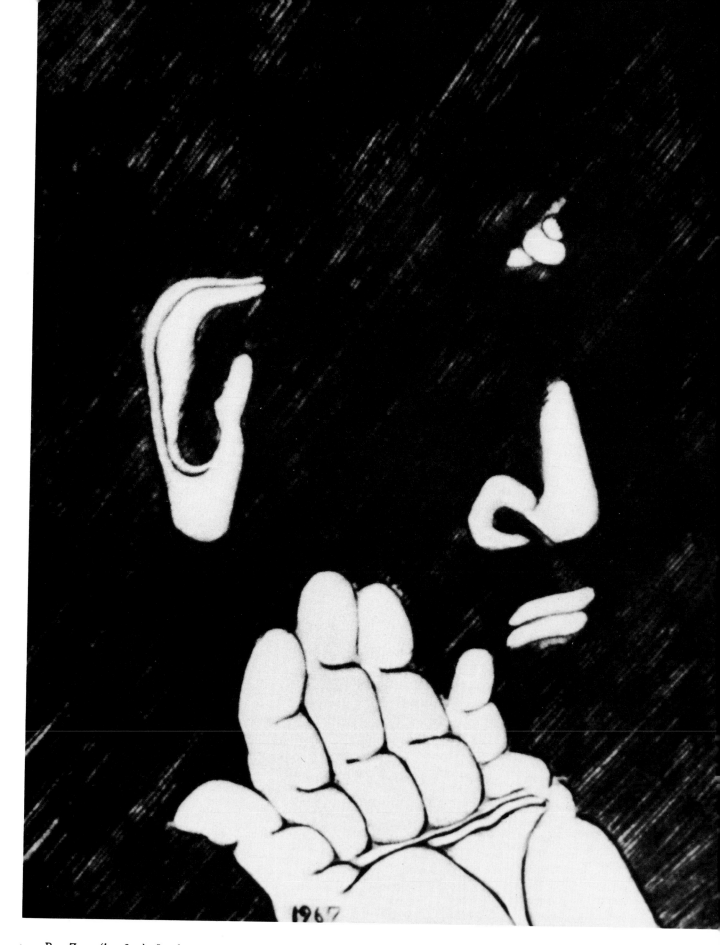

74 BEN-ZION (b. 1897), *In the Grip of the Five Senses* from *In Search of Oneself*, Pl. 14, 1967. Etching, 19×15 (sheet) (48.2×38). Photo courtesy the Artist.

75 JONES, JOHN PAUL (b. 1924), *Annunciation,* 1959. Etching, soft ground, 27⅞ × 24⅞
(70.5×66.3). Collection, The Brooklyn Museum.

1947, as a blind man, 1948, as a draftsman, 1950, with a mask, 1958, and finally in 1967 a self-portrait with the symbols of the five senses. Introspective and sometimes poignant, they are uncompromisingly direct. They become a sensitively realized visual diary of the face and the hand of a gifted artist.

John Paul Jones was born in Iowa in 1924 and grew up in midwestern United States. Between 1943 and 1946 he served in the Field Artillery of the U. S. Army in Okinawa. On his return, he completed his formal education at the University of Iowa, where he worked with Mauricio Lasansky. Thereafter, he embarked on the career of an artist and teacher, interspersed with several journeys to Europe. His early work in abstract images already showed him to be an artist of unusual sensitivity. Perhaps he has benefited by his understanding of the structural strength of Jacques Villon's engravings and the luminosity of Odilon Redon's lithographic fantasies. His work has ranged from basic figure studies to abstractions, noted in *Suspension,* an etching and engraving of 1953. In his print *Return,* 1955, the figure again emerges from an otherwise abstract composition. This print demonstrates the realization of dreamlike forms held within the disciplines of superb craftsmanship. In later work he is concerned with compositions in which figures float and merge with slightly defined cloud forms, as noted in the *Pietà* compositions, 1957–58, *Walking Woman,* 1961, and in *Women of the Cross,* 1958. This group of prints appear to be a distillation of a mystical idea rather than the delineation of an actual event. The traditional iconography of the Crucifixion is of less interest to him than its abstract force. The figures of the *Pietà* compositions with their undefined symbols have a compelling intensity which is observed in the large print issued in 1959 entitled *Annunciation.* Ranking high among John Paul Jones's graphic works, it has subtle nuances and a resulting mood of expectancy which are achieved through the employment of the full range of intaglio techniques. The quiet dignity and aloofness of the central figure, the contrapuntal effects of horizontal and perpendicular rhythms hold the composition in balance. They reaffirm and restate Redon's earlier idea of the relationship of the seen to the unseen—"putting the logic of the visible, as far as possible, at the service of the invisible." The figurative work of John Paul

Jones has been compared to that of Francis Bacon in its romantic aspects. However, where Bacon reveals a vision of private despair, the figures of Jones's imagination appear wrapped within their own alluring dreams where space becomes a world in which violence and destruction have no part.[11]

Two major themes dominate the graphic works of Milton Avery and his painting: the figure and views of landscape and sea. His figures, in their economy of presentation, are sometimes devoid of facial expression. Nevertheless, they remain completely individual personalities. His landscapes have the bewitching quality of recalling to each observer a particular landscape. Avery was concerned with those elements which make up time and space. The immediacy of the moment is captured and translated into a few significant lines and simple forms that hold the essence of a blithe and poetic vision.[12]

Not until 1948 did Milton Avery seriously consider the printing of the drypoint plates he had completed more than a decade earlier. At this time Chris Ritter, a friend of Avery's and the Director of Laurel Gallery in New York City, selected five plates for one of the *Laurel* portfolios. As a means of presenting contemporary American artists to a wider public Ritter offered original prints in various portfolios. One of Avery's was included in the second portfolio. The fourth portfolio was composed entirely of Avery's prints, issued in an edition of one hundred in 1948. They were printed at Atelier 17 under the supervision of Stanley William Hayter and contained five of Avery's finest prints. Ironically enough they found no sale even at twenty-five dollars for the portfolio. Included were the favored subjects of Milton Avery: *By the Sea, Riders in the Park, Head of a Man,* and a large reclining *Nude.*

In the 1950s Avery made a few woodcuts. He also began a long series of some two hundred monotypes issued during a period of ten years. To Avery this medium was a most auspicious one in its soft brushstrokes and the disciplined order of its color sequences. The resulting forms offered still another means of capturing the very essence of an image.

A self-styled Realist, Caroline Durieux is also a satirist whose keen sense of the absurd is apparent in her black and white lithographs of the 1940s. Her

series *Carnival Ball* records the raucous spirit of the Mardi Gras and its amusing social hierarchies. Her restless imagination also appears in her technical innovations of the 1950s and '60s, when she developed what she terms the "electron print" by applying radioactive isotopes as the agent in a duplicating method. Her experiments in a new method of color printing have produced some unusual abstract compositions, achieved by combining a dye-transfer process with a variation of the cliché verre principle.

Michael Siporin and Jack Levine, both well-known painters and draftsmen, have also been concerned with social themes. Their lithographs and etchings, extending from the 1930s into the '60s, reflect their strong advocacy of the figurative tradition.

Max Kahn, for many years associated with the School of the Art Institute of Chicago, has worked consistently in the media of the lithograph and woodcut. His work is representational and often Expressionist in style. A year spent in Mexico greatly expanded his interest in color and in bold figurative subjects. Working within the tradition of his chosen media, he has created more than 250 prints.

Benton Spruance, except for trips abroad, spent most of his professional life as an artist and teacher in Philadelphia. He began printmaking in 1928 at Desjobert's shop in Paris. Among his earlier works are *Church at Night*, 1933, and *Arrangement for Drum*, 1941. The culmination of his work in lithography is his series entitled *The Passion of Ahab*, completed shortly before his death in 1967. The twenty-seven prints which compose this series serve as a fitting summary to his nearly forty years of printmaking.

A few artists working in the decades of the 1940s and '50s held to a classic tradition in subject, scale, and technical means. The woodcuts of Jacques Hnizdovsky and the wood engravings of Fritz Eichenberg continue the classic tradition of the relief print in style and scale. They are well known as illustrators; nonetheless, their individual prints reveal their skills and consistent images. They employ the chisel and the burin with the same ease that a calligrapher employs a pen or brush. Jacques Hnizdovsky, born in the Ukraine in 1915, came to the United States in 1949.

His delight in the world of nature is evident in all of his work. His images are presented singly or in tightly grouped repeats that the artist envisions with a direct simplicity and often an amiable humor. His woodcuts in color appearing in the 1950s are few in number and approach abstraction in their muted color areas. Hnizdovsky's graphic oeuvre of woodcuts and linocuts numbers more than two hundred examples. Fritz Eichenberg is known for his woodengraved illustrations of literary works. His single engravings often reflect the "angst" of a Gothic vision. Janet Turner, working in California, has issued incredibly detailed linoleum cuts in color during the late 1940s and into the '60s. Her clinical eye and craftsman's skills have recorded minute sections of nature and studies of animals with superrealistic results along before the sharp-focus Realists of the past decade.

Letters and Signs

Letters, words, fragments of words and phrases were exploited by the Cubists in Paris early in this century and also formed part of the calligraphic imagery of Paul Klee, Kurt Schwitters, and Joan Miró. Letters and words or signs were employed by the American painter Stuart Davis, although they seldom are seen in his lithographs. Gustave Baumann, whose graphic work falls in the earlier decades of the twentieth century, had found through the undeciphered petroglyphs in Arizona and New Mexico a visual means of capturing in his woodcuts the mystery and the nostalgic enchantment of the past. Sometime later, the petroglyphs in the Indian territories of the northwestern United States were a source of imagery for Worden Day's large abstract woodcuts in color. The later cellocuts of Boris Margo often carry tracings of a mysterious alphabet, intuitive and strangely eloquent. The scriptlike flourishes found in some of the intaglio prints of Arthur Thrall re-create the tensions and rhythms emerging from a historic document. Clinton Hill in a large woodcut in color entitled *First Page*, 1956, combined, in parchment tones, ancient linear images and deft color accents. Ramon Oeschger crowded a jumble of letters into disquieting compositions that arrest the eye and pro-

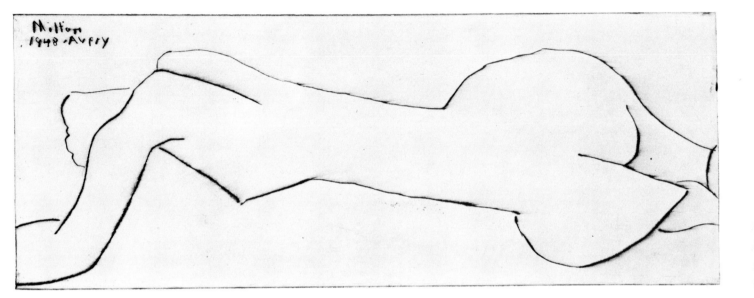

76 AVERY, MILTON (1893–1965), *Nude with Long Torso,* 1948. Drypoint, 5⅞ × 14⅞
(15 × 37.8). Photo courtesy Associated American Artists, Inc.

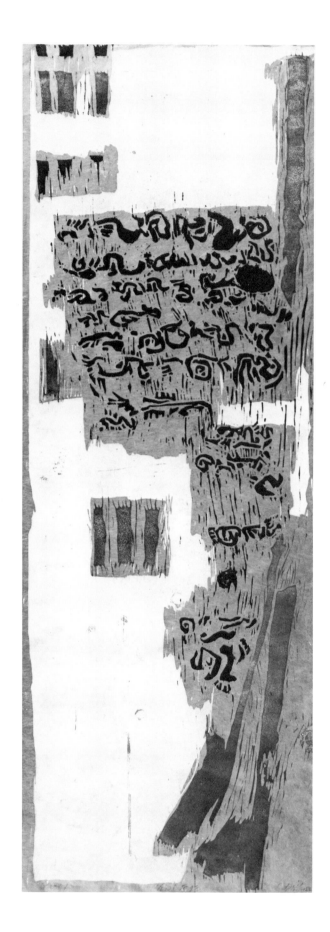

77 HILL, CLINTON (b. 1922), *First Page*, 1956. Woodcut, 33⅝ × 11⅝ (85.4 × 29.6).
Collection, The Brooklyn Museum.

voke the imagination. The screen prints of Ben Shahn hold images that are rooted in the calligraphy of ancient alphabets and literary connotations.

In the prints of Corita Kent words, phrases, biblical quotations and modern poetry are woven into the colorful abstract backgrounds of her large compositions. From the earlier religious figures to her acceptance of the visual realities of Pop imagery she has maintained a firm conception of both religious and philosophical ideas, including those of Carl Jung, Rainer Maria Rilke, e. e. cummings, and others. The liveliness of her imagination is seen in the freshness and spontaneity of her prints, which, since 1952, number some 200 examples. Meaningful, sometimes subtle or disarmingly direct, her graphic oeuvre of screen prints presents an independent vision. Ben Shahn, long an ardent partisan of human rights, described Corita Kent as "a happy revolutionary." Her employment of words and phrases in her graphic work was a reflection of her own philosophy. Later, in the 1960s, letters and words were to acquire a different significance when they served to accent the detachment of the artist. They became ironic, ambiguous, lightly absurd or witty images whose interpretation was left to the viewer.

PRINT ORGANIZATIONS AND EXHIBITIONS

A measure of the development of the modern print in the United States may be seen in the proliferation of exhibitions that featured the new ideas and expanding technologies in printmaking in the decades of the 1950s and 1960s. In 1940 the Silk Screen Group had been organized and in 1944 it was enlarged to an organization called the National Serigraph Society. Among its many members were Edward Landon, Robert Gwathmey, Steve Wheeler, Dorr Bothwell, Philip Hicken, and others. In the 1950s the screen print continued in the innovative work of Dean Meeker, Sylvia Wald, and Harold and Dorothy Bradford. In the 1960s professional workshops made available new techniques, special colors, screens, inks, and papers, which have been widely utilized by both painters and sculptors.

In 1947 a group of American painter-printmakers organized an independent exhibition to demonstrate that painters, not merely professional printmakers, were working seriously in the growing field of the modern print. Loosely organized, this group varied in size from seven exhibitors to the final fourteen. It disbanded in 1955 with a large exhibition at the Brooklyn Museum. Entitled *14 Painter-Printmakers,* it included three paintings and three prints by each of the exhibiting artists.[13] This demonstration and several others served, in part, to re-establish the role of the print among painters and sculptors which was to grow remarkably in the decades of the 1960s and '70s. In the spring of 1947 the Brooklyn Museum began its National Print Exhibition with the display of some two hundred graphic works in all the print media and sizes. This was in response to a need for the showing of contemporary and experimental prints within the greater New York area, where much of the experimental printmaking was then being pursued. At this time there were only a few regularly scheduled, well-established print exhibitions in the United States. They were sponsored by the Library of Congress, the Society of American Etchers, the Philadelphia Print Club, the Northwest Printmakers Society, the San Francisco Art Association, the Chicago Society of Etchers, and a few others. Some held to a strictly conservative point of view and made little concession to the growing interest in the large-scale print. In the fall of 1947 the American Institute of Graphic Arts, commemorating its forty-five years of activity in fine printmaking, presented, in the Brooklyn Museum's print galleries, a retrospective exhibition: *American Printmaking 1913–1947.* One hundred prints were selected by the artist Jean Charlot, whose lively comments emphasized the changes that had occurred in American graphic art. The selection, an unusually broad one, was an early summing up of twentieth-century printmaking in the United States. In 1950 the Cincinnati Museum of Art established the international biennial exhibition of contemporary color lithography which continued through 1963.

78 WALD, SYLVIA (b. 1914), *Dark Wings,* 1953–54. Screen print, 18½ × 23½
(47 × 57.2). Collection, The Brooklyn Museum.

During its years of activity it established a special concentration of interest in color lithography and also enriched the Museum's own collection of prints.

During the years of the 1950s several other print organizations were developed. In 1951 the International Graphic Art Society was established under the direction of Theodore J. H. Gusten and a governing board. Its purpose was to promote interest in and knowledge of modern prints and to issue membership editions of approximately two hundred impressions at established low-cost rates to a specified membership. Although the prints it issued were international in scope, it also featured a large number of works by well-known American artists. It was to function successfully as a nonprofit organization for some twenty years. In 1959 a large exhibition entitled "American Prints Today/1959," with a fully illustrated catalog, was issued by the Print Council of America. It included forty-four artists and sixty-two prints, many in large scale and shown in sixteen major museums in various parts of the United States. It served as a preview of the prints issued by Ameri-

can artists at the end of a decade. Still other print exhibitions have been held in many sections of the United States. Also, many exhibitions of American prints have been sent to European countries and to Asia under the sponsorship of the Federal Government program and through private organizations.

For the first time extensive exhibitions of contemporary American prints were shown in European countries and in Asia through the sponsorship of the United States Government and under the auspices of the United States Information Service and later through the International Arts Program administered by the National Collection of Fine Arts and its staff. The special exhibitions of prints were widely circulated through the various America Houses and Libraries. The exhibitions were well and seriously reviewed in the press. These visual communications were often accompanied by illustrated catalogs translated into the languages of the countries in which they were shown. Since that time European museums and private collectors have acquired many twentieth-century American prints.

CHAPTER III

PRINTS BY SCULPTORS

The Figurative Tradition · Diversity of Abstract Images · Other Views of Sculpture · Minimal and Conceptual Modes

Sculptors by the very nature of their work visualize it in terms of three-dimensional space or in the displacement of a given space. They are concerned with the volume and sculptural thrust of an object. In other words, its basic bones give that object volume and weight, movement and balance. Furthermore, their graphic notations take into consideration the material to be utilized in the final sculpture, whether it be wood, stone, bronze, steel, plastic, or soft material. The sculptor may make brief sketches which merely indicate the volume or scale of a particular image. He may delineate complete or finished compositions, or he may compose large free-flowing prints or drawings which serve to create an atmosphere wherein he finds his sculptural image. Within these loosely defined categories lie an infinite number of variations, dependent on not only the temperament of the artist but also a definite concept and how it is to be translated into sculpture.

Since the early twentieth century new points of view, styles, and unlikely materials have led to differing visual ideas of structural forms. The uncompromising imagery of found or machine-made objects and the restrictive defining of enclosed space have dictated other changes. Finally, the grandiose size has challenged the creative thinking of many present-day sculptors. These varying directions are also present in their prints.

THE FIGURATIVE TRADITION

Unlike European sculptors early in the present century, few American sculptors were then interested in producing prints. Already mentioned are the woodcuts and linoleum cuts of William Zorach issued in 1915 through the 1920s (see p. 42) and the etchings of Mahonri Young (see p. 41). It was during this period that the sculptor and collector of folk art Elie Nadelman fashioned a few dozen drypoints. They are deft studies of full-length figures and imposing heads where special recognition is given to sculptural planes and volumes. A decade earlier Nadelman had made a few linoleum cuts but found that the immediacy of the drypoint line best suited his unerring draftsmanship. The actual application of the tool to the metal plate seemed of more interest to him than printed editions of the copper or zinc plates. Thus Nadelman made only artist's proofs often in several different states. These were completed during the period of his wife's illness when he closed his house and studio at Riverdale-on-Hudson and took up temporary quarters at the Gotham Hotel in New York City. The plates themselves were discovered carefully stored away in his studio after his death in 1946.

Six years later, in 1952, Curt Valentin published a portfolio containing twenty-two of the unpublished drypoints. The plates were cleaned and printed by the master printer Charles S. White in an edition of

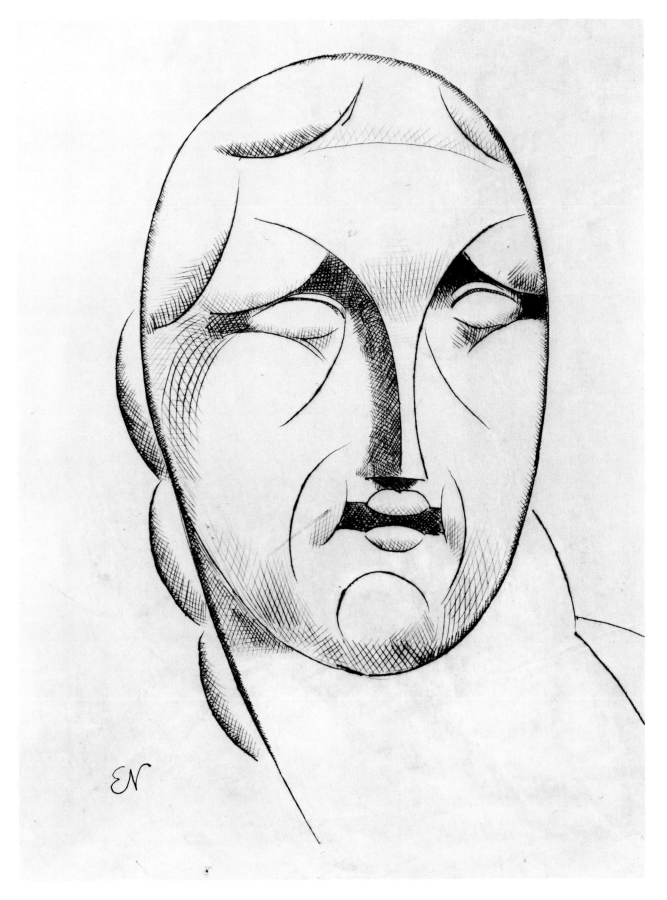

79 NADELMAN, ELIE (1882–1946), *Vers la Beauté plastique* [Female Head], c. 1921–
23. Drypoint, 7×6 (17.8×15.2). The Metropolitan Museum of Art, The Elisha Whittelsey
Collection, The Elisha Whittelsey Fund, 1951.

80 REDER, BERNARD (1897–1963), *Lady with Veil,* 1957. Woodcut, monotype,
27×17⅞ (68.5×44.9). Collection, The Brooklyn Museum, Dick S. Ramsay Fund.

fifty and were accompanied by a brief explanatory introduction by Lincoln Kirstein. Some of the large heads in drypoint reflect Nadelman's earlier analytical drawings of 1906–9. The full-length figures are studies for his various cherrywood sculptures. His *Female Nude Standing* (Portfolio No. 22) delineates Nadelman's sculptural sense of unified forms. The drypoint lines are often enhanced by delicate cross-hatchings of varying densities. The portfolio itself is known to exist presently in but two public collections: the Metropolitan Museum of Art and the New York Public Library. The Metropolitan Museum also has a master set of the artist's proofs.

It is to be remembered that Max Weber fashioned a few Cubist sculptures that were related to his small woodcuts. These have been discussed earlier in the present chronicle. Although Weber is principally a painter, his Cubist works in woodcut and in sculpture remain an important part of his oeuvre.

Among the older established European sculptors who came to live and work in the United States were Alexander Archipenko, Bernard Reder, and Jacques Lipchitz. During their long and productive careers they issued lithographs, woodcuts, and intaglio prints. Archipenko, born in the Ukraine in 1887, went to Paris for study in 1908, where he was to remain for the ensuing fifteen years. In Paris, he was involved in the visual explorations of the Cubists. His first polychrome sculptures were seen at the Armory Show in New York in 1913. It was at this time that he began working in etching and lithography. His early color lithographs had been made in the South of France, where he lived during World War I. In Germany from 1920 to 1923, Archipenko issued a number of prints, one of which appeared in the now-famous *Die Bauhaus Mappen*. In 1923 he left France for the United States, where he continued a singularly active and creative life as a sculptor and teacher. From time to time he issued lithographs that were basically studies for his sculpture or were further notations on already completed sculptural works. His last portfolio of ten lithographs, *Les Formes Vivantes,* printed in St. Gallen, Switzerland, was issued in 1963. It reflects his involvement and his pioneer work in new concepts of volume, space, and color in modern sculpture.

Bernard Reder was born near Czernowitz in the Carpathian Mountains in 1897, when this region was a part of the Austrian Empire. In 1919 he worked in sculpture and woodcut at the Academy of Fine Arts in Prague. Some time later he went to France, where he received friendly encouragement from Maillol. No sooner had he held his first exhibition in Paris than he found himself in the flood of refugees fleeing first to the South of France and thence to Spain, Portugal, Cuba, and finally to the United States in 1943. In this same year Reder held his first exhibition in the United States at the Weyhe Gallery in New York, where his drawings and prints were featured. In an overriding desire to make up for his lost years of work, Reder embarked on an almost inhuman schedule, working mostly in stone. In 1945 a severe illness forced him into less strenuous activities and he began his woodcuts in color. He already had completed his black and white series on the *Life of Gargantua,* 1939, and *The Apocalypse,* 1940. This was the first time that he had explored the extended range of the woodcut in color. In this pliant medium, his boundless pictorial fantasy and exuberant imagination found a perfect release. As a sculptor he well understood the possibilities of the woodcut and made the most of them. He found that this was a form of relaxation from strenuous work in sculpture. The woodblocks themselves are like low relief sculpture in their heavily gouged-out areas and in the bold standing relief which carries a patterned network of lines. When printed, the result is one of an infinite variety of thinly veiled colors. The printing achieved by employing greatly thinned inks and oil paint permitted the full exploitation of the wood grain of the block itself. Save for a few series of black and white prints, his graphic work from 1949 is in color. The riotous imagery of his strange fantasy and the deftness of his color nuances are combined with an eloquent graphic vision. *Bird Bride,* 1951, and *Lady with a Veil,* 1957, woodcuts, show the facility of his talents. Reder ignored, as do most twentieth-century artists, the composition built on the idea of a key block. Instead he built his composition in a series of images and patterns. Reder enjoyed the woodcut medium but had little interest in the possibilities of multiple prints. Thus he often made but a single impression, which in many instances is a combination of woodcut and monotype. Reder successfully combined in his

graphic oeuvre, which included a few lithographs, the robust exuberance of his sculpture and the technical disciplines of the printed image.

Another European sculptor, Jacques Lipchitz, came to the United States in 1941. He had worked in Paris prior to World War II and was concerned with incorporating Cubist planes into sculptural volume. His intaglio prints, only seven in number, were begun in Paris and the remaining five were completed at Atelier 17 in 1943 soon after his arrival in New York. Based on the theme of the Minotaur, they are rich and inventive studies and variations in Cubist volume by a sculptor whose bronze works are among the most distinguished achievements in twentieth-century sculpture.

Peter Lipman-Wulf, born in Berlin in 1905, is a sculptor whose graphic work is perhaps better known in Europe than in the United States. His formal studies were completed in Berlin and in Paris. His ambitious intaglio series entitled *Exodus,* issued in 1960, and his large-scale color woodcut entitled *Strasburg Cathedral,* composed in five large panels, demonstrate the range of his work, which numbers more than 250 prints.

An American-born sculptor, Peter Grippe, began his graphic work at Atelier 17 in 1944 in etching, later moving to engraving. He found that the metal plate best suited his sculptural sensibilities. Strongly stroked crosshatched lines delineate the blunt forms of his composition and give them the weight and volume of low-relief sculpture. At Hayter's return to Paris, Peter Grippe became one of several succeeding directors at Atelier 17. It was during this time that he developed a special technique for lift ground, which made it possible to draw directly on the prepared plate with a pen. He had utilized this method in many of his own etchings. Although Grippe completed approximately fifty etchings and engravings between 1944 and 1959, no formal editions of his work exist. The artist has pulled but two or three finished prints from his plates, with the exception of his large plate entitled *Sacrifice of Iphigenia,* 1956, which exists in eight or nine proofs. Not particularly interested in carrying out the printing of complete editions, he was also reluctant to allow anyone else to

print them. As a result, Grippe's prints are rarely seen, although they are in a few public and private collections.

Leonard Baskin held his first exhibition of sculpture in New York in 1939. Twelve years later, in 1951, his prints were first exhibited at the Galleria Numero in Florence during the time that he was studying at the Accademia di Belle Arte. Many of his prints, especially his woodcuts, are directly related to his sculpture, as noted in *Man and Dead Bird,* 1951, and *Death of the Laureate,* 1957. He also has fashioned vignettes of precisely observed grasses, flowers, and insects in wood engravings of unsurpassed clarity. His later graphic work has been in intaglio as well as in wood engraving. He has done many portraits of historical personages who, in the long tradition of humanism, have held for him a special significance. In spite of a devoted following of younger artists, Baskin's work stands alone as a somberly eloquent expression of the moral turbulence of this century (see Chapter II, p. 102). His own statement sums up his vision and his conviction:

"Artists have ever turned to the print for the expression of specific ideas, impelled by an immediacy of purpose that often is alien to the slower, more contemplative medium of painting. Or to give wider circulation to an attitude, a feeling, a position that the inescapable singleness of a painting is incapable of. Reaction to the disasters of war was etched by Goya, the miseries of war engraved by Callot and Rouault, the cycle of war on wood by Käthe Kollwitz, the lie of war by Picasso, and the lunatic brutality of war by Otto Dix. The roster of artists who thus employed the print for social and programmatic ends is formidable. These are the moralists and the political partisans. I ally myself with this tradition, seeking for guidance in prints both learned and unlearned, ever aware of their long popular tradition, seeing in their quintessential black and whiteness the savagery of Goya, the melancholy of Dürer, and the gentleness of Rembrandt."[1]

A reinterpretation of a religious theme dominated the lithographs that Robert Cremean completed at the Tamarind Workshop in 1967. The sculptor chose to explore in graphic detail the disturbing concept of the individual being destroyed by the dogma and power of a particular group. His suite of fourteen

prints entitled *Fourteen Stations of the Cross, 1966,* is strictly formal in its presentation. The artist's compositions demanded an evenly printed background of a butcher-brown color accented by deepening or fading tones of pink. Progression of the hairline images was articulated and maintained through an established axis that carried the thrust of the repeated figure and the cross. Cremean has employed familiar images throughout the series, but his interpretation is a distinctly personal one.

In his prints as well as his sculpture, Sigmund

Abeles maintains a traditional imagery. Nude figures, portraits, and several self-portraits are rendered in a detailed draftsmanship. In 1966 the artist completed a series of etchings in color entitled *Gift of America (Napalm Made in U.S.A.).* In their strictly detailed anatomical delineations they are prints of protest and social concern. The artist's sense of fantastic and bizarre imagery is heightened by his ability to convincingly distort the figure. Also issued in the 1960s is Abeles' small but effective etching *Self-Identified,* an unusual composition handled with inventiveness and skill.

DIVERSITY OF ABSTRACT IMAGES

Ezio Martinelli began his career as an abstract painter, then turned his considerable talents to sculpture. From time to time he has issued intaglio prints that demonstrate a highly individual approach to graphic art. As a sculptor he found the metal plate a logical means of extending his visual ideas. Of no school or particular movement, Martinelli's work has a baroque exuberance. A skilled and even a compulsive draftsman, he may delineate, with his brush or pen, the leaves and tendrils of plants and vines or the enlarged details of the nude figure. A finely disciplined profusion characterizes his prints. This is to be noted in the busy atmosphere of his color etching entitled *Bog,* issued in 1952. In a more ambitious etching, *Possessed,* 1954, the movement of the composition cascades to a thunderous climax of lines and swirling forms that gather at the base of the narrow composition. Martinelli has developed his own special version of the three-dimensional print. He has, through a process of soldering and burnishing metals, added various metals to the basic plate. By actually burning out other areas with a blowtorch he has achieved in the resulting printing a particularly sculptural intaglio print, exemplified in his *Figurines,* 1962. His prints, all too few in number, give to American printmaking a fluent eloquence.

Meanwhile other important innovators were forging their careers in the United States. Outstanding among them are Alexander Calder, David Smith, and Louise Nevelson. They have acknowledged and

defined twentieth-century experience through fresh ideas, idioms, and new materials. They have fashioned new sculptural forms into playful, aggressively strong and mysterious presences and images. Their variously differing works in both sculpture and prints mirror the accomplishments and the creative flexibilities of their time.

Calder was the first modern American artist to receive international acclaim. The consistent vitality of his large oeuvre holds within its radius the playfulness and movement of the circus, of whirligigs, weather vanes, and tree branches touched by the wind. He has managed to banish weight and retain the volume of sculpture in his work. Calder was among the many artists who found creative stimulation at Atelier 17, where he completed the soft-ground etching entitled *The Big I* in 1944. He later issued a number of large-scale lithographs and screen prints. The flying discs, curving lines, and expanding circles that compose his prints are given a semblance of images existing in space through the device of swirling corkscrew lines that pulsate like small springs on the surface of the paper. Bright blues, reds, and yellows play over the surface like spotlights in a circus as they reveal a succession of sudden changes in movement.

David Smith worked briefly at Atelier 17 in Paris, after he had visited Jacques Lipchitz's studio in 1935. He made a few further experiments in printmaking

81 MARTINELLI, EZIO (b. 1913), *Bog,* 1952. Etching, stencil, $17\frac{3}{4} \times 11\frac{7}{8}$ (44.5×30.2).
Collection, The Brooklyn Museum, Dick S. Ramsay Fund.

82 CALDER, ALEXANDER (1898–1977), *Flying Saucers,* 1968. Lithograph, 42¾×27⁵⁄₁₆
(107.7×70). Collection, The Museum of Modern Art, New York, Gift of Dr. and
Mrs. Barnett Malbin.

at Margaret Lowengrund's studio in Woodstock, New York. His work in sculpture had begun a few years earlier and it was to remain his chief creative expression. Perhaps the flood of his talents in sculpture was too tempestuous to be contained within the disciplined media of prints. Nonetheless, his abilities as a draftsman are to be seen in countless drawings and a few prints. A series of what he termed stencil drawings for sculpture appeared in the late 1950s. These basically were stencils achieved through a system of cardboard collages placed on large sheets of paper and spray-painted. On removing the cardboard forms he obtained compositions that revealed images in a variety of weights and balances. These lively constructivist notations became studies for his later sculpture in bronze and steel.

Along with David Smith and a few other sculptors, David Hare began work in welded sculpture in the early 1940s. A qualified chemist, he worked in color photography from 1938 to 1943. Also at this time Hare was experimenting in color lithography. One of the few Americans whose work was acceptable to the visiting European Surrealists, Hare edited the magazine entitled *VVV* during 1942–44 and also exhibited his sculpture at Peggy Guggenheim's gallery, "Art of This Century." Many years later David Hare returned to lithography during a sojourn at the Tamarind Institute of Lithography at the University of New Mexico in 1972. There he completed a series of nine lithographs in color under the title of *Cronus Suite,* based on the legend of one of the ancient Greek gods, known in Roman times as Saturn.

The exceedingly large monotypes of Harry Bertoia appeared in the early 1940s and vied with contemporary paintings both in scale and in their freedom of execution. Printed from a number of movable blocks, they served as an intermediary stage in the evolution of Bertoia's sculpture. Despite their rarity these prints brought a provocative sense of dimension and veiled colors to the relief print in the United States.

Louise Nevelson is a fearless and indomitable explorer in the realm of the printed image. In the mid-1940s she had visited Atelier 17 and entered into discussions with the international group of artists who were gathered there. However, it was not until 1953 that she actually began work at Atelier 17 on her first series of intaglio prints. The formal techniques of printmaking were of little consequence to Nevelson. Instead, her overriding desire was to find a means whereby an artist of her intuitive powers could seize and exploit selected elements emerging from unpredictable images. Nevelson sought a new means of expanding the many ideas and forms that were already appearing in her sculpture.

The creative excitement generated by these plastic forms was channeled not into the development of a technique or style but into constructed forms that heralded a different if not new idiom. These were images of Byzantine richness and splendor set within a Gothic intensity. Nevelson's exploitation of symbolic forms was similar to that employed by Surrealist artists. However, she never allowed a style to dominate or interfere with her ideas. Louise Nevelson's prints fall within various periods of concentrated work. The first series, completed between 1953 and 1954, was restricted to etching and variations within this particular medium. Her preparation of the metal plate was unconventional and followed no prescribed rules. Often while the plate was reposing in the acid bath the artist worked on it with any available or likely tool at hand, thus disturbing or re-accenting the etch. The prints appear deeply etched and darkly inked, with a resulting effect not unlike that of her black sculptures. Among her earlier prints are *The Stone Figures That Walk in the Night* and *Ancient Sculpture Garden,* issued in 1955. Perhaps they are Nevelson's tribute to the great sculptural heritage of Mexico and Central America that she had sought out in her travels to Latin America.

It was some ten years later in 1963 that Nevelson embarked on a second period of her graphic work. During this time she completed twenty-six large-scale lithographs—nineteen in black and white and seven in black and white and a single color. She spent six weeks at the Tamarind Lithography Workshop in Los Angeles, where with able professional assistance she explored the intricate nuances of lithography. She found this a most sympathetic medium, in tune with her tremendous energy and responsive to her intuitive method of working. Her lithographs, mostly untitled, are free of the sculptural forms that often dominated her earlier intaglio work. These abstract prints chart a shadowy world of reflections. They appear as

83 NEVELSON, LOUISE (b. 1900), *Tropical Leaves* from lead intaglio series, 1970–73.
30⅛×25¼ (76.3×64.2). Photo courtesy Pace Editions.

84 BOURGEOIS, LOUISE (b. 1911), *Plate No. 4, "In the mountains of central France forty years ago, sugar was a rare product"* from *He Disappeared into Complete Silence*, series of nine engravings, 1947, 6¾×5⅝ (17.2×12.6). Collection, The Museum of Modern Art, New York.

great night landscapes with clusters of glittering lights and piercing white lines that stab into the depths of space. As in her intaglio prints, Nevelson's handling of the lithographic medium in unconventional. Her inventiveness and her ability to work around the clock taxed even the splendid capabilities of the well-organized Tamarind Lithography Workshop.

A third period of her involvement with the printed image began in 1965 at Irwin Hollanders workshop in New York. In a single day she completed eight etched plates. *Totem's Presents* is an outstanding example. At this time she also selected a group of her early intaglios, which were then printed in formal editions on heavy Rives paper by Emiliano Sironi. Only a few proof prints of the earlier designated editions had been printed by the artist. Nevelson is inventively at ease in the various print media. Her graphic work reflects her unique insights as a creative artist and her ability to sustain a developing imagery rather than in a virtuoso manipulation of a particular medium. In the past decade Nevelson has issued not only lithographs, aquatints with collage, and screen prints but also a small group of unusual lead relief prints. The latter, completed between 1970 and 1973, are among the more than 130 works that presently make up her graphic oeuvre and are the most closely allied to her sculpture. They were executed in Milan, Italy, at the graphic workshop of Sergio and Fausta Tosi and published in New York by Pace Editions, Inc. in editions of 150. In the half dozen prints which compose this group Nevelson has held within a two-dimensional plane the three-dimensional qualities of her sculpture. Printed on heavy rag paper, the lead film was effectively bonded to the paper. The resulting soft textures and mat tones eventually would slightly change through the "aging" of the metal film. This quality of the lead relief print appealed to the artist as a subtle acknowledgment of the elements of both time and change. Nevelson has observed with both wit and seriousness: "If you want an empire, dear, you have to build it." This is in reference not to a personal domain but to the far different realm of creative ideas, insights, and reflections. These Nevelson has built into significant sculptural and graphic forms that mirror the challenges of a personal style and the changing images of her own time.[2]

Louise Bourgeois, born in Paris, came to the United States in 1938. Although her principal interest was sculpture, she soon began a few experiments in the various print media. Her early efforts in burin engraving led her to Atelier 17. The directness and purity of the medium and Hayter's insistence on professional craftsmanship in printmaking was much to her own interests. She also came to know Miró during the time that he was working at the Atelier and to admire his imaginative Surrealist approach to the printed image. His concern with a very personal imagery and his free use of the intaglio medium inspired Bourgeois to work in her own fashion. From 1945 through 1947 she remained at the Atelier 17.

Varying themes of individual frustrations and a deep sense of aloneness underlie much of the artist's sculpture and prints. In 1947 in a period of intensified work Louise Bourgeois composed a series of nine engravings entitled *He Disappeared into Complete Silence.* These small prints are illuminations of short parables by the poet Marius Bewley and are characterized as "tiny tragedies of human frustration." The engravings graphically symbolize the lonely state of the individual in an urban environment—in milling crowds and overshadowing architecture. It may be recalled that a similar element of detachment also was touched upon by the painter Attilio Salemme in a rare screen print entitled *One Against Many,* issued in 1946. The Bourgeois series is an abstract yet intimate delineation of man as a wanderer, if not a mendicant, in his own society. Ladders to somewhere, a sketchy evocation of the Hudson River as it flows at the edge of the city, a stray tree branch taken out of its natural context—all contribute to an impersonal cityscape. They become a reticent Surrealism that emphasizes a private eroticism. This fleeting vision is noted again in a later single work called *Hangings,* issued in 1949. In the manner of a "symboliste intime," Louise Bourgeois has composed a modest oeuvre of fine copper engravings.

At the time of Lipchitz's arrival in the United States in 1941, the Russian constructivist sculptor Naum Gabo also came to New York after some years in Paris and London. In 1946 he moved to Middlebury, Connecticut, and in 1952 he became a United States citizen. Among his friends and neighbors in Connecticut was William M. Ivins, Jr., retired curator

of prints at the Metropolitan Museum. Ivins, appreciative of the precision and taut linear quality of Gabo's sculpture, although he did not approve of his point of view, brought to the artist's studio a few engraving tools and a cross-cut block of wood to demonstrate the basic principles of the wood-engraving method of printmaking. For Gabo wood engraving with many added variants was to become a challenging means of graphically setting down his own ideas and images. He immediately began a series of experiments that were carried on at various times during the remainder of his lifetime. The accidents and irregularities of the printing appealed to him rather than the issuing of identical editions. Thus the changes and inventive variations in almost every print give to each image the unique quality of a monotype or monoprint. His long experience in the translucent and transparent plastic sculptures led him to search for ways of achieving their luminous, elusive qualities in his printed images. He seldom used black but preferred tones of sepia and umber. After 1956 he discarded these somewhat somber tones for strong blues, greens, and oranges. Gabo engraved and printed eighteen basic designs but he selected only twelve for a projected portfolio, simply designating them as Opus 1 through Opus 12. Each block appeared in some twenty-five variations. Undated, the series covers the years from 1950 through 1973. Michael Mazur, in his perceptive and carefully detailed essay, remarked that "Gabo had to invent a special world of engraving for his own purposes."[3]

Gabo was reluctant to make the final selections and sequences for his portfolios. Mazur notes that in 1976 the artist was still concerned about the order and presentation of his prints. Largely unknown, the monoprints of Naum Gabo, in their deft and mysterious imagery, are a noteworthy testament of a highly imaginative artist and meticulous craftsman.

Louis Schanker and Worden Day began working in sculpture after considerable years of painting. Most of their prints were issued during the earlier period of their paintings. Their contributions to the modern print in the United States have been discussed earlier in the present chronicle (see pp. 82, 86, 116).

In the 1940s, Sue Fuller, working at Atelier 17, issued a group of intaglio (soft ground) and woodcut prints wherein she explored the differing tensions and densities of line and variations in textures. Her intent was to work out "collages in a metal plate medium." Such graphic works led her to compose what she called "string compositions," begun in the early 1960s, that are sculptures composed within a three-dimensional steel frame. Densely strung acrylic threads whose tensions and colors and intricate focal points create a fine web of transparent lines, they, in turn, produce subtle lights and balances within shifting shadows and colors. Among her prints are *Sailor's Dream,* an etching issued in 1944, *Hen,* an etching and engraving of 1945, and *Bat,* a soft-ground color etching, issued a year later.

Dorothy Dehner has long been concerned with prints, first in intaglio and later in lithography. During a period of work at Tamarind she found the many possibilities of the lithographic stone were well suited to her work in sculpture. Sections or special forms of her sculpture seem to float on the surface of her lithographs. Set apart by hairlike lines radiating from them, the images appear again in her most recent drawings. She states that such drawings are the direct result of her lithographs.

Edmund Casarella's major work in prints was accomplished in the 1950s and '60s, although he continues to work in intaglio as an accompaniment to his present work in bronze and steel constructivist sculpture. His extensive work in relief prints shows the development of his imagery built within a central thrust of layered forms. This is demonstrated in his relief print *Civita Vecchia* of 1953 and his *Signal,* a color relief print of 1957. His interest in color led him to fashion intricate cardboard relief "blocks," which permitted the printing of many colors from a single block, and to employ countless ink rollers to produce such large works as *Rock Cross,* 1955, and *Triggered,* 1959. (See color illustration no. 6.) Casarella has made outstanding innovations in the evolution of the modern relief print and the monotype. His splendid talents in cardboard relief prints, lithographs, monotypes, and etchings as well as in Constructivist sculpture reflect the range and quality of his creative work. Among his later prints are small "printed ikons" which are figures cut to the etched line of the image and printed, then mounted on a similarly cut

85 DEHNER, DOROTHY (b. 1908), *Lunar Series, No. 6,* 1971. Lithograph, 24×36
(61×91.5). Courtesy the Artist.

86 CASARELLA, EDMUND (b. 1920), *Rock Cross,* 1955. Cardboard relief, 23¾×22
(61×56). Collection, The Brooklyn Museum, Dick S. Ramsay Fund.

board, giving the image an actual third dimension. This is mounted as a low relief within a shallow frame, in reality a printed ikon. However, it is in his large cardboard reliefs that Casarella's graphic talents are most evident, for in them he employs a wide range of carefully integrated colors and shapes whose tensions, balances, and shadings are united in a single, purposeful statement.

Harold Paris began serious work in sculpture after his return from military service in the European theater of World War II. Largely self-taught, he also worked briefly in prints at Atelier 17 and at Robert Blackburn's Graphic Workshop in New York. In 1948–51, haunted by disturbing reflections on war, he embarked on a series of lucite relief prints under the title of *Buchenwald Series*. In 1958, he completed, in both intaglio and lithography, a second and much larger series. Originally called *Eternal Judgment,* it later became the *Hosannah Series* of thirty-one prints. The artist's own grave personal anguish is apparent as he visualizes the guilt, despair, and suffering caused by war and its futile demands on human life. After completing this series, Paris decided against printing it in a formal edition, and the only complete copy is located in the Philadelphia Museum of Art, although individual artist's proofs exist. The motivating force of troubled imagery that dominates this series may be compared to Georges Rouault's *Miserere* series, which was completed for Ambroise Vollard in Paris during and after the years of World War I. Paris resumed his work in prints at the Tamarind Workshop in 1961, at which time he completed large-scale figurative works freely composed and seemingly little involved with moralistic problems.

Angelo Savelli has utilized inkless intaglio and relief cut methods combined with pale tones or washes of lithographic color to obtain prints with subtle patterns of light. Born in Calabria, Italy, in 1911, Savelli understands the vast changes in light as it plays over landscape and architecture. His interest in prints developed soon after his arrival in the United States in 1954. His own imagery, derived from abstract Expressionism, grew into a kind of geometry of forms which were enhanced by tones of white. In 1960 he began to explore new dimensions in lithography within his white-on-white paper reliefs. His intent was to enrich the quality of whiteness in his paper rather than to create explosive forms. He remarks that

". . . the necessity of activating the flat surface and modifying the image itself is to suggest a real displacement of the planes of the composition and not the fiction of it."[4]

His prints, in their arrangement of planes and the resulting variations in light, skillfully impart Savelli's objective.

Yasuhide Kobashi, a sculptor and designer, has lived in the United States since the early 1960s. In Japan, during the American occupation, he studied at Kyoto Technical University. His father, a master potter from a long line of master ceramists, encouraged his son to work in terra-cotta. As a result, Kobashi was well known as a sculptor and printmaker before his arrival in New York. Briefly he taught at Pratt Institute and continued his own experimental work in the relief print. His sculptures in terra-cotta, bronze, and steel and his designs for the theater and dance illustrate his versatility as a creative artist. His work in prints extends from the 1950s into the '60s. Kobashi's approach to printmaking is unconventional and does not adhere to any one method. His modest-scale prints are often witty in their wry comments and have been compared to the satirical music of Erik Satie.[5] His relief prints often carry abstract symbols, as noted in his *Lead Colored Plant* and *Requiem for a Pierrot* of 1955. Presently the artist has discontinued his work in prints to devote his talents to sculpture. His clustered hanging spheres of terra-cotta float in space with an airy weightlessness. His masks and fanciful figures, also in terra-cotta, are a subtle blend of Japanese and Mayan cultures.

Joseph Konzal, a sculptor who works within the Constructivist style, has issued a small number of prints. At the age of twenty he came to New York to study at the Art Students League. He recalls that his work with Max Weber in the mid-twenties at the League was the most rewarding and eventually led to his own Constructivist sculpture in wood and bronze.

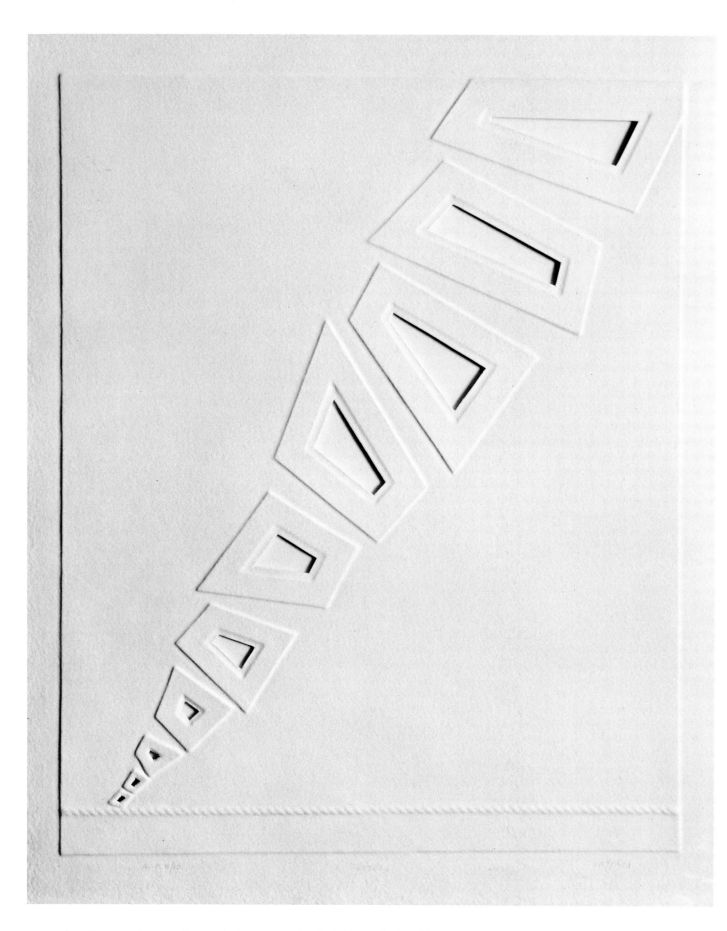

87 SAVELLI, ANGELO (b. 1911), *Lotus,* c. 1967–68. Inkless relief, 23¼ × 18¾
(59 × 47.7). Courtesy The Weintraub Gallery.

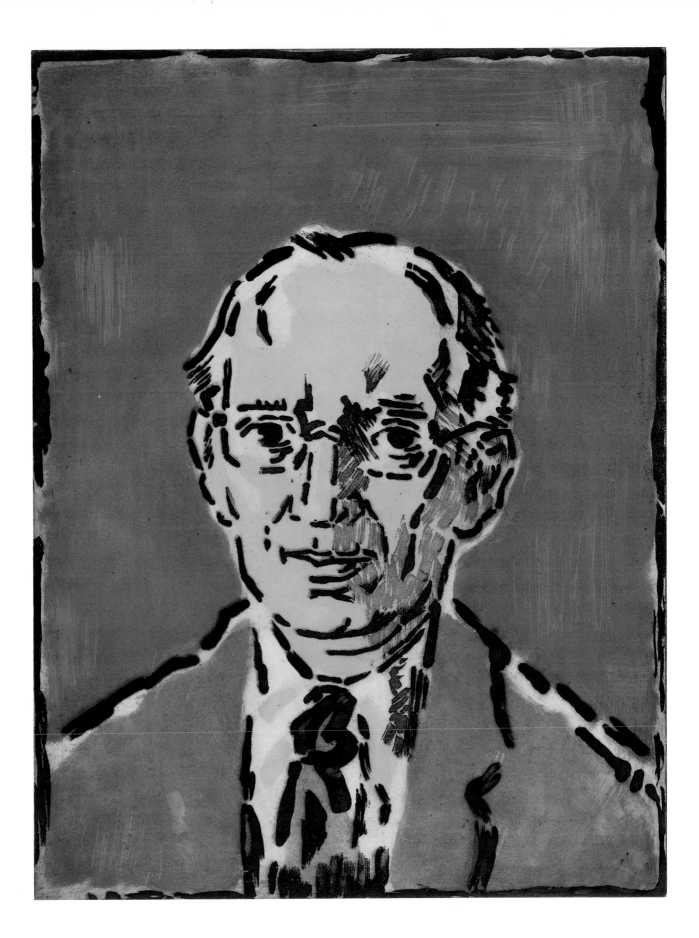

15 SCHRAG, KARL (b. 1912), *Portrait of Bernard Malamud,* 1970. Aquatint, 24 x 18
(61 x 45.8). Photo courtesy Kraushaar Galleries.

16 LASANSKY, MAURICIO (b. 1914), *Young Nahua Dancer,* 1961–73. Mixed media including etching, mezzotint, drypoint, reversed soft ground, engraving, electric stippler, scraping, and burnishing, 48 1/4 x 26 7/8 (122.6 x 68.3). Photo courtesy Jane Haslem Gallery.

17 KOHN, MISCH (b. 1916), *Construction with F*, 1977. Etching, engraving, chine colle
on handmade paper, 11 x 15 (sheet) (28 x 38). Photo courtesy Jane Haslem Gallery.

18 BARNET, WILL (b. 1911), *Singular Image,* 1964. Color woodcut, printed on Japanese
paper by the artist, 32 1/2 x 22 (80 x 56). Collection, The Brooklyn Museum.

19 MOY, SEONG (b. 1921), *Black Stone and Red Pebble,* 1972. Cardboard relief, 30 x 20
(76 x 50.8). Photo courtesy the Artist.

20 SUMMERS, CAROL (b. 1925), *Rajasthan,* 1967. Woodcut, 36 3/4 x 36 (93.4 x 91.5).
Private collection. Photo courtesy the Artist.

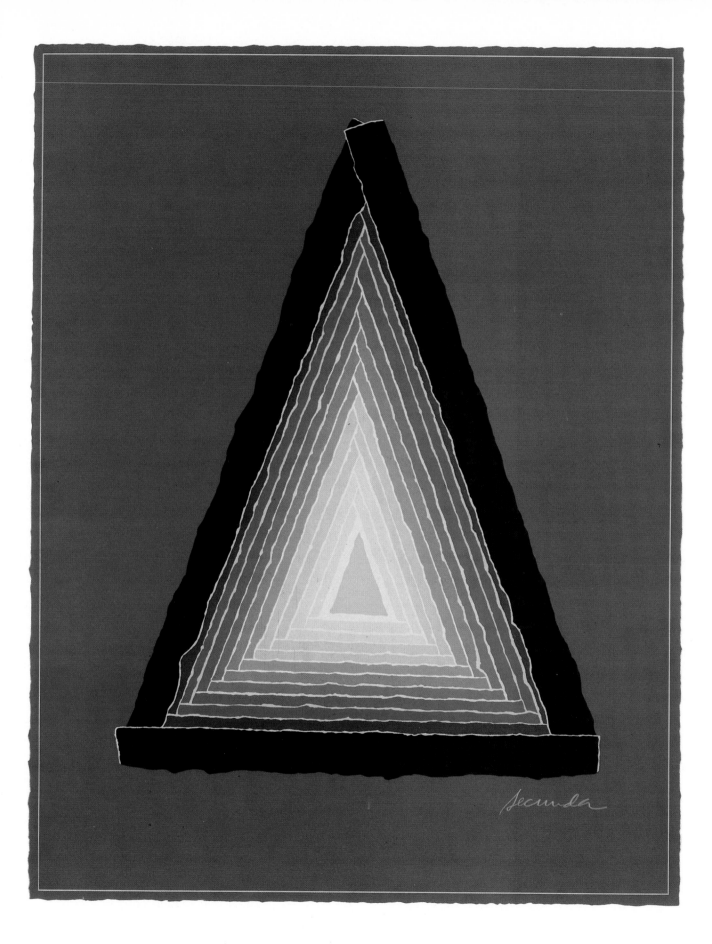

21 SECUNDA, ARTHUR (b. 1927), *The Road to Arles,* 1976. Screen print, 30 x 22 (76.4 x 56).
Photo courtesy the Artist and Musée Réattu d'Arles (France).

22 ANTREASIAN, GARO (b. 1922), *Untitled (78.2 — 1 a & b)*, 1978. Lithograph, 59 x 44
(150 x 112). Photo courtesy the Artist.

88 KOBASHI, YASUHIDE (b. 1931), *Lead Colored Plant,* c. 1960. Relief, 13¾×9
(34.8×22.9). Private collection.

89 KONZAL, JOSEPH (b. 1905), *Tubularities,* 1970. Screen, embossment, 24×18
(61×45.7). Photo courtesy the Artist.

He did not begin printmaking until 1964, when he issued a number of woodcuts and cardboard relief prints. To these he added a few that combined photography, screen printing, and embossments based directly on his sculptural work in polished brass tubing. All of his prints are in small editions of not more than ten in number and have been printed by the artist himself. They preceded more extensive work in collage. Among his prints are three series entitled *Saratoga Moon, Utica,* and *Tubularities* issued in the later 1960s and early '70s.

Sculptors, as well as painters, have received artist fellowships at Tamarind Lithography Workshop during its flourishing decade of existence in the 1960s. Reuben Kadish worked there in 1961. The following year Robert Mallary completed his *Tuxedo Series* of nineteen lithographs.

Reuben Kadish began his professional work as a painter and later turned to sculpture. His first efforts in printmaking were in 1933–34 with Fletcher Martin, who was then involved in photography and lithography in a studio in California. Later Kadish made a few etchings with Arthur Millier in San Francisco, where he met Hayter in 1939. In the mid-1940s he came to New York and worked at Atelier 17 and completed a number of etchings and aquatints, including *Lilith,* 1945. It was not until 1961 that he again turned to printmaking. At this time he spent a month at Tamarind soon after it opened as a lithographic workshop. In the later 1960s he issued a number of etchings on zinc plates. Recently in 1977 he became interested in the sculptural qualities of heavily etched intaglio prints, including inkless relief prints that continue the forms and ideas of his relief sculptures. From the early figurative compositions to the present forthright abstract intaglios the graphic oeuvre of Reuben Kadish retains the strong and distinctive imagery of an independent sculptural vision.

Earlier in his career, Robert Mallary had composed small figurative etchings and lithographs in both Mexico and the United States. His lithographs, issued at Tamarind in the 1960s, are abstract elaborations of the assemblage methods he employs in his sculpture. Gabriel Kohn, who had made a few woodcuts some years earlier, came to Tamarind in 1963. His use of collage and his intricate and skillful overprinting produced an exceptional series of lithographs in abstract forms and veiled patterns. Abstract compositions also constitute the graphic work of George Sugarman during his stay at Tamarind in 1965.

Richard Hunt, born in Chicago in 1935, is a sculptor who works in welded metal. In 1953 he began an exploration of the two-dimensional discipline of the lithograph which brought into clear focus the linear thrusts, balances, and tensions that so forcefully characterize his steel sculptures. A large-scale lithograph entitled *Crucifix Figure,* 1957, demonstrates his skillful handling of the lithographic stone. Its luminous washes and bold scrapings accent the strong linear quality of his work. In early 1965 at Tamarind, Hunt resumed his work in printmaking and issued some two dozen lithographs under the inclusive title of *Details* which freely improvise sculptural forms or objects within the limits of two-dimensional compositions.

Other sculptors are known for their paintings as well as their prints. Among them are Ilya Bolotowsky (see color illustration no. 7), Ellsworth Kelly, and Alexander Liberman. Their lithographs and screen prints carry forward the meticulously rendered abstract forms that characterize their individual works. Conrad Marca-Relli, like Bontecou, has combined painting and sculptural forms. However, in his lithographs Marca-Relli has utilized a system of collage. A light mood prevails in the lithographs of H. C. Westermann. His Tamarind portfolio of seventeen prints issued in 1968 entitled *See America First* introduces an engagingly humorous vision with somber undertones.

Hans Hokanson's modest graphic oeuvre consists principally of large-scale woodcuts in color. Unlike his abstract sculptures, they are traditional and represent ordinary images, of which *Shirt,* 1976, a woodcut printed in black and three grays, is an example. Lucas Samaras has brought together his "box forms" and screen printing in an ingenious three-dimensional work entitled *Book,* 1968. His later screen prints, published by Pace Editions in 1972, are composed of labyrinthian lines in dense, convoluted surface patterns. In contrast the etchings and aquatints of Larry Zox are compositions of pure abstraction

90 KADISH, REUBEN (b. 1913), *Untitled, No. 3,* 1975. Etching, 7¾×11½ (19.8×29.3).
Photo courtesy the Artist.

91 HUNT, RICHARD (b. 1935), *Untitled*, No. 17, c. 1965. Lithograph, 30⅛ × 21⅞
(76.5 × 55.7). Collection, The Brooklyn Museum, Gift of Mr. and Mrs. Samuel Dorsky.

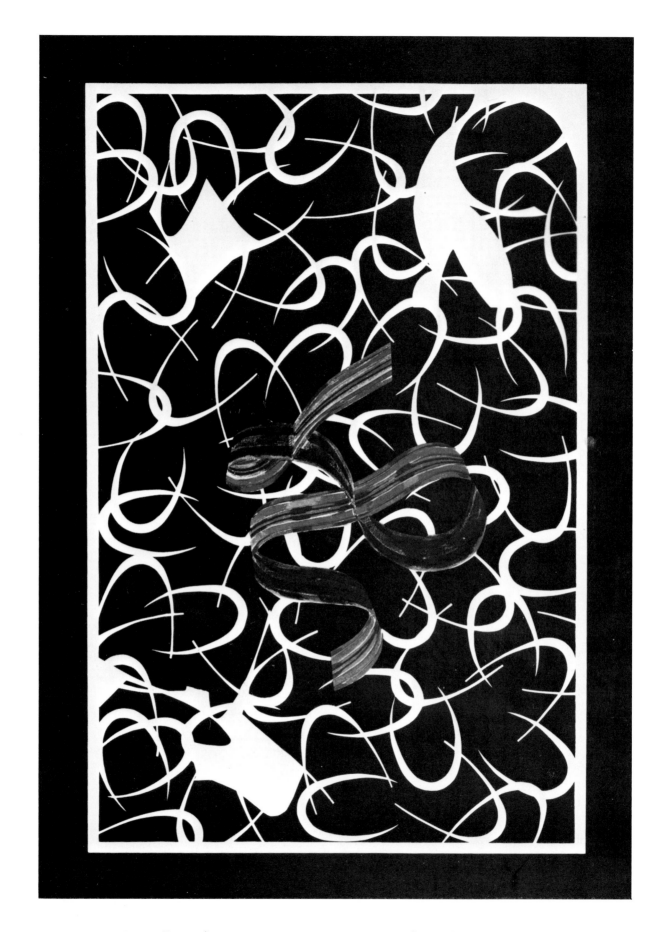

92 SAMARAS, LUCAS (b. 1936), *Ribbon,* 1972. Screen print, 37×26 (94×66). Photo courtesy Pace Editions.

where color itself becomes the image. Utilizing the rich, luminous tones of the aquatint, Zox has exploited its qualities in large and varying flat areas of brilliant colors.

OTHER VIEWS OF SCULPTURE

William King and Ernest Trova, although their work is based on the development of the human figure, employ widely differing points of view. King's slate relief prints are reminiscent of his large flat stalking figures cut out of metal sheets or fashioned from soft materials. They are often humorous and occasionally ironic comments on current happenings. His relief print entitled *Leave the Moon Alone,* issued in 1965, with its figures within a chain of constellations, is a wry comment on man's ventures into space. Ernest Trova, on the other hand, presents his figures in a much more serious vein. His screen prints have the repetitive formality of his "falling man" series of sculptures in highly polished metals. His prints are silhouette patternings of the figure arranged in formal circles, diagonals, and squares. The dense colors of the screen print itself accentuate the formality of the design and also serve to eliminate any sense of space.

Lee Bontecou is one of the first American artists to create three-dimensional compositions that are at once painting and sculpture. Her lithographs and intaglio prints have retained a remarkable degree of dual concepts of space. She has created within the flat surface of the lithographic stone and its printed image a private universe. A dark center or abyss smolders within large, encircling forms. Her particular vision has been achieved through the polarization of images that are direct in their simplicity and scale. They induce the observer to explore the pulsating vortex of a mysterious universe but also withhold its ultimate vision. Her works are generally untitled but usually carry the number of the lithographic stone. Thus in 1968–72, she completed a later lithograph, designating it as *Fourteen Stone.* Some years earlier in 1967, she issued a few fine intaglio prints in color. These are titled. Her modest oeuvre has been printed and published at Universal Limited Art Editions, under the direction of Tatyana Grosman.

Claes Oldenburg, one of the artists who first developed the idea of Pop art, has worked in both sculpture and painting. However, his major interest lies in the more tactile characteristics of sculpture. Molded plastics and other pliant materials have served his talents. Little escapes his notice in the clutter of objects that are a part of urban society. He has referred to them as "city nature." His interest in "environments" and "happenings" led him from painting into works of three dimensions. He came reluctantly to printmaking after he had decided to abandon all two-dimensional work. His prints, like his soft sculptures, sewn canvas and vinyl, present a single commonplace object. Oldenburg's first etchings and lithographs were composed at the Pratt Graphics Center in 1961. In the same period he also made some fifty monotypes. In 1964 he issued the lithograph *Flying Pizza,* which was printed at Tanglewood Press. In 1967 he worked at the Mourlot Lithography Workshop, then newly established on Bank Street in New York. In 1968–69 he was at Gemini in Los Angeles, where it was possible to combine printmaking with the elaborate fabrication of nonprinted multiples. He enjoyed the ideas of commercial materials being harnessed to individual printmaking techniques. His work in prints generally reflects his interest in the single object or image whether it be in lithography, etching, the screen print, or in offset lithography. The single image may be a lipstick, stuffed replicas of food, a clothespin, a faucet, or a giant letter conceived as an architectural unit. Designed for large-scale, they are rendered with a clear, sometimes classic draftsmanship. He terms his series of twelve lithographs in a complexity of colors and completed at Gemini as

"a suite of 'monuments' which may be defined as objects or parts of the body increased to colossal scale and set in a landscape . . ."[6]

Inconsequential objects make up his themes of "city nature." Recently the artist returned to etching at

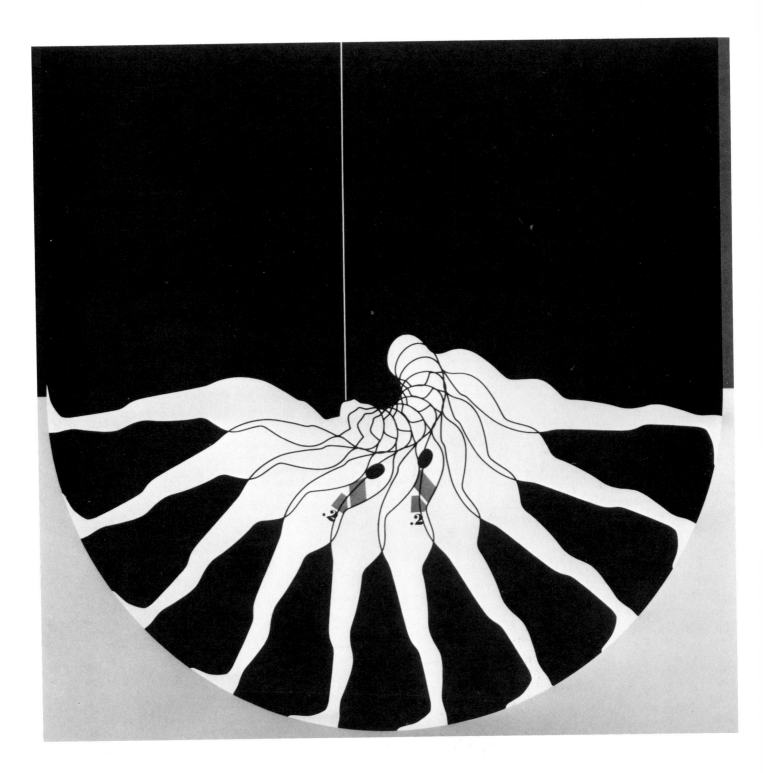

93 TROVA, ERNEST (b. 1927), *Manscapes*, 1969. Screen print, 28×28 (71×71). Photo
courtesy Pace Editions.

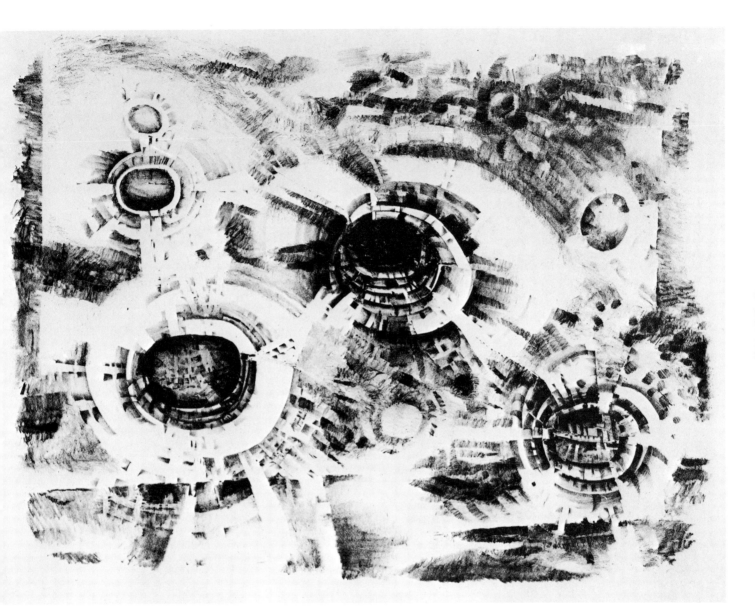

94 BONTECOU, LEE (b. 1931), *First Stone,* 1962. Lithograph, 12×15⅝ (30.6×39.7).
Collection, The Museum of Modern Art, New York, Gift of the Celeste and Armand
Bartos Foundation.

Crown Point Press. His familiar themes are continued in the dozen intaglio prints completed in late 1975 and 1976. The very process itself would appear to harness and discipline his immense facility as a draftsman and gives a measured and monumental quality to these prints. Oldenburg considers his large etching and aquatint entitled *Floating Three-Way Plug* to be one of his most important prints. (See color illustration no. 8.) It was first conceived in 1965 as a drawing of an electric plug resting in a watery base. Oldenburg remembers that in his fantasy it became a "floating cathedral." As sculpture this image appears in both "soft" and "hard" versions along with numerous sketches.

Marisol also has worked most successfully at the Grosman studio, often translating segments of her sculptural forms into prints. Thus a hand or a series of hands or a handbag became an illusive and isolated notation. A single image, although treated lightly and often with intentional humor, approaches the underlying symbolism of a private totem. Her response to people and also to objects is an extremely personal one. In 1970 Marisol composed several black and white etchings entitled *Phnom Penh I* and *II*. These were countered by a similar number of white on black etchings entitled *Kalimpong I* and *II*. In the latter two etchings, the artist has given the tracings of her own hand in the enclosing composition that is at once personal and universal. Published by Universal Limited Art Editions, they are prints of exceptional sensitivity.

MINIMAL AND CONCEPTUAL MODES

A different concept motivates the works of many sculptors in the past two decades. They no longer are concerned with the commanding presence of large abstract forms. Both Sol LeWitt and Carl Andre are involved with diagrammatic meditations composed of small identical lines, cubes, or grids. Their work has been described as Minimalist and Conceptualist, although these are somewhat inconclusive terms. Since the subtle grids that first appeared in Agnes Martin's paintings of the late 1950s, Sol LeWitt has consistently and persuasively developed a system of basic grids that appear in his prints and drawings as well as in his sculpture. His early training in three-dimensional design with the architect I. M. Pei developed his interest in basic enclosures. Fine lines held within a fixed order of permutations form the basic elements of LeWitt's prints. Small meticulously rendered grids, with lines that cross or narrowly approach at angles other opposing lines, produce a sense of fluctuating images. The seemingly faultless logic of regular patterns, on closer observation, are slightly irregular grids of intricate tensions and variety in their controlled sequences and intervals. The variety of tensions obtained within the serial grids give a lean, calligraphic character to his etchings, lithographs, and screen prints. The color mutations in his etchings are a triumph in printing technology that was first carried to completion at Kathan Brown's Crown Point Press in California. The infinite mutations that compose LeWitt's graphic work have been precisely calculated and planned before the actual project is begun. Thus the final execution may be completed by carefully trained assistants. In the course of more than a decade Sol LeWitt has issued numerous suites of serial works totaling more than 200 individual prints.

Minimal refinements characterize the prints by sculptors Donald Judd, Robert Morris, Dan Flavin, Fred Sandback, Ronald Bladen, and Richard Tuttle. As in earlier decades a number of these artists came to sculpture by way of painting, and their graphic work often is influenced by this discipline. The woodcuts of Donald Judd are reminiscent of his early paintings in their clustered open or closed parallel stripes. A series of woodcuts issued in 1961–69 is composed of straight lines on a dark background, and an untitled diptych of 1975 utilizes the grain of the wood in its printing. A few black and white etchings completed in 1974 continue Judd's exploration of the minimal image. Robert Morris, Ronald Bladen, and Fred Sandback also began their professional work as painters. Sandback has issued woodcuts and etchings, but unlike Judd his more traditional sense of pictorial

95 MARISOL (ESCOBAR) (b. 1930), *Phnom Penh I,* 1970. Etching, 23⅝×17¾ (57.5×45).
Collection, Dorothy and Leo Rabkin.

96 LeWitt, Sol (b. 1928), *Untitled* from series of sixteen, 1971. Etching, 12¾×12⁹⁄₁₆
(32.5×31.9). Collection, The Museum of Modern Art, New York, Gift of the Artist,
Parasol Press, and The Wadsworth Atheneum.

space is noted in his linear diagrams, which may be read as lines or as suggestions for his structures. Dan Flavin produced a series of etchings and drypoints at Crown Point Press in 1974. Richard Tuttle issued prints in which a series of single lines whose placement on a sheet of paper suggests brief visualizations of an elemental language through strategically arranged sticks.[7] Mel Bochner prefers aquatint to chart the relationship of a single image to the physical as-

pects of the paper itself. In his *QED* portfolio of etchings and aquatints he secures his repeat images by a restricted series of dots or identical perforations within a specific triangular space.

The reductive images of these artists and others of similar intent demand much of the printer as well as the viewer. A traditional medium becomes the vehicle for a deliberately chaste vision and new approaches to a severely regulated idiom.

CHAPTER IV

EXTENSIONS OF THE PRINTED IMAGE

The Monotype • The Embossed Print • Plaster Relief Prints • Inkless
Intaglio • New Methods in the Use of Paper • Cast-Paper Relief and Cut-Paper
Prints • Paper Pulp into Prints • Other Innovations

THE MONOTYPE

The monotype was invented in the seventeenth century by the Italian artist Benedetto Castiglione, who lived in Genoa. Little was done to further its development until the innovations of William Blake in England and later in France where Degas, Gauguin, Rouault, and others found it a sympathetic and rewarding medium. Paul Klee, Max Ernst, and Jean Dubuffet also found the monotype and its unpredictable imagery a challenging source for new ideas and images. Twentieth-century American artists have achieved outstanding results in this elusive medium, including Maurice Prendergast, John Sloan, Eugene Higgins, Pop Hart, Abraham Walkowitz, and—in some rare examples—George Luks and Edwin Dickinson. Still later, the monotype was most successfully employed by Milton Avery, Mark Tobey, Harry Bertoia, Morris Graves, Naum Gabo, Boris Margo, and

Hedda Sterne. Many variations in both figurative and abstract imagery are to be noted in the monotypes of Louis Schanker, Leon Goldin, Adja Yunkers, Sam Francis, Edmund Casarella, Michael Mazur, Joseph Solman, Nathan Oliviera, George Miyasaki, and Matt Phillips.

These artists and others have found in the monotype medium a free and immediate means of obtaining a colorful printed image without the technical demands of etching, engraving, or lithography. It is also a medium that permits the artist entire control of the work itself. All that is basically required is a smooth, rigid surface—a piece of glass or a metal sheet—on which to paint in oil, watercolor, or printer's inks the desired image. The tantalizing risks involved often result in unforeseen subtleties in color and composition.[1]

THE EMBOSSED PRINT

Present-day artists have devoted much effort to the possibilities and variations of the relief or embossed print. Not a new development, it was employed most effectively in nineteenth-century Japanese woodblock

prints where inkless printing or blind stamping (gauffrage) techniques were utilized to enhance the rich textures of an actor's robes or a special segment of landscape. Such embossments are seen in the prints

97 SCHANKER, LOUIS (b. 1903), *Plaster Print,* No. 6, 1955. 12×24½ (30.5×62.3).
Photo courtesy The Brooklyn Museum.

98 MARGO, BORIS (b. 1902), *Pathway,* from portfolio 12 Cellocuts, 1960–71. 18¾×27
(47.5×68.5). Private collection.

of Harunobu and later in the stylized woodblock prints of Utamaro. In the West nineteenth-century commercial printing houses applied embossed designs to special calendars, trade cards, and other advertising devices.

In the twentieth century the metal prints of Rolf Nesch in Norway are classic examples of the low relief print. In Paris, Pierre Courtin issued rare works of great sensitivity. In Italy, Micossi sought out unlikely vistas of little-known hill towns to create romantic cameo-like compositions. Also in Italy, Lucio Fontana created repeatable printed images from plates whose surface projections pierce the paper during printing. After many experiments with both plates and presses Fontana was able to produce editions of identical impressions. Printed in a rich, solid black, they are exceptional examples of fine modern printmaking. In the United States the embossed print has been in evidence since the early 1940s.

Plaster Relief Prints

Compositions in plaster with their sharply cut-out areas and pulsating lines were part of the experimental work at Atelier 17 in New York. These were imaginatively developed by the painter John Ferren in his rare plaster relief plaques "pulled" from inked metal plates. Misch Kohn, from 1952 to 1957, printed his large-scale wood engravings under extreme pressure to obtain deeply embossed surfaces of unusual richness. Notable examples are his *Kabuki Samurai* of 1954 and *Processional,* issued in 1955.

In 1960 Louis Schanker issued a series of woodcut-plaster prints in which he introduced in a heavily embossed picture frame, semblance of a third dimension. Such prints approach low-relief sculpture by exploiting the expansional properties of the paper itself and also ingenious printing methods. This idea had been employed at Atelier 17 in inkless embossments and also in the metal prints of Rolf Nesch. However, Schanker's work in the relief woodcut and plaster relief print was an unusual innovation. Because of the complicated printing procedures Schanker printed only small editions or a few artist's proofs.

Inkless Intaglio

As early as 1953 Margo initiated the printed cellocut in some of his paintings, which were shaped canvases. In 1960 he began a further development of the cellocut medium, employing the cellocut plate as an inkless intaglio combined with the soft rich tones of lithography. His 1972 portfolio of twelve large prints is a summing up of his work from 1960 to 1972. In it the fantastic and surreal imagery which often appears in his oeuvre is greatly simplified. Color serves as a subtle background against which the heavily embossed images catch and hold the angle of light. Margo has remarked:

> "As time goes on, I feel the greatest virtues are in simplicity. One result of this growing conviction is that color, to me, becomes most effective when least evident. Many of my recent cellocuts exist primarily through the shadows cast by their raised surfaces on the white paper."[2]

Other artists have enlarged the scope of the embossed print through varying interpretations and techniques. Nevertheless, most have worked within the limitations of the paper itself. They have stretched or expanded the paper to its limits, but generally they have chosen not to pierce or cut the carrying agent of their images. Josef Albers, in 1958, worked briefly in inkless intaglio to create pristine images of the square. Other intaglio methods have been employed by Ezio Martinelli, Doris Seidler, Adja Yunkers, Glen Alps, Robert Broner, Romas Viesulas, and Minna Citron. Through the skillful application of inks of varying viscosity Dean Meeker has raised the surface of his image through the screen print, demonstrated in his print entitled *Black Mood,* issued in 1955.

Special note should be made of the entire graphic oeuvre of Omar Rayo, a Colombian artist who has lived and worked for extended periods in New York. His highly competent low-relief intaglio images are printed from inked or inkless plates on heavily sized English watercolor papers. They may be total abstractions of flawless elegance or they may be composed of a single readily discernible image. A safety pin or a sneaker is handled with the same knowing crafts-

99 ALBERS, JOSEF (1888–1976), *Embossed Linear Construction, 2-A*, from series of
eight inkless embossed prints, 20×26 (sheet) (51×66). Photo courtesy The Brooklyn
Museum.

100 RAYO, OMAR (b. 1928), *Last Night in Marienbad,* 1963. Intaglio embossment,
30¼×22 (76.8×56). Collection, The Brooklyn Museum.

manship in the production of suave and amusing compositions that lightly acknowledge, with cool sophistication, the images of Pop art.

Roberto De Lamonica also has employed Pop art images in his large and complex embossed compositions. The abstract image is effectively handled in the intaglio prints of Romas Viesulas and the minimal prints of Luis Camnitzer of the mid-1960s. Patricia

Benson's portraits of historical personalities are achieved through lucite intaglio relief plates amusingly reminiscent of a nineteenth-century daguerreotype set within a framework of embossments. She has issued a group of large-scale portraits under the general title of *American Indian Series,* 1969. These are freely delineated and are encompassed within an embossed cluster of Indian motifs.

NEW METHODS IN THE USE OF PAPER

The pioneer work in the fabrication of fine modern handmade papers by Douglas Howell and a few other special craftsmen gave to American artists the opportunity of rediscovering and utilizing the rich modern results of papermaking. It became possible for an artist to obtain papers of a specified tone and texture, in a variety of sizes and of an amazing resilience and toughness. Thus paper became not only a carrying agent for the artists' images but also an integrated part of the total design.

Cast-Paper Relief and Cut-Paper Prints

Michael Ponce de Leon interprets the print as a sculptural medium achieved with or without the integration of printed colors. In 1956–57 he spent some months with Rolf Nesch at the latter's studio in the remote Hallingdal region of Norway and was greatly influenced by this calm, highly intuitive artist. Ponce de Leon returned to the United States to further experimentation in the area of the three-dimensional and cast-paper print. In discussing his own methods of approach he explains at length:

"Using the methods of collage, I weld to the main plate a complex of shapes of varying thicknesses to create a pulsating interaction in depth . . . The inking is done in sections in as many colors as necessary, since each shape is either welded on a different level or adjusted freely as a jigsaw puzzle. I make my own inks and use several kinds of oils and other media to attain densities and transparencies . . . To print from my plates I had to design a new kind of hydraulic press embodying the principles of die-cast-

ing. Paper, one of the most important features of my work, is made by Douglas Howell, who refers to it as 'the carrier of the work of art.' This handmade paper, one quarter inch thick, is prepared out of pure linen in long fibers to enable it to stretch to the limit of its cohesion and embrace the matrix in all its details. In the final step, the union of the wet paper, ink, and idea by means of ten thousand pounds of pressure against the relief plate is transformed into a final, living image, a paper cast in color."[3]

Ponce de Leon's *Enchanted Mountain,* 1958, issued soon after his return from Nesch's studio, and his later *Succubus* of 1967 demonstrate the new approaches to the low-relief print and to the techniques of fashioning paper pulp into the cast-paper relief print. (See color illustration no. 9.)

Louise Nevelson recently has extended her large and impressive graphic oeuvre to include several exceedingly fine cast-paper relief prints. These rich black images, entitled *Nightscape,* 1975, a large horizontal composition, and *Moon Garden,* 1976, a vertical image, complement and extend her well-known sculpture. These later cast-paper relief prints published by Pace Editions are issued in editions of seventy-five impressions each.

A few artists have disregarded the physical limitations of the paper itself and have sought a three-dimensional elaboration by cutting away or piercing the surface of the paper, thus displacing or changing the visual aspects of the picture plane. In the United States this has been successfully accomplished by Jack

101 VIESULAS, ROMAS (b. 1918), *Yonkers II,* 1967. Lithograph, intaglio embossment, 26×39¼ (66×99.7). Collection, The Brooklyn Museum, Bristol Myers Fund.

102 SONENBERG, JACK (b. 1925), *Perimeter,* 1975–76. Intaglio, relief, 41×29¼ (104.2×74.3). Photo courtesy the Artist.

103 KOPPELMAN, CHAIM (b. 1920), *Retired Napoleons,* 1965. Intaglio, cut paper,
12⅞×14¾ (31.5×37.5). Collection, The Brooklyn Museum, Dick S. Ramsay Fund.

Sonenberg, Chaim Koppelman, Garner H. Tullis, Angelo Savelli, among others.

Jack Sonenberg arrived in New York from Canada in the early 1950s. He is a painter and printmaker, and his woodcuts in color are closely allied to his early abstract paintings. More recently, working in sculptural forms, he has issued what he terms the cast-paper woodcut printed in a solid black. In other prints he has obtained cut-out areas to accent the more sculptural elements. Also he has employed the collagraph medium where minimal triangular images carry an attached black thread or string that assumes a random free-flowing or improvised line in the composition. An example is his series entitled *Dimension,* completed in 1969. In the later 1970s Sonenberg forged a fine series of very large low-relief intaglio prints whose strong images and rich black tones continue to reveal, with exceptional authority, his Constructivist vision.

Chaim Koppelman, through skillful use of the intaglio process and a cut-surface technique, has fashioned an unusual three-dimensional print of stereoscopic depth entitled *Retired Napoleons,* 1965. More extreme are the "embossments" of Garner H. Tullis. First working in woodcut and later in cast-bronze plates, Tullis is perhaps more interested in the process than the printed image. If in the printing of his plate the surface of the paper is "ruptured," Tullis allows this to happen. This accidental effect he views "as spoor or footprints which leave their impression in the imagination as well as on paper."[4] Angelo Savelli's development of the white-on-white embossed print is noted in his large-scale prints in which he incorporates lithography and cut paper (see Chapter III, p. 137).

Paper Pulp into Prints

After several decades spent in the exploration and inventive exploitation of the visual possibilities in modern printmaking, Robert Rauschenberg turned his many talents to the processes and possibilities of papermaking itself. In 1973 Rauschenberg, with the active support of Gemini G.E.L., went to the centuries-old handmade paper fabricator, the Richard de Bas in France. Here, by prearrangement, the artist spent five days working with vats of paper pulp. The artist recalled that he had no preconceived ideas concerning the project other than that he wanted to utilize the papermaking process in the actual formation of prints. From the contents of two large vats ranging in tones of dark unbleached pulp to very light, bleached pulp the number of available tones was increased to five smaller vats that contained the "material" of his prints. Following the screening and couching the artist then fashioned his prints into the series *Pages* and *Fuses. Pages* is composed of five prints relating to sculptural forms in editions varying from eleven to thirty-five; *Fuses* contains seven prints relating to the two-dimensional possibilities of printmaking in editions of from fourteen to thirty-six.[5] *Pages* and *Fuses* in their successful blending of paper, screened images, colors, and textures reveal the artist as an adroit *jongleur* of materials, processes, and his particular idiom.

The painter Clinton Hill has been involved with the making of prints since the 1950s, when he and Vincent Longo first worked in the medium of the woodcut. Later Hill turned to intaglio prints but was never entirely satisfied with the results he obtained in these abstract compositions. However, in 1973 he produced a series of innovative prints which he describes as surface-printed Fiberglas intaglios. The images, achieved by deft manipulation of the loosely meshed Fiberglas material, are then secured to a cardboard or plate. The resulting surface is printed by roller and considerably thinned-out inks. Although the prints first appear as random designs, a closer observation reveals a subtle and sensitive control of the composition. Their improvisations within an all-over grid result in prints where form and movement are held within carefully prescribed compositions. These experiments in Fiberglas intaglios have led to the direct incorporation of paper into his work. By varying the texture, tones, and the thickness or density of the paper Clinton Hill has developed a new flexibility wherein the paper itself becomes the total image. Presently Hill's graphic oeuvre numbers more than a hundred prints, all issued in very limited editions.

Leo Rabkin has placed specially colored threads in planned designs on a plate to which he adds his own handmade paper pulp. This is then carefully rolled through an etching press onto a sheet of dampened

paper. In other intaglio works Rabkin has eliminated all trace of the plate mark in strategic sections of his prints, allowing the image to flow without any inden-

tation into the margin of the paper itself. These uninterrupted visual passages have resulted in colorful, abstract compositions of unusual sensitivity.

OTHER INNOVATIONS

Juan Gomez-Quiroz, a Chilean-born painter and printmaker, and for the past two decades a resident of New York, has taken still another graphic point of view toward the three-dimensional print. Three intaglio plates with interrelated images have been printed on a single sheet of paper. The resulting triptych was twice folded with the remaining edges hinged together to create a triangular column. This resulting form was then closely encased in a correspondingly three-sided clear acrylic column. The three panels, printed in colors, present the artist's vision of a time-space idea within a sculptural form. An amusing and witty example is entitled *Machine to Hunt Stars,* issued in 1965 in a small edition of ten.

Shiro Ikegawa, born in Japan in 1933 and now living in California, has issued other variations of the intaglio print and formed paper in deep relief. His early graphic work depicts Buddhist themes and special landscapes. Among his oriental subjects are the large intaglios in color: *One-Ten* and *Noroi,* issued in the mid-1960s. In his landscapes he combines the subdued tones of eastern painting with the abstract forms of modern western art. Ikegawa, in 1969, completed *Boxed Sky,* an ambitious work combining intaglio and cast paper in a large square format with a two-inch relief.

Alan D'Arcangelo and Larry Rivers have experimented with mirrored surfaces and vacuum-form printing. Composer John Cage has screen-printed abstract notations on eight separate clear plastic panels, which in turn are mounted upright in a progressing order, and secured them on a walnut base. Entitled *Not Wanting to Say Anything about Marcel, Plexigram I,* 1969, this complex composition charts the changing patterns of images, letters, and words in differing sizes that appear to be suspended in space. The entire assemblage was based on Cage's readings

of the Chinese I Ching and on chance juxtapositions of the individual images.

Other approaches to the low-relief print are to be seen in the somewhat loosely defined lead prints of Jasper Johns and in the metal-surfaced prints of Louise Nevelson and a few other experimenters. The Johns prints were an offshoot of his lead relief sculptures of the 1960s. His prints of thin metal and paper were fabricated at the Gemini G.E.L. Work Shop in editions of sixty each. In 1970–73 Louise Nevelson in collaboration with the Sergio and Fausta Tosi Workshop in Milan, Italy, created a small but important series of lead prints whose images parallel those in her sculpture. Free of any stylistic games, they are a direct and eloquent meshing of two somewhat unlikely materials.

In various explorations of the low-relief print, Luis Camnitzer, Kosso (Kosso Eloul), Liliana Porter, and Dorothea Rockburne have carried forward their ideas of the minimal image. Camnitzer has used the traditional woodcut and an experimental polyester mold. Kosso, working at Gemini G.E.L. in the early 1970s, has succeeded in combining the lithographic line with partly cut or folded areas of his paper to create special tensions and paradoxes.

A further departure from the mainstream of printing is seen in the works of Liliana Porter and Dorothea Rockburne. Liliana Porter has chosen to pierce the sheet of paper with a grouping of nails which are then retained as part of the composition. Dorothea Rockburne, working at Crown Point Press, has fabricated a series of shadowed images by the somewhat esoteric manner of partially folding or scoring the sheet of paper on which appear several etched lines printed in black and slightly toned areas of aquatint. No defined image comes to the aid of the viewer in his attempt to make a critical judgment of

104 CAGE, JOHN (b. 1921), *Not Wanting to Say Anything about Marcel, Plexigram 1,*
1969. Screen on plastic panels, 14×20 (35.5×51). Collection, The Brooklyn Museum,
Bristol Myers Fund.

the work. These Rockburne prints demand what may be termed a complete purity of vision.[6]

Other variations are noted in the lithographs of Joe Goode, mostly issued as untitled compositions in the 1970s. His latest series, entitled *Rainy Season,* 1978, is a departure from the earlier blending of pastel shades to compositions of glossy blacks and chalk whites. He continues his manner of slashing the background color field with the strokes of a razor blade, thus seemingly canceling out the surface abstraction. These random marks slightly expose the edges of the black sheet and interrupt the flow of movement in the color field in what might be termed a sensitive visualization of a creation/destruction point of view. Most of Goode's lithographs have been printed and published at Cirrus Editions in Los Angeles.

The embossed or low-relief print and its numerous variations have freed the artist from the limitations of a conventional two-dimensional surface. At its most imaginative it has extended the technology of printmaking and enlarged the visual possibilities of the twentieth-century print.

CHAPTER V

GRAPHIC WORKSHOPS

Early Workshops in the United States and Individual Master Printers · Major Developments in the 1960s and 1970s · Universal Limited Art Editions · Tamarind Lithography Workshop · Other Workshops · University Workshops

EARLY WORKSHOPS IN THE UNITED STATES AND INDIVIDUAL MASTER PRINTERS

In the later decades of the nineteenth century Whistler and his follower, Joseph Pennell, printed their lithographs in England. Later in the United States, Pennell and Bellows entrusted their lithographs to Bolton Brown and George Miller. Arthur B. Davies brought some of his lithographed stones to Frank E. Nankivill in New York. Graphic workshops where a professional artist with no special experience in printing might try out and develop his own ideas and images under the tutelage of a skilled printer were rare in the United States. Previously mentioned were the graphic workshops established under the auspices of the Works Progress Administration in various cities in the United States. A most important one that gave a new and stimulating direction to the modern print was Hayter's Atelier 17 in New York during the 1940s and early 1950s and brought a new vision and interest in the intaglio print. Among the early lithography workshops in the United States were those under the direction of George C. Miller in New York, Lynton R. Kistler in Los Angeles, and Lawrence Barrett in Colorado Springs.

The George C. Miller lithographic printing shop, in existence since 1917, has been a family business for two generations. At the age of fifteen George Miller served an apprenticeship in the commercial printing field, where eleven members of his family also worked. Eventually Miller set up his own shop—a shop that printed lithographs on stone and zinc for artists. Miller counted among his earliest clients the artists Albert Sterner, Joseph Pennell, and George Bellows. All three of them had their own lithographic presses but found Miller's skills of special importance in the editioning of their works. Between the two World Wars, Miller printed the lithographs of Arthur B. Davies and Childe Hassam. Adolf Dehn, Thomas Benton, Wanda Gag, Raphael Soyer, and Louis Lozowick also brought their lithographic stones to Miller. The roster of artists whose work came through Miller's studio seems unending, including lithographs by Reginald Marsh, Lyonel Feininger, Ivan Le Lorraine Albright, Ernest Fiene, William Gropper, Yasuo Kuniyoshi, Robert Riggs, Federico Castellon, Stow Wengenroth, and Grant Wood. The Mexican artists Orozco and Siqueiros had their lithographs, commissioned by E. Weyhe, printed at Miller's shop. Today under the direction of Burr Miller the still-modest shop continues to serve artists as it has done for nearly sixty years.[1]

Some twenty-five years later, Lynton R. Kistler opened his lithographic printing shop in Los Angeles. He recalls that his father, a letterpress printer, was among the first to convert his letterpress plant into an

offset lithography operation. The son became interested in lithography on stone through the encouragement of Merle Armitage, impresario of the Los Angeles Grand Opera Company and a collector of fine prints and books. Kistler printed his first lithograph for Jean Charlot in 1933. It was in two colors and small in size. Charlot had previously worked in black and white at the George Miller shop in 1929–31. Later Kistler bought some "five tons" of lithographic stones from the Crocker Company—all he could then afford. The remaining stones were dumped into San Francisco Bay by the company, much to the consternation of Kistler. Kistler's work in both black and white and in color was exhibited in 1933 at the Stendahl Galleries in Los Angeles. Other artists brought work to his shop, including Man Ray, Eugene Berman, and S. Macdonald-Wright. Kistler remembered with some remorse that he had refused to do lithographic work for Max Ernst although Kistler's assistant, Joe Funk, worked with Ernst on a few etching plates. The costs of lithographic color printing were such that only Jean Charlot and a few others could afford it. The popular demand for Charlot's color prints made possible his venturing into the large-scale color print. In the later 1940s a growing number of West Coast artists, including Rico Lebrun, June Wayne, and Clinton Adams, worked at the Kistler shop.

It was here that June Wayne made an intensive study of the process and its many possibilities. Between 1948 and 1956 she issued some thirty-eight prints and in 1955–58 she worked briefly in offset lithography. Also in Paris she worked with Marcel Durassier. She skillfully utilized the many tones of lithography in the growth of her own ideas and their presentation. Lynton Kistler recalls that

> "she was a meticulous worker. It took her a long time to do a stone; she didn't just rattle them off. All her subjects were intellectual, and she was insistent that the meat of her ideas should be reflected in the competence of her work. Sometimes it would take her three or four months to get something out of the stone that she was willing to accept. Gradually she worked on larger and larger stones. It took two men to get the heavy stones into her studio so she could work on them."[2]

Finally a painful allergy to acids used in stone lithog-

raphy forced Kistler to discontinue this method of printing. His last edition on stone was a print by Charlot completed in 1958. However, Kistler continued his work with artists by employing offset lithography.

Lawrence Barrett, artist and lithographer, taught at the Fine Arts Center in Colorado Springs from 1936 to 1952. An excellent lithographic printer, he worked with Boardman Robinson, Jean Charlot, Rico Lebrun, and Adolf Dehn. He especially admired the prints of Dehn, who shared Barrett's interest in western landscape. A conservative artist in a most conservative school, he often preferred the solitude of his own studio. For a period when lithography was considered of little importance, he printed lithographs in color with exceptional understanding and skill.[3]

In the 1930s and 1940s individual artists who were in reality master printers and had access to etching or lithographic presses often printed editions for their colleagues or their students. Among this group were Bolton Brown, Frank Nankivill, and a few others. Another printing source for New York artists was a master printer employed by the printing firm of Anderson and Lamb, located near the Brooklyn Bridge. Will Barnet early in his career printed small editions for his friends and some of his students at the Art Students League. Charles S. White maintained his own studio where he printed intaglio editions for artists.

An early self-supporting cooperative print workshop called Printmaking Workshop was established in New York City in 1949 under the painstaking direction of Robert Blackburn. Many well-known artists printed their stones here. Among the early group were Will Barnet, Boris Margo, John von Wicht, Chaim Koppelman. The Workshop was later expanded and provided ample work space, presses, and other necessary equipment as well as expert knowledge and printing skills. It has been in continuous operation for nearly thirty productive years.

A somewhat different approach to printmaking was instigated by the painter and printmaker Margaret Lowengrund, who opened a gallery for graphic arts and combined it with a print workshop. This

imaginative operation was later to be taken over by Pratt Institute and developed into a much larger and international print workshop now known as Pratt Graphics Center in New York. Initially under the direction of Fritz Eichenberg and presently directed by Andrew Stasik, it maintains a wide-ranging teaching program although it no longer prints editions for artists. Pratt Graphics Center has published a number of important print exhibition catalogs as well as two annual print journals. The first one, *Artist's Proof,* appeared from 1961 through 1971 under the editorship of Fritz Eichenberg. The present journal, *Print Review,* has been published since 1972 with Andrew Stasik as editor.

MAJOR DEVELOPMENTS IN THE 1960s and 1970s

Two of the most influential graphic workshops first initiated in the late 1950s and in full operation in 1960 were Tatyana Grosman's Universal Limited Art Editions located on the East Coast at West Islip, Long Island, and the Tamarind Lithography Workshop on the West Coast at Los Angeles established and directed by the artist and lithographer June Wayne. The two approaches were vastly different, but their final goal was similar—that of fostering and producing significant modern lithographs of high artistic quality.

Universal Limited Art Editions

Great credit must be given to Tatyana Grosman, founder and director of the Universal Limited Art Editions, who singlehandedly, with unerring taste and a remarkable eye for American avant-garde art, set out to attract to her very modest shop the outstanding young professional artists of the later 1950s and 1960s. In 1943, after several eventful years of uncertain wanderings as refugees in France and Spain, the Grosmans arrived in New York with few personal belongings and even less money. For some years they lived in a studio on Eighth Street in Greenwich Village, where Maurice Grosman pursued his career as a painter. They also managed to spend a number of summers in a small house located on the grounds of a Benedictine monastery at West Islip, Long Island. After Maurice's serious illness they moved permanently to this summer dwelling. It was here that Tatyana Grosman began her career as a printer and publisher of fine prints and editions de luxe. She had long been an admirer of the lithographs of modern French artists she had observed in galleries and shops in Paris. By chance and many eventful years later, she discovered several lithographic stones of fine Bavarian limestone used as stepping stones in her garden at West Islip. After carefully cleaning and preparing them, Mrs. Grosman brought them to a neighboring artist, Larry Rivers, and suggested that he attempt some lithographs. Intrigued by this "odd" idea, Rivers and a poet friend, Frank O'Hara, eventually collaborated in the creation of a series of twelve black and white lithographs with accompanying free verse entitled *Stones.* This first venture, now a well-known and coveted portfolio, was begun in 1957. Meanwhile a small lithographic press was purchased, proper papers, inks, and some technical skills were acquired. Also several appreciative and understanding collectors were found to help finance the project. Published in 1959, *Stones* was printed on a fifteen-dollar flatbed press in the Grosman's living room by the artist and printer Robert Blackburn, who also had a graphic workshop in New York. During the protracted work on *Stones,* Larry Rivers, anxious now to carry out further experiments in lithography, completed several other individual prints. The Grosman operation grew with larger lithographic presses and a move to more convenient quarters in the nearby garage. Other avant-garde artists whose paintings appealed to Tatyana Grosman were carefully selected and invited, and occasionally cajoled, to work in the shop. Among them were Fritz Glarner, Jasper Johns, Robert Rauschenberg, and, later, Lee Bontecou, Robert Motherwell, Grace Hartigan, Helen Frankenthaler, Jim Dine, Marisol, Sam Francis, and a few others.

In 1966 a grant from the National Endowment for the Arts made possible the acquisition of an etching press and the enlargement of the printing shop. Intaglio printer Donn Steward, whose training in-

cluded work with Mauricio Lasansky at the University of Iowa, began the etching operation with artists Lee Bontecou, Helen Frankenthaler, Jasper Johns, Marisol, and Robert Motherwell to create intaglio prints that were equal in quality to their lithographs. Each artist was free to make his own discoveries in the fascinating materials of fine limestone, inks, the securing of the image on the stone or the etching plate and final printed impression as it emerged on snowy sheets of handmade papers. Out of the direct and responsive atmosphere have come many daring and unusual compositions whose images and ideas were often incorporated into the artists' painting or sculpture. Here came alive a visual diary of images reflecting the artists' experiences in present-day environments. Fragments of familiar images and trivial objects in accidental juxtapositions and brushed onto the stone or etched into the metal plate assume a new and often unexpected life of their own.

Many other outstanding prints and portfolios have been created and published at ULAE since the first series, *Stones.* Among them are Jasper Johns's early lithographic series *o Through 9,* his famous *Ale Cans* of 1964, and his complex *Decoy I* and *Decoy II.* Since 1960 Johns has made more than 100 lithographs at this shop. Also to be noted is James Rosenquist's large-scale *Off the Continental Divide* of 1973–74 and Robert Motherwell's tasteful and brilliantly printed abstract illuminations for *a la Pintura* by Rafael Alberti.

The workshop itself, now internationally famous, remains small and intimate—a quiet, seemingly leisurely haven where creative ideas are fostered and take precedence over time, effort, and expense. Its staff is now only slightly larger. Another printer, Zigmund Priede, who had been Robert Blackburn's assistant, soon took over Blackburn's work. He, in turn, was followed by several other master printers. Tony Towle, a young New York poet, "developed a thorough aesthetic and statistical knowledge of every print" and ably assists Mrs. Grosman in the general administrative duties. Tatyana Grosman best sums up her success and her enthusiastic work with American artists:

". . . But the technical aspects of printing are not really important to me, and 'technique' should never be a predominant feeling in a print. What matters is that the print be alive, with the heartbeat of the artist in it . . . It must not be rushed. Sometimes it is good just to let it sit for a while, and maybe you will later add something or take something away. I think it is my responsibility that the artist should not ever have reason to regret what he has done."[4]

Tamarind Lithography Workshop

On the West Coast, the Tamarind Lithography Workshop, taking its name from an otherwise undistinguished street in Los Angeles, opened its doors officially in 1960 after more than a year of intensive preparation. Its basic objective was "the stimulation and preservation of the art of lithography" in the United States. This objective was to be achieved through the establishment of a graphic workshop where artist-printers were to be fully trained as master printers in lithography and also to offer fellowships for selected professional artists who desired to produce fine lithographic prints. Tamarind was founded and imaginatively directed by June Wayne with generous support from the Ford Foundation's Division of Humanities and the Arts. As originally planned, it functioned for a specified ten-year period, and through the concentrated efforts of June Wayne, the Tamarind staff, and the many artists and master printers, the entire medium of lithography in the United States was transformed into a vigorous and professional art form.[5]

In its initial stages June Wayne and Garo Antraesian, both artists and dedicated lithographers, realized the need for expert printers and a well-equipped studio where printers as well as painters and sculptors might acquire adequate skills in the production of fine lithographs. Most American artists went to Paris or to other European cities to have their lithographs printed by experienced master printers. In the United States those few professional workshops that usually functioned as a private business often held to the tradition of "shop secrets" and viewed with understandable alarm time-consuming and costly experimentation.

With admirable resourcefulness June Wayne set about procuring large presses and other necessary equipment along with special papers of uniform quality suitable for lithographic printing. In short order, Tamarind became a splendidly equipped shop. One of the presses and a few of the larger stones

were purchased from Lynton Kistler and other still larger ones were soon acquired. No expense or energy was spared to obtain a backlog of fine stones and zinc plates of the highest quality. New methods were devised for the handling of the immensely weighty stones, and an efficient means of grinding down the print surface of the stones was developed. The entire space itself was conducive to concentrated work; a small adjoining courtyard with a few benches invited the artists and printers for occasional relaxation. The Tamarind editions were small, allowing the artist twenty impressions of fine quality. The Tamarind collection retained another five signed impressions of each print on particular papers for its special donors or supporters. Tamarind also developed a knowledgeable and complete system for the documentation and preservation of the modern print. With a fine flourish, Tamarind, through its fact sheets and other timely publications, taught not only artists but publishers, dealers, and more than a few museum curators how to properly record the many aspects of the modern print. Clinton Adams, who functioned as an Associate Director, Program Consultant, member of the selection panel, and also an Artist fellow, has succinctly summarized the Tamarind program:

"The test of the value of the Tamarind program to artists and to lithography is that while few American artists made lithographs in the 1950s there are few in the 1960s who have not done so, either at Tamarind or at the workshops established as a consequence of the Tamarind program."[6]

Among the outstanding lithographs printed and published at Tamarind are those created by Josef Albers, Garo Antraesian, Richard Diebenkorn, Sam Francis, Rico Lebrun, Louise Nevelson, Nathan Oliviera, Karl Schrag, Romas Viesulas, and Adja Yunkers. Within its ten years of existence Tamarind had trained approximately seventy master printers, awarded fellowships to ninety-five artists and fifty-seven guest artists. It produced more than twenty-five hundred official editions totaling some seventy-five thousand quality impressions. It also produced a complete manual of lithographs under the authorship of Garo Antraesian and Clinton Adams. In 1970 Tamarind was affiliated with the University of New Mexico in Albuquerque under the title of the Tam-

arind Institute. It is presently directed by Clinton Adams.

The proliferation of professional lithographic workshops in the United States today is due in great measure to Tamarind's original and very efficient program. The first shop, established by a Tamarind-trained printer, was Kanthos Press in Los Angeles in 1963. It was initiated by the master printer Joe Funk, who was later joined by Joe Zirker. Kanthos Press was followed by others in various cities in the United States.

Irwin Hollander and Ken Tyler were among the first to receive training as master printers in lithography at the Tamarind Lithography Workshop. Hollander established his own workshop in New York in 1964, the first such establishment in the eastern section of the United States to grow out of the Tamarind operation. Approximately fifty artists have worked at Hollanders Workshop, including De Kooning, Vicente, Tworkov, Motherwell, Nevelson, Francis, Pearson, Steinberg, and Lindner. In 1967 Hollander printed and published his *Portfolio 9*, featuring nine well-established artists whose prints demonstrate the stylistic range of the lithograph in the United States. Although it is no longer active, Hollanders Workshop was instrumental in enlisting the interest of many important painters and sculptors.

In 1965 Kenneth Tyler, a master printer trained at Tamarind, opened his graphic workshop, Gemini Ltd., in Los Angeles. It soon became the most fully equipped and venturesome workshop in new as well as traditional fine printing methods. In 1966 the administrative staff was enlarged to include Sidney Felsen and Stanley Grinstein. It also expanded its name to Gemini Graphic Editions Limited, thereafter known as Gemini G.E.L. At this shop a new technology in printmaking was being forged. Its first major and innovative project was Josef Albers' *White Line Squares*, two portfolios of lithographs, completed in 1966. The degree of critical registration and the accuracy of the fine lines and flat, clear colors were previously uncertain or unknown in lithographic printing. Since that time Gemini G.E.L. has printed many exceptional prints by world-renowned artists. Among their printing achievements are Frank

Stella's work, including his *Star of Persia* series of 1967, Jasper Johns's spectacular *Color Numerals: Figures from 0 to 9* of 1968–69, Robert Rauschenberg's *Booster and 7 Studies* of 1967, and an extended series of the eloquent color improvisations of Sam Francis. No less distinguished are the lithographs of Claes Oldenburg, John Altoon, Edward Ruscha, Roy Lichtenstein, Alan D'Arcangelo, and Charles White. At present, Kenneth Tyler, having relinquished his partnership at Gemini G.E.L., has established a new highly tooled and sophisticated printing shop at Bedford, New York, a short distance from New York City, under the name of Tyler Graphics. Here many artists of the New York area work in lithography as well as in other print media in an imaginative and superbly equipped graphic workshop.

Other Workshops

In San Francisco, Editions Press, formerly known as Collector's Press, works mostly with West Coast artists and artists from Mexico. Cirrus Editions in Los Angeles and Landfall Press in Chicago both produce excellent lithographic and intaglio editions. The Landfall Press, established by Jack Lemon in 1970, often works with those artists who are thoroughly experienced in lithography and in etching, from the securing of the image on the stone or plate through the intricacies of the press work. Among this knowledgeable and professionally demanding group are Will Barnet, Jacob Kainen, Claes Oldenburg, and others.

Another exceptional workshop is the Crown Point Press in Oakland, California, where intaglio printing is carried forward with both skill and sensitivity. Kathan Brown, its founder and director, is both a painter and a master printer. She credits her appreciation and knowledge of etching to her years of study in London, where she began painting under the direction of William Trumbull and Roger Hilton and other English artists and was later inspired to work in etching with Merle Evans and a somewhat taciturn French printer employed at the school. On her return to the United States, she found that:

> "people had become aware of lithography through the work done at Tamarind and at Universal Limited Art Editions, but professional shops in America were not seriously pursuing etching. Since I like etching better than lithography or silk screen, and know more about it, Crown Point Press has always involved itself only with etching."[7]

Crown Point Press is located near downtown Oakland in a large light-filled loft in what was formerly Richard Diebenkorn's studio. Today "it houses two etching presses, a small geared Crafttool and a large motorized Griffin," and has ample space for other preparatory work. Aside from Kathan Brown, it employs four skilled printers. Established in 1962 as a very modest effort, it has grown into a highly skilled and experienced operation capable of issuing traditional etchings as well as incredibly difficult assignments that demand the imaginative execution of the full range of intaglio printing. The roster of artists who have completed significant prints at Crown Point Press includes Wayne Thiebaud, Richard Diebenkorn, Beth van Hoesen in 1965. In 1970–76 Chuck Close created his giant-size mezzotint *Keith* and Sol LeWitt composed his complicated series of conceptual etchings in color. The first etchings of Dan Flavin and aquatints of Claes Oldenburg were designed and printed at the Crown Point Press. Artists working in the minimal manner have found the atmosphere and facilities at Crown Point Press most helpful. To be mentioned are Robert Ryman, Brice Marden, Robert Mangold, Edda Renouf, and Dorothea Rockburne.[8] Donald Feldman of Parasol Press and Marion Goodman of Multiples in New York have worked closely and most successfully with Crown Point Press and have generously supported particular artists in their explorations and discoveries in the often unfamiliar medium of the intaglio print.

In Boston, Impressions Workshop was founded by the late George Lockwood in 1959. Its special printing interests were originally in lithography and intaglio and, later, the screen print and relief letterpress. Presently it is under the direction of Stephen Andrus and has branched out into print restoration and some special bookbinding. Its master printers have worked with many artists living in New England and also artists from the New York area. Well-known artists who have worked at the Impressions Workshop include: Sigmund Abeles, Robert Birmilin, Bernard Childs, Sam Gilliam, Michael Mazur,

Peter Milton, Aubrey Schwartz, Saul Steinberg, and Adja Yunkers.

More recently established graphic workshops are those of Donn Steward and Judith Solodkin. Donn Steward, formerly a master printer at Universal Limited Art Editions, operates an intaglio workshop at Halesite, New York. Judith Solodkin's Solo Press is located in lower New York City and specializes in fine and intricate lithographic printing.

The screen print, also designated as the silk screen print or serigraph, has been widely utilized by both American painters and sculptors during the past two decades. Originally a colorful commercial printing process, it was initially developed at the graphic studios of the Works Progress Administration (see p. 65). Most recent of the fine printing process, it is also the most simple of the color processes. Today screens of more durable plastic materials and an extensive array of specially ground colors in myriad tones and various viscosities are readily available. In the 1950s many artists carried out their own printing. Today fine professional shops are well equipped. The Ives-Sillman shop in New Haven, Connecticut, was among the earlier professional shops under the direction of Norman Ives. In 1967 it printed the Josef Albers portfolio *Ten Variants,* among other works. The Chiron Press, founded and directed by the artist Steve Poleski in the early 1960s, was the first to undertake professional screen printing for artists in the greater New York area. Styria Studio in New York, under the direction of Adolph Rischner, and Cirrus Editions in Los Angeles also are known for their work in screen printing. William Weege at the Jones Road Print Shop and Stable in Barnevald, Wisconsin, maintains an active professional shop specializing in screen printing and lithography. As an artist he has issued a number of lively and daring protest prints since the time of the Vietnam War. He has successfully combined screen printing with an added flocking as well as other experiments in the printing field.

University Workshops

The department of graphic workshops within the curriculum of a university or college has been an important influence on the modern print in the United States. These shops, under the direction of well-known professional artists, have trained students who later became professional artists in their own right. Other students have learned about print processes, compositions, and materials. Some have become teachers, dealers, or amateur collectors in the field of prints. Among the earliest and best-known graphic workshops are those at Yale under the direction of Gabor Peterdi and at the University of Iowa under Mauricio Lasansky. Other universities have established active shops at Illinois, Indiana, Minnesota, at a number of branches of New York University, at Tamarind Institute at the University of New Mexico, at Wisconsin, Tyler School of Art at Temple University, and others throughout the United States. These shops are well equipped due in part to state and federal grants. Important art schools also have long maintained distinguished print workshops, including the Art Students League in New York, the School of the Art Institute of Chicago, the Brooklyn Museum Art School, and a few others in various sections of the country.

Graphicstudio, established at the University of Southern Florida at Tampa, under the direction of Donald Saff, attempted to combine a shop for both the professional artist and the university student. Its inclusive rationale was "to explore new areas through research that will contribute in a substantive way to knowledge."[9] Approximately twenty professional artists and an undesignated number of the University's students enjoyed its largesse and its well-equipped studio. However, in spite of the efforts of its director and a skilled staff, it was not self-supporting. Unable to obtain continuing educational grants, it was closed in 1977. A venture into metal and plastic casting and the acquisition of both special equipment and skills proved to be a costly one and was perhaps overly ambitious for a university graphic workshop. Its distinguished graphic work appears in the lithographs of Arakawa, Philip Pearlstein, James Rosenquist, and Adja Yunkers.

The artist no longer lacks professional printing facilities in the United States where his work may be expertly printed and he may choose the shop that offers the facilities and tools that best satisfy his requirements. As always there remain conflicting points of view regarding the degree of involvement of an

artist in the intricate processes of the original print. Today skilled printing, elegant papers, rich colors, pristine margins, and perfect runs of an edition are taken for granted by artists, dealers, publishers, and collectors. An advanced technology in prints has brought sophisticated tools to the making of prints. Nevertheless, there remain artists who continue to be involved in the complete process, from the drawing of the images through the entire run of an edition. They consider all aspects to be part of the stamp or bench mark of their prints. Others, especially in the past two decades, prefer to work in a shop where the stimulating cooperation and skills of both the creative artist and the master printer may be utilized to the greatest advantage. Many of today's artists strive to eliminate any suggestion of a personal involvement. Their basic idea is to obtain "total objectivity" in their prints. Whatever means may be employed, it is important that the artist remain in command of these "tools" and also retain his own imagery and his par-

ticular vision. A disquieting observation may be made as the decade of the 1970s comes to a close. In the most sophisticated and highly tooled professional graphic workshops where "anything can be printed" the creative artist, unless he holds strong convictions, runs the risk of becoming a willing prisoner, if not an endangered species.

Only a small selection of the major graphic workshops have been noted in the present chronicle. However, there are more than a hundred professional and adequately equipped workshops that are active in the United States. Many are now equipped to work in all the current print media. It may be said that artists have never before had access to such a large number of professional printing centers. In the United States today's printmakers need not be concerned with any lack of skills but rather with the delicate balance in the teamwork between the artist and printer in order to maintain the freshness of the creative image in the final rendition of the print itself.

IDEAS AND IMAGES OF THE 1960s AND 1970s

Pop Art and the Printed Image · Development of Commonplace Images · Optical and Geometric Modes · Abstract Expressionism · The Classic Presence of Nature and the Human Figure · Other Independents and Their Prints · Oriental Artists and American Prints · Superrealism · Minimal and Conceptual Modes

In the later 1950s a radical change in the vocabulary of the modern print became increasingly evident. In the 1960s it reached revolutionary proportions. Young artists trained under the aegis of Abstract Expressionism began to rebel against what they considered a circumscribed vision that had little to do with present-day realities. In short order new symbols, images, content, and ambiguous meanings unhinged a long tradition. Instead of forms inspired by nature and filtered through the imagination of the artist, ready-made images were plucked directly from the commercial world and the mass media. The artists' intent was to avoid any personal gesture or comment and to create an entirely different visual vocabulary. Some chose standard primary colors—strong reds, blues, and yellows—and utilized them with untempered directness in their large-scale paintings and prints. The mass media welcomed and promoted what came to be called "Pop art" with highly visible enthusiasm. The public found the images familiar and entertaining. It viewed Pop art less as a revolt against abstract art and an effete vision than as a novelty and a nonmystifying art derived from well-known everyday objects. For the participating artists it was a somewhat ironical thrust toward a changing concept of art. They accepted the blatant, the grotesque and abrasive elements of the modern urban world and expanded them into vast improvisations of reconstituted images and ideas. Prints lost their unique position as printed originals. Now objects with or without printed images—banners, targets, flags, and handies—all were designated as "multiple originals."

POP ART AND THE PRINTED IMAGE

"Pop" images held the attention of many young artists in the United States and Great Britain. Among the American artists who, in their paintings and prints, became its most famous advocates were Andy Warhol, Roy Lichtenstein, James Rosenquist, Robert Indiana, Tom Wesselmann, and Claes Oldenburg.

Not only were ready-made images employed, but the technical trappings of commercial printing—the repetitive textured tones of Ben-Day dots in photographic reproductions—were painstakingly enlarged in paintings and prints. In general, odds and ends of advertising and almost unnoticed everyday objects were

sought out and employed with the bizarre effects of movie stills and fleeting news clips. A startling visual impact was achieved through repetition, flatness, and impersonal, sometimes witty presentation of objects.

Andy Warhol, Pop art's most flamboyant practitioner, began his career as a commercial artist and decided to become a serious artist when his colleagues in the fashion business became actively interested in American art. Utilizing the stencil basis of screen painting and the blown-up reproductions of photographs, Warhol launched his now-famous series of paintings and prints—the enlarged and repeated single image of a Campbell soup can. His prints were developed directly from his paintings. His first signed and numbered print probably was *Cooking Pot*, 1962, devised from a reproduction in a newspaper ad, and appeared in an edition of sixty impressions. A three-color screen print, *Portrait of Elizabeth Taylor*, was issued in 1963–64 to be followed by an offset lithograph entitled *Liz* in 1965. His four *Flowers* print, photoscreened in various color combinations, first appeared in 1964 in an unnumbered and partly unsigned edition. Warhol consistently challenged the idea of originality and uniqueness of a work of art in endlessly repeating his chosen but limited subjects. Thus *Flowers* appeared in some three thousand canvases and screen prints. In 1967 he issued his screen print series of *Ten Marilyns*. It was among his numerous canvases and prints of Marilyn Monroe, whose ill-fated career and suicide made her a symbolic figure for the generation of the 1960s. A more recent Warhol portfolio of ten screen prints entitled *Mick Jagger* was issued in 1975. A numbered edition of 250 with fifty artist's proofs, it is signed by both Warhol and Jagger. Each print is based on a different photographic image of Jagger with Warhol's drawing accenting the face and hands. This was a device first employed by Louise Nevelson in her line drawing delineating the basic contour lines on her profile study taken by the photographer Lotte Jacobi. Warhol in his series of Jagger portraits has enhanced the entire composition by the use of collage. Warhol, in a seemingly offhand manner, managed to evoke a sense of animation in his portraits and also a glimpse of their mystery in the forthright implementation of a greatly enlarged and abstracted photograph accentuated by the mechanics of the screen print medium itself. The

artist once remarked that he greatly admired the work of John Sloan, who, with appealing amiability, recorded his time in a "slice of life" point of view. Warhol chose to record the mundane and the ordinary, the boring images of an urbane culture with a vision that deliberately set out to be primitive, impersonal, and insistent as he forced the viewer to observe his particular "slice of life." He declared: "The things I want to show are mechanical. Machines have less problems. I'd like to be a machine . . ."[1] Warhol had studied pictorial design at the Carnegie Institute of Technology in Pittsburgh, receiving a degree in 1949. Also in 1949 he came to New York. In 1955 Warhol was experimenting with various monotype methods, using rubber stamps and stencils. He came to screen printing on paper by way of his screen paintings of the early 1960s. He issued twenty-six screen prints on paper from 1962 to 1970 and six prints on Plexiglas.

Other artists who pursued the images of Pop art also came to printmaking by way of commercial advertising and screen printing techniques, including Lichtenstein, Rosenquist, and Robert Indiana. It may be recalled that Lichtenstein was making woodcuts and etchings in the manner of comic strips as early as 1950. He has since issued both lithographs and screen prints. His images have grown out of the comic strip and also from the free or gestural brushstrokes of the Abstract Expressionists who worked within a deliberately flattened and enlarged picture plane.

To Robert Indiana, Pop art "is the American dream, optimistic, generous, and naïve . . ." Indiana, along with other Pop artists, was captivated by the appearance of a single word in highway signs and in commercial advertisements. His large painting entitled *Love* first appeared as a squared design on canvas in 1965. It became the highly decorative and symbolic image or "logo" of the hippie generation, who found it appealing and perhaps comforting. It later became a screen print issued in various color combinations. Its image was appropriated or pirated in posters, multiples, and a large steel sculpture. Some years later, in 1973, it was issued as a United States eight-cent postage stamp. Fashioned by capable government engravers and printers, it was, in fact, an engaging miniature print whose edition ran to 150 million impressions.

105 WARHOL, ANDY (b. 1928), *Mick Jagger,* 1975. Screen print 44×29 (120×74).
Photo courtesy Multiples, Inc.

106 LICHTENSTEIN, ROY (b. 1923), *Peace Through Chemistry IV,* 1970. Screen print, 28×28 (71×71). Photo courtesy Brooke Alexander, Inc., New York.

107 ROSENQUIST, JAMES (b. 1933), *Off the Continental Divide,* 1973–74. Lithograph,
42×78 (106.7×198). Photo courtesy Brooke Alexander, Inc., New York.

James Rosenquist found that his experiences as a billboard painter were advantageous in transforming large-scale images to canvas and to paper. He has issued lithographs that also take direct advantage of the images of advertising art. His interest is in visual inflation of objects or specific scenes which carry personal associations. This point of view is evident in his 1965 lithograph entitled *Spaghetti and Grass.* In 1966 Rosenquist worked at Universal Limited Art Editions, where he completed a number of lithographs of a quietly humorous intent. In 1970 he again worked in lithography, issuing *Area Code,* a two-panel lithograph in sixteen colors. It was at Graphicstudio in Tampa, Florida, in 1971 that he completed an extensive series of graphic works. Here he became so intent on his printmaking that he did little or no painting. The eleven lithographs issued at Tampa reveal new visual explorations that had little to do with the confining ideas of Pop art. Where Rauschenberg may resort to the literal image, Rosenquist has visualized a more symbolic image, as noted in *Moon Box* and in *Pylon: Earth and Moon.* More than half of his lithographs composed in 1971 carry an earth-moon idea. The moon is simply a flat disc reflecting a cold light upon a strange and unreal landscape. A suggested enclosure occupies the center of the composition and through its latticed roof are sifted shadows revealing newspaper headlines. Rosenquist's work, like that of Jim Dine (p. 183), is often autobiographical. His *Fedora,* perched atop a pole, recalls a fashion in hats of the 1920s but its symbolic meaning remains undisclosed. In his 1971 Tampa series Rosenquist is not wholly concerned with the vision of inflated objects or scenes but with changing ideas of space and light and the troubling question of man's ability to preserve his own environment. Rosenquist's oeuvre, which began as a protest against the dominating style of Abstract Expressionism, in this series becomes a protest of a more subtle order.[2] One of his most ambitious series is his *Horse Blinders,* 1973, four very large-scale panels in an elaboration of lithographic and screen printing techniques with the addition of strips of pressure-sensitive silver foil. The edition of eighty-five was printed at Styria Studio in New York. Culled from commercial printing, the images are carefully cropped to appear as abstractions save in a few arresting instances—in a stylized finger, the fringed end of an electrical cable—and the reflecting surface of silver foil.

Rosenquist continues his magnification of environmental elements in *Off the Continental Divide.* A hand-drawn offset lithograph on Japan paper, it was produced at the studios of Universal Limited Art Editions on a hand-fed proofing press in 1973–74. As in *Horse Blinders,* its scale (42×78 in.) and its broad images approach that of mural painting; its rich voluminous surface is filled with objects of special autobiographical significance. In a juxtaposition of images appears a large segment of a staircase behind which is an oddly crumpled surface, a car window, and four clusters of nails over which is spread an open book.[3] The artist relates:

> ". . . the whole print is about the idea of source and about myself . . . I leave the middle of the country—and I can either go West or East. I went East and it culminated in the ideas of my recent life . . . When I started out, I could have gone to California and become a cattle rancher. I thought, 'No, I'll go East and go to school!' "[4]

Much of Rosenquist's graphic oeuvre is concerned with the massive buildup of incongruities and seemingly disparate objects or images. Their well-defined shapes and color intensities create a lively source for improvisations that are forceful and provocative.

DEVELOPMENT OF COMMONPLACE IMAGES

A controversial and perhaps oversimplified statement has been advanced that two artists, Jasper Johns and Robert Rauschenberg, have been responsible for the revolutionizing of the imagery and the visual range of the twentieth-century print. There can be no doubt that the sheer volume of their work and its probing inquiries into the visual attitudes and changing ideas of the twentieth century have caught the attention of a worldwide audience. They have chosen commonplace objects and fleeting images to develop a new and often startling visual vocabulary. In its studied detachment and determined objectivity their

work discloses a significant contemporary vision and the quickened sense of immediacy that has dominated American printmaking of the 1960s and '70s.

The prints of Jasper Johns present an elusive imagery that is at once commonplace and unconventional whose casual juxtapositions touch off visual games slightly reminiscent of those that had earlier delighted the Neo-Dadaists. Since the early 1960s when Johns, Larry Rivers, Rauschenberg, and a few of their friends first explored the basic elements of lithography at Tatyana Grossman's shops, Johns has been seriously committed to the media of prints. An accomplished draftsman, Johns instinctively accommodates his talents and ideas to the medium at hand. The commonplace image of a coat hanger becomes a single vision. The image of a target is carried through large segments of his work. Its circular form haunts his lithographs, etchings, and screen prints with its varying moods, tensions, movement, and scale. It may stand as a single image or as a dominating part in a larger composition. In his *White Target,* 1960–61, a lithograph from seven stones printed in white on black Japan paper laid down on French Canson paper, the familiar image becomes fragmented in layers of white shadings, but its force and movement remain mysterious.

Concurrently Johns developed an elaborate lithographic series under the title *0 Through 9.* The initial black and white group was completed at the Universal Limited Art Editions shop in 1960–63 after a long period of work. The artist has visualized each number through the faint tracings of the others within the sequence. Perhaps this intricate use of numbers and alphabets as images and symbols was a reinterpretation of those engravings of letters and numbers that appeared in the seventeenth-, eighteenth-, and early nineteenth-century writing manuals wherein the flat interweaving of a continuous linear web encases an initial letter or a number and embellishes the principal trace. Johns has greatly enlarged the scale and enhanced the ambiguities of his images through the softer lithographic lines. In Johns's prints the varying undertones and suggested fragments are visual improvisations introduced within the progressing sequence. A second run of the *0 Through 9* series was printed in high-keyed translucent colors. The first plate, 0, begins with the three primary colors, red,

yellow, and blue; the last plate, 9, ends the series with the three secondary colors, orange, green, and purple.[5] Splendidly printed, the clarity of the original monochromatic series is now veiled in bright bands of fused colors. This ambitious sequence is one of Johns and Gemini's most spectacular printing achievements.

Johns often repeats or reuses a particular plate or stone in a different context, a procedure employed by a number of American artists, including Margo, Yunkers, Bertoia, and Frasconi. Of note are Johns's lithographs *Hatteras* and *Red, Yellow, Blue,* issued in 1962–63. Working at Gemini in 1968, Johns continued his monochromatic works with the large lithograph entitled *Gray Alphabets.* Each subtly defined letter is interwoven into a dense web where forms and meanings are envisioned through a haze of soft grays, with suggestions of deeper tones. Johns's superb command of these low-keyed tonal values has rarely been equaled in the field of prints. Since 1967 Johns occasionally has turned to etching. His repertory of graphic techniques includes not only the classic methods of printmaking but also screen printing, photoengraving, offset lithography, and combinations of lithography, linocut, and woodcut as noted in his print *Scent,* issued in 1976. A complex visual review, noted in the familiar print entitled *Decoy,* completed in 1971, mirrors nearly a decade of John's graphic oeuvre. A few of Johns's familiar images have been expanded into the metal surface or lead-relief print. In the graphic work of Jasper Johns the observer is compelled to look beyond the immediate appearances to a recurring but elusive pattern of perception. Johns's print *Scent,* a lithograph, linocut, and woodcut published by Universal Limited Art Editions in 1975–76, and *6 Lithographs (after Untitled, 1975),* issued by Gemini G.E.L. in 1976, are skillful orchestrations of nearly indiscernible repeats whose patterned clarity seems deceptively simple.[6]

Johns's recurring images have been drawn from many sources and in numerous variations. It has been noted that the design culminating in *Scent* and several other prints was based on Johns's observation of the stripes painted on a tree that stood in front of a Mexican barber shop. (See color illustration no. 10.) It also echoes the rhythmic lines appearing in a Matisse gouache and cut-paper composition that had appeared in 1952.[7] Jasper Johns has utilized with skill

108 JOHNS, JASPER (b. 1930), *Target*, 1960. Lithograph, 22½×17½ (57.2×44.5).
Photo courtesy Brooke Alexander, Inc., New York.

109 JOHNS, JASPER (b. 1930), *Decoy,* 1971. Lithograph, 41⁷⁄₁₆×29⁵⁄₈ (106×75.3).
Collection, The Museum of Modern Art, New York, Gift of Celeste and Armand
Bartos Foundation.

and imagination the technology of printmaking to refocus and restate his own particular images and ideas. His prints, presently numbering some 260 examples, are among the most provocative and occasionally controversial works issued in the past two decades.

Robert Rauschenberg has issued a number of exceptional lithographs at Universal Limited Art Editions. However, his interest in the mechanics of commercial printing as well as in reproductions and photographic aids led him to the Gemini workshop in Los Angeles. Like Albers, Oldenburg, Stella, and Lichtenstein, Rauschenberg employs to advantage the highly technical capabilities of Gemini. (See p. 162.) News layouts and magazine illustrations become an assemblage of images in endless transition. In a consciously contradictory fashion the artist fuses or blurs sections of his compositions on the lithographic stone and achieves interweavings of disparate fragments. His illusionary themes thus carry a special freight of ambiguity and unexpected irony.

In his print *Urban*, 1962, Rauschenberg had established his basic method of utilizing unrelated photographic images transferred to the stone from printer's plates and of controlling the emphasis of particular images by means of hand pressure. The composite images are fused or blurred through the application of a brushed-out tusche. The exploitation of familiar and ordinary or unrelated images in this fast-moving process gives a lively immediacy to the final print. Rauschenberg draws his images from a repertory of reproductions including sports, environment, familiar works of art, and portraits of specific interest. From this clutter or random order he extracts his final complex composition. In 1969 Rauschenberg was invited to attend the launching of Apollo II at the Kennedy Space Center. This experience resulted in his *Stoned Moon* series, in which the imagery is closely factual. Individually titled, the thirty lithographs vividly record an artist's response to this spectacular event. He describes the sight of "Apollo II, covered and shimmering in ice" and the takeoff as "the bird's nest bloomed with fire and clouds . . ." In the prints Rauschenberg employs intricate diagrams of the supporting system. These are combined with views of the rocket itself, known as "the bird," its looming tower, palm trees, images of

native Florida birds, an early version of a flying figure equipped with flimsy gear, and other free association images. In a brief running notation he remarks:

"V.A.B. Man's largest construction . . . Only possible to think how big it is. Can't feel it. Enter. Inside larger than all outsides . . . Launching control aware of 2 ideologies, man and technology, responsive responsible control and counter control."[8]

The *Stoned Moon* series reveals Rauschenberg's attempt to give meaningful visual expression to a single and demanding theme. It is only partially successful, as little of the drama, tensions, the terrifying immediacy, and the almost magical sense of scientific disciplines and conclusions are revealed in this large series. Perhaps it demands more than an improvisation of images or the running juxtaposition of news clips and flashbacks skillfully brushed onto a lithographic stone. Nevertheless, Rauschenberg's large lithographic oeuvre mirrors a special awareness of new technologies and their varied influences on the thinking and sensibilities of the twentieth-century artist.

The prints of Jim Dine and Kitaj do not share the calculated boredom and dead-pan objectivity of the Pop artist. They view special objects or circumstances from a more personal point of view. Dine's particular visual penetration into the objects that hold his attention gives them a special presence. His prints become an affable running dialogue with the interested viewer. His superb draftsmanship is accompanied by an unobtrusive whimsicality. Jim Dine began printmaking at Pratt Graphics Center in 1960. A series of approximately half a dozen lithographs entitled *Car Crash I Through V* and *End of Car Crash* was an artist's disturbing commemoration of the death of a friend in an automobile accident. In the following year Dine produced his *Tie* series, a group of drypoints which forecast many of his later prints. In 1962 Jasper Johns took Dine to Tatyana Grosman's graphic workshop, which was much to Dine's liking. Here in the ensuing years he completed a number of exceptional prints. Dine says simply:

"I make prints because it is another way of talking . . . Prints are the reason for some of my paintings. Lithographs take enough time,

110 RAUSCHENBERG, ROBERT (b. 1925), *Front Roll,* 1964. Lithograph, 41¼×29
(104.7×73.7). Photo courtesy Brooke Alexander, Inc., New York.

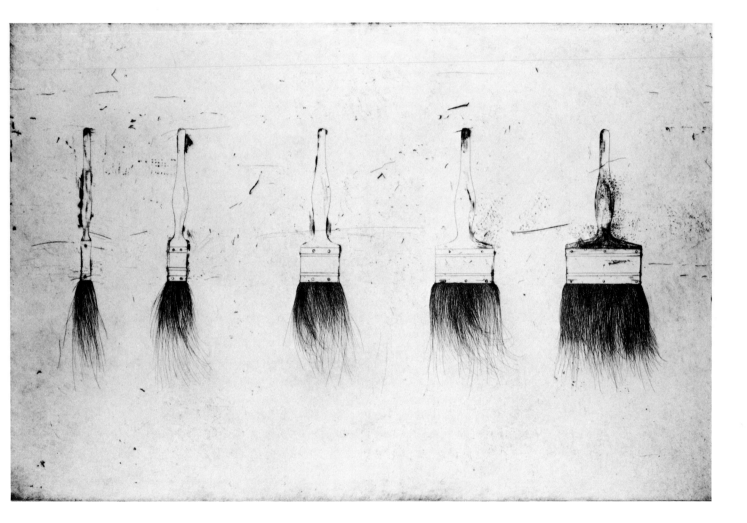

111 DINE, JIM (b. 1936), *Five Paint Brushes,* 1972. Etching, 23½×35½ (59.7×90.2).
Collection, The Brooklyn Museum.

more than anything else I do, so that they make me think about everything. I do not care what it takes to make a print . . . I don't deal exclusively with the popular image—I'm more concerned with it as a part of my landscape."[9]

Dine's images are presented not as blunt matter-of-fact objects but are rendered with an intuitive and sensitive realism. He sees objects as "a vocabulary of feelings."

Dine reveals his private vision with a warm personal reticence, and the objects that appear in his prints are of a private significance. The artist delights in taking chances with those images that hold his attention and surprise the viewer. They are often daring and unexpected and lend an engaging mystery to his work. In 1965 he issued *Boot Silhouettes*, a black and white lithograph, and a year later his *Tool Box*, a portfolio of ten screen prints and collage in red. For Dine these were not merely objects but symbols reminiscent of his own childhood. In 1965 he had completed an etching entitled *The Bathrobe*, a composition he returned to in 1969, this time in a group of lithographs. They form a progression of self portraits with the figure itself eliminated. The artist's large etching entitled *Five Paint Brushes,* 1972, existing in a number of states, is a baroque work of singular appeal. For Jim Dine "reality itself is the mystery." Perhaps in his recent intaglio series *Eight Sheets from an Undefined Novel,* 1976, and in several self portraits completed in 1978 Dine envisions a more encompassing and troubling reality.[10]

The prints and paintings of Kitaj are the most obscure in their scattering of strangely juxtaposed images. To seemingly unconnected visual ideas he combines, or uses as a type of footnote, phrases, sentences, or allusions of a literary or precise scientific nature. His work is a condensing of events presented in an endless succession of visual flashes. Both Dine and Kitaj in their earlier works are capable of drawing from a vast repertory of images not only humor and pathos but also a casual wit.

Larry Rivers began printmaking somewhat inadvertently through the initial efforts of Tatyana Grosman, who, in 1957, brought to his nearby studio a small lithographic stone, along with a few grease crayons, and suggested that he make a drawing on it and she would then print it. Eventually Rivers collaborated with Frank O'Hara in a series of lithographs and poems whose casual, free-form compositions are exploratory notations. (See p. 168.) In 1960 Rivers issued a small edition of his *Jack of Spades* and in 1965 his well-known *Nine French Bank Notes*. Interested in the art of packaging, Rivers' approach to mundane subjects is not one of imitation but of visual variations. In his prints and paintings he views these subjects through a shifting or oblique focus. In his large lithographs entitled *Once More Paul Revere I & II,* issued in 1967–70, he improvises on an earlier theme. His large-scale lithograph entitled *For Adults Only,* in three colors, appeared in 1971. The bold stance of a single, well-articulated figure against a patterned background attests Rivers' abilities as a modern draftsman, as does his 1970–71 series *Diane Raised III.*

OPTICAL AND GEOMETRIC MODES

The solemnity and recurring images of Abstract Expression were countered by those artists whose prints carried a precise, geometric imagery. After a lapse of some years, Josef Albers, in 1958, resumed his graphic presentations of the square in a series of inkless intaglio prints. (See color illustration no. 11.) Henceforth, through the decade of the 1960s, he issued many distinguished portfolios of lithographs and screen prints in an eye-stopping range of colors. His adherence to Bauhaus principles and his own teachings in color theory influenced many American

artists. Albers' paintings and prints herald much of Optical art in the United States.

Richard Anuszkiewicz, a former student of Albers at Yale, continues this optical development. He creates lithographs and screen prints that glow with colors of high intensity in repetitive squares, rectangles, dots, and lines. He describes his purpose in creating these compositions as

"an investigation into the effects of complimentary colors of full intensity when juxtaposed, and

112 RIVERS, LARRY (b. 1923), *Diane Raised III,* 1970–71. Lithograph, 25×33
(63.5×83.8). Photo courtesy Fendrick Gallery, Washington, D.C.

the optical changes which occur, as a result; as well as a study of the effect of the changing conditions of light and the effect of light on color."[11]

Instead of the severe color control and the equally severe basic grid that Albers employs with mathematical regularity, Anuszkiewicz controls his colors within a much more complex hierarchy. His patterned squares and rectangles have been described as a colored geometry that

"becomes a kind of crazy quilt corridor into which the eye is drawn and held dizzily as in an enchanted fun house."[12]

Each print has its own internal rhythm, similar to that of a musical score. Each color has its particular pattern, which ripples through the composition as a light beam suddenly illuminates ghostly shapes. They, in turn, reappear in other vibrating forms and tones like the colors of a Persian miniature that have burst suddenly into the abbreviated idiom of the twentieth century.

The enhancement of color through minimal means is evident in compositions of undulating lines that characterize the lithographs of Henry Pearson and Reginald Neal. Larry Poons has utilized small forms —dots, dashes, and broken lines—played against subtle color fields to create optical changes. Garo Antreasian, in superbly rendered large-scale lithographs, has flattened curved forms and given them infinite gradations of colors. The highly regulated stripes and chevrons of color that characterize the paintings of Frank Stella also appear in his lithographs and screen prints from the late 1960s. In these strictly circumscribed compositions the artist has held in balance or equalized an illusory sense of the third dimension within the confines of a flat surface. Stella first worked in prints at Gemini G.E.L. in 1967 to issue his *Black* series and *Star of Persia, Nos. I and II*. In his linear bilateral stripes and chevrons the artist continues the ideas noted in his painting, but in the prints the scale is reduced, although they still retain the sensibility of his canvases. In 1971 Stella issued his *Newfoundland* series of large-scale screen prints. These continue his ideas in a strictly regulated structure. Late in 1976–77 during a period of work at Tyler Graphics Limited an entirely new imagery is

noted in a series of color lithographs and screen prints. Individually titled, they are freely rendered drafting instruments envisioned in bright reds, blues, yellows, and greens set against a variegated background and bordered by the thin mechanical lines of graph paper. Their swinging, freely rendered images seem to defy the disciplines of the professional draftsman and perhaps the carefully regulated earlier prints of the artist. These remnants of the French curve have become exotic birds carrying such titles as *Eskimo Curlew, Puerto Rican Pigeon,* and *Steller's Albatross.*

A severe, uncompromising vision appears in the prints of the painter Alan D'Arcangelo. From his earlier compositions of geometric abstractions D'Arcangelo has developed a leitmotiv that becomes a "highway vocabulary" of signs and signals set within an abstract landscape. In 1966 he embarked on an extended series depicting roads and highways whose images stem from Pop art and the enclosing forms of geometric abstraction. In his lithographic work, the artist reduces landscape to ribbons of green and highways to neutral-colored strips. In a swiftly converging sequence of greens, yellows, reds, and black the artist-driver spins through changing signs and signals into space and time. A sense of speed and direction is achieved through pointing arrows, changing lights, and the ominous starkness of the black and white stripes of railroad barriers. Recently, the artist has been engaged in producing multiples in which highway views from the driver's seat are screen-printed on Plexiglas and mirrors.

Jack Youngerman, Ellsworth Kelly, and Alexander Liberman have created lithographs and screen prints wherein a single geometric form exists in undefined space. Youngerman's series of eight screen prints entitled *Changes,* 1970, further explores the fluidity and subtle changes that may occur in a single geometric form placed within a uniformly toned background. (See color illustration no. 12.) Other variations in geometric forms mark the prints of Paul Brach, Billy Al Bengston, and Nicholas Krushenick. The prints of sculptors Ilya Bolotowsky and Larry Zox demonstrate their precise vision and their ability to expand and vary geometric images through well-integrated colors.

ABSTRACT EXPRESSIONISM

It is of some historical interest to observe that the key artists in Abstract Expressionism did not turn their attention to prints until the 1960s after the main thrust of this movement had given way to later trends and more aggressive points of view. Their concentration on color and the immediacy of the gestural image left little inclination for the demanding disciplines of the print media. Perhaps they and their dealers belatedly discovered what European painters had long understood, that the modern print was a highly creative expression and often a remunerative one as well. Also the growing availability of well-equipped graphic workshops with skilled master printers who were able and willing to place their knowledge and skills at the service of established painters and sculptors made joint efforts feasible and enticing. Among those Abstract Expressionist artists who have made prints are Robert Motherwell, Adja Yunkers, Willem de Kooning, Fritz Glarner, Philip Guston, Estaban Vicente, James Brooks, Adolph Gottlieb, John Grillo, Cy Twombly, and Jack Tworkov. Late in the 1950s, soon after Mrs. Grosman established her shop, Barnett Newman made a few lithographs. He was beginning to explore the etching medium at the time of his death in 1970.

Early in his career as a painter, in 1941, Robert Motherwell made a brief study of engraving at the studio of Kurt Seligmann, where he also met many of the Surrealist artists in exile. In 1945 he worked for a short time at Atelier 17. It was not until the early 1960s that he joined some of his colleagues who were exploring the intricacies of the lithograph at Tatyana Grosman's graphic workshop in West Islip. Here in 1961 he issued his large-scale lithograph entitled *Poet I, 1961*, in a small edition of twenty-two impressions. During 1965–66 Motherwell worked at Hollanders Workshop, where he completed twenty-five editions of lithographs and etchings, the latter printed by Emiliano Sorini. They are variations of his familiar gestural imagery that appears in his paintings and often carry the same titles. Among his lithographs are *Automatism A, 1965*, and *Summertime in Italy*. Since 1968 Motherwell has been working chiefly in intaglio

at West Islip, at Gemini in Los Angeles, and still later at Tyler Graphics in Bedford, New York.

In 1968 Motherwell embarked on his long-considered project, his illuminations for Rafael Alberti's remarkable poem *A la Pintura* (Homage to Painting), first published in 1948. The artist's twenty-one aquatints printed in luminescent colors are subtle variations of the square and rectangular images. The plates were etched and printed by Donn Steward, master printer at Universal Limited Art Editions, under the supervision of Tatyana Grosman. The text was translated from the Spanish by Ben Belitt. The Spanish text is printed in the individual colors that are eloquently described in the Alberti poem; the English translation is printed in black. The designing and printing of each page, the format, the choice of paper and inks are flawless. Signed on the colophon, this unbound illuminated volume is issued in a small edition of forty copies. Motherwell's later intaglio prints include a series of five etchings, *Calligraphic Studies, I Through V*, printed by Catherine Mousley at the artist's studio in Greenwich. During this period he also completed the large, authoritative composition entitled *The Wave*, a soft ground etching with collage. (See color illustration no. 14.) His graphic oeuvre spans a period of nearly forty years and records his superb mastery of the gestural image in abstract art.

To an already notable graphic oeuvre Adja Yunkers has added in the past two decades a number of lithographs in color and a few screen prints. Composed in his familiar Abstract Expressionist style, these later prints are greatly simplified. Their bold, elegant forms and their clear colors are definitive statements of an artist who understands and utilizes the essential elements of his particular idiom and presents them with discernment and strength. Among his prints issued in the 1970s are the lithographic triptych whose central panel is entitled *Plentitude of Blue* and whose accompanying panels printed on separate sheets of paper are *Summer Palace*, a three-color lithograph, and *Yo*, in two colors with embossments. The tour de force of this latest period in

113 MOTHERWELL, ROBERT (b. 1915), *Automatism A,* 1965. Lithograph, 19½ × 14¼ (49.7 × 36.3). Photo courtesy The Brooklyn Museum.

Yunkers' graphic work is the edition de luxe: *Blanco,* a love poem by Octavio Paz richly illuminated by the artist. Octavio Paz, a longtime friend of Yunkers, wrote his love poem to his wife while serving as Mexican ambassador to India in 1966. Two years later Yunkers began work on an illuminated edition of the Paz poem that was to consume much of his thought and his creative energy during the next seven years. The artist desired that it be in the great tradition of the modern French éditions de luxe. However, he could not take his project to Paris as his other work demanded that he remain in New York. He himself would be not only the artist but the producer and publisher as well. He searched out skilled and dedicated professionals to assist him in this rather awesome project and finally settled on a small press known as The Press on Washington Street in New York. In 1974 "this edition of *Blanco* by Octavio Paz illuminated by Adja Yunkers with an Introduction by Roger Shattuck and translated from the Spanish by Eliot Weinberger" appeared. It was issued in a limited edition of fifty copies, with hand-set text in Baskerville types and with illuminations in lithographs, screen prints, embossments, and collage with some handpainting, all printed on Arches heavy rag paper. For both poet and artist it is a splendid achievement.

Willem de Kooning only rarely applied his enormous talents to printmaking. He has worked in lithography, which allowed him a freedom that approximated that of his brush and was a means of extending his drawings. Two of his most successful prints are early lithographs, printed in black and white from large stones in a small studio-garage near the University of California at Berkeley by George Miyasaki and Nathan Oliviera in 1960. Untitled, their large, freely rendered black forms appear in a strong movement that charts a forceful stream of energy. However, in spite of the combined efforts of the three artists involved, only small editions of the two prints were successfully pulled before the stones were accidentally broken in the process of printing. The larger and darker image (116.6×80.7 cm.) was printed in an edition of nine; the lighter image (108.6×78 cm.) has an edition of eleven impressions.

In 1970–71 de Kooning again turned to lithography at Hollanders Workshop. Included are the ti-tles *Landscape at Stanton Street, Mini Movers,* and *The Preacher,* with editions of sixty impressions each. The title *With Love* was printed in an edition of forty impressions. De Kooning has continued brief periods of work at several other workshops in the New York area.

Estaban Vicente composed his first lithographs in 1962 at Tamarind and later continued at Hollanders in New York. Also, John Grillo returned to printmaking in 1964 with a series of free-form compositions in black and white. James Brooks was not a newcomer to printmaking. In 1931–36, he had issued a number of lithographs in a social-realist genre. In 1934 the Dallas Museum of Fine Arts awarded him a first prize for his prints. In 1970 Brooks again took up lithography. These prints reflect the authority and intellectual control that characterize his abstract paintings. The print oeuvre of a number of the Abstract Expressionists is due in large part to the encouragement and the sensitive cooperation of Tatyana Grosman and Irwin Hollander, who made the facilities of their respective workshops available to the individual artists.

In the early 1960s Arthur Deshaies developed his ambitious large-scale plaster-relief prints which suit the ebullience of his talents. Long concerned with recording the movement of the sea and its tides, he has photographed swirling waves and currents along the Atlantic Coast and the rugged shorelines of the Mediterranean. These graceful or menacing abstract forms have become a subjective force, symbolizing an inclusive cycle of man's inner being. They become for the artist a "larger sea of being and unbeing" in the strong drive of a creative temperament.

In a few frenzied weeks of concentrated work Deshaies completed more than a dozen large relief prints. The large plaster "blocks" were carved by all manner of tools from knives and chisels to machine tools and dentist drills. Some sections were worked over before the plaster surface was completely set. The speed of the work kept pace with the artist's immediate ideas as if he were brushing paint upon a canvas. This ambitious series, entitled *Cycle of a Large Sea,* was completed in January 1962. After an interval of painting Deshaies returned to printmaking, this time to large intaglio compositions employ-

114 DE KOONING, WILLEM (b. 1904), *Untitled,* 1960. Lithograph, 45^{15}⁄$_{16}$ × 31^{13}⁄$_{16}$
(116.6×80.7). Photo courtesy Brooke Alexander, Inc., New York.

115 DESHAIES, ARTHUR (b. 1920), *Cycle of a Large Sea. Unbeing Myself, January 24, 1961*, 1962. Plaster relief engraving, 54×36¾ (137.1×93.3). Collection, The Brooklyn Museum.

ing the fleeting subjects of Pop art to which he added more erotic symbols. The graphic work of Arthur Deshaies from his early stencil prints, his work in acrylic and metal plates and plaster molds is characterized by inventiveness, skill, and liveliness. It reflects the diversity that prevailed in American prints during the 1950s and '60s.

The influences of the original Abstract Expressionists are continued in the paintings and prints of Helen Frankenthaler, Grace Hartigan, and Joan Mitchell. Frankenthaler has consistently explored the possibilities of the print media in the furtherance of her particular imagery. Her first venture into prints was in 1960 at Tatyana Grosman's graphic workshop, where she experimented with the subtleties of lithographic washes. Somewhat later she completed a group of aquatints with etching and drypoint.

Among these was the colorful *Pompeii,* printed and published by Donn Steward at Halesite, New York, in 1976. The following year Frankenthaler worked in the unlikely medium of the woodcut in color at Tyler Graphics, where she issued a seven-color woodcut entitled *Essence Mulberry,* printed on buff-color Japan paper whose random texture was incorporated into the total design.

Other approaches to the implementation of clear, intense colors in abstract imagery are to be noted in the lithographs of Paul Jenkins and in the intaglio prints of Elaine Breiger and the large screen prints of Norio Azuma. Large curtains of color flood the prints of Paul Jenkins. The intaglio works of Elaine Breiger are fashioned from many smaller plates that make up the total composition in deft blendings of colors. The final results are, in effect, printed collages of exceptional richness and variety.

THE CLASSIC PRESENCE OF NATURE AND THE HUMAN FIGURE

The artists whose innovative ideas and images characterized much of the graphic work of the 1950s continued their work throughout the next two decades. Sustained by a knowledgeable sense of traditional values and a mastery of their métier, their prints maintain stability and quality in a time when startling change, new symbols, and artificially established prices are fashionable. Often a "famous" signature on a large print brings status rather than aesthetic enjoyment to the owner or collector. It is of interest to note that the traditional print has held a steady value in the marketplace as well as among collectors. Among these earlier innovators are Gabor Peterdi, Karl Schrag, Mauricio Lasansky, Misch Kohn, Will Barnet, and Seong Moy.

The images and ideas presented in Peterdi's prints of the 1960s (for earlier works see pp. 98–101) are the result of travels in the western United States and in Alaska, where he flew with a native bush pilot over the Arctic Circle, and, later still, a journey through the Hawaiian Islands. They constitute the artist's response to new facets of landscape—landscape locked within the cold tensions of glacial ice and wind-

blown snows or in the contrasting luxurious growth in tropical lands. The imposing theme of many landscapes and their philosophical implications occupy the thoughts and creative energies of Gabor Peterdi. (See color illustration no. 13.) His prints have brought a refreshing sensibility to the modern print in the United States.

Beginning in the 1960s Karl Schrag has added more than seventy-five prints to his already important oeuvre. (See p. 101.) Occasionally he has turned to portraiture. His subjects have been members of his family, his friends, and also the artist himself. He has approached these compositions in much the same manner as his landscapes, seeking to go beyond the general appearances and to capture the essences of character. He has sought to indicate a special mood and, through color, line, and textures, has given a visual summation of those essential elements that distinguish and make unique a particular character. Notable are *Self Portrait with a Burning Match,* completed in 1969, and *Portrait of Bernard Malamud* a year later. (See color illustration no. 15.) Both portraits are in pure aquatint. In the latter the composi-

116 HARTIGAN, GRACE (b. 1922), *Untitled,* 1961. Lithograph, 20×14 (50.8×35.6).
Collection, New York Public Library.

117 AZUMA, NORIO (b. 1928), *Image of a City,* 1962. Screen print, 24×17¾ (61×45).
Collection, The Brooklyn Museum.

118 SCHRAG, KARL (b. 1912), *Silence Above the Storm*, 1964. Etching, aquatint,
24×15 (61×38). Private collection.

119 BARNET, WILL (b. 1911), *Waiting,* 1976. Lithograph and screen print, 34×33
(86.4×83.8). Photo courtesy the Artist.

tion is built up in soft yet pulsating colors. Broad areas of yellow, blue, orange, and a greenish-tone black are placed against a glowing red background. The entire work is bathed in a shimmering luminosity. Here, as in his landscapes, the masses of bright color not only provoke surprise and accentuate the intensity of the work, they also soften or mute the smaller areas to give a heightened sense of mystery and uniqueness to the character of the sitter or to a particular landscape.

The prints of Mauricio Lasansky have remained firmly within the figurative tradition. Very large in scale and involving intricate techniques of the intaglio process, his prints chart the progression of his life and that of his family. The small ironies of life as well as its grave problems hold his attention. (His earlier work is discussed on pp. 101–2.) During the first half of the 1960s Lasansky was greatly preoccupied with the development of a long series of life-size drawings that he designated as *The Nazi Drawings.* Some of the images had their roots in his earlier prints. The artist's intent was to record in unforgettable and unrelenting images the inhumanity and violence that is still possible in the twentieth century. Perhaps as a relief from the tensions and stabbing imagery of these drawings Lasansky also issued a number of prints of a different order. Their titles suggest a distant and possibly more peaceful culture. Strong blacks and bright colors now encompass broken or fragmented forms, as may be observed in the large intaglio *Quetzalcoatl* of 1972 as well as in the artist's composition *Young Nahua Dancer,* completed in 1973 after nearly a dozen years of work. (See color illustration no. 16.) The fifty-four plates required in the final orchestration of the work are a measure of the tenacity and completeness of Lasansky's vision and his command of his highly technical medium.

A new departure marks the graphic work of Misch Kohn in the later 1960s and is apparent in the intaglio-collage in color issued in 1968. In the present decade Misch Kohn has developed an imagery that is almost entirely abstract. His technical virtuosity and his imaginative use of materials have given diversity to his work. He fabricates his own papers, often utilizing discarded trial proofs from earlier editions. A single composition may include engraving, aquatint,

woodcut, and chine colle. Symbols and calligraphic notations used in earlier prints (pp. 86, 91), wine labels, letters and fragments, old prints and personal memorabilia have been incorporated into this later work. Clear, rich colors give an added coherence to the lively turmoil of images. Kohn's amusingly titled etching with chine colle, *Blow Up Your Balloon and Tie with E,* and his *Construction with F,* issued in 1977, are splendid examples of his recent prints.[13] (See color illustration no. 17.)

Will Barnet continued his abstract works in both the woodcut and the intaglio medium (see pp. 82–83) with equal success. His woodcut *Singular Image* of 1964 (see color illustration no. 18) and his two aquatints of 1967 related to the totemic symbols of the Northwest Coast Indians are entitled *Big Grey* and *Compression—Spokane.* Their simplicity and power record Barnet's response to the landscape of the Northwest and its early Indian inhabitants. His later large-scale figurative prints in silhouetted forms and dark colors are often set against a geometric background. Appearing in the later 1960s, these highly stylized compositions are a fusion of his long interest in the genre work of the late eighteenth- and nineteenth-century itinerant painters and his own abstract images mentioned above. Issued in lithography, aquatint, and screen printing, they demonstrate his knowledge of the media of the modern print.

The spiraling forms and calligraphic elements prominent in early woodcuts of Seong Moy (see pp. 83, 86) have gradually been submerged into simplified and contemplative abstract images in muted colors. This change in style appears in his large color relief prints and in his acrylic collages on canvas during the past two decades. A singularly contemplative mood prevails in the subtle imagery of *Black Stone and Red Pebble,* a relief print issued in 1972 (see color illustration no. 19), and in a number of other compositions of the later 1970s. In these tempered graphic works Seong Moy brings together the elusive elements of an eastern heritage and the directness of a contemporary abstract vision.

In the summer of 1978 Schanker again returned to woodcuts in a series of very large prints often printed

in as many as ten colors. These late works are composed of intricately cut curved shapes printed in black which are combined with other flat abstract forms in a surging array of clear, high-keyed colors. These large compositions are achieved in a single printing, the entire operation being carried out by the artist. The graphic oeuvre of Louis Schanker (see also p. 82), with its bold, forthright images and its range of color nuances, lucidly documents the versatility of the twentieth-century relief print and the imaginative utilization of a printing technique.

Artists who have widely different geographic backgrounds have worked in the figurative tradition. Their major prints appear in the 1960s and continue into the following decade. Their independent search for meaningful images that mirror their ideas and experiences form a telling counterpart to Abstract Expressionism and to the styles of Pop and Op prints. Many of the artists working in the figurative tradition saw foreign military service and later spent a year or more in Europe or in the Orient on grants made available through federal or private funds. Prints are a well-established part of their total creative oeuvre. Representative of those artists in the New York area are the intaglio prints of Chaim Koppelman, Gerson Leiber, and Al Blaustein.

Chaim Koppelman has issued prints of figures within a larger landscape. However, his compassionate concern with social change, war and its effect on ordinary human beings soon becomes uppermost in the delineation of his work. It is as a moralist and a partisan for peace that he makes his most eloquent visual statements. He is not deterred from tough-minded appraisals of the destructive consequences of war and of political experiences. He has harnessed his skills and his unblinking imagery to the troubled, often controversial problems of our times. Among his large graphic oeuvre is *Retired Napoleons*, 1965, in which the surface of the paper is cut to reveal three identical faces, and a later embossed intaglio, *Murdered, Vietnam*, 1968. Koppelman is not alone in his visual and partisan demands for humanistic values; nevertheless, he is one of the most eloquent. His fine draftsmanship is, also, to be noted in his 1970 aquatint, *Homage to Degas*.

The intaglio prints of Gerson Leiber, a prolific artist, register an entirely different approach. New York is his microcosm, and he views it with perceptive vision and irony tinged with geniality. The vastness of the city panorama and its tides of humanity are caught in sharp vignettes. They are keenly observed and set down in graphic statements whose greatest impact is made through a warm detachment and an understatement of compelling facts. The sustained caliber of his etchings is to be noted in *The Beach*, 1965, and *Pigeon Woman*, 1971, both etchings.

Al Blaustein, born in New York City in 1924, is a painter and printmaker who has also worked in sculpture. He studied at Cooper Union and later worked with Gabor Peterdi at the Yale Summer School of Art at Norfolk, Connecticut. The recipient of many scholarships, he has traveled extensively in Europe, Africa, Japan, and India. Blaustein's interest in people and their various modes of life is reflected in his drawings, which constitute the basis of his etchings. In his intaglio work, Blaustein is concerned chiefly with western ideas and subjects. An introspective mood prevails in *The Recluse*, issued in 1958. Thoughtful but strange fantasies lurk in the depths of *The Music Room* and in *Faigele*. Often preoccupied with problems of society, this artist turns his attention to figurative works that express individual disquietudes and occasional enchantments.

Dean Meeker has issued both intaglio and screen prints of note. (See p. 155.) Although born in Colorado, he has lived mostly in the Middle West. Since 1946 he has taught painting, drawing, and printmaking at the University of Wisconsin, where he holds a professorship. As an artist, his recurring interest has been in historic and mythological subjects. He remarks:

"The Hero, Icarus, Genghis Khan all are out of the fabric that stimulates the detachment and transfiguration necessary to the creative impulse. The Hero and his typical metamorphosis, separation, initiation, return, his love of fate that is inevitably death, is vital to my own feeling. Ultimately one reshapes these impulses and retells a story that is not mythological or literary but graphic, with symbols that may or may not communicate depending on the frame of ref-

120 LEIBER, GERSON (b. 1921), *The Beach*, 1965. Etching, 21½×27¾ (54.7×70.5).
Collection, The Brooklyn Museum.

121 MEEKER, DEAN (b. 1920), *Genghis Khan,* 1962. Collagraph, screen print, 27¾×17¾ (70.4×45). Collection, The Brooklyn Museum.

23 FRANCIS, SAM (b. 1923), *Untitled,* 1978. Lithograph, 38 1/3 x 26 (97.5 x 71.1).
Photo courtesy Brooke Alexander, Inc., New York.

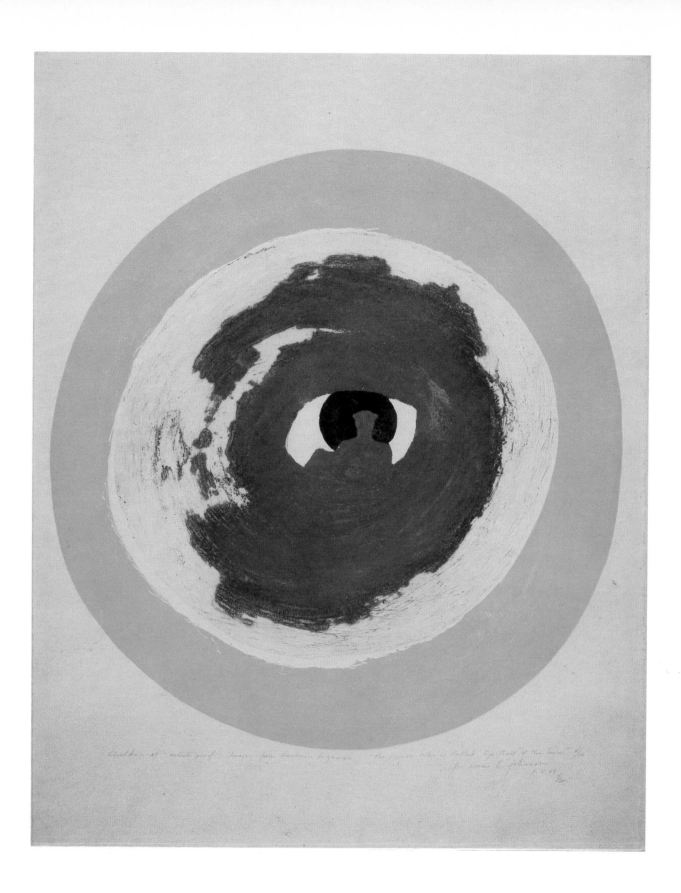

24 CHILDS, BERNARD (b. 1910), *Eyeball of the Sun* from *Images from Hawaiian Legends,*
1968. Intaglio-collagraph, 19 1/2 x 18 5/8 (49 x 47). Private collection.

25 LONGO, VINCENT (b. 1923), *Untitled,* 1976. Aquatint, 14 x 12 (35.6 x 30.5). Photo courtesy The Brooklyn Museum.

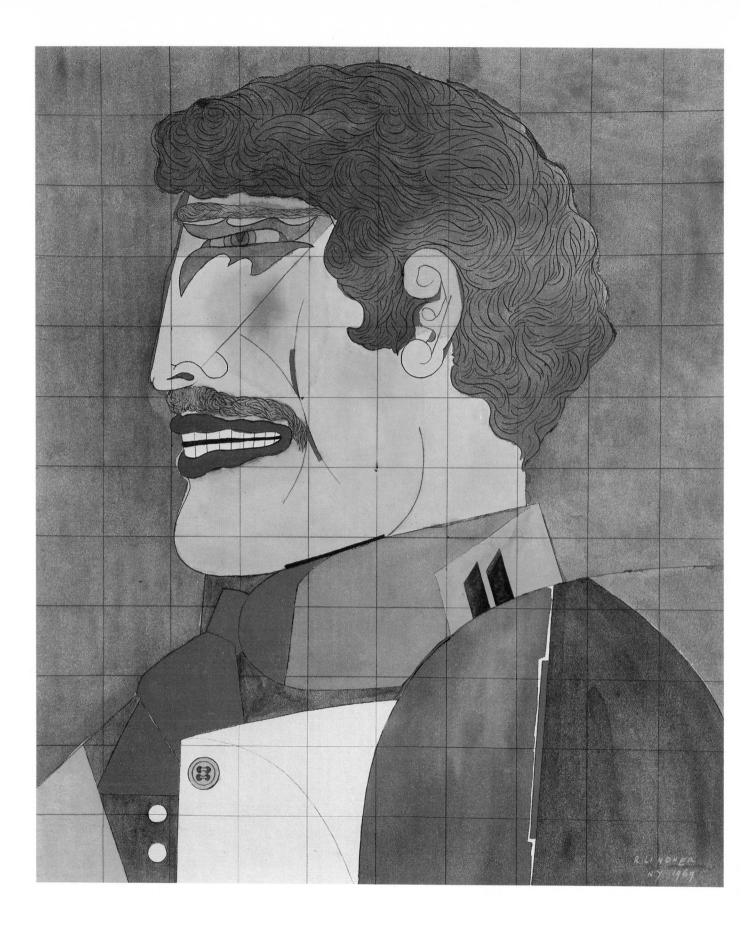

26 LINDNER, RICHARD (1901–1978), *Profile* from series *Afternoon*. Lithograph, 24 x 19 7/8 (61 x 49.8). Photo courtesy Shorewood Publishers.

27 POND, CLAYTON (b. 1941), *Doubledoozium cum Skinnionic et Scrawlium* from series
Capital Ideas, 1974. Screen print, 37 x 29 (94 x 73.5). Photo courtesy the Artist.

28 UCHIMA, ANSEI (b. 1921), *Light Mirror, Water Mirror,* 1977. Woodcut, 18 1/4 x 28
(46.4 x 71). Photo courtesy the Artist.

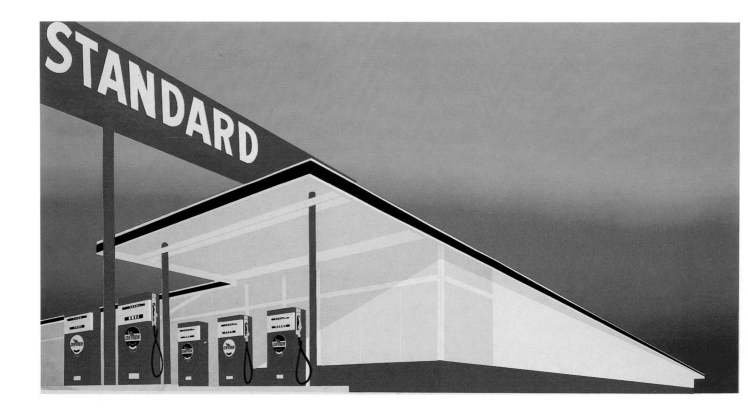

29 RUSCHA, EDWARD (b. 1937), *Standard Station,* 1966. Screen print, 25 3/4 x 40 1/8
(65.4 x 101.9). Photo courtesy Brooke Alexander, Inc., New York.

erence of the viewer and the success of my statement."[14]

Meeker's work reflects a number of technical developments in printmaking, including a lightweight press capable of great pressures in printing and aluminum plates built up in relief with a plastic and marble aggregate base called polymar. These collagraph plates are printed with a skillful manipulation of various hard and soft rollers. He may use and control multiple colors that carry a three-dimensional quality, as noted in *Tower of Babel* and in *Houdini,* 1968. Recently he has turned to sculpture, working in bronze and marble.

Yet another diversification of the figurative tradition is to be seen in the prints of Warrington Colescott and James McGarrell. Their subjects are woven into complex intricate patterns which are employed as flashbacks or subtle restatements of underlying themes.

Colescott first received recognition for his screen prints. However, after studies with Anthony Gross at the Slade School in London, he found that the etched line served his purpose in achieving what was more conducive to the swift movement and abrupt tensions that he wished to maintain in his compositions. Colescott takes topical subjects of present interest and through a churning movement of the figures achieves a staccato-like graphic reporting. He may utilize a comic strip technique with its harsh play of colors spotlighting the story. These syncopated rhythms are carried out in a combination of intaglio and screen printing and accent the chain of events that conclude the specific drama.

In the etchings and lithographs of James McGarrell, the figure is literally interwoven within a textured composition. The observer is taken through a private world held together in an unobtrusive chain of related vignettes. No sharply accented lines and no disturbing forms guide or arrest this visual journey. Nevertheless, it is the figure, whether casually seated or standing, that becomes the focal point of the composition. McGarrell was among the early recipients of an Artist fellowship at Tamarind in 1962. Of special interest are his prints that were issued in the 1950s and '60s.

Malcolm Myers, painter and printmaker, studied with Hayter at Atelier 17 in New York and later with Lasansky at the University of Iowa. After travels abroad, he developed a well-known graphic workshop at the University of Minnesota. His own graphic work, mostly in intaglio, is tempered by a genial and often whimsical approach to his subjects. His *Improvisation on the Night Watch* and his *Yellow Cannon,* 1962, are amusing and audacious reflections on prints of Rembrandt and Dürer. His color and subjects may have little to do with the original themes they so clearly parody, nevertheless their low-keyed presentation holds one's attention. The artist's intaglio in color entitled *Fox in Costume,* 1967, is a fine example of his work.

Robert Broner began exhibiting his intaglio prints in the mid-1950s after several years of study with Hayter at Atelier 17 and work in painting with Stuart Davis in New York. His early prints are composed of large frieze-like and semiabstract figures in textured colors. Later his images became entirely abstract. He was among the first to experiment with metal collage prints based on his knowledge of small electronic circuits and his sense of their functional motifs. The blending of specific technological components and other abandoned metal materials resulted in printed compositions of unusual variety. Recently he has concentrated on the graphic aspects of the human eye presented as two identical images, a phenomenon that does not exist in reality. In Broner's prints these larger-than-life images assume a romantic and arresting symbolic significance. This new visual approach has led the artist to work in lithography with supporting photographic aids that make the identical double image possible. To the sensitized lithographic plates the artist has added other lines and suggested forms to accent the original photo-image and to achieve a hypnotic and masklike effect. As an imaginative innovator and experimenter in graphic images Broner, throughout his career, has brought a lively inventiveness to the vocabulary of the modern print.

A distinguished West Coast artist, Richard Diebenkorn has worked in the manner of the Abstract Expressionists. With admirable sensitivity he has at-

tempted to reconcile recognizable and abstract forms into a personal idiom. In his lithographs and etchings he has maintained a representational or figurative point of view. Perhaps no other artist in the United States today has delineated the figure in the fine tradition of Matisse with more conviction than has Diebenkorn. He has found it unnecessary to break with this tradition; nonetheless his compositions bear the stamp of a later time. Clothed or nude figures are convincingly set down in graphic statements that need no further embellishments to attract or hold the attention of the viewer. His figures are conceived not as individual characters with specific gestures or features but as a universal expression of the figure itself. In 1961 Diebenkorn worked at Tamarind, where he composed both figurative and landscape compositions in strong, direct lines and soft-toned lithographic washes. In 1965, working with professional printers at Crown Point Press, he issued a notable figurative series of forty-one etchings and drypoints. Twelve years later, again working at Crown Point Press, Diebenkorn issued his latest series of nine etchings and drypoints published by Parasol Press in 1978.

Rico Lebrun returned to lithography (see p. 102) in 1961 on an Artist fellowship at the Tamarind Lithography Workshop. This medium well suited his vigorous draftsmanship. In 1963 his *Drawings for Dante's Inferno*, containing seven original lithographs, was published by Kanthos Press. His death the following year brought to a close the career of an artist whose somber but powerful images often served as a bridge that combined the human currents underlying modern and renaissance times. His lithographs in black and white and in dark colors chart the vision of an artist who with compassion and concern records man's proclivity for living in spite of himself.

The figurative works of Romare Bearden is deeply rooted in the mores of black Americans. His knowledge and understanding of their lyrical spirit and also their frustrations have brought to his collages and prints a finely tuned sense of "the feelings and emotions that are common to all humanity." Born in North Carolina in 1914, Romare Bearden studied at New York University and at the Art Students League with George Grosz in 1936–37. In the 1940s he served intermittently as a case worker for the New York City Department of Social Services, during which time he also exhibited his paintings. After a year in Paris he returned to New York in 1951 to concentrate on the composing of popular songs, many of which were published. He resumed his preferred career as a painter in 1954 and worked in an abstract idiom. Some six years later he reintroduced figurative elements into his compositions and began extensive work in collage and in lithography and screen printing. His collages were exhibited at the Museum of Modern Art in New York in 1971 where they received well-deserved acclaim. His prints, rich in color and complicated in design, convincingly present his particular theme of "the prevalence of ritual" as "the choreography of daily life."

The direct immediacy of Expressionism is to be noted in the prints of Jacob Landau. His work adheres to the figurative tradition and reflects his concern with social issues. His figures are held within a whirling pivot or exist under the crush of an impending catastrophe. Landau's prints, however, are not visions of despair but symbols of the survival qualities of human life. Landau represents a company of artists whose work acknowledges the influences of Ben Shahn and Shahn's sense of man and his work. Landau's early prints are woodcuts, although much of his present work is in lithography.

Landscape

A persistent interest in landscape or the natural environment has survived in the United States since the time of the early almanacs when modest woodcut vignettes signaled the changing seasons. In the nineteenth century the landscape print often carried a small, romantic figure that served as an implied unit of measurement for the grand scale and mystery of a specific landscape or panorama. In the twentieth century the landscape itself became the sole element of the composition. In succeeding decades artists have held to the long tradition of interpreting nature through the cultivation of a contemplative vision and the ability to impart that vision to a perceptive viewer. This personal vision has been noted in the intaglio prints of Gabor Peterdi, Karl Schrag, and John Paul Jones; in the woodcuts and lithographs of Adja

122 MYERS, MALCOLM (b. 1917), *Fox in Costume,* 1967. Mixed media, 36×23¾
(91.4×60.3). Collection, The Brooklyn Museum, Frederick E. Loeser Fund.

123 DIEBENKORN, RICHARD (b. 1922), *Plate No. 3* from *41 Etchings and Drypoints*, 1965. Soft ground etching, $9\frac{5}{8} \times 7\frac{1}{8}$ (24.5×18). Photo courtesy Martha Jackson Gallery.

124 BEARDEN, ROMARE (b. 1914), *Prevalence of Ritual,* 1974–75. Screen print, 36×29
(91.5×73.8). Photo courtesy Associated American Artists, Inc.

Yunkers and in the plaster-relief prints of Arthur Deshaies. It is present in the large woodcuts, lithographs, and screen prints of Carol Summers, whose prints of the 1960s bring a heightened sense of color and simplified forms to imposing landscapes. Among his well-known compositions are the woodcuts *Rajasthan,* 1967 (see color illustration no. 20), and *Road to Ketchikan* of 1976. Other important examples are to be found in the graphic oeuvre of Peter Takal, Harold Altman, Rudy Pozzatti, Moishe Smith, Beth van Hoesen, Richard Ziemann, Arthur Secunda, Robert Bero, Sidney Goodman, Robert Kipniss, and a few other artists.

Peter Takal, born in Bucharest, Romania, in 1905, received his formal education in Paris and Berlin. After an early career in the theater he decided to become an artist. At the suggestion and encouragement of an artist friend he attended several art academies in Paris but considers himself to be self-taught. The thrust of his work remains within the European tradition with influences of Segonzac and also the Surrealists, especially Yves Tanguy. He first exhibited his drawings in the United States at the Katharine Kuh Gallery in Chicago in 1937. In 1939 he came to live in the United States. Since that time Takal has traveled throughout the United States and Mexico with extended sojourns in Spain. He began working in etching and engraving in the early 1950s. He remarks that for him "the train of imagination travels on the rails of lines." His major etchings, engravings, and lithographs celebrate the less spectacular landscapes and the more intimate views of nature. His figures and portraits are composed through the minimal use of direct and meaningful lines. His etching *Harvest Field,* 1960, is a lyrical interpretation of a universal landscape while his large etching *Growth,* issued in the same year, holds within its fragile web of lines brief suggestions of Surrealism. The artist, working at Hollanders Workshop in 1969, produced a number of large-scale compositions and extended into lithography the fluency of his linear landscapes.

Harold Altman subscribes to the traditional use of the short-stroked etching line and its attendant cross hatchings. This manner of working formed the basis for his early Impressionist landscapes. Occasionally, lightly designated figures on sticklike legs move through such landscapes as in a dream. Their seeming remoteness arrests the eye and accents the sweep of the landscape itself. The artist avoids the drama of a spectacular landscape and instead emphasizes the quiet rhythms and measured changes of more intimate views. His recent and long-continuing series depicting in detail the parks of Paris exemplifies this point of view. In Altman's large graphic oeuvre perhaps his earlier work best records his fine talents.

More varied in their total effect, Rudy Pozzatti's prints capture the familiar forms and changing moods of Italian architecture. The soaring curves of the great domes and the maze of arches are characteristic of his early work and reflect the influences of a long sojourn in Italy. In later etchings he has combined architectural forms and the figure in a series of half-length portrait panels or friezes. Pozzatti well understands the media of the fine print and since 1948 has issued some two hundred individual works. Among his most distinguished prints are the woodcut *Venetian Sun,* a landscape of 1954, and an etching entitled *Baptistry,* issued in 1964.

Beth van Hoesen has worked almost exclusively in graphic art since 1956. Her landscape and figurative compositions are composed with a splendid clarity of vision. The richly refined lines that characterize her prints, including etching, drypoint, engraving, and roulette, are accomplished with an unerring draftsmanship. Her large drypoints of the early 1960s include the landscape *Black Hill* and a figure study entitled *Nap.* Issued in small editions, they were printed at Crown Point Press. Beth van Hoesen was born in Idaho and studied in Mexico at the Escuela Esmeralde and in Paris at the Académie de la Chaumière. Most of her professional life has been spent in the San Francisco area.

The intaglio prints of Moishe Smith attest to his major interest in landscape compositions. A series of large landscapes entitled *The Four Seasons,* issued in 1958, is well known. Since that time he has found inspiration in the Italian countryside, which he delineates with traditional romanticism.

For Richard Ziemann the vision of a "pure landscape" has governed his serious work in prints since

125 ALTMAN, HAROLD (b. 1924), *Luxembourg November,* 1965. Lithograph, 14⅜ × 17 (37.5 × 43.3). Photo courtesy Associated American Artists, Inc.

126 VAN HOESEN, BETH (b. 1926), *Nap,* 1961. Drypoint, 17½×19¼ (44.3×49).
Collection, The Brooklyn Museum, Dick S. Ramsay Fund.

the later 1950s. His large-scale prints, approximately thirty by forty inches in size, are etched and engraved directly on the plate in the particular landscape itself. These individual visual essays are developed slowly over a period of several years but retain freshness and spontaneity. The shifting patterns and subtle tonalities of landscape are deftly orchestrated and give unity to his work. His poetic vision and his classic handling of his medium are fully evident in his giant triptych whose overall width is nearly ninety inches. Entitled *Back Woods,* it was completed during a five-year period from 1971 to 1976.

Arthur Secunda, a painter and printmaker, regularly makes extended visits to European countries where his work has often been exhibited. Known for his earlier Expressionist paintings, he has done extensive work in lithography, intaglio, and screen printing. He has ignored traditional technical restrictions by integrating collage, photography, and a variety of oxidizing textural washes applied to zinc lithographic plates. An early print, *Looters,* caught the revolutionary atmosphere of the Haight-Ashbury region of San Francisco, as did his *Easy Riders,* a lithograph composed and printed at Tamarind Institute in Albuquerque, New Mexico, in 1972. A few years later, returning from Provence where he lived near the outskirts of Arles, Secunda issued a large screen print entitled *The Road to Arles,* 1976. (See color illus-

tration no. 21.) The particular qualities of light and the shadows along a tree-lined road leading from Arles to Tarascon captured his interest. It led him to assemble a collage, triangular in shape, and filled with stripes of soft colors. Later this formed the basis for his screen print of the same title. The torn, ragged edges of the papers in the collage were carried over into the print, but now a fine undulating white line accented the rich colors of the abstract image. This complicated print of nineteen separate runs of opaque and transparent colors with three glazes of blues and two overprintings of black required more than half a year of work by the artist and the master printer Jeff Wasserman. Secunda views it as a symbolic homage to Van Gogh, who had known the roads leading to Arles.

Further variations in landscape are seen in the prints of Robert Bero, Sidney Goodman, and Robert Kipniss. Bero's large woodcuts and linoleum cuts often record in bold and strongly patterned images the lakes and bleak flatlands of northern New York State. Sidney Goodman envisions, in his accomplished etchings, the clearly divided progressions of a landscape where each rectangular section forms a new layer of perception and reinforces the total composition. In contrast, the airless landscapes of Robert Kipniss are frozen visions where neither color nor images disturb the artist's composition.

OTHER INDEPENDENTS AND THEIR PRINTS

There remains a large and distinguished company of American artists who consistently have pursued their particular ideas and images in a marked diversity of idioms. With a few exceptions their first or major prints appear in the 1960s. Their ages range from that of Mark Tobey, born in 1890, to a younger generation born in the 1920s and '30s. Their contributions to the growth of the twentieth-century print in the United States are often unacknowledged or ignored.

Mark Tobey, who traveled in China and Japan in

1934, was among the first American artists to seriously study eastern art and its governing philosophies. He was seeking an inner vision that would encompass a more universal point of view. He studied eastern landscape painting and at Zen monasteries he explored the art of calligraphy and its forceful rhythms. On his return Tobey sought to visualize in his own paintings a magic web of tangled lines and elusive images. Their inner rhythms and colors became visual canticles that celebrate an expanding universe.

In 1961, at the age of seventy-one, Tobey began a

127 TOBEY, MARK (1890–1976), *Trio from Suite Transition,* 1970. Aquatint, 12½ × 10½ (31.8 × 26.7). Photo courtesy Martha Jackson Gallery.

long series of monotypes and lithographs. He had settled in Basel, Switzerland, and was having a retrospective exhibition of his work at the Musée des Arts Décoratifs in Paris. He found near his quarters several discarded sheets of Styrofoam packing materials. Their texture and lightness of weight intrigued Tobey and he carried them to his studio. Instead of using the traditional sheet of glass as the carrying surface for his monotypes he painted in watercolor on the clear surface of the Styrofoam sheets. The printed result of the fine-grained texture and his own images of layered lines brought a new sensibility to his graphic works. They were first exhibited at the Jeanne Bucher Galleries in Paris in 1965. His monotypes, numbering more than a hundred, vary in scale from that of a large sketch pad to a modest-size envelope. Whatever their size, their lines and luminous images chart a meditative journey through time and space. Tobey's microscopic scenes and their running scripts of small images become a deft and orderly cosmos. He enjoys and has often found inspiration in the concentrated activities of a public marketplace. Its continuous movement, its changing patterns of colors, and its linear accents become a small throbbing universe. Tobey's prints covering the 1960s are the visual musings of an artist who remains a romantic visionary and, as Janet Flanner earlier described him, a "mystique errant."[15]

A notable exception is to be found in the prints of Isabel Bishop, for her graphic work first appeared in the 1920s. (See pp. 46, 51.) The realistic details of her earlier genre figures are supplanted, in the 1960s, by a large single figure or by groups of walking figures who are aloof, even remote, from the stream of humanity but who are most definitely "going somewhere."[16] The artist's concern is with the motion and mobility of such figures, each enveloped in his own private world, as they emerge from the subway or office building. In some of her later etchings Isabel Bishop has employed patches of aquatint to separate the many figures and to give depth and fluidity to the entire composition. These persuasive graphic statements sensitively refine the non-activist vision that envelops many of the prints and paintings of the past two decades.

Isabel Bishop is perhaps a perfectionist. No gesture or mood is left unnoticed. Her discerning eye has been trained through years of observation and is free of sentimentality, seeking what might be termed the special aura of an individual character or scene. All her graphic works, whether in prints or in drawings, are conceived as disciplines for her paintings. Isabel Bishop has affirmed:

> "Yes, I am ambitious. Not for fame nor for money, but to make a positive contribution to American twentieth-century art."[17]

With pencil, brush, or etching tool, Isabel Bishop always seeks to delineate the special aura of forms in space—forms touched with the illusive magic of glowing light.

In the 1950s Garo Antreasian began composing very large lithographs in color during the time he was teaching at the John Herron Art Institute in Indianapolis. He had studied printmaking with Will Barnet and with Hayter at Atelier 17 in New York. In 1960 he became technical director at Tamarind Lithography Workshop and later was joint author with Clinton Adams of a definitive work on lithography entitled *The Tamarind Book of Lithography*. In 1965 Antreasian completed his very large abstract lithograph *New Mexico I* at the Tamarind shop. Printed in warm earth colors, it also carried an unusual band of embossment punctuated by a fine white line. Only the essence of landscape and a few symbolic images are contained in its highly abstract composition. The artist's *Quantum series* of 1967 and the *Octet Suite* of 1969 record his ability to obtain and control a great range of colors within a simple and unshadowed imagery. Ten years later, in 1978, Antreasian issued a two-part lithograph large in scale but with greatly subdued colors. This latest work is printed from aluminum plates with the images produced with gum stencils. The final composition required five runs through the press. In a discussion of this work, *Untitled, 78.2—1 a and b*, (see color illustration no. 22) the artist observes that

> "scale and large size have always been important in providing presence and projection in my work. I am less interested in the elaborate techniques of lithography that I once employed and find increasingly that I am using the simplest means available to focus the attention on the dynamics of the forms rather than on the surface

of the print. Throughout this recent work there appears a fragmentation of the forms, originally around the outer edges and more recently (as in this example) there is internal disintegration of the image . . .”[18]

Antreasian's refinements of color and his ability to free lithography from the descriptive role of images on a background have given distinction to the lithograph in color.

Aside from developing and administrating the Tamarind Lithography Workshop (see pp. 169ff.), June Wayne has found time to complete a number of her own prints in black and white and in color. In 1965 she issued the lithograph *At Last a Thousand* and in 1970 *Burning Helix* and the *Genetic Code* series. Her recent work entitled *Stellar Winds* was issued in 1978 wherein the artist seeks to visualize some of the vast energies of the universe. This series is based on the magnification of special details from an earlier lithograph, *Silent Winds*. Utilizing the optical effects of webs of patterned color, June Wayne has created unexpected symbols within a varied color field. The entire sweep of the series establishes an enigmatic point of view whose narrative symbols intentionally are obscure. The *Stellar Winds* series has been printed in the artist's studio by the master printer Edward Hamilton and is one of the artist's most knowledgeable graphic achievements.

Sam Francis was a well-established painter and world traveler before he turned to printmaking. Although he had first exhibited his paintings in his native California, the major exhibitions of his earlier work had been held in Europe. It was in Paris, in the summer of 1960, after an extended second trip around the world, that Francis issued early lithographs in the studio of Emil Matthieu.[19] This series of fifteen lithographs in color was published by Kornfeld and Klipstein in Switzerland, who also exhibited many of his subsequent works. After a long illness in Berne, Switzerland, Sam Francis returned to California to establish his studio at Santa Monica in 1962. From this vantage point he makes frequent journeys to Japan. In 1963 at the Tamarind Lithography Workshop he completed more than 100 lithographs in color.

First recognized in Europe and in Japan, the prints of Sam Francis are vast constellations of colors that ring the outer areas of fine white papers. Their aerial quality is sustained in webs of translucent primary colors held within a pulsating rhythm. Also in 1963 at the Joseph Press in Venice, California, Francis explored further reaches of color in a series of monotypes. This medium had a desired immediacy of form and color and also added the disciplines of its color sequences. Through 1969, Francis occasionally worked at Hollanders Workshop in New York and produced lithographs ranging from a few colors to as many as nineteen. Presently, the artist has his own print shop in his California studio with Histoshi Taketsuki as his printer. His color, now often in muted nuances of blues, grays, greens, with suggestions of yellow, is splashed over a basic composition of grids in a swirling density of images. (See color illustration no. 23.)

Another California painter, Nathan Oliviera, began work in lithography late in the 1950s. At Tamarind in 1963–64 he completed a series of symbolic heads whose disquieting images progressed to nearly abstract compositions. These large black and white lithographs were followed by a long series of sizable monotypes. Flooded with warm but muted colors, these abstract prints each contained a small, realistically rendered image whose origins were found in the American Indian culture. This unexpected accent required the eye of the viewer to make a sudden adjustment from abstraction to the presence of a realistic image. They demonstrate, in an unpredictable, somewhat teasing manner the artist's skill and his imaginative utilization of the monotype medium.

Bernard Childs, like Sam Francis, began serious work in prints in Paris. He had gone to Europe in 1951 to continue his career as a painter. In 1954 he began extensive experiments in the medium of the intaglio print. With characteristic thoroughness, Childs visited all the major printing shops that specialized in the intricate and sometimes secretive methods of intaglio printing in quest of methods and techniques of the modern print. He was not only interested in traditional processes but also hoped to develop other approaches and, if need be, new tools. His goal was to create modern prints that would have the impact

128 Bishop, Isabel (b. 1902), *Little Nude,* 1964. Etching, aquatint, 5¾×5 (14.7×12.7).
Photo courtesy The Brooklyn Museum.

129 LONGO, VINCENT (b. 1923), *Temenos,* 1978. Etching, aquatint, 24×18 (61×45.9).
Photo courtesy the Artist.

of paintings. His understanding of color gained from years of painting, his knowledge of metals, and his dexterity in the use of tools soon led him to new approaches in the field of creative printmaking.

He was among the first to employ machinist's power tools exclusively in the fashioning of his metal plates. Under his hand, power rotary burrs and drills feather the surface of a metal plate with all the velvety textures of the traditional aquatint and incise a line as deft as that produced by a hand graver. In 1960, Childs completed a series of twelve prints which he titled *Book of Months.* Because of the highly demanding printing procedures and the artist's insistence on a perfect impression, a small edition of twelve was pulled. However, in 1964, he issued a second edition of twelve prints which are of equal quality.

In 1966, after fifteen years in Paris and an extended journey around the world, Childs returned to the United States to establish artist's quarters in New York. Since 1968 he has been employing a new kind of plate that combines his own direct engraving and allows the utilization of high-speed presses. He remarks that this new plate may be used on the traditional hand-manipulated etching press or on the great power presses normally employed in high-speed commercial printing. His large print *Eyeball of the Sun,* 1968, one of a series, *Images from Hawaiian Legends,* is engraved on these new plates. However, this series was printed by the artist on his own etching press. (See color illustration no. 24.)

For Childs there are two separate arts in the realm of the original print—etching or engraving the plate and the printing of that plate. He is among those artists who continue to carry out the entire process of the print from the creation of the image on the plate to the last pull of the edition. He considers his old French press an instrument of re-creation rather than a reproductive machine. All colors in Childs's prints are applied to a single plate in one operation. An expert and tireless printer, the artist produces editions with only slight variations. The editions are, however, sometimes no more than five impressions and seldom more than fifteen. Through his craftsmanship and his concern for the unlimited possibilities of the printed image, Childs's own visual vocabulary is easily recognized in his carefully ordered compositions.

Built with the knowledgeable orchestration of jewel-like colors and subtle linear tensions under a technical mastery of infinite variety and purpose, his intaglio prints blend elements of the contemporary milieu with a very personal imagery. They record the reflections of an artist skilled but not lost in the techniques of his métier.[20]

The major part of Vincent Longo's graphic work appears in the past two decades and records his steadfast development of the abstract image through a strict limitation of basic forms. Longo had studied painting at Cooper Union in New York and in Europe, where he held a Fulbright fellowship. In the later 1950s he began intensive work in printmaking, acquiring a full understanding and command of the relief and the intaglio processes. He chose to elaborate the abstract image through the circle, the square, diagonal lines and their corresponding grids. (See color illustration no. 25.) The artist works directly on his plate or block without preliminary sketches or elaborate notations. Observing the strict formality and simplicity of his restricted idiom, Longo is able to create a sense of freedom, ease, and spontaneity in his prints. His compositions are rich in visual nuances and in finely tuned patterns of a superior order. This is amply demonstrated in his etching entitled *Other Side,* 1967, in the etching and aquatint *Broken Lattice* of 1969 and his more complicated etching with aquatint and brush bite entitled *Temenos,* issued in 1978. Longo's prints make no concession to an inconclusive vision or a superficially held sensibility. Their conceptual undertones, consistent clarity, and seemingly unstudied images bring a personal point of view to present-day prints.

Michael Mazur's first ventures in printmaking were woodcuts and engravings which he made in the early 1960s with Leonard Baskin as his mentor. Shortly thereafter he studied with Peterdi at Yale, where he was also "very much aware of the aesthetic struggle between expressionist-romantic Rico Lebrun and precisionist-romantic Josef Albers." During a period of teaching at the Rhode Island School of Design, Mazur and several of his students volunteered their services at the State Mental Hospital. This disturbing experience eventually led to some

sixty etchings and lithographs under the titles of *The Closed Ward* and *Images from a Locked Ward*. Mazur rendered with superb draftsmanship, objectivity, and understanding the lost world of mentally disturbed persons who spend their lives in mental hospitals. The prints, stripped of any Expressionist bravura, unveil their hauntingly poignant themes of loneliness and despair. Figures detached or fragmented within varying planes of perspective are propelled by an unseen force, upraised hands reach for a ball or a universe that escapes them. Violence is held as a presence but remains inactive or arrested. Such concepts are measured against an all-embracing vision of humanity. Although Mazur completed the initial sketches in a brief period of time, the two series of prints with their larger and sometimes disturbing interpretation required some three years to complete.

In 1967–68, Mazur issued a portfolio of etchings and shaped plates entitled *The Artist and the Model* in which two silhouetted figures are juxtaposed in a seemingly static ballet. Later these same plates were utilized in a series of experimental monotypes which continued the imagery. In 1968, Mazur spent several months at Tamarind completing approximately thirty large lithographs under the general title of *Studio Views*. The two plaster figures which had served as models for the previous intaglio series are again present. However, in the lithographs the artist becomes the observer and the compositions are more complex. Perhaps they are a visual soliloquy of remembered figures, windows, and other familiar objects of the artist's studio which have been projected into a strange setting. This idea has been explored recently by Mazur in a skillfully composed etching in color simply designated as *Bench and Chair*, 1973. In lightly washed monotypes Mazur continues his studio series.

With the issuance of a large number of lithographs in the 1970s, Jacob Kainen returned to printmaking and to painting. He had served for a number of years as curator of prints and as consultant at the Smithsonian Institution in Washington, D.C. In 1971–73, working at the Landfall Press in Chicago, he completed a group of large-scale lithographs in color and in black and white. Abstract compositions, they are assured in their strongly stroked calligraphic statements and carry a glistening range of translucent washes.

The prints of Michael Biddle delineate his involvement in and admiration for the European tradition of engraving. His graphic work recalls the engravings of Marcantonio Raimondi and his sixteenth-century followers. Biddle's meticulously detailed renditions also acknowledge the stark imagery of the northern European masters. His portfolio of etchings entitled *Victims—Thirteen Images*, issued in 1973, contains richly interwoven fantasies that extol the varying symbols and imagery that had preoccupied the medieval artist. Biddle, like Paul Cadmus, several decades earlier, is concerned with complicated figurative compositions built up through engraved or etched lines. His prints reflect not only his interest in the tradition of engraving but also his concern with the continuing ills and problems of present-day society. Born in New York City in 1924, the artist received his formal education at Harvard and at the London School of Arts and Crafts, then continued his studies in Paris and Salzburg. His skilled draftsmanship is amply evident in all his graphic work.

Fritz Scholder is a pioneer in the development of the new American Indian painting whose prints as well as paintings have received international attention. Born in Breckenridge, Minnesota, in 1927, he holds degrees from Sacramento State College in California and from the University of New Mexico. A student of Wayne Thiebaud, he was also influenced by the paintings of Francis Bacon. In 1970 he issued a series of lithographs at Tamarind Institute at the University of New Mexico entitled *Indians Forever*. In rapped-out Pop images, Scholder surveys the status of the Indian in American society in ten wry, humorous, and sometimes bitter observations. A later lithograph which he calls *Screaming Artist* is a statement of protest echoing the haunting images of Kollwitz and Rouault.

The most eloquent prints of protest in the western hemisphere were those issued in unlimited editions by the artists of Mexico in the early decades of the twentieth century. Their cause was both social and political, and they pursued it with unrelenting zeal.

130 MAZUR, MICHAEL (b. 1935), *Three Beds, No. 14* from series *Images from a Locked Ward*, 1962. Etching, 18¾×31¾ (50.2×80.6). Photo courtesy Associated American Artists, Inc.

131 MILTON, PETER (b. 1930), *Daylilies,* 1975. Etching, 19¾×31¾ (50.2×80.6).
Photo courtesy Associated American Artists, Inc.

In the United States artists have issued prints of protest, but these have been restrained and seldom militant.

Personal Visions

Of contrasting interest are the works of a few individual artists whose visual ideas originate within their own fantasies or private dreams. Among this eloquent company of artists may be cited the prints of Peter Milton, John Altoon, Peter Paone, John Dowell, Jr., Frank Roth, Rudolfo Abularach, Leon Golub, and Ronald Markman.

Peter Milton, born in Lower Merion, Pennsylvania, in 1930, became interested in Surrealism by way of the cinema rather than through the plastic arts, which he viewed with some distrust. He studied with Albers and Peterdi at Yale in the 1950s and later taught at Yale and traveled in Europe. His early prints are panoramic landscapes of a marked delicacy. These large intaglio works in varying levels of vision recall Chinese landscapes with their large vistas and small figures. They also acknowledge the carefully delineated landscapes of the Dutch Masters. This is revealed in Peter Milton's print entitled *Breughelscape No. 1* issued in 1964. A similar layering of vision is to be noted in the more complicated composition of 1967, entitled *Julia Passing*. In this intaglio print a pictorial dialogue between past and present, a dreamlike juxtaposition of images, carries wit and an engaging indulgence of fantasy rather than a subjective emphasis of Surrealism. In the tensions of lines and shifting perspectives the artist creates an eery sense of dream reality and the telescoping of time in a remembered environment. This strange and somewhat disquieting world, in its hide-and-seek quality, transports the observer into the artist's private world. Perhaps Peter Milton's sense of differing ambiguities of objects may be contrasted to the more detached visual sensibilities that appear in the prints of Johns and Oldenburg.

Permeating the private fantasies of Peter Milton is the wistful drift of memories through past events and particular individuals. In his etching *Child's Play,* 1966, a tree house with a catwalk approach is set against a fragment of landscape and the more formal details of a section of architecture. In *Victoria's Children,* an intaglio print issued the following year, the vistas of a private world unfold. Neither morbid undertones nor moralistic echoes cloud Peter Milton's prints. His easy command of the techniques of etching and lithography frees his private visions and accents his meticulous draftsmanship. In his later prints he has employed photographic aids to give to his prints a heightened sense of fantasy. His special sense of fantasy is notably achieved in his etching *Daylilies,* issued in 1975. Unfortunately the eloquent symbols appearing in the foreground of this splendid print, including the small black cat and the spray or sheaf of day lilies, are lost to view when the work is radically reduced in reproduction.

Leon Golub returned to printmaking in 1965, after a lapse of some fifteen years. In the early 1950s he had issued a few lithographs on primitive themes where ancient figures, especially pre-Columbian, held the artist's interest. Golub, like Lebrun, is concerned in his art with the fate of man and man's ability to survive in the modern world. In his paintings, he often turns to ancient sources to confirm his own visual sensibilities. After an extended stay in Italy, Golub drew ideas from classical themes to emphasize his own disturbing images of man. It was not until 1965 that he again seriously worked in lithography. During a stay of several months at Tamarind Workshop, Golub completed some two dozen prints. These compositions are improvisations on ideas from pagan myths. His *Agon Suite* of eight lithographs is based on the concept of the sphinx and is an interpretation of the artist's vision of that strangely contrived and forbidding monster and its implied riddles.

Ronald Markman's prints are the result of a resourceful imagination and a skilled hand that produce in nonstop shorthand a flood of images. In a dense network of etched lines appear minuscule figures, strips of elegantly printed statements, cartoon loops, and imaginary structures—all arranged in a seemingly casual order. Markman, a native New Yorker, began making prints in the late 1950s. His visual limericks and their ambiguous combinations of objects and figures transcribe the musings of an artist

132 DOWELL, JOHN JR. (b. 1941), *Free Form for Ten*, 1973. Etching, 24×18 (61×45.8).
Photo courtesy the Artist.

133 ABULARACH, RUDOLFO (b. 1933), *Untitled,* Nov. 1967. Lithograph, 12×12
(30.5×30.5). Photo courtesy Associated American Artists, Inc.

who views the passing scenes through an indulgent fantasy.

In 1965, without promotional fanfare, John Dowell, Jr., issued a suite of eight lithographs entitled *Triangular Fugue*. Its uncompromising presentation of an artist's private world of fantasy left no doubt that here was an artist whose special vision was in the fine tradition of those artists whose personal symbolism has brought a new and lively vision to the arts of the twentieth century. Each of the eight lithographs in *Triangular Fugue* is composed of an open-ended triangular form which floats within intuitive calligraphic notations. Its emotional impact is played against a deft undertone of musical phrases of considerable elegance and sophistication. Following this early series is an extended series of intaglio prints whose subjects are a further development of the artist's sense of fantasy and dreams. They are visual responses to strong emotional currents and dreams that lie concealed in the deft calligraphic forms defining the thrusts and counterthrusts of each composition. They are visions of a private subterranean world, sometimes troubled, sometimes joyous, of an artist whose realm is in the visual tradition of Masson, Matta, and Miró but whose fantasies have been molded by a familiarity with the sights and sounds of a later decade. Dowell has a splendid technical background, first at Tyler School of Art, with Garo Antreasian at the John Herron Art Institute in Indianapolis, and later at Tamarind in Los Angeles. In 1969 he issued a number of individual lithographs in black and white and in color, of which *Drownin' on Dry Land* is an example. His compositions carry a crowded yet disciplined calligraphy which is clustered within the upper sections of his work and which, in turn, falls like small after-images into the lower region of his compositions. His recent prints, composed of small visual explosions of energy, are lively webs of fantasies that delight the eye and challenge the imagination. Dowell's interest in modern music and the dance is revealed in his etchings *Free Form for Ten* of 1973 and *Lines Played W/ Soul*, 1976. The artist explains:

> "Using my work as musical scores and notations for choreography, my prints become the actual sheet music and the directions for movement."

A deceptively vague environment with overtones of Surrealism and faintly reminiscent of Magritte characterize the prints of Frank Roth. Strange, undefined objects, triangles, and squares float in a landscape or interior. A symbolic intent lurks within the dreamy, abstract forms and shifting tensions of his meticulous compositions, but their relationship to the artist's fantasies remain obscure. Roth's lithographs issued in the 1960s are often untitled and become tantalizing visual conundrums composed with skill and sensitivity.

A single image inspires the work of Rudolfo Abularach. Born in Guatemala in 1933, he has lived in New York since 1958. He began his work in printmaking at Pratt Graphics Center and later worked at Tamarind Lithography Workshop. It was during his stay at Tamarind that Abularach began extensive studies of the human eye as a symbolic image. From realistic representations to wholly abstract forms, it becomes the vehicle of this artist's private world. A world of fantasy and myth is suggested in a vision that looks out upon a world it neither acknowledges nor ignores. Its finely modulated contours and intensified highlights give a larger-than-life image a haunting and arresting presence. Its strange locked-in vision may recall the Symbolist prints of Odilon Redon.

Directly concerned with the fantasies of a private world, the prints of Saul Steinberg and Richard Lindner are the worldly and sophisticated counterparts of their younger colleagues. Both are Europeans by birth. Their experiences and activities have been colored by the thrust and developments of Cubism, Surrealism, and Dada. Steinberg was born in Bucharest and educated in Milan, Italy, where he was the recipient of two degrees in architecture. However, his specific talent in drawing led him to other areas of art. Since 1941 his linear caprices have appeared regularly in *The New Yorker* magazine. It was not until the 1960s, at the urging of Irwin Hollander, that Steinberg began to work in lithography. In this medium, he continued his delightfully quirky compositions, now often supplemented with color. In Steinberg's graphic work a few figures and their odd perambulations are spun out into linear essays that are witty, wry, and timely. In 1967, Steinberg's *Cenotaph*

134 CASTELLON, FEDERICO (1914–1971), *Mimi as a Florentine,* 1965. Etching, 11×9½ (28×24.2). Photo courtesy Associated American Artists, Inc.

135 BERDICH, VERA (b. 1915), *Fabricated Mirror*, 1957. Aquatint, drypoint, mezzotint, 17¾×13¾ (45.2×35). Photo courtesy Kennedy Galleries.

appeared in Hollander's portfolio of nine lithographs by as many artists.[21] A year later, he completed *Certified Landscape*, a lithograph printed in blue, brown, and black. His portfolio of six color lithographs entitled *Six Drawing Tables* was printed at Impressions Workshop in Boston in 1970, Steinberg's delightful graphic scribblings of figures, objects, seals, symbols, and shibboleths lightly caricature the fantasies and foibles of today.

Richard Lindner's prints have played a minor role to his paintings. In reality, the lithographs and screen prints are representations of complete sketches or compositions in gouache or watercolor and have the full benefit of modern printing technology. His prints have been issued since the mid-1960s. A few of his designs have appeared in posters issued in New York, Paris, and Spoleto. Lindner's print *The Parrot Lady,* 1969, is an elaboration of printing techniques, including lithography, screen, collage, and pochoir. It demonstrates Lindner's ability to create a figure whose existence in space is reduced to the flatness of the king of hearts in a deck of playing cards. In 1967 he began a protracted series of works on the theme of Marilyn Monroe, a theme whose ambience for Lindner stemmed from the 1920s period in Berlin and Munich. The seventeen lithographs entitled *Marilyn was Here* was published in Stuttgart in 1971. In the same year appeared his album of five screen prints, *Shoot,* printed in an edition of one hundred by Ives-Sillman at New Haven, Connecticut, and published by the London Arts Group.

His most popular series is *Fun City,* published by Shorewood Press in New York, also in 1971. It was an immediate success and is typically Lindner. This series was followed several years later by a portfolio of eight lithographs entitled *Afternoon,* printed and published jointly by Shorewood Press and Wolfsenberger of Munich in an edition of 250. All the compositions in this latter series had appeared earlier in *Fun City* as plates fifteen through twenty-two and after Lindner's watercolors of 1968–69. The *Afternoon* series had slight variations in the colors and titles which were recorded as *Heart, Man's Best Friend, Miss American Indian, Portrait No. 1, How It All Began, Profile, Portrait No. 2,* and *Circle and Pillow.* (See color illustration no. 26.) Some print authorities in the United States and Germany registered objections to the high prices established for lithographs fashioned after Lindner's delightfully audacious watercolors. Nevertheless, they have proved to be a much-sought-after series.

Richard Lindner began his career as a painter in 1951 at the age of fifty. In 1933 he had fled from Germany to Paris and later joined the French Army. In 1941 he left Paris for the United States. In New York he became an illustrator for several exclusive magazines where his keen observations of urban life and his skills as a draftsman were soon recognized. His drawings, witty, incisive, celebrated the grotesque characters and bizarre scenes of the city's street life. The erotic images of his fantasies and his ironic observations are corseted in enamel-like, offbeat colors— colors grayed in the atmospheric light of New York. His masked figures, dressed like circus performers, are an amalgam of details and objects put together from visions of street life and his own restless imagination. He views their blunt gregariousness with a blending of irony and detached melancholy. Perhaps it is the symbolic content and a particular presentation of the darker vulgarities of present-day urban life and the unblinking revelation of subterranean fantasies that hold, in Lindner's oeuvre, such a fascination. The echoes of a strange folk vision are noted by Dore Ashton in her thoughtful essay on the artist. She observes:

> "These masked creatures with their foibles painted or draped upon them are really none other than the medieval fools depicted by the German woodcut masters in the *Totentanz.*"[22]

Federico Castellon throughout his professional career as an artist was devoted to printmaking as well as to painting. (See also p. 81.) The experiences of his travels in Europe, China, India, South America, and the United States are perceptively reflected in his prints. To be remembered is his series of eleven etchings entitled *China Portfolio,* issued in 1950. Beginning in the 1960s his lithographs and etchings chart a world of extraordinary fantasies and dreamlike symbols rather than the romantic Surrealism of his earlier lithographs. Among the most outstanding is his series of eight lithographs in color, *Self Portrait in Symbols,* published by the artist in 1965. At this time he also composed a few small portraits that are particularly sensitive and imaginative, as noted in his etching

Mimi as a Florentine. In 1969 appeared his last large portfolio of sixteen lithographs in color, inspired by Edgar Allan Poe's story *The Mask of the Red Death.* An edition of 150 impressions was printed by Desjobert in Paris in 1969, less than three years before his death in 1971. Castellon, over the years, carried forward a cherished project of finely etched miniatures. Numbering some 150 examples, they were never issued in formal editions. They remain, nonetheless, an important part of the 360 recorded prints that make up his distinguished graphic oeuvre.

In 1962, Peter Paone, a Philadelphia artist, issued a large portfolio of etchings entitled *The Ten Commandments of Ambrose Bierce,* which carried engaging and convincing Surrealist images. A prolific artist, Paone in his subsequent prints and paintings turned to private fantasies whose images are often bizarre and erotic and occasionally contrived. He has composed a number of fine portraits, mostly of family and friends, that are a perceptive analysis of individual character.

Outside the New York area the artists Louis Bunce and Vera Berdich were pursuing their individual interpretations of Surrealism. Bunce composed lithographs and screen prints in color along with his major paintings. Printed in small editions, his graphic work is seldom seen. Early in the 1960s Bunce produced a number of lithographs at the Tamarind Lithography Workshop.

Vera Berdich was born in Chicago above a violinmaker's shop on Hamilton Avenue in an old Bohemian neighborhood where music was very much a part of daily life. Perhaps her interest in the intaglio print was in its tensions of lines and the soft color tones that seemed an extension of her own musical background. She was introduced to Dada and Surrealist art, to collage and to photographic aids in printmaking at the Art School of the Art Institute in Chicago. Since that time she has thoroughly explored many unusual approaches in the different print media. She realized that the many variations in graphic techniques and methods, when applied with imagination and skill, could produce images of fantasy and also unlikely Surrealist reflections. In 1957 the Surrealist note was evident in *Fabricated Mirror*

and in *The Eye of Eros,* which demonstrate her mastery of the mezzotint, aquatint, and drypoint. In 1963 a Surrealist vision was expressed in her print. *The Doors were Closed,* which also skillfully combines a photo image with mezzotint and drypoint. Still later, in 1969, Berdich completed a large diptych called *Mutations I and II,* achieved by the combination of traditional techniques and an X-ray negative photographed onto the plates. A fastidious experimenter, Vera Berdich employs her skills and her ideas, Surrealist or otherwise, with a creative and lively vision.

The Surrealist lithographs in color of a California artist, John Altoon, are an extension of his watercolors. Crowded gangly images whose veiled eroticism chart a sea of private fantasies float in pale washes of color. Altoon became interested in lithography in the early 1960s and continued work at Tamarind in 1965, where he completed some twenty lithographs in color. Later at Gemini he produced a similar series as an accompaniment to Robert Creeley's poems entitled *About Women.* The ease and facility of Altoon's draftsmanship enabled him to weave together both abstract and Surrealist images.

Clayton Pond first began exhibiting his etchings in 1961, including a suite of ten etchings entitled *My Studio on Broome Street.* The artist soon found that the screen print medium with its large color range and its crisp stencil-like quality well suited the patterned designs that form the basis of his graphic work. Pond's colorful screen prints are drawn from the ordinary, unprepossessing furnishings of his studio. They become lightly held fantasies presented as playful, highly embellished images. The flattened commonplace images are woven into intricate compositions, reminiscent of folk art, that the artist presents with obvious pleasure and amusing sophistication. In 1975 Pond issued a portfolio of seven screen prints that was a departure from his long involvement with studio views. Entitled *Capital Ideas,* each print is a fanciful detail from the capitals of cast-iron columns on old buildings that the artist had observed in the SoHo district of New York City. (See color illustration no. 27.) Some of the appeal of Pond's prints lies in their bright colors and the amiable incongruity of their being a "nostalgic" Pop art.

ORIENTAL ARTISTS AND AMERICAN PRINTS

Special note has been made of artists of oriental heritage who have become an important force in the milieu of American art in the present century. In the 1960s a younger group has given a vigorous international emphasis to the modern print in the United States. To be considered are Ansei Uchima, born in Stockton, California, in 1921 of Japanese parentage, Walassie Ting, born in Shanghai, China, in 1929, and Masuo Ikeda, born in Mukden, Manchuria, in 1934, returning to Japan after World War II.

Ansei Uchima's career as an artist began very differently from that of most American-born artists. Born in the United States, Uchima went to Japan at the age of nineteen and remained there for a second span of nineteen years. His first two years in Japan were spent studying architecture at Waseda University in Tokyo, after which time he turned to painting under private Japanese tutors. During this time he also served as special translator and interpreter for American officials and visitors. In 1954 he embarked on a concentrated study of the woodcut as developed and practiced by many generations of Japanese artists. He later regularly exhibited his prints at the Tokyo International Print Biennial Exhibition. In 1959 Uchima returned to the United States to establish himself as an artist and teacher.

The woodcut in color was a graphic medium employed by a number of American painters and sculptors in the decades of the 1940s and 1950s. However, the younger artists of the 1960s found that the lithograph and the screen print were more effective counterparts of their painting whether the immediacy of the image was related to Pop art, geometric abstraction, or sharp-focus realism. Also, graphic workshops, where there were special technological skills and sophisticated equipment in lithographic and screen printing, were increasingly available to them. Perhaps it is those artists, working in Japan and in the United States, who have most consistently given to the modern woodcut its present validity and exceptional diversity.

Uchima works within the traditional techniques of the Japanese woodcut; nevertheless, his creative imagination is touched and influenced by present-day experiences and his awareness of the changing images and ideas of today. In 1957, while still in Japan, Uchima completed a very large-scale woodcut entitled *White Tide Rhythm*. Printed on fine Japan paper in strong blues, whites, green and black, it is an amalgamation of bold abstract images and the contemplative undertones often envisioned in oriental painting. Its lively orchestration of color and forms and its direct visual intent is a measure of many distinguished prints to come. Uchima's first portfolio, *Evening Calm,* issued in 1962, is a poetic summary of the preceding decade of the artist's life. Uchima is concerned with meaningful abstract compositions where color appears to originate in a great depth of space rather than in a surface color field. A recent woodcut issued in 1977 and entitled *Light Mirror, Water Mirror* suggests an inner landscape existing in space where color is light. (See color illustration no. 28.) Imbued with a vigorous yet poetic vision, Uchima's work is free from the eccentricities of this decade and perhaps implies a new vision of reality.

Walassie Ting arrived in the United States in 1963, after a ten-year sojourn in Paris. He has remarked:

"When four years old paint in sidewalk; ten years draw on wall; twenty years old left China to travel after reading the book of I Ching. In 1953, arrived in Paris . . . Living in a six inches window room. Paint there, eat there. In 1963, arrived in New York City. Eat there, paint there. Self taught. Individual. Not belong to any group."[23]

To this capsule autobiography should be added a long list of one-man exhibitions, a number of individual prints and portfolios, and several volumes of poetry. The deluxe editions of his poetry carry original prints. His lithographic work since his arrival in the United States was done first at Tamarind Lithography Workshop and at Hollanders Workshop. His

lithographs contain a fast-moving galaxy of images thrust into the field of vision. Perhaps his exuberant use of color is derived in part from his friendship with Anger Zorn and Karel Appel, original members of the Cobra group. However, Ting's colors are translucent and have none of the raw intensity that characterize Cobra. Ting's skills allow him to work in an abstract or an Expressionist idiom. His early venture in prints was an ambitious portfolio containing original lithographs and screen prints by thirty American and European artists whose work reflected the avant-garde points of view in the 1960s. It was a feat of considerable proportions to enlist the cooperation of so many artists who actively held vastly differing ideas and attitudes. Ting himself arranged the various collaborations, contributed a number of his own prints, and composed the free verse. Entitled *1¢ Life,* it was edited in Switzerland by Sam Francis, who added several lithographs and also procured financial assistance for the project. It was published in 1964 in a special edition of one hundred unfolded copies signed by each of the participating artists and an additional two thousand copies, unsigned, and printed in a double-fold format.[24] Its free-wheeling imagery, its profusion of brilliant colors, and the resourcefulness of Walassie Ting recapture an atmosphere of exuberant bohemianism.

Also in 1964, Ting worked at Tamarind Lithography Workshop, where he completed two suites of lithographs in color: *Hollywood Honeymoon* and *Fortune Kookie,* each series containing ten lithographs. Several years later at Hollanders Workshop in New York he issued a number of large-scale prints. Among them are his *Star Umbrella,* 1967, and *Flower,* 1969. They demonstrate his exuberant sense of color where umbrellas become stars and a flower explodes in a burst of fireworks. Recently he has turned to the more restrictive black and white lithograph in a large-scale series of "odalisques."

Masuo Ikeda began his etchings in color in Tokyo in 1956 at the age of twenty-two. Ten years later his prints were first exhibited outside of Japan at the Museum of Modern Art in New York. In 1966 he was the recipient of a Japan Society fellowship for extensive travel in Europe and the United States. Also at this time he was awarded the International Grand

Prize for Graphics at the 33rd Venice International Biennial. During a visit to the West Coast he worked in lithography at Tamarind and thereafter issued several suites of prints at Collectors Press in San Francisco. These included a suite of ten lithographs in color entitled *Some Town Without a Name,* completed during 1968–70 in an edition of forty-five impressions printed on German etching paper and fifty-five impressions printed on Arches.

Ikeda's superb talents and skills appear most clearly in the range and refinements of the intaglio print. The fluidity of his drypoint line combined with a more sturdy etched line and the richness of the mezzotint field are nowhere surpassed in twentieth-century prints. His international reputation rests not alone in his virtuosity but rather in the ideas and preoccupations of a highly creative vision. Aside from a veiled eroticism his style is remote from that of traditional Japanese printmaking. A wry irony pervades his work wherein any sense of time or perspective is obscured in an overriding vision of the absurd elements in contemporary life. He frankly shares his fantasies and his preoccupation with the theme of the western woman. Her classically elegant countenance is without expression or any overt response. It is only in the portrayal of hands that an intensity of expression is permitted. This mysterious figure is often surrounded by unexpected objects and magical, cubed box-like forms that mirror fleeting clouds or waves from some unknown place. In 1970 Ikeda carried this intriguing theme into a series of six large intaglio prints in color which he titled *Portrait of Sphinx.* This portfolio, published by Associated American Artists in New York, was printed in an edition of sixty with six deluxe editions.[25]

Since 1972 the artist has made his home on Long Island near Easthampton. A part of each year is spent in Japan, whose landscape and language affords him both relaxation and inspiration. In his early prints, which often contained paper collage and calligraphic notations, and throughout his mature work, Ikeda's sensitivity to the life about him is always evident. Wit, satire, and a lively sense of the absurd prevail in much of his work. An engaging frankness further allows him to envision and define a deep feeling of pathos combined, occasionally, with a fleeting shadow of violence. During the decades since 1956 Masuo

136 TING, WALASSIE (b. 1929), *Miss U.S.A.,* 1977. Lithograph, 24×36 (61×91.4).
Courtesy Lefebre Gallery, New York.

137 IKEDA, MASUO (b. 1934), *Portrait of Sphinx* from series *The Sphinx*, 1970. Mezzo-tint, etching, 12×10½ (30.5×26.7). Photo courtesy Associated American Artists, Inc.

138 REDDY, KRISHNA (b. 1925), *Sun Awakens,* 1978. Engraving, etching, 13¾×17½
(35×44.5). Private collection.

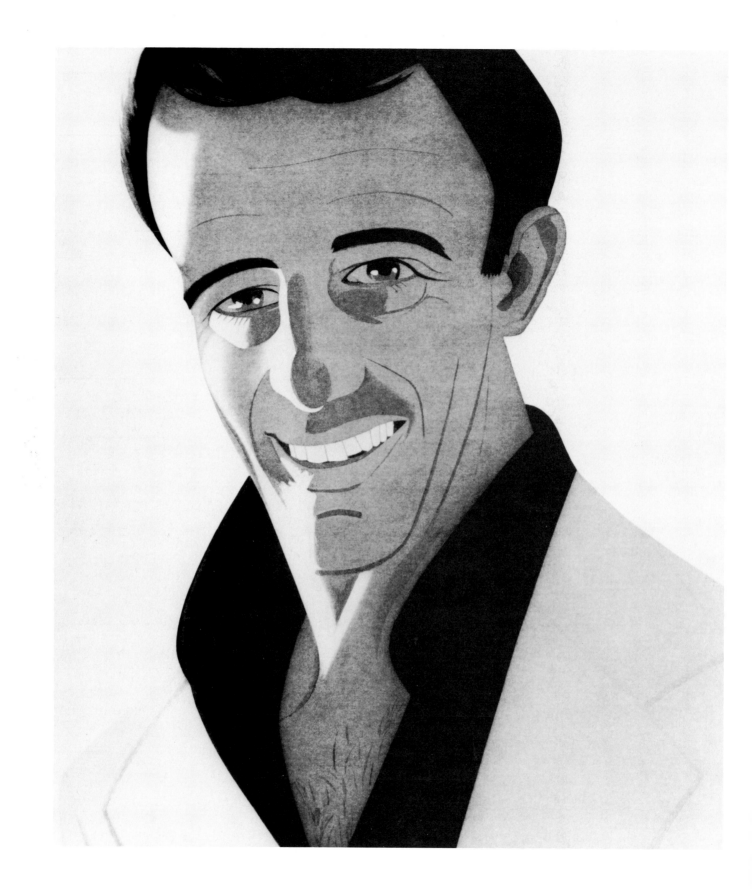

139 KATZ, ALEX (b. 1927), *Self Portrait,* 1978. Aquatint, 36×30 (91.5×76.2). Photo
courtesy Brooke Alexander, Inc., New York.

Ikeda has produced, first in Japan and later in the United States, an internationally known graphic oeuvre of more than six hundred prints.

Representative of those younger artists in Japan who go abroad on fellowships and attain their first success outside of Japan are Ay-O and Akiko Shirai. They live and work in New York and their prints are in the idiom and the techniques of the West. Ay-O was among the first to create "Environments" in New York in the early 1960s. He has issued large-scale screen prints in a rainbow of colors. Akiko Shirai has chosen to work in intaglio and her modest oeuvre contains etchings of quality and discernment.[26]

Recently settled in New York after many years in Paris, Krishna Reddy is a sculptor and printmaker of international note and is presently in charge of the Division of Graphic Art at New York University. His early studies in sculpture were with Ossip Zadkine in Paris, and he also worked with Marino Marini in Italy and Henry Moore in England. From 1958 until 1976 he was actively associated with Atelier 17 in Paris and from 1965 served as co-director with Stanley William Hayter. It was in 1954 that Krishna Reddy and his friend Moti first began experimenting in the possibilities of simultaneous color printing from a single engraved or etched metal plate. Earlier at Atelier 17 Joan Miró had printed several colors in a single run of his inked plate through the press. However, the process was always unpredictable and no further research into the problem of printed color had been made. It was found that by analyzing the oil content of the color and controlling the type of oil and the amount used, a reliable viscosity could be achieved and the range of color extended. This method led to a transforming of color printing that is now widely employed in many graphic workshops. Recently Krishna Reddy has further developed the processes of color printing in what he terms the broken color or pointillist technique. Variations in the depth of an etched or engraved line and variations in the depth of the surface textures, combined with the controlled viscosity of the inks, produce prints of unusual clarity and richness. Krishna Reddy's most recent intaglio prints carry an aura of mystery heightened by an exceedingly sensitive use of colors.

SUPERREALISM

When Abstract Expressionism was at its height, there remained a few artists who held to a strictly realistic approach in engraving, etching, and aquatint. Among the American group were Gabriel Laderman and Alex Katz. Both are fine draftsmen whose interests are in the figure, interiors, and occasional landscapes. Laderman, in the early 1950s, issued a number of large intaglio prints of crowded interiors where sharply etched objects were treated with equal importance.

The intaglio prints of Alex Katz are similar to his paintings of large frontal portraits and abbreviated landscapes, which led Nicolas Calas to remark that Katz had eliminated the middle ground in his work. Katz does not allow his somewhat flattened image to become merely decorative. In his large lithograph in color issued in 1970 entitled *Portrait of a Poet, Kenneth Koch* and in the series of smaller etchings and aquatints of 1972 the artist has retained the structural elements of Realism in linear forms. The individual features of his portraits and landscapes are enlarged and stylized, thus minimizing their particular individuality. This is to be noted in his aquatint entitled *Self Portrait,* issued in 1978.

Late in the 1960s a number of exhibitions in various sections of the United States featured new approaches to Realism, designated as New Realism, Photorealism, Superrealism, Radical Realism, Sharp-focus and Artificial Realism, largely reflecting the individual points of view of the artists themselves. The literalness of Pop art and the hard edges of Geometric Abstraction with the assistance of the photograph

brought a new consideration of the object or figure. The results of this interest became evident in the large International Print Exhibitions of contemporary work in Europe, Japan, and the United States. Photography itself had become the necessary tool for the "New Realists," whose paintings and prints are delineated by a wide-focus or Artificial Realism. Shunning the ideas of Abstraction, Pop art, and Expressionism, the New Realist, or Superrealist, recorded not only what was visible to the naked eye but also what could be observed only from a composite of photographs. All details were of equal importance regardless of their position in the picture plane. William M. Ivins, Jr., near the close of his exceptional treatise *Prints and Visual Communication,* first published in 1953, observed:

> ". . . it was photography, the pictorial report devoid of any linear syntax of its own, that made us effectively aware of the wider horizons that differentiate the vision of today from that of sixty or seventy years ago."[27]

In the microscopic delineations of the New Realists little was left to the imagination of the viewer. Their etchings, lithographs, and screen prints became a glittering technical performance. Some of the various degrees of Realism achieved entirely or in part through photographic aids are noted in the prints of Richard Estes, Robert Becktle, Mel Ramos, Edward Ruscha, Dennis Rowan, and Philip Pearlstein.

Becktle and Estes employ their own photographs and color slides, which they project or crop to achieve the desired effect. Photographs allow them to acquire accumulated information not necessarily apparent to the eye alone. Becktle, influenced by the work of Diebenkorn, had first painted as an Abstract Expressionist. However, it was Pop art that made him aware of the particular possibilities of commercial art techniques. He is concerned with the immaculate image of parked cars, multiple dwellings, and other urban scenes. Becktle has been known for his lithographs since 1960.

Richard Estes, unlike Becktle, has always been a figurative painter and printmaker. His screen prints are similar to his paintings in that they scrupulously depict motionless views of business streets and modern commercial buildings. Each print becomes an elaborate composite of angles, doors, windows in which glass and highly polished metals are splintered by changing lights and reflections. Estes is interested in recording the gleaming artificiality of splintered light and visionary shadows where forms take on muted colors and the vast conglomerates of steel and glass and stone are the overpowering reality. They exist in a vacuum. Estes' most notable prints are the series of eight screen prints entitled *Urban Landscape,* 1972, published by Parasol Press. Its printing is a technological achievement in which a single print might require a run of more than 150 screens. Perhaps only a large and highly technical printing shop and a most enterprising publisher would attempt such a portfolio.

The lithographs of Mel Ramos are a combination of a photographic background of a shadowy nude figure and the artist's very professional drawings of birds. This juxtaposition of images produces a weird Realism whose erotic undertones are reminiscent of earlier lithographs by the Norwegian artist Edvard Munch.

Edward Ruscha, a painter and printmaker who lives in Los Angeles, prefers to be known as "an artist." He remarks that he began painting in 1961 after having seen some of Jasper Johns's paintings. Ruscha soon found that the large-scale paintings and the noncommittal images of Pop art were of less interest than the smaller scale, more personal works on paper. He has taken impersonal elements of an environment and transformed them into new and uncommon images. An isolated word, swarms of insects, and distant billboards become special trompe l'oeil achievements. The uniformity of a gas station holds his attention. (See color illustration no. 29.) Ruscha has been influenced by Duchamp and Magritte, Neo-Dada and color field paintings. To date, Ruscha has issued more than sixty-five prints in lithography and screen, a print environment, and approximately sixteen folded books, each printed in offset in small editions. His involvement in a single expressive word may dissolve into fragile drops of water or boldly stand against a bright orange sky in a Parthenon-like silhouette. Insects—ants and cockroaches—may be strewn over a sheet of paper in a casual yet orderly

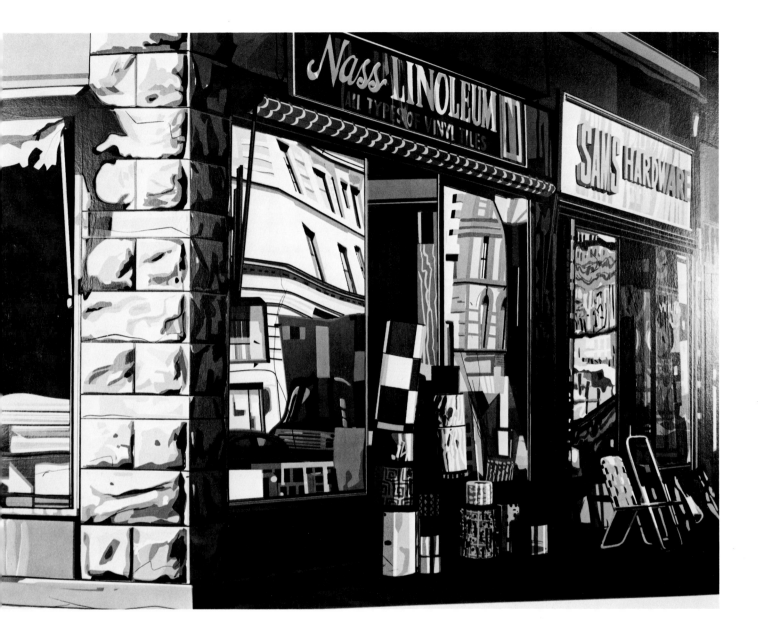

140 ESTES, RICHARD (b. 1936), *Nass Linoleum,* 1972. Screen print, 15×17¹⁵⁄₁₆
(38×45.6). Collection, New York Public Library.

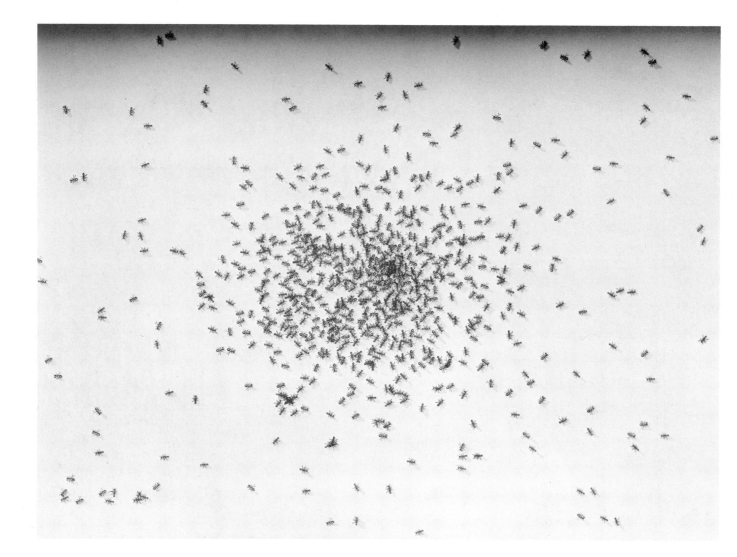

141 Ruscha, Edward (b. 1937), *Swarm of Red Ants* from portfolio *Insects,* 1972.
Screen print, 20×27 (51×68.6). Collection, The Brooklyn Museum, National
Endowment for the Arts and Bristol Myers Fund.

142 PEARLSTEIN, PHILIP (b. 1924), *Untitled* from portfolio *Six Lithographs Drawn from Life,* 1970. Lithograph, 30×22 (76.2×56). Photo courtesy Brooke Alexander, Inc., New York.

143 SCHWARTZ, CARL E. (b. 1935), *Heirloom 4,* 1975. Lithograph, 22×30 (55.8×76).
Photo courtesy the Artist.

array oddly recalling the minute clarity of Jacques Callot's seventeenth-century etchings of foot soldiers marching off to battle.

Philip Pearlstein, a painter in the Realistic tradition, issued his first lithographs in the late 1960s. Working directly from the model or from photographs, he portrays the nude figure or figures close up and occasionally placed against an elaborately rendered background. His willful exaggeration of a forearm, a shoulder, or a bent knee lends a sense of detachment and incongruity to the total composition. Often his figures appear cropped, seemingly too large for the space they occupy. This device serves to accent the volume and also to arrest the attention of the viewer. Among Pearlstein's most ambitious prints is a series completed in 1970 under the forthright title *Six Lithographs Drawn from Life,* two in color and four in sanguine. They were printed at Landfall Press in Chicago from aluminum plates in an edition of fifty. His graphic oeuvre of lithographs and aquatints is derived directly from his accomplished drawings and gouaches.

Photographic Aids

Carl E. Schwartz, also an established figurative painter, has been actively involved in lithography as an expressive medium since 1955. Formerly he printed his own work and understands the many nuances possible in this medium. He is an excellent draftsman, and his studies of the nude figure have assurance and authority. In his large and distinguished graphic oeuvre, *Heirloom,* printed in 1975 at Landfall Press, may be noted. He presently utilizes photographic aids in some of his larger compositions.

The majority of artists who employ photographic aids to obtain their particular interpretation of Realism issue prints in the media of lithography or the screen print. There are, however, a few who work with intaglio plates. Among them are Dennis M. Rowan and Chuck Close.

Dennis Rowan has been working with the intaglio print since 1955 and in 1968 began experimenting with the combining of photoengraving and etching. A year later he issued his large print entitled *Femme*

et Poire in which a startlingly realistic photoengraved portrait is presented in the manner of a closeup movie still. In the foreground is an enlarged pear-shaped object which lends an air of ambiguity and Surrealism to the composition. A more ambitious and perhaps more successful print, *Encore,* was issued by Rowan in 1972. A self portrait, it consists of a casual frontal photographic view of the artist and is repeated in five diminishing layers of vision which becomes in its final frame a blank white rectangle. Its receding size suggests a multilayered reflection. The discs of lights surrounding each of the receding frames trap the eye in its search for a nonexistent focal point but offer no logical conclusion. It is a skillful performance in visual ambiguity that is both daring and witty.

The larger-than-life portrait by Chuck Close entitled *Keith* leaves no doubt as to its extreme range of focus. The artist's intent was to obtain an image that had an all-over grayed effect and a wide, equally detailed focus rather than the varying contrasting tones that would lead the eye to a specific center of interest. The original image of the portrait of *Keith* was obtained through a collage of photographic enlargements which was subsequently rephotographed to the desired scale of the final print. This basic image was then transferred by the artist through a process of hand-scraping and burnishing onto the plate itself with the aid of corresponding grids on the photograph and the copper plate.

The Close print was widely publicized as "the largest mezzotint ever made." Kathan Brown, resourceful director of Crown Point Press in Oakland, California, where the Close plate was printed, explained:

"I called that a mezzotint because in an old etching textbook written by Lumsden the definition of mezzotint is that the artist works from dark to light on a plate that has been made so that it will print black. We have never made a traditional mezzotint ground in the sense that the plate was hand-rocked, simply because it's too time-consuming. For *Keith,* the plate is almost three by four feet and it was impossible to hand-rock a plate that size. We put the black on the field with the photographic imprint of a very fine halftone screen with two hundred dots to the linear inch—that's actually finer than the

144 ROWAN, DENNIS (b. 1938), *Encore,* 1972. Intaglio and photoengraving, 36×24
(91.5×61). Photo courtesy The Brooklyn Museum.

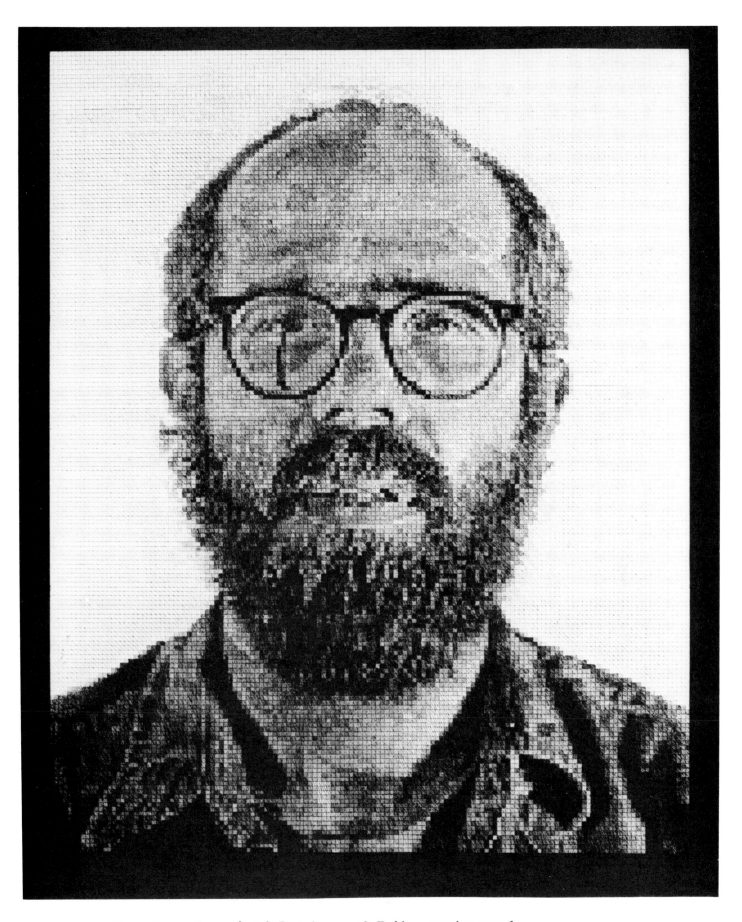

145 CLOSE, CHUCK (b. 1940), *Self Portrait*, 1977–78. Etching, aquatint, 45×36
(114.3×91.4) (sheet). Photo courtesy Pace Editions.

traditional mezzotint rocker. That was the only part done photographically, just to correct a misconception. Chuck scraped and burnished the plate the usual way. But the fact that we figured out how to do the ground and were technically able to put the halftone screen on that large a plate and have it print black made it possible to do a mezzotint that size. So that extends the medium too. We use photography as a tool, but not as a reproduction method."[28]

Chuck Close has noted that his involvement was chiefly in the production of the plate itself rather than in any printed image pulled from the plate. Only a small edition of ten was printed and published by Parasol Press in 1972. Since this first venture in prints, Close has issued several other large-scale portraits, including *Self Portrait* of 1977. Developed from a watercolor and further studies in grids, dots, and lines, the final hard-ground etching is accented by the softer tones of aquatint. Produced at Crown Point Press, it was published by Pace Editions.[29]

It is only within the past dozen years that artists have extensively applied photographic aids in their printmaking. In his screen prints Andy Warhol utilizes straightforward photographic reproductions. Jasper Johns, Larry Rivers, and Robert Rauschenberg employ photo-offset to create some of their images. William Weege issued photo screen prints with an added flocking; Peter Milton in his later work combined a complicated etching and photo-etching process. R. B. Kitaj, Robert Burkert, John Loring, and Edward Ruscha found that other variations served their particular imagery.

Photographic aids are less often employed by artists who work in an abstract style where the desired effect remains in the gestural rhythm itself. An exception may be noted in some of the lithographs of Andrew Stasik. His experiments include the placement of small discs drawn on a lithograph plate and printed. This printed sheet of images was photographed, which in turn was photographed, then folded, cut, and reassembled as a construction. The resulting construction was also photographed under special illumination and transferred to sensitized printing plates. Through an elaboration of techniques Stasik arrived at the desired repeatable image. The final compositions are an orchestration of forms, shadows, and their varying tonal effects. These extensive experiments culminated in his lithographic series entitled *Still Life Landscapes* issued in 1969.

The prints of Agnes Denes often are keyed to photographs and X-rays. These inventive works are usually in black and white. Recently she has issued a three-color lithograph printed at Solo Press in New York by Judith Solodkin and published by Pace Editions. Entitled *Map Projections: The Snail,* 1978, it projects Denes' stylized vision of the world as a "helical toroid" and appears in two tones of blue-green held within an orange grid. Also in 1978, Agnes Denes completed *Probability Pyramid,* a large lithograph with flocking in which a single image carries both strength and delicacy of tone.

In contrast to the Artificial Realism pursued by a number of artists in the mid-1960s, the intaglio prints of Richard Haas stand as unusual, if not unique large-scale compositions. He follows the tradition of the architectural print but his concession to contemporary vision is in the scale and angled perspective that characterize his work. Also, Haas relies on his own trained eye and skills in the composing, etching, and the printing of his plates. He employs neither photographic aids nor complicated printing methods. His large-scale drypoints *The Dakota* and *New Era Building* with added aquatint in color appeared in 1971. In 1973 Haas completed his imposing etching with drypoint, *The Flatiron Building,* in which he exploits the scale and perspective of this architectural landmark. Printed in an edition of sixty impressions, it was published by Brooke Alexander in New York.

Those Realists and their supporters who had hoped for a return to a traditional presentation of reality were doomed to disappointment. The New Realists stripped their images of any romantic introspection or nostalgic memories. Rather, they presented scenes or objects in a glittering all-inclusive focus where every facet of the composition was carefully delineated. Their particular Realism defined what a myriad of camera shots could tell them, not what was generally visible to the eye. New technologies and skills brought a desired sense of detachment and artificiality to their prints and paintings.

146 STASIK, ANDREW (b. 1932), *Still Life Landscape, No. 5,* 1969. Lithograph, photo
aid, 23⅞×20 (60.5×51). Photo courtesy the Artist.

147 DENES, AGNES (b. Budapest), *Probability Pyramid,* 1978. Lithograph with flocking, 29×36 (73.8×91.5). Photo courtesy Pace Editions.

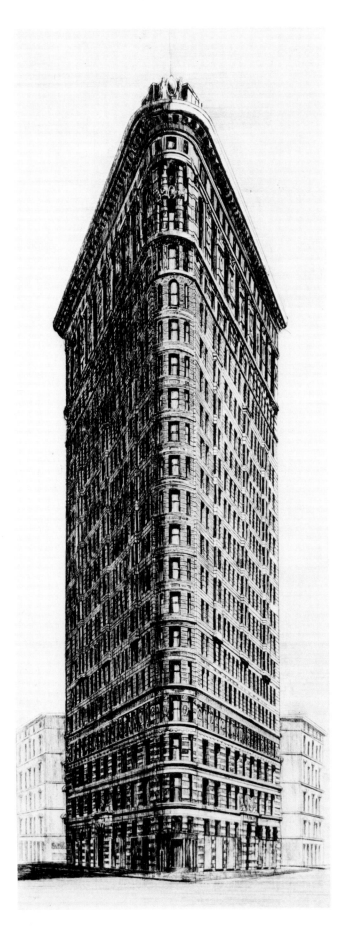

148 HAAS, RICHARD (b. 1936), *The Flatiron Building,* 1973. Etching, drypoint,
41¼ × 17½ (104.8 × 44.5). Photo courtesy Brooke Alexander, Inc., New York.

MINIMAL AND CONCEPTUAL MODES

The quest for the basic essentials in art is not a new phenomenon. In the later decades of this century sculptors and painters have sought out primary structures and minimal forms. They have avoided in their prints any reference to Abstract Expressionism, Pop art, Hyperrealism, or the dexterous employment of ambiguous images and private symbols. Some have been influenced by varying interpretations of recent philosophical theories, especially those of Ludwig Wittgenstein. [30]

Agnes Martin, a Canadian-born artist presently living in New Mexico, had a studio on South Street in the area of the Coenties Slip in lower Manhattan during the 1950s and into the 1960s. It was in the New York studio that Sol LeWitt and a few other artists first saw her unusual square canvases in reductive grids and straight lines. Her portfolio of prints entitled *On a Clear Day* was issued in 1973, more than fifteen years after her minimal paintings first appeared. The series of thirty screen prints in two tones of gray charts the extremely sensitive vision of a gifted artist. No single element, no assertive idea disturbs the calm equilibrium of these rectangular grids and lines. Instead, the intuitive and understated vision of the artist creates a particular sense of contemplation and repose. The small scale of the prints (9×9 inches, designated mat opening) and the surface flatness characteristic of the screen process tend to lessen the mysterious eloquence so evident in her large-scale square canvases. Nonetheless this welcome series serves to demonstrate the disciplined nuances possible in a Minimalist image composition. Agnes Martin carefully explains:

"Art work that is completely abstract, free from any expression of the environment, is like music and can be responded to in the same way. Our response to line and tone and color is the same as our response to sound and, like music, abstract art is thematic. It holds meaning for us that is beyond expression in words. These prints express innocence of mind. If you can go with them and hold your mind as empty as and as tranquil as they are and recognize your feelings

at the same time, you will realize your full response to this work." [31]

The Martin portfolio was printed under the supervision of Luitpold Domberger in Stuttgart from the artist's precisely rendered sketches and published by Parasol Press in an edition of fifty with fourteen artist's proofs lettered A–N.

Some of the younger painters have produced prints that reflect other aspects of the Minimalist/Conceptualist vision. Among them are: Robert Ryman, Brice Marden, Robert Mangold, and a few others. Robert Ryman first began printmaking in 1972 at the Crown Point Press, where he issued his portfolio simply titled *Seven Aquatints*. Two years later he completed a second series that continued his basic explorations of the aquatint medium and its properties as well as the materials involved in this particular process. In this series, the artist develops particular judgments and choices in regard to the subtleties of the white inks of the aquatint as opposed to the white tone of the paper, the linear sequences of the straight or deckle edges, or the occasional diagonal slant of a triangular form. Ryman condones no outside references and limits his nearly square compositions to a consideration of the materials and the process of aquatint. He firmly states:

"It is absolutely necessary for me to work with a skilled printer sensitive to all of the variables involved in such things as etching the plates and running the press. I do all of the initial process myself, the actual making of the plates, decisions about how thick the ink should be, what the texture should be like, which paper to use, etc. The way the prints are signed, the location of the signature and edition numbers, the use of dry stamps—all these things are important and part of the essential process of printmaking. The aquatint plates themselves are not so much the image as they are printed portions of a whole which is the sum of every visual element within the prints." [32]

The formal aspects of the physical properties of the intaglio print are also the concern of Robert Man-

149 ARAKAWA, SHUSAKU (b. 1936), *The Signified or If,* 1975–76. Etching, aquatint, 30×
42 (76.4×106.7). Photo courtesy Multiples, Inc.

gold, Brice Marden, Edda Renouf, and a few others. Their work, like Ryman's, was first accomplished at the Crown Point Press. Mangold's preferred forms are those of the circle and square and their slight distortions. His ability to balance lines and soft, muted tones of orange and brown gives special refinement to otherwise predictable forms. Brice Marden considers etchings and aquatints as secondary to and somewhat detached from his paintings and drawings. Perhaps they serve the artist as exploratory exercises in the differing values and intensities of solid rectangles and grids. They are presented as complete in a series of five to seven prints arranged in strict sequences. One of Marden's most searching series is his early portfolio *Ten Days*, issued in 1971. The artist has utilized old copper plates that still carry faint traces of earlier images along with the scratches and accident nicks of its former usage. These random elements Marden has incorporated into his own paneled grids, resulting in a muted, patterned surface that is both rich and often obscure.

Since the Cubists' use of letters or random names in their visual explorations, modern artists have pursued the visual properties of a language, whether it be a single word, phrases out of context, or in directional diagrams. Linguistic aids and variations of minimal images have concerned the recent Conceptualists. Posters, signs, instructional directions, maps, and the trappings of commercial advertising and mathematical equations have been the source of progressing visual ideas and symbols. One of the most gifted of these artists acknowledging the Conceptualists' vision is Shusaku Arakawa. Born in Japan in 1936, he has lived and worked in New York for the past decade. His serious work in printmaking began at Tamarind in 1965. Unlike those artists who consider "the idea" itself as the work of art and delegate the physical completion to trained assistants, Arakawa is deeply and actively involved in the entire operation. His knowledge of and his superb skills in the print media are ready tools to be utilized in his ambitious pursuit of "making visible the invisible." His early works are composed of abstract words juxtaposed with diagrammatic lines. These are soon followed by large-scale prints in designated series. To achieve his "visual" goals Arakawa states that he draws upon the disciplines of philosophy, science, mathematics, linguistics, and aesthetics because "one is not enough." Each of

Arakawa's series is a spirited journey into time and space requiring agile mental and visual gymnastics of no small order. Through multiple perspectives, open-ended grids, subtle color fields, and unexpected aphorisms Arakawa creates a sense of disorientation and provokes confusion and sly visual riddles. His orchestration of conflicting perspectives and multidimensional space produces a beguiling linear poetry leading the eye to "somewhere" or "nowhere" in an exploration of time and space.

Arakawa's recent series, *The Signified or If*, 1975–76, charts some of Wittgenstein's philosophical theories that have held the interest of conceptual artists.[33] On occasion Arakawa has questioned or brushed aside the Wittgenstein conclusion that "What we cannot speak about we must pass over in silence." Arakawa's improvisations become a vast network of interlocking systems wherein the artist seeks out new and perhaps unrelated meanings that are thought provoking, startling, and sometimes wittily nonsensical. This series of seven large-scale etchings with aquatint and the succeeding *Flash Gravity* of 1977, a twenty-seven-color lithograph and screen print, both published by Multiples, Inc., are among Arakawa's most arresting prints. In his long and continuing investigation of "meaning" Arakawa, through his finely honed abstract imagery and his distinctive sense for language, has produced a graphic oeuvre that is highly visual and introspective.

Unlike the artists of the 1950s and a few independent artists of the 1960s, the utilization of color is muted and plays a secondary role in the prints of those artists who subscribe to the Superrealist, Minimal, or Conceptual modes of expression. Their quest for a purity of vision is through the utilization of strict photographic details or through the reductive means of analyzing and interpreting basic elements in terms of lines, grids, restrictive symbols, and textures. Some artists confine their visual essays within the mechanics of a single print process in order to designate minute variations in texture and tonal effects. How long their particular images may hold the attention of the viewer or of the artists themselves remains to be ascertained. Their decisive and restrictive imagery and the differing imagery of many other artists must finally chart printmaking in the remaining two decades of this century.

EPILOGUE

This chronicle has attempted to chart the major developments and changes that have occurred in American prints during the past eight decades of this century. In the later years of the 1930s the artist began an exploration of new modes of expression and new materials. These efforts rapidly grew in momentum. In the decades of the 1940s and '50s an enlarged technical development continued to be fueled by the artists' interest in the basic structures of the natural environment in both a figurative and an abstract idiom. Images and compositions in large scale, the expanding utilization of strong, clear colors, further technical experimentation in the combining of different print media demanded imagination and skills. Generally during this period the printing itself was accomplished by the artist, often in his own studio. Early in the twentieth century a sense of the third dimension was carried out through the manipulation of established laws of perspective. By mid-century the artist began a search for a change in the surface plane rather than in the conventional use of formal perspective. Occasionally this was accomplished through variations in low-relief printing or by the actual piercing of the paper itself to give depth and shadows to a composition.

The 1960s saw a determined thrust away from the abstract image and the traditional concept of nature as the basis for works of art. With sudden dispatch the most commonplace images and cast-off objects of an urbanized society flooded the new prints and paintings. Also, it was the period when lithography became a highly professional print medium in the United States. The growing numbers of well-trained master printers gave new impetus to the American print. Many painters and sculptors turned to prints not to fashion new techniques but to utilize the existing print technologies in the pursuit of their own particular visual ideas. Their intent was to maintain an objective, noncommittal attitude toward the images they sought to portray. No clues were given in the presentation of their private and often ambiguous symbols. The "message," if there was one, was apt to be concealed in the subtle manipulation of the medium itself. The proliferation of professional graphic workshops gave encouragement to other modes or styles, including Minimal and Conceptual expressions where the emphasis was on the point of view that "less is more." Perhaps the Conceptualist vision presented through systems of grids, lines, and limited color tonalities forces the viewer to a more concentrated observation. It also invites and sometimes requires a literary or verbal accompaniment. Possibly the end result is to clear the retina from its accustomed acceptance of great splashes of color, amorphous forms, grandly gestural imagery, and illusive ambiguities. A more contemplative vision may lead to still other directions for prints in the remaining decades of this century. In turn, Minimal and Conceptual images may become repetitive and even devoid of a sustaining interest.

As the period of the 1970s came to a close, no single style or mode dominated the field of prints. The beguiling and sometimes dangerous gift of facility may lead to a thinness of vision and a mindless repetition of motifs. In the end it is not the technical proficiencies and the glib conceits of an era but the imaginative ideas and sensibilities of the artist that create and finally measure a work of art. It has been the American artist's will to explore and his ability to accept and utilize change in a volatile environment that have given diversity, vigor, and a sense of exuberance to the many distinguished prints of this century.

NOTES

CHAPTER I

1. Nathaniel Pousette-Dart. *Ernest Haskell: His Life and Work*. New York: T. Spencer Huston, 1931, p. 11.
2. Cadwallader Washburn. "Notes of an Etcher—Maine and Mexico." *Print Collector's Quarterly*, Vol. 1, October 1911, pp. 477–78.
3. Emanuel Mervin Benson. *John Marin: The Man and his Work*. Washington, D.C.: American Federation of Arts, 1935, pp. 65–66.
4. From 1901 to 1906 Dow issued a continuing series entitled *Ipswich Prints*. Woodcuts based on his watercolors, they were intended as study guides to be used in public schools.
5. Una E. Johnson. *American Woodcuts, 1670–1950. A Survey*. Brooklyn: The Brooklyn Museum, 1950, p. 20.
6. ———. "The Woodcuts and Lithographs of Max Weber." *The Brooklyn Museum Bulletin*, Vol. 9, no. 4, 1948, p. 38.
7. Daryl P. Rubenstein. "Max Weber. A Catalogue raisonné of His Woodcuts and Lithographs." Manuscript. Courtesy of the author.
8. Jo Miller. "The Prints of Arshile Gorky." *The Brooklyn Museum Annual*, Vol. VI, 1964–65, pp. 57–61.
9. See Thomas Moran's lithograph *Solitude*, 1869, for his successful graphic presentation of a large vista.
10. Winifred Austin. "Catalogue raisonné of the Etchings of George Elbert Burr." *The Print Connoisseur*, Vol. 3. January 1923, pp. 81–86.
11. *Etchings by Charles Woodbury*. Exhibition catalog, February 18–March 14, 1925. New York: Frederick Keppel & Co., unp.
12. *George Overbury "Pop" Hart 1868–1933*. Exhibition catalog of oils, watercolors, drawings, and prints. Newark, N.J.: The Newark Museum, 1935, pp. 21–22.
13. Thomas Beer. *George Bellows. His Lithographs*. New York: Alfred A. Knopf, 1927, p. 22.
14. Norman Sasowsky. *Reginald Marsh*. Introduction by Isabel Bishop. New York: Frederick A. Praeger, 1956, p. IX.
15. Una E. Johnson. *Paul Cadmus, Prints and Drawings, 1922–1967*. Catalog Listing by Jo Miller. Nos. 76 and 78. Brooklyn: The Brooklyn Museum, 1968.
16. Laurance P. Hurlburt. "The Siqueiros Experimental Workshop, New York, 1936." *Art Journal*, Vol. 35, no. 3, Spring 1976, pp. 237–46.

CHAPTER II

1. Seong Moy. [Portfolio of Five Original Woodcuts in Color.] Introduction by Una E. Johnson. New York: Ted Gotthelf Publisher, 1952.

　　Titles: 1. Inscription of T'Chao Pae No. II. 2. Yen Shang.
3. The Royal Family. 4. Study of Kuang Kung. 5. Dancer in Motion.
2. *Worden Day. Paintings, Collages, Drawings, Prints*. Exhibition catalog, October 4–25, 1959. Introduction by Una E. Johnson. Montclair, N.J.: Montclair Art Museum, 1959.
3. Mercedes Molleda. *Tres pintores norteamericanos en España: von Wicht, Narotzky, Ulbright*. Madrid: Museo de Arte Contemporaneo (Contemporary Arts Press), 1960, unp.
4. Carol Summers. "Print Techniques in the 1962 Cincinnati Biennial Exhibition." *Artist's Proof*, No. 4, 1962, p. 32.
5. *Rico Lebrun Drawings*. Foreword by James Thrall Soby. Los Angeles: University of California Press, 1961, pp. 4–5.
6. Anne Lyon Haight, ed. *Portrait of Latin America as Seen by Her Printmakers*. New York: Hastings House Publishers, 1946, illus. p. 24.
7. "Graphic Artists: Leonard Baskin." *Art in America*, Vol. 44, no. 1, February 1956, p. 48. See also: Alan Fern. *Leonard Baskin*. Annotated by Leonard Baskin. Washington, D.C.: The Smithsonian Institution Press, 1970, p. 15.
8. Ben Shahn. *Paragraphs on Art*. New York: The Spiral Press, 1952, unp.
9. Sid Hammer. "The Thermo-Intaglio Print." *Artist's Proof*, No. 4, Fall/Winter 1962, pp. 43–44.
10. Michael Croydon. *Ivan Albright*. Foreword by Jean Dubuffet. New York: Abbeville Press, Inc., 1977, pp. 8–9.
11. Una E. Johnson. *John Paul Jones. Prints and Drawings, 1948–1963*. Catalog Listing by Jo Miller. Brooklyn: The Brooklyn Museum, 1963, p. 13.
12. ———. *Milton Avery, Prints and Drawings, 1930–1964*. Commemorative Essay by Mark Rothko. Catalog Listing by Jo Miller. Brooklyn: The Brooklyn Museum, 1966, p. 14.
13. The Brooklyn Museum. *14 Painter-Printmakers*. Exhibition catalog, November 16, 1955–January 8, 1956.

CHAPTER III

1. William S. Lieberman. "Printmaking and the American Woodcut Today." *Perspectives U.S.A.*, No. 12, Summer 1955. New York: Intercultural Publications, 1955, p. 54.
2. Una E. Johnson. *Louise Nevelson. Prints and Drawings 1953–1966*. Catalog Listing by Jo Miller. Brooklyn: The Brooklyn Museum, 1967, p. 14.
3. Michael Mazur. "The Monoprints of Naum Gabo." *The Print Collector's Newsletter*, Vol. 9, no. 5, November–December 1978, pp. 148–51.
4. Joan Farrar. "The Embossed Lithographs of Angelo Savelli." *Artist's Proof*, No. 8, 1965, pp. 41–42.
5. Y. Ernest Satow. "An Appreciation of Yasuhide Kobashi." *Artist's Proof*, No. 2, 1961, pp. 24–25.

6. Joseph E. Young. "Claes Oldenburg at Gemini." *Artist's Proof*, Vol. 9, 1969, pp. 44–52.
7. John Loring. "Judding from Descartes, Sandbaching and Several Tautologies," *The Print Collector's Newsletter*, Vol. 7, no. 6, January 1977, pp. 65–68.

CHAPTER IV

1. *The Monotypes of Joseph Solman*. Introduction by Una E. Johnson. New York: DaCapo Press, 1977, unp.
2. Michael Ponce de Leon. "The Metal Collage Intaglio Print." *Artist's Proof*, No. 7, 1964, pp. 52–54.
3. Garner Handy Tullis. "Embossments." *Artist's Proof*, Vol. 7, 1967, p. 87.
4. Nancy Tousley. *Prints: Bochner, LeWitt, Mangold, Marden, Martin, Renouf, Rockburne, Ryman*. Exhibition catalog, December 18, 1975–January 18, 1976. Toronto: Art Gallery of Ontario, 1975, pp. 45–46.
5. Joseph E. Young. "Pages and Fuses: An Extended View of Robert Rauschenberg," *The Print Collector's Newsletter*, Vol. 5, no. 2, May–June 1974, pp. 25–30.
6. Carter Ratcliff. "Dorothea Rockburne: New Prints." *The Print Collector's Newsletter*, Vol. 5, no. 2, May–June 1974, pp. 30–32.

CHAPTER V

1. Janet Flint. *George Miller and American Lithography*. Exhibition catalog, National Collection of Fine Arts, 1976. Washington, D.C.: The Smithsonian Institution, 1976.
2. Clinton Adams. "Lynton R. Kistler and the Development of Lithography." Tamarind Technical Papers, No. 8, Winter 1977–78, pp. 100–9.
3. ———. "Lawrence Barrett: Colorado's Prophet of Stone," *Artspace*, Vol. 3, no. 4, Fall 1978, pp. 38–43.
4. Calvin Tomkins. "The Moods of a Stone [Tatyana Grosman]." Profiles, *The New Yorker*, June 7, 1976, p. 76.
5. Museum of Modern Art. *Tamarind: Homage to Lithography*. Introduction by Virginia Allen. Exhibition catalog, April 29–June 30, 1969. New York: The Museum of Modern Art, 1969, p. 10.
6. Ibid., p. 10.
7. Kathan Brown. *Crown Point Press*. Oakland, California: Crown Point Press, 1977, unp.
8. Nancy Tousley. *Prints: Bochner, LeWitt, Mangold, Marden, Martin, Renouf, Rockburne, Ryman*. Exhibition catalog, December 18, 1975–January 18, 1976. Toronto: Art Gallery of Canada, 1975.
9. *Graphicstudio U.S.F. An Experiment in Art and Education*. Introduction and Interview by Gene Baro and Donald Saff. Exhibition catalog, May 13–July 16, 1978. Brooklyn: The Brooklyn Museum, 1978, p. 7.

CHAPTER VI

1. There are various recorded versions of Warhol's remarks. See Samuel Adams Green, Introduction to the first Warhol retrospective exhibition at the Institute of Contemporary Art, Philadelphia, 1965. Reprinted excerpts in *The New Art. A Critical Anthology*. Edited by Gregory Battcock. New York: E. P. Dutton & Co., paperback edition, 1966, p. 231.
2. Roberta Bernstein. "Rosenquist Reflected: The Tampa Prints." *The Print Collector's Newsletter*, Vol. 4, no. 1, March–April 1973, pp. 6–8.
3. It is coincidental that Liliana Porter earlier in the 1970s made a number of screen prints in which she utilized actual nails to pierce the printed surface of the print to contrast images and create a sense of the third dimension.

4. James Rosenquist. "Prints and Portfolios Published." *The Print Collector's Newsletter*, Vol. 5, no. 3, July–August 1974, p. 66.
5. Richard Fields. *Jasper Johns. Prints 1960–1970*. Introduction and Catalog raisonné. Philadelphia: Museum of Art, 1970. Introduction, unp.
6. Gemini G.E.L. "Jasper Johns, 6 Lithographs (after *Untitled 1975*)." Introduction by Barbara Rose. Los Angeles: Gemini G.E.L., 1976, unp.
7. Suzi Gablik. "Jasper Johns's Picture of the World." *Art in America*, January–February 1978, pp. 62–69.
8. Lawrence Alloway. *Topics in American Art Since 1945*. New York: W. W. Norton & Company, 1975, pp. 134–35. Quotations from Robert Rauschenberg, "Notes on Stoned Moon," *Studio International*, Vol. 178, 1969, pp. 246–47.
9. "Two Artists Discuss Their Recent Work," *Studio International Supplement*, Lithographs and Original Prints, Vol. 175, June 1968, p. 337. See also *Artist's Proof*, Vol. 6, 1966, p. 101, "Prints: Another Thing" by Jim Dine.
10. Jim Dine and Thomas Krens. *Jim Dine Prints: 1970–1977*. Essay by Riva Castleman. New York: Harper & Row, Publishers in association with Williams College, 1977. Catalog nos. 199–208.
11. Richard Anuszkiewicz. "Simple Form, Simple Color," *Time*, Vol. 82, no. 3, July 19, 1963, pp. 56–59.
12. Ibid.
13. Jane Haslem Gallery. "Misch Kohn: Recent Prints," *Newsletter*, Winter 1977, unp.
14. Dean Meeker. "Statements by the Artist." *Dean Meeker*. Exhibition catalog, October 4–November 13, 1964. Miami Beach: Washington Federal Bank, 1964, unp.
15. Janet Flanner. "Tobey, mystique errant." *L'Oeuil, Revue d'Art Mensuelle*, no. 8, June 15, 1955, pp. 26–31.
16. Jill Dunbar. "Isabel Bishop: Painter in Residence at the 14th Street 'School' for Six Decades." A feature article, *The Village Voice*, New York, September 15, 1977.
17. From the documentary film *Isabel Bishop. Portrait of an Artist*. New York Film Co., Inc. Production. Directed by Patricia De Pew. Produced and photographed by John Beymer, 1977.
18. Quoted from a letter from the artist to the author dated 11.22.78.
19. Sam Francis' first attempt in lithography was at Universal Limited Art Editions in 1959. These prints were not completed until nine years later after the artist had worked in Paris and at Tamarind.
20. Una E. Johnson. "The Intaglio Prints of Bernard Childs." *Art in America*, November–December 1969, pp. 118–21.
21. Hollanders Workshop. Portfolio 9. Original lithographs by Willem de Kooning, Sam Francis, Ellsworth Kelly, Roy Lichtenstein, Richard Lindner, Robert Motherwell, Louise Nevelson, Henry Pearson, and Saul Steinberg. Introduction by Una E. Johnson. New York: Hollanders Workshop, n.d.
22. Dore Ashton. *Richard Lindner*. New York: Harry N. Abrams, 1970, p. 63.
23. Lefebre Gallery. *Walassie Ting*. Exhibition catalog, September 24–October 18, 1969. New York: Lefebre Gallery, 1969, unp.
24. Walassie Ting. *1¢ Life*. Portfolio of original lithographs assembled by Walassie Ting with his text. American artists represented: Jim Dine, Sam Francis, Robert Indiana, Alfred Jensen, Allen Kaprow, Alfred Leslie, Roy Lichtenstein, Joan Mitchell, Claes Oldenburg, Mel Ramos, Robert Rauschenberg, James Rosenquist, Kimber Smith, Walassie Ting, Andy Warhol, and Tom Wesselmann.

25. *Masuo Ikeda, Etchings and Lithography from 1968–1970.* New York: Associated American Artists, 1970, Exhibition catalog, nos. 26–31.

26. Rand Castile. "Japanese Printmaking Today." *The Print Collector's Newsletter,* Vol. 1, no. 3, July–August 1970, pp. 54–57.

27. William M. Ivins, Jr. *Prints and Visual Communication.* Cambridge: Harvard University Press, 1953, pp. 156–57.

28. Nancy Tousley. "In Conversation with Kathan Brown." *The Print Collector's Newsletter,* Vol. 8, no. 5, November–December 1977, p. 133.

29. Michael Shapiro. "Changing Variables: Chuck Close and His Prints." *The Print Collector's Newsletter,* Vol. IX, no. 3, July–August 1978, pp. 69–73.

30. Ludwig Wittgenstein was born in Vienna in 1889, one of a large family all of whom were aesthetically and musically talented. The father considered such interests as merely sidelines for his sons. The only career was his own, that of a civil engineer. Ludwig, the eighth child, went to Manchester, England, to study engineering at the age of about nineteen but in 1911 his greatest interest had become the philosophy of mathematics. He went on to Cambridge to study with Bertrand Russell. From 1912 to 1917 he was deeply involved in a work now known as *Tractatus Logico-philosophicus,* the greater part of which was written while in active service in the Austrian Army. He later made a number of revisions to this work.

31. Nancy Tousley. *Prints: Bochner, LeWitt, Mangold, Marden, Martin, Renouf, Rockburne, Ryman.* Toronto: The Art Gallery of Ontario, 1975, Exhibition catalog, December 18, 1975–January 18, 1976, p. 37.

32. Ibid., pp. 49–50.

33. John Loring. "Re Turning Point and Revolutions." *The Print Collector's Newsletter,* Vol. 8, no. 2, May–June 1977, pp. 37–39.

34. Ludwig Wittgenstein. *Tractatus Logico-philosophicus.* London: Routledge & Kegan Paul, 1961. See also: G. E. M. Anscome. *An Introduction to Wittgenstein's Tractatus.* Philadelphia: University of Pennsylvania Press, 1971, paperback reprint.

SELECTED BIBLIOGRAPHY

Alasko, R. R. *Robert Indiana Graphics*. Notre Dame: St. Mary's College, 1969.

Alexander, Brooke. *Selected Prints, 1960–1977. A Catalogue of 247 Prints*. New York: Brooke Alexander, Inc., 1977.

Alloway, Lawrence. *Topics in American Art Since 1945*. New York: W. W. Norton & Company, Inc., 1975.

American Abstract Artists. *The World of Abstract Art*. New York: George Wittenborn, [1957].

American Artists Congress. *American Printmaking Today. A Book of 100 Prints*. New York: American Artists Congress, 1936. Paperback published by Da Capo Press, New York, 1977.

Artist's Proof. Annual of Printmaking, Vols. 1–11, 1961–71. Edited by Fritz Eichenberg. Published by Pratt Graphics Center, New York.

Ashton, Dore. *Richard Lindner*. New York: Harry N. Abrams, 1970.

Austin, Winifred. "Catalogue raisonné of the etchings of George Elbert Burr." *The Print Connoisseur*, Vol. 3, January 1923, pp. 81–86.

The Baltimore Museum. *The Work of Antonio Frasconi 1952–1963. Woodcuts, Lithographs and Books*. Exhibition catalog, November 1963. Baltimore: The Museum of Art, 1963.

Will Barnet Etchings, Lithographs, Woodcuts, Serigraphs, 1932–1972. Catalogue raisonné. Compiled and edited by Sylvan Cole, Jr. Introduction by Robert Doty. New York: Associated American Artists, 1972.

Baro, Gene. *Louise Nevelson, the Prints, 1953–1974*. New York: Pace Editions, 1974.

Baro, Gene and Donald Saff. *Graphicstudio U. S. F. An Experiment in Art and Education*. Exhibition catalog. Brooklyn: The Brooklyn Museum, 1978.

Barooshian, Martin. "Folio of Three American Regionalist Printmakers [Gene Kloss, Reginald Weidenaar, Armin Landeck]." *Print Review*, No. 4, 1975, pp. 40–58.

Bartholmew, Richard. *Krishna Reddy*. Contemporary Indian Art Series. New Delhi: Lalit Kalā Akademi, 1974.

Basshan, Ben L. *John Taylor Arms, American Etcher*. Madison, Wisconsin: The Elvehjem Art Center, 1975.

Battcock, Gregory, ed. *Idea Art. A Critical Anthology*. New York: E. P. Dutton & Co., 1973, paperback.

———. *Minimal Art. A Critical Anthology*. New York: E. P. Dutton & Co., 1968, paperback.

———. *The New Art. A Critical Anthology*. New York: E. P. Dutton & Co., 1966, paperback.

Beall, Karen F. *American Prints in the Library of Congress. Catalog of the Collection*. Baltimore: The Johns Hopkins Press, 1970.

Bearden, Romare. *The Prevalence of Ritual*. Introductory Essay by Carroll Greene. Exhibition catalog, March 25–June 7, 1971. New York: The Museum of Modern Art, [1971].

Benson, Emanuel Mervin. *John Marin: The Man and His Work*. Washington, D.C.: The American Federation of Arts, 1935.

Bernstein, Roberta. "Rosenquist Reflected: The Tampa Prints." *The Print Collector's Newsletter*, Vol. 4, no. 1, March–April 1973, pp. 6–8.

Bloch, E. Maurice. *Words and Images*. Exhibition catalog sponsored by UCLA Arts Council. Los Angeles: Dickson Art Center, 1978.

Breeskin, Adelyn D. *The Graphic Work of Mary Cassatt. A Catalogue raisonné*. New York: H. Bittner, 1948.

———. *The Graphic Art of Mary Cassatt*. New York: The Museum of Graphic Art and Smithsonian Institution Press, 1967.

The Brooklyn Museum. National Print Exhibition. Catalogs 1947– . Brooklyn: The Brooklyn Museum, 1947– .

Castleman, Riva. *Modern Art in Prints*. Exhibition catalog, 1973. New York: The Museum of Modern Art, 1973.

———. *Prints of the Twentieth Century: A History*. New York: The Museum of Modern Art, 1976.

Charlot, Jean. *American Printmaking, 1913–1947*. Retrospective exhibition at The Brooklyn Museum. November 18–December 16, 1947. New York: American Institute of Graphic Arts, 1947.

Childs, Bernard. "Tropical Noon: High Speed Presses and the Unlimited Edition." *Artist's Proof*, Vol. 10 (1970), pp. 84–86.

Clayton, Leonard. *Handbook of the Complete Set of Etchings and Drypoints of Childe Hassam*. Introduction by Paula Eleasoph. New York: The Leonard Clayton Gallery, 1933.

Cochrane, Diane. *Michael Ponce de Leon*. New York: Pioneer-Moss Gallery, 1975.

Colsman-Freyberger, Heidi. "Robert Motherwell: Words and Images." *The Print Collector's Newsletter*, Vol. 4, no. 6, January–February 1974, pp. 125–31.

Cortissoz, Royal. *Catalogue of the Etchings and Drypoints of Childe Hassam*. New York: Charles Scribner's Sons, 1925.

Cox, Richard. *Caroline Durieux. Lithographs of the Thirties and Forties*. Baton Rouge: Louisiana State University Press, 1977.

Crone, Rainer F. *Andy Warhol*. New York: Frederick A. Praeger, 1970.

Davis, Richard A. "The Graphic Work of Yasuo Kuniyoshi. 1893–1953." *Archives of American Art Journal*, Vol. 5, no. 3, July 1965.

De Cordova and Dana Museum. *Fifty American Print-makers*. Exhibition catalog, April 30–June 11, 1961. Lincoln, Mass.: De Cordova and Dana Museum, 1961.

Drewes, Werner. *Woodcuts*. Essay by Jacob Kainen. Exhibition catalog by Caril Dreyfuss. National Collection of Fine Arts, August 15–October 5, 1969. Washington, D.C.: Smithsonian Institution Press, 1969.

Drot, Jean-Marie. "Le Peinture Americain Bernard Childs." *Connaissance des Arts*, Mai 1976, pp. 56–63.

Dückers, Alexander. *Philip Pearlstein: Zeichnungen und aquarelle: Die Drückgraphik*. Berlin-Dahlem: Staatliche Museem Preussischer Kulurbesitz Kupferstech Cabinett, 1972.

Eichenberg, Fritz. *The Art of the Print*. New York: Harry N. Abrams, 1976.

Farrar, Joan. "The Embossed Lithographs of Angelo Savelli." *Artist's Proof*, No. 8, 1965, pp. 41–42.

Fath, Creekmore. *The Lithographs of Thomas Hart Benton*. Austin: University of Texas Press, 1969.

Fern, Alan. *Leonard Baskin*. Annotated by Leonard Baskin. Published for the National Collection of Fine Arts. Washington, D.C.: Smithsonian Institution Press, 1970.

Fields, Richard S. *Jasper Johns. Prints 1960–1970*. Philadelphia: Museum of Art, 1970.

———. *Jasper Johns. Prints 1970–1977*. Middletown, Conn.: Wesleyan University, 1978.

Finkelstein, Irving L. "Julia Passing: The World of Peter Milton." *Artist's Proof*, Vol. 11, 1971, pp. 71–77.

Flanner, Janet. "Tobey, mystique errant." *L'Oeuil*, Paris, June 15, 1955, pp. 26–31.

Flint, Janet A. *Jacob Kainen: Prints. A Retrospective*. Published for The National Collection of Fine Arts. Washington, D.C.: Smithsonian Institution Press, 1976.

———. *George Miller and American Lithography*. Exhibition catalog. Published for The National Collection of Fine Arts. Washington, D.C.: Smithsonian Institution Press, 1976.

———. *Herman A. Webster. Drawings, Watercolors and Prints*. Exhibition catalog, February 15–April 21, 1975. Published for The National Collection of Fine Arts. Washington, D.C.: Smithsonian Institution Press, 1974.

Foster, E. A. *Robert Rauschenberg Prints, 1948–1970*. Exhibition catalog. Minneapolis: Institute of Art, 1970.

Francis, Sam. *Werke, 1960–1961*. Berne, Switzerland: Kornfeld and Klipstein, 1961.

Frankenthaler, Helen. "The Romance of Learning a New Medium for the Artist." *The Print Collector's Newsletter*, Vol. 8, no. 3, July–August 1977, pp. 66–67.

Freeman, Richard B. *Ralston Crawford. Paintings and Prints*. University, Alabama: University of Alabama Press, 1953.

Freundlich, August L. *Federico Castellon, His Graphic Works, 1936–1971*. Syracuse, N.Y.: Syracuse University Press, 1978.

Friedman, Martin and Claes Oldenburg. *Oldenburg—Six Themes*. Minneapolis: Walker Art Center, 1975.

Friedman, William. *The Work of Mauricio Lasansky and Other Printmakers Who Studied with Him at the University of Iowa*. Exhibition catalog. Buffalo, N.Y.: Albright Art Gallery, 1959.

Gablik, Suzi. "Jasper Johns's Picture of the World." *Art in America*, January–February 1978, pp. 62–69.

Geske, Norman. *Rudy Pozzatti—American Printmaker*. Lawrence, Kansas: University of Kansas Press, 1971.

Getscher, Robert H. *The Stamp of Whistler*. Introduction by Allen Staley. Exhibition catalog. Oberlin, Ohio: Allen Memorial Art Museum, 1977.

Gilmour, Pat. *Modern Prints*. New York: Studio Vista/Dutton, 1970.

———. "Thoughts of a Dry Brain in a Dry Season." *Visual Dialog*, Vol. 3, no. 3, Spring 1978, pp. 2–4.

Godefroy, Louis. *The Etchings of J. W. Winkler, 1915–1923*. *The Print Connoisseur*, Vol. 4, April 1924, pp. 169–91.

Gordon, John. *Jim Dine*. Exhibition catalog. New York: Whitney Museum of American Art, 1970.

———. *Karl Schrag*. New York: The American Federation of Arts, 1960.

Grayson, Gard. *Graven Image. The Prints of Ivan Albright, 1931–1977*. Lake Forest, Ill.: Lake Forest College, 1978.

Griffith, Fuller. "Lithographs of Childe Hassam." *U. S. National Museum Bulletin*, No. 232, Washington, D.C., 1962.

Hamilton, George Heard. *Josef Albers: Paintings, Prints, Projects*. Exhibition catalog. New Haven, Conn.: Yale University Gallery, 1956.

Hayter, Stanley William. *About Prints*. London: Oxford University Press, 1962.

———. *New Ways of Gravure*. London: Oxford University Press, 1966, rev. ed.

Heller, Jules. *Printmaking Today*. New York: Holt, Rinehart and Winston, 1972, 2nd ed.

Hentoff, Nat and Charles Parkhurst. *Frasconi. Against the Grain*. New York: Collier Books, 1974.

Hurlburt, Laurance P. "The Siqueiros Experimental Workshop New York, 1936." *Art Journal*, Vol. 35, no. 3, Spring 1976, pp. 237–46.

"The Ides of Art." With commentary by eleven artists. *Tiger's Eye*, Vol. I, no. 8, June 1949, pp. 17–18.

Ikeda, Masuo. *Masuo Ikeda, Etchings and Lithographs*. Introduction by Jo Miller. Compiled and edited by Sylvan Cole, Jr. New York: Associated American Artists, 1970.

———. *Graphic Works*. Tokyo: Bijutsu Shuppan-sha, 1972. (Text in Japanese and English.)

Johnson, Elaine L. *Contemporary Painters and Sculptors as Printmakers*. Exhibition catalog. New York: The Museum of Modern Art, 1968.

Johnson, Ellen M. "Jim Dine and Jasper Johns." *Art and Literature*, Vol. 6, Autumn 1965, pp. 128–40.

Johnson, Una E. *American Woodcuts, 1670–1950. A Survey*. Brooklyn: The Brooklyn Museum, 1950.

———. *Milton Avery. Prints and Drawings, 1930–1964*. Commemorative Essay by Mark Rothko. Catalog listing by Jo Miller. Brooklyn: The Brooklyn Museum, 1966.

———. *Isabel Bishop, Prints and Drawings, 1925–1964*. Catalog listing by Jo Miller. Brooklyn: The Brooklyn Museum, 1964.

———. *Paul Cadmus, Prints and Drawings, 1922–1967*. Catalog listing by Jo Miller. Brooklyn: The Brooklyn Museum, 1968.

———. *Bernard Childs, Paintings/Prints/Images in Light*. Exhibition catalog, July 26–October 31, 1969. Mountainville, N.Y.: Storm King Art Center, 1969.

———. "The Intaglio Prints of Bernard Childs." *Art in America*, November–December 1969, pp. 118–21.

———. *John Paul Jones, Prints and Drawings, 1948–1963*. Catalog listing by Jo Miller. Brooklyn: The Brooklyn Museum, 1963.

———. *Louise Nevelson, Prints and Drawings, 1953–1966*. Catalog listing by Jo Miller. Brooklyn: The Brooklyn Museum, 1967.

———. *Gabor Peterdi, Graphics, 1934–1969*. New York: Touchstone Publishers Ltd., 1970.

———. *Gabor Peterdi, Twenty-five Years of His Prints, 1934–1959.* Brooklyn: The Brooklyn Museum, 1959.

———. *Ten Years of American Prints, 1947–1956.* Brooklyn: The Brooklyn Museum, 1956.

———. "The Woodcuts and Lithographs of Max Weber." *The Brooklyn Museum Bulletin*, Summer 1948, Vol. 9, no. 4, pp. 7–12.

———. *Adja Yunkers, Prints, 1927–1967.* Catalog listing by Jo Miller. Brooklyn: The Brooklyn Museum, 1967.

Kainen, Jacob. "Prints of the Thirties: Reflections on the Federal Arts Project." *Artist's Proof*, Vol. 11, 1971, pp. 34–40.

Karshan, Donald. *Archipenko: The Sculpture and Graphic Art.* Including a Print Catalogue raisonné. Tübingen, Germany, Ernst Wasmuth, 1974.

Kastner, Fenton. *Etchings, Drawings and Boxes: John W. Winkler.* Exhibition catalog, November 16–December 15, 1974. San Francisco: Palace of the Legion of Honor, 1974.

R. B. Kitaj, Complete Graphics 1964–1969. Berlin: Galerie Mikro, 1969.

Kraeft, June and Norman. *Armin Landeck.* Catalogue raisonné of his prints. Bethlehem, Conn.: June 1 Gallery, 1977.

Krens, Thomas. *Jim Dine's Prints, 1970–1977.* Conversations with Jim Dine. Essay by Riva Castleman. Williamstown, Mass.: Williams College, 1977.

Mauricio Lasansky, Printmaker. Introduction by Alan Fern. Catalog by Stephen Rhodes. Iowa City: University of Iowa Press, 1975.

Library of Congress. *Papermaking—Art and Craft.* An account derived from the exhibition presented in the Library of Congress, April 21, 1968.

Lieberman, William S. "Printmaking and the American Woodcut Today." *Perspectives U.S.A.*, No. 12, Summer 1955, pp. 43–58.

Lindner, Richard. *Fun City Original Watercolors.* Excerpts from *Richard Lindner* by Dore Ashton. Exhibition catalog, October 12–November 24, 1971. New York: Spencer A. Samuels & Co., 1971.

Livingston, Jane. "Frank Stella Lithographs, Gemini." *Art Forum*, November 1967, pp. 66–67.

Lefebre, John. *Walasse Ting.* Exhibition catalog, September 24–October 18, 1969. New York: Lefebre Gallery, 1969.

Longo, Vincent. *Printing Retrospective Exhibition 1954–1970.* Introduction by Gene Baro. Exhibition catalog, April 3–May 17, 1970. Washington, D.C.: The Corcoran Gallery, 1970.

Loring, John. "Re Turning Points and Revolutions." *The Print Collector's Newsletter*, Vol. 8, no. 2, May–June 1977, pp. 37–39.

Lunn, Harry H. *Milton Avery, Prints 1933–1955.* Washington, D.C.: Graphics International Ltd., 1973.

McCarron, Paul. *Martin Lewis. The Graphic Work.* New York: Kennedy Galleries, 1973.

McCausland, Elizabeth. "The Lithographs of Marsden Hartley." *Artist's Proof*, No. 3, 1962, pp. 30–32.

McNulty, Kneeland. *The Collected Prints of Ben Shahn.* Essay by the Artist. Philadelphia Museum of Art, 1967.

———, ed. *Peter Milton. Complete Etchings, 1960–1976.* Boston: Impressions Workshop, 1977.

Malanga, Gerard. "A Conversation with Andy Warhol." *The Print Collector's Newsletter*, Vol. 1, no. 6, January–February 1971, pp. 125–27.

Margo, Boris. *12 Cellocuts by Boris Margo. A Selection 1960–1971.* Introduction by Una E. Johnson. New York: Published by the Artist (portfolio of original prints), 1971.

Martin, Agnes and Ann Wilson. *The Untroubled Mind.* Philadelphia: Institute of Contemporary Art, 1973.

Mason, Lauris. *The Lithographs of George Bellows. Catalogue raisonné.* Millwood, N.J.: Kto Press, 1977.

Mazur, Michael. "Notes by the Artist." *Artist's Proof*, Vol. 10, 1970, pp. 19–29.

The Metropolitan Museum of Art. *American Watercolors, Drawings and Prints.* A national competitive exhibition, December 5, 1952–January 25, 1953. Cambridge, Mass.: Harvard University Press, 1952.

Michelson, Annette. *E pluribus unum: Les monotypes de Mark Tobey.* Exhibition catalog, April 1965. Paris: Galerie Jeanne Bucher, 1965.

Miller, Jo. *Josef Albers: Prints 1915–1976.* Brooklyn: The Brooklyn Museum, 1973.

———. "The Prints of Arshile Gorky." *The Brooklyn Museum Annual*, Vol. 6, 1964–1965, pp. 57–61.

Miller, Kenneth Hayes. *Etchings and Drypoints.* Introduction and catalog by Francine Tyler. Exhibition catalog, March 5–31, 1979. Edited by Sylvan Cole. New York: Associated American Artists, 1979.

Moffatt, Frederick C. *Arthur Wesley Dow, 1857–1922.* Published for the National Collection of Fine Arts. Washington, D.C.: Smithsonian Institution Press, 1977.

Morphat, Richard. *Andy Warhol.* Exhibition catalog, February 17–March 28, 1971. London: The Tate Gallery, 1971.

Morse, Peter. *John Sloan's Prints.* A Catalogue raisonné of the etchings, lithographs, and posters. New Haven, Conn.: Yale University Press, 1969.

Moser, Joan. *Atelier 17.* A 50th Anniversary Retrospective exhibition. Madison: University of Wisconsin, 1977.

Moy, Seong. *Rio Grande Graphics. Portfolio of Five Prints by Seong Moy.* Introduction by Una E. Johnson. New York: Ted Gotthelf, 1952 (original prints).

The Museum of Modern Art. *The Sculpture of Richard Hunt.* Introduction by William S. Lieberman and statements by Richard Hunt. New York: The Museum of Modern Art, 1971.

———. *Tamarind. Homage to Lithography.* Introduction by Virginia Allen. New York: The Museum of Modern Art, 1969.

The Newark Museum. *George Overbury "Pop" Hart, 1868–1933.* Exhibition catalog. Newark: The Newark Museum, 1935.

Oldenburg, Claes. *Recent Prints.* New York: M. Knoedler & Co., 1973.

Onichu, A. P. *Omar Rayo Prints, 1960–1970.* 473 illus. Bogotá, Colombia: Italgraf, n.d.

Pearlstein, Philip. *The Lithographs and Etchings of Philip Pearlstein.* Essay by Richard S. Fields. A Catalogue raisonné. Springfield, Mo.: Springfield Art Museum, 1978.

Peterdi, Gabor. *Printmaking. Methods Old and New.* New York: The Macmillan Company, 1959.

Ponce de Leon, Michael. "The Metal Collage Intaglio Print." *Artist's Proof*, No. 7, 1964, pp. 52–54.

Pousette-Dart, Nathaniel. *Ernest Haskell, His Life and Work.* New York: T. Spencer Huston, 1931.

Prasse, Leona. *Lyonel Feininger. A Definitive Catalogue of His Graphic Work. Etchings, Lithographs, Woodcuts.* Cleveland: Museum of Art, 1972.

Prescott, K. *The Complete Graphic Works of Ben Shahn.* New York: Quadrangle, 1973.

The Print Club of Cleveland. *Drewes.* The Catalog of an exhibition of Prints and Drawings by Werner Drewes. November 7–December 31, 1961. Catalog by Leona Prasse and Louise Richards. Cleveland: Cleveland Mu-

seum of Art, 1961.

————. *Gabor Peterdi.* Catalog of an exhibition of prints and drawings, 1943–1961. July 17–September 16, 1962. Cleveland: Cleveland Museum of Art, 1962.

————. *The Work of Antonio Frasconi, 1943–1952.* Exhibition catalog. Cleveland: Cleveland Museum of Art, 1952.

The Print Collector's Newsletter. Jacqueline Brody, ed. Vol. 1, 1970– .

Print Collector's Quarterly. An Anthology of Essays on Eminent Printmakers of the World. Selected and edited by Lauris Mason and Joan Ludman. Millwood, N.J.: Kto Press, 1977. (10 vols.)

Print Council of America. *American Prints Today.* 1959 and 1962. Exhibition catalogs. Edited by Theodore J. H. Gusten, illus. New York: Print Council of America, 1959 and 1962.

Print Review. Edited by Andrew Stasik. No. 1, 1973. New York: Pratt Graphics Center, 1973– .

Prints/Multiples. Exhibition catalog, November 16–December 23, 1969. Henry Gallery. Seattle: University of Washington, 1969.

Rauh, Emily. *Dan Flavin: Drawings, Diagrams and Prints. 1972–1975.* Exhibition catalog. Fort Worth, Texas: Fort Worth Art Museum, 1975.

Reese, Albert. *American Prize Prints of the 20th Century.* New York: American Artists Group [1949].

Reich, Sheldon. *John Marin: Oils, Watercolors and Drawings Which Relate to His Etchings.* Philadelphia: Philadelphia Museum of Art, 1969.

Reynolds, G. *The Engravings of S. W. Hayter.* London: Victoria and Albert Museum, 1967.

Rhys, Hedley Howell. *Maurice Prendergast, 1859–1924.* Boston: Boston Museum of Fine Arts and Harvard University Press, 1960.

Rose, Barbara. "Jasper Johns: Pictures and Concepts." *Arts Magazine,* Vol. 52, no. 3. November 1977, pp. 148–53.

————. *Jasper Johns, 6 Lithographs (after Untitled 1975), 1976.* Los Angeles: Gemini G.E.L., 1977.

————. *Readings in American Art Since 1900. A Documentary Survey.* Edited by Barbara Rose. New York: Frederick A. Praeger, 1968.

Rose, Bernece. *Jackson Pollock: Works on Paper.* New York: The Museum of Modern Art in Association with The Drawing Society, 1969.

Ross, John and Clare Romano. *The Complete Printmaker.* New York: The Free Press (Collier Macmillan Ltd., London), 1972.

Rothenstein, Michael. *Frontiers of Printmaking.* London: Studio Vista, 1962.

Russell, John and Suzi Gablik. *Pop Art Redefined.* New York: Frederick A. Praeger, 1969.

Saff, Donald and Deli Sacilotto. *Printmaking, History and Process.* New York: Holt, Rinehart and Winston, 1978.

Sasowsky, Norman. *The Prints of Reginald Marsh.* New York: Clarkson N. Potter, Inc., 1976.

Schmeckebier, Laurence. *Boris Margo. Graphic Work, 1932–1968.* Catalogue raisonné by Jan Gelb and Alexandra Schmeckebier. Syracuse, N.Y.: Syracuse University, 1968.

Karl Schrag. A Catalogue raisonné of the Graphic Works, 1939–1970. Commentary by Una E. Johnson. Syracuse, N.Y.: Syracuse University, 1971.

Schrag, Karl. "Light and Darkness in Contemporary Printmaking." *Print Review,* No. 7, 1977, pp. 44–48.

Scott, David W. and E. John Bullard. *John Sloan, 1871–*

1951. His Life and Paintings. His Graphics. Washington, D.C.: National Gallery of Art, 1971.

Seeber, Louise Combes. *George Elbert Burr, 1859–1934.* Catalogue raisonné and Guide to the Etched Works. Flagstaff, Arizona: Northland Press, 1971.

Serger, Helen. *Kurt Seligmann, His Graphic Work.* Exhibition catalog, March–April 1973. New York: La Boetie Gallery, 1973.

Shapiro, Michael. "Changing Variables: Chuck Close and His Prints." *The Print Collector's Newsletter,* Vol. 9, no. 3, July–August 1978, pp. 69–73.

Shahn, Ben. *The Shape of Content.* Cambridge, Mass.: Harvard University Press, 1957.

Raphael Soyer. Fifty Years of Printmaking, 1917–1967. Compiled and edited by Sylvan Cole, Jr. New York: Da Capo Press, 1978, rev. ed.

Tahir, Abe M., Jr. *Hnizdovsky Woodcuts, 1944–1975.* Gretna, La.: Pelican Publishing Co., 1976.

Tarbell, Roberta. *Peggy Bacon. Personalities and Places.* Checklist of prints by Janet A. Flint. National Collection of Fine Arts. Washington, D.C.: Smithsonian Institution Press, 1975.

Tomkins, Calvin. "The Moods of a Stone [Tatyana Grosman]." Profiles, *The New Yorker,* June 7, 1976, pp. 41–76.

Tousley, Nancy. *Prints: Bochner, LeWitt, Mangold, Marden, Martin, Renouf, Rockburne, Ryman.* Exhibition catalog, December 18, 1975–January 18, 1976. Toronto: Art Gallery of Ontario, 1975.

University of Kentucky. *Graphics Series.* Annual exhibition catalogs of recent American prints. 1958–1968. Lexington, Ky.: University of Kentucky.

Waldman, Diane. *Roy Lichtenstein, Drawings and Prints.* New York: Chelsea House, 1972.

Andy Warhol. Exhibition catalog. October 8–November 21, 1965. Philadelphia: Institute of Contemporary Art, University of Pennsylvania, 1965.

Wechler, Jeffery. *Surrealism and American Art, 1931–1947.* With collaboration and Introductory Essay by Jack J. Spector. Exhibition, March 5–April 24, 1977. New Brunswick, N.J.: Rutgers University Press, 1977.

Weitenkampf, Frank. *American Graphic Art.* New York: Henry Holt, 1912. Rev. ed. with Introduction by E. Maurice Bloch. New York: Johnson Reprint Corp., 1970.

Weyhe Gallery. *Prints and Drawings by Howard Cook.* Exhibition catalog, February 8–27, 1937. New York: Weyhe Gallery, 1937.

Whitney Museum of American Art. *Annual Exhibition—Sculpture and Prints, 1966.* New York: Whitney Museum of American Art, 1966.

Wight, Frederick A. *Lithographs from the Tamarind Workshop.* Catalog. Exhibition organized by UCLA Art Galleries, 1962–1963. Los Angeles: University of California Press, 1963.

Wittgenstein, Ludwig. *Tractatus Logico-philosophicus.* Introduction by Bertrand Russell. Trans. by D. F. Pears and B. F. McGuiness. London: Routledge & Kegan Paul, 1961, rev. ed. See also Anscome, G.E.M., *An Introduction to Wittgenstein's Tractatus.* Philadelphia: University of Pennsylvania Press, 1971.

Wuerth, Louis A. *A Catalogue of the Etchings of Joseph Pennell.* Boston: Little, Brown & Company, 1931. See also Beall, Karen F. *American Prints in the Library of Congress.*

Young, Joseph E. "Pages and Fuses: An Extended View of

Robert Rauschenberg." *The Print Collector's Newsletter,* Vol. 5, no. 2, May–June 1974, pp. 25–30.

Zigrosser, Carl. *The Artist in America.* New York: Alfred A. Knopf, 1942.

———. *The Complete Etchings of John Marin.* Catalogue raisonné. Philadelphia: Philadelphia Museum of Art, 1969.

———. "The Etchings of Edward Hopper." *Prints,* thirteen essays on the art of the print selected for the Print Council of America. New York: Holt, Rinehart and Winston, 1962, pp. 155–73.

———. *Misch Kohn.* Catalog for a Retrospective Exhibition. New York: American Federation of Arts, 1961.

———. *Mauricio Lasansky.* New York: American Federation of Arts, 1960.

———. "John Sloan Memorial. His Complete Graphic Work." *The Philadelphia Museum of Art Bulletin,* Vol. 51, no. 248, 1956.

INDEX